Art, Activism, and Oppositionality

ESSAYS FROM *AFTERIMAGE*

Edited by Grant H. Kester

Duke University Press Durham and London 1998

©1998 Duke University Press

All rights reserved

Printed in the United States of America on acid-free paper ∞

Typeset in Melior by Keystone Typesetting, Inc.

Library of Congress Cataloging-in-Publication Data

appear on the last printed page of this book.

Contents

Acknowledgments

I would like to express my sincere gratitude and thanks to all of the current and former *Afterimage* staff members who helped to make this anthology happen. These include Lynn Love (former managing editor), Nadine McGann (former coeditor), Karen vanMeenen (current managing editor), Gloria H. Sutton and Judith Nicholson (Nathan Cummings Foundation editorial interns 1994–95), and Anne Martens and Christine J. Russo (Visual Studies Workshop interns). I'd also like to thank Ken Wissoker for his great patience, David Trend for his encouragement and suggestions, and of course Nathan Lyons, for founding, and continuing to support, such an important publication. This anthology could not have been possible without the work of the editors, editorial staff members, designers, and interns who commissioned, edited, designed, fact-checked, and published these articles. They include Becky Boutch, Martha Chahroudi, Ruth Cowing, Charles Desmarais, Aimée Ergas, Brad Freeman, Lucinda Furlong, Bill Gaskins, Martha Gever, Catherine Higgins, Kurt Jones, Lorraine Kenny, Carol LaFayette, Patricia Lester, Rebecca Lewis, Verna Long-Baumgarten, Catherine Lord, Joan Lyons, Laura U. Marks, Scott McCarney, Dan Meinwald, Peter Mitchell, Tom Ognibene, Susan Dodge Peters, Lincoln Pettaway, Roy Robbennolt, Ellen Sanders Robinson, Annie Searle, Cylena Simonds, Anna Sobaski, Michael Starenko, David Trend, Barbara Warrick-Fischer, and Charles A. Wright Jr.

Grant H. Kester

Ongoing Negotiations: *Afterimage* and the Analysis of Activist Art

One or Two Things I Know about *Afterimage*

> In 1969, when the universities were being assaulted by students and police, Nathan Lyons and a handful of photographers and graduate students began to transform a wood-working shop into an educational center.—Alex Sweetman, *Afterimage*

Afterimage is the journal of the Visual Studies Workshop (VSW), the "artists' space" established by photographer, curator, and writer Nathan Lyons in Rochester, New York, in the late 1960s. Lyons founded the workshop after leaving the George Eastman House/International Museum of Photography (IMP) in Rochester, where he had been assistant director and chief curator. At the George Eastman House, Lyons was the editor of an IMP journal called *Image*. Thus when he decided to start a publication at the newly founded workshop, the name he chose marked both a personal and an institutional departure. What Lyons left behind was the restrictive environment of a traditional museum and archive. What he founded was an open-ended space that took a variety of forms—gallery, library/archive, educational program, media center, journal and book publishing—reflecting his varied interests, as well as those of Joan Lyons (who developed and continues to direct the book publishing and artists' books component of the workshop) and the many talented students and artists who have moved through the space over the years.

The quote above, from an essay by Alex Sweetman in the inaugural issue of *Afterimage,* captures something of the spirit of the early '70s.[1] There was at the time a desire to question existing structures of creative and intellectual practice while trying to build new institutional models. The quote also points to some of the issues that are at the center of this anthology. What is the relationship between art production and more direct (or at least more conventionally recognizable) forms of political struggle and protest? What constitutes an activist art practice? And what is the role of criticism, and the critic, in relation to such a practice? In the following introduction I will address these questions

from two perspectives. First, I will outline the general methodological approach employed by this anthology's contributors in analyzing activist cultural practices. This involves an attempt to identify the productive tensions that exist between activist practitioners and the specific ideological and institutional structures within which they work. In the second half of this introduction, I will outline some of the broader theoretical issues raised by a critical engagement with activist art.

It is necessary to begin by providing a sense of the historical background of *Afterimage,* and of the context in which these essays were written, published, and initially read. In the early days of *Afterimage,* the act of pushing against the boundaries of the image culture was seen as having at least some relationship to the broader climate of political dissent and activism. Charles Hagen begins his editorial in the first issue of *Afterimage* with a quote from Mao Tse-Tung ("All genuine knowledge originates in direct experience"), albeit, one suspects, with some degree of irony.[2] Issues of *Afterimage* from the mid-'70s are filled with images of intent, long-haired, (mostly) white young men grappling with copy stands and printing presses in a fluorescent-lit industrial space that was the original home of the workshop. Editorials and articles during this period convey an almost messianic fervor to advance a new understanding of visual meaning and visual production. There were, generally speaking, two primary modes of resistance enunciated at the workshop, and in the pages of *Afterimage.* First, there was an attempt to contest the then dominant tendency to view art photography as a form of pure expression that must remain uncontaminated by more mundane or quotidian uses of the medium. The challenge to this tendency was expressed by the incorporation of vernacular imagery in works by VSW students, as well as by the attention given to family snapshots, commercial photography, travel photography, and documentary by curators, historians, and critics in *Afterimage* articles and in the VSW exhibitions program.[3] Second, there was a desire to break down the division between the practicing artist and the historian or critic, resulting in new hybrid figures such as the "artist/curator" or the "artist/critic." Hollis Frampton, for example, made films and also wrote criticism. Nathan Lyons was a photographer as well as an editor, writer, and curator. Both the embrace of the vernacular and the desire to challenge disciplinary specialization anticipated the more recent interest in interdisciplinary approaches and popular, especially visual, culture in fields such as art history, cultural studies, and American studies.[4]

These modes of resistance or activism need to be understood in the context of the struggle taking place during the late '60s and early '70s to gain a greater legitimacy for photography, video, and artists' books as art forms. When the workshop was founded, there were still relatively few MFA programs in photography, film, or video, and the system of photography galleries, museum departments devoted to photography and video, festivals, alternative presses,

and media centers was just beginning to expand. Looking back over the early issues of the publication, it is clear that *Afterimage,* along with the workshop, was trying to build something quite new—a space (both textual and physical) dedicated to the interdisciplinary study of visual culture in all its manifestations. There was also a degree of populism involved in this endeavor, since artists' books, photography, and video were understood as potentially more democratic media than, for example, oil painting or marble sculpture. Thus the workshop was an early advocate of media literacy programs in Rochester's public schools and worked to widen the circulation of artists' books through the touring VSW Book Bus.

Both of these modes of resistance, the challenge to aesthetic purity and the challenge to existing disciplinary boundaries, were constituted within certain horizons dictated by the historical moment, institutional constraints, and the ideological orientation of the participants. Although there was a desire to explore the relationship between high art and vernacular culture, the ultimate goal was not, by and large, to eliminate the social category of the art photograph itself, but rather to expand this category and make it more reflective of the broader cultural functions of photography. In the same way, the effort to break down the specialization of the "critic" and the "artist" was not undertaken in order to challenge the cultural authority of either figure, but, at least in part, to provide some legitimacy for what was understood as the special knowledge brought to the act of writing history or criticism by the "practitioner." Thus, Michael Lesy, in a somewhat notorious attack on Susan Sontag's *On Photography,* questions the author's qualifications to discuss photography: "This is not a book of primary research, but rather a series of inventive, witty, and perversely whimsical suppositions and intuitions, based on second hand reports, brought by a messenger from the outside world. There is no evidence in the book that its author has ever used a still camera, engaged in research in a photographic archive, or interviewed any practitioners of the medium."[5]

Despite the defensiveness suggested by Lesy's nervous reference to the "outside world," the concern with practice and the figure of the practitioner (as opposed to the mere "consumer" of images) conveys a certain egalitarianism by insisting that the image maker possess not only a set of technical skills but also a legitimate form of analytic knowledge. It also challenges the separation of theoretical and practical knowledge. The attempt to bridge the gap between theory and practice created a conflict, evident in the pages of *Afterimage* itself, between the demand for a more systematic account of visual meaning (one that would employ "unique methods of interpretation and standards of evaluation," to cite an early essay) and the desire to preserve what was viewed as the polyvalence (and for some the utter ineffability) of the image, especially the art/photographic image.[6] Within this hermeneutic investigation, the social context of both art practice and criticism, although implicit in many ways, was

often bracketed. The practitioner was assumed to be universal in theory, even though he was, more often than not, straight, white, male, and middle-class. At the same time, activism was defined largely in terms of the struggle to establish both a new model of visual and media arts practice and the interpretive norms appropriate to this practice. There were certainly essays in *Afterimage* that addressed broader questions of cultural politics, such as the advocacy of visual or media literacy programs. However, this was primarily a period of consolidation in which simply supporting informed criticism of photography, independent film and video, and artists' books constituted an implicit protest against their exclusion from the institutional and critical apparatus of the mainstream art world.

These two interrelated questions—the specific identity of the practitioner and the cultural location of political struggle—would become the fulcrum points for a new approach to the analysis of art and culture in *Afterimage* beginning in the early 1980s, under the editorial leadership of Martha Gever, Catherine Lord, and David Trend. During this period politically engaged visual and media artists were working to bridge the gap between their practice and the "outside world," beyond the gallery, art school, or studio. This new activist practice was informed by two historical factors: the growing cultural diversity of visual and media artists and the consolidation at approximately the same time of an organized movement of religious and political conservatives opposed to the public funding of "controversial" art. During the late '70s and early '80s the fields of photography and independent film and video underwent a considerable expansion as new journals, exhibition spaces, and educational programs emerged across the country. This growth was combined with certain demographic transitions as more women, gays and lesbians, and people of color began to move through MFA programs and into positions as teachers, writers, curators, and practicing artists. Although their numbers were hardly overwhelming, they were sufficient to pose a challenge to nascent critical and creative methodologies in art photography and independent film and video. This shift was evident in *Afterimage* coverage of the activities of the "Women's Caucus" of the Society for Photographic Education (SPE). The Women's Caucus was formed in the early 1980s in an attempt to make SPE programming and policies more responsive to the organization's increasingly diverse membership. Extended battles were staged over the allocation of funds for conference programming, the editorial direction of the SPE journal *exposure,* and the generation of studies of hiring practices in the field, which were scrupulously reported in *Afterimage*'s reports following the annual SPE conference. Photographic historian Bill Jay's jeremiad against the Women's Caucus, published in *Shots* in 1989 (in which he describes it as "a nasty little pimple on the face of photographic education"), illustrates the level of rancor that these changes evoked among some members of the photographic community.[7]

At a time when most mainstream art magazines were celebrating the heroic return of painting (at least by male neo-expressionists) or the art collecting boom in western Europe, *Afterimage* was publishing articles and interviews that openly challenged hagiographic models of art history.[8] Editors Lord and Gever and, somewhat later, Nadine McGann, were instrumental in bringing analyses of sexual difference and queer theory to the pages of *Afterimage* in discussions of media and visual artworks by gay and lesbian producers.[9] In the case of Jan Zita Grover's widely reprinted essay "Visible Lesions: Images of PWA's" (summer 1989) or Ann Cvetkovich's "Video, AIDS, and Activism" (included here), the work was created in response to the growing AIDS crisis. This ongoing investigation into the construction of identity was expanded to include questions of racial and ethnic difference. Coco Fusco's "Fantasies of Oppositionality" (included here) explores the problematic status of the racial or ethnic Other in "avant-garde" film programming. Fusco's essay, along with Lorraine O'Grady's essay on black female subjectivity (also included here), advances a critique of feminist psychoanalytic theories of identity based on their implicit privileging of a white, European subject. Recent *Afterimage* essays by Darrell Moore and Mable Haddock and Chiquita Mullins Lee (included here as well) have questioned the liberal openness of "multicultural" patronage and programming in the visual and media arts.

At the same time, *Afterimage*'s writers were bringing attention to an increasingly diverse range of oppositional practices, from labor cable access shows to Felipe Ehrenberg's mimeograph workshops, and from community video projects to the strategically altered billboards of Australia's B.U.G.A.U.P. (Billboard-Using Graffitists against Unhealthy Products). Artist and critic Richard Bolton developed a series of text-based installations and essays that expanded the possibilities of an explicitly pedagogical approach to art activism. His essay "Enlightened Self-Interest: The Avant-Garde in the '80s" (included here) was written in conjunction with an installation that examined the ways in which art and the figure of the artist are capitalized on by both the media and the market. David Trend published a series of influential articles on the production of community-based art projects (including "Cultural Struggle and Educational Activism," which appears in this volume) and established an important rapprochement between critical pedagogy and media activism in the pages of *Afterimage* through his own writings and through interviews with figures such as Henry Giroux.[10]

Although the essays published in *Afterimage* are not characterized by any single, unifying theme or point of view, it is possible to identify a general set of concerns, which are represented in the two sections of this anthology. The first group of essays offers analyses of cultural patronage. More specifically, these essays examine the relationship between forms of patronage and the pedagogical work of the curator, programmer, artist, and educator. Patronage is un-

derstood here to refer not only to the question of how cultural production is funded, but also to the process by which audiences or constituencies are formed by a given work. Clearly, funding agencies and the gallery and museum system itself, whether they are explicitly acknowledged or not, constitute one of the primary "audiences" for the artists' work. As Owen Kelly has noted in regard to community art practice in the United Kingdom: "The communities with whom we work are not really our customers. . . . they are the raw material upon which we work, on behalf of our customers, who are the agencies to whom we sell the reports and documentary evidence of our work."[11] Yet the artist can also play an active role in constructing new kinds of relationships with a range of different audiences. Further, the subject positions that the artist makes available to potential viewers can be quite varied. Audience members might be positioned in a given piece or project through sympathetic identification, shock and provocation, didactic education, active collaboration, and so on. The essays in the second section of this anthology provide analyses of activist art practice in a variety of disciplines, including film and video, photography, installation, and community-based works. The areas of activism examined include struggles over AIDS, reproductive rights, and racial identity, as well as both progressive and conservative forms of political organizing.[12]

Having established this conceptual or thematic division, it is at the same time necessary to challenge it. The essays on activism in many cases include discussions of audience and funding structures, while the essays on patronage also include case studies of particular activist projects and producers. What is significant here, as the reflection of a new direction in the analysis of art and culture, is the attempt to combine readings of the broader institutional and ideological structures of cultural patronage with readings of specific examples of art practice. Often these areas of research are treated independently, with discussions of art practice taking place as though the act of making a work bore little or no relationship to the structuring discourses of the institutions that contain and present it, or the funding sources that help bring it into public existence. At the same time, readings of patronage often tend to overlook the complex negotiations that take place as individual artists produce projects with and through these broader institutional networks. I do not want to suggest that what I have termed patronage (referring to both the financial/institutional basis for a work and the audience for that work) and practice (or the discrete set of actions engaged in by a given artist in the production of a given work) constitute a kind of langue and parole of art making in which implacable "structures" dictated by monolithic institutions predetermine the artists' every move. These structures are not monolithic, although they do establish certain horizons for practice that often go unacknowledged. However, these horizons, once recognized, are themselves subject to contestation and expansion as well as contraction. In addition, in some community-based projects, practice and patronage are not separate activities, but rather are integrated as part of a more

dialogical form of collaboration. It is precisely the interaction between institutional structures and practice that has been neglected by most mainstream art criticism (with its focus on "text" over "context") during the last decade and a half. And it is this same interaction that has engaged many of *Afterimage*'s most thoughtful contributors.

One of the virtues of the essays collected here is that they attempt to preserve the complexity of the relationship between the domain of individual decision making and negotiation (understood as "creative," "political," etc.) and the institutional structures within which those decisions are made. This acknowledgment can produce a new set of ideas about what constitutes art as well as activism. The works under discussion here demand a new critical methodology that can replace conventional concepts such as the static and autonomous "work of art" with a more subtle and comprehensive analysis of the unfolding *process* of meaning production. This is a process in which the specific subject positions of both the maker and the viewer, rather than being repressed under the guise of an aesthetic transcendence, are continually renegotiated. The essays in this anthology insist on the continuing relevance of an activist orientation to contemporary art practice and criticism. Further, they insist on the significance of an engaged art practice that is aligned with, but not identical to, social or political activism per se. There is a not uncommon perception in the arts today that the fashion for an activist or politically engaged art has passed. On the one hand, some artists and critics are anxious to move "beyond" the perceived limitations of this work, while at the same time they are relieved to get back to the "real business" of art making.

This double movement is clear in the recent call for a return to the aesthetic philosophy of the early modern period. Concepts such as beauty, taste, or the sublime that might have previously been dismissed as outdated are now being presented as the hallmarks of a new and challenging form of art that manages to be both visually seductive and politically powerful.[13] In this view an overtly activist art practice is seen to sacrifice the unique power of the aesthetic to convey a subversive pleasure. I would argue, however, that an activist art practice, far from being antithetical to the "true" meaning of the aesthetic, can also be viewed as one of its most legitimate expressions. As I will argue in the second half of this introduction, the questions raised by the aesthetic during the early modern period provide a useful framework through which to understand and evaluate activist art.

Frameworks—Activism and the Aesthetic

Take away from a painting all representation, all signification, any theme and any text-as-meaning, removing from it also all the material. . . . efface any design oriented by a determinable end, subtract the wall-background, its social, historical, economic, political supports, etc.; what is left? The frame.—Jacques Derrida, *The Truth in Painting*

One of the most important contributions that *Afterimage* has made to the analysis of contemporary art lies in the ongoing attempt by its contributors to challenge and expand the techniques of traditional criticism. This is particularly evident in essays that are concerned with activist or politically engaged works that require the critic to fundamentally rethink the nature of the work and experience of art. A traditional, formalist critical approach is premised on a clear separation between the realm of the artwork and the realm of political decision making, and between the artist as a private, expressive subject and the domain of social exchange and collective will-formation. In order to engage with, and evaluate, works that challenge this separation it is necessary to develop new analytic systems. At the same time activist artists and critics are confronted by the need to preserve the specificity of activist *art,* as a practice that is discrete from other forms of political activism. As I have suggested above, we can discover a basis for this endeavor by turning back to the construction of the aesthetic as a unique form of knowledge in early modern philosophy.

In the writings of Kant, Schiller, Hutcheson, and Shaftesbury, the aesthetic is linked to the social and the political through its function as a mediating discourse between subject and object, between the somatic and the rational, and between the individual and the social (e.g., Shaftesbury's *sensus communis* or Kant's *Gemeinsinn*). There are two interrelated features of the aesthetic that are particularly significant for the analysis of activist art. First, the aesthetic can be defined as an ideal political and ontological form (i.e., the aesthetic as the telos, norm, or utopian goal of social organization or of intersubjective communication). It is in this sense that the aesthetic can be said to incorporate a moral dimension, as the expression of a utopian drive to imagine a more ideal form of social life beyond the brute facticity of what is. Second is the capacity of aesthetic knowledge to overcome the particularity of existing systems of representation and to comprehend a larger totality defined by otherwise suppressed interrelationships—to literally visualize or embody these relationships. These aspects combine to provide the aesthetic with a unique ability to identify and describe the operations of political, social, cultural, and economic power, while at the same time allowing it to think beyond the horizons established by these forms of power.

This transgressive and critical power has been linked in the modern era with a very specific set of restrictions. The tradition of aesthetic liberalism, embodied in Greenbergian formalism, is postulated on the belief that art can retain its authenticity only by remaining within the charmed circle of social disengagement.[14] Once art steps beyond this circle, and moves from a sublime self-reflexivity to direct involvement with the social or the political, its moral authority vanishes and it becomes instead a mundane extension of everyday culture. It is interesting to note the similarities between this view of the aes-

thetic and Victorian models of femininity that argued that women possessed an inherent moral superiority that could be exercised only so long as they withdrew from the public world of work and politics and remained within the home. From this sanctuary they could maintain the uncontaminated purity of their moral power and thereby provide their husbands with the armor necessary to survive the temptations and challenges of the dirty and dangerous world beyond. Women gained their moral transcendence over men and the "real" world of work precisely through their detachment from it.[15] In the same way the aesthetic retains its moral transcendence by steadfastly refusing any direct engagement with the social world beyond the "domestic" enclave of the gallery and the museum.

We find echoes of this outlook in the work of more contemporary critics such as Michael Fried, who, in his influential essay "Art and Objecthood" (1967), rejected the insolent "theatricality" of artworks that impetuously solicit the viewer in favor of a chaste and demure "presentness." Fried differentiates "literalist" art, in which the viewer is implicated, from an artwork that presents itself as timeless and indifferent to anything but itself, existing thereby in a state of "grace" (the inevitable moral dimension of the aesthetic, which Fried allows only in the closing line of his essay).[16] For Greenberg the production of "avant-garde" art requires that the artist "retire . . . from the public altogether."[17] Within this disabling domesticity an exaggerated and compensatory rhetoric of virility and heroism is attached to the most mundane symbolic actions (Pollock's dribbles, de Kooning's slashes, Yves Klein's leap, Schnabel's broken plates, etc.). This gesture of withdrawal has been one of the most common methods by which modern art has registered its protest against any number of cultural and political conditions (kitsch, fascism, or a generalized sense of anomie, malaise, and fragmentation associated with modernity), and expressed its longing for some organic and integrated expression of human creativity.

Artists during the post–World War II era displayed remarkable ingenuity in embodying their ambivalence and/or anger about modern cultural and political life through the production of discrete objects. However, this vast ingenuity is suddenly arrested when it comes to thinking creatively about how these objects might produce meaning and interact with viewers beyond the precincts of the gallery, the museum, the art school, or the pages of art magazines. Thus the moral dimension of the aesthetic, its drive to envision a more just and equitable society, has often been expressed through the manufacture of a highly coded commentary (in turns wry and ironic, serious and austere, elegiac, cynical, impassioned, or euphoric) on the demise of various humanist values and virtues (the integrity of the well-crafted object, creative labor, spirituality, community, beauty, etc.). At the same time, the ability of aesthetic knowledge to grasp the complex totality of a given system of meaning has

within this tradition often been confined to the exploration of the formal and technical conditions of the art-making process itself, whether in terms of the formal elements of shape, line, color, and mark, or the abstracted conceptual categories of object, process, and transformation. This didacticism of materials, the call for a "return" to the object and somatic forms of knowledge, has become especially pronounced in recent years, as part of a more general art world backlash against the twin specters of multiculturalism and theory.

Is it possible to think of the aesthetic differently? Is there another way in which the systematic orientation, self-reflexivity, and moral vision of the aesthetic might be figured or reclaimed? We can discover one set of answers to these questions if we turn to contemporary activist art practice. Hans Haacke's work, and in particular the shift that took place in his practice during the early '70s, provides a valuable set of coordinates for what might be termed an activist aesthetic philosophy. Moreover, it can shed some light on the questions of art and political engagement that would subsequently emerge in the pages of *Afterimage*. Haacke's early works, such as *Condensation Cube* (1963/65), *Live Airborne System* (1965/68), *Grass Grows* (1967/69), and *Circulation* (1969) combined his interest in systems theory with a conceptual art focus on process to examine ecological or environmental systems (the climate of the gallery, the growth of grass on a mound of dirt, etc.). These works can be viewed as part of the general interest at that time among artists such as Michael Heizer, Robert Smithson, Helen and Newton Harrison, and others in nature as a site at which to deploy various conceptual art strategies, and as a way to escape the perceived limitations of the conventional "white cube" of the gallery.[18] Here the transgressive power of the aesthetic is expressed in the desire for a more comprehensive way to frame and analyze a particular location (the desert, the ecosystem, etc.). Further, the interest in "site-specific" projects functioned to challenge the immanence of the modernist art object. Robert Irwin's light "sculptures," for example, raised the question of how the specific location of a work, or the viewer's orientation toward it, changed the work's perceptual meaning. This concern is made even more explicit in Adrian Piper's works during the early '70s, such as the "Catalysis" series of site-specific performances. (See the interview with her by Maurice Berger in the second part of this volume.) As Piper wrote at the time, "I've been doing pieces the significance and experience of which is defined as completely as possible by the viewer's reaction and interpretation. Ideally the work has no meaning or independent existence outside of its function as a medium of change; it exists only as a catalytic agent between myself and the viewer."[19] Dan Graham's video, installation, and performance works during this period provide another example of the interest in what might be termed the spatial politics of the spectator or viewer.[20]

In these works aesthetic knowledge transgresses existing boundaries and

categories (the verities of an aesthetic epistemology that posits the art object as the repository of an immanent and noncontingent meaning). However, if one is willing to question the way in which the physical environment, location, or orientation of the viewer changes the meaning of a piece, why not expand that inquiry to include the way in which the viewer's social "location" changes that meaning as well? This is the decisive step that Haacke took with his *Gallery-Goers Birthplace and Residence Profile* at the Howard Wise Gallery in 1969. Haacke collected information from viewers (who identified their homes by placing pins in a map of New York), demonstrating just how "closely confined" the "art world" is.[21] This marks a decisive shift in Haacke's art to works that openly acknowledge the presence of the viewer, not as an anonymously transcendent subject, but as the product of particular social, economic, and geographic conditions. (It is similar to the shift that I identified above in the essays in *Afterimage* that began to focus on the artist as an individual positioned by specific differences of race, sexuality, gender and class.) Further, it suggests that these conditions act as mediating factors in the work's production of meaning. Piper's *Mythic Being* series (1973–75) and later works provide an equally important manifestation of this shift.[22]

In *Shapolsky et al. Manhattan Real Estate Holdings, a Real-Time Social System, as of May 1, 1971* and *Sol Goldman and Alex DiLorenzo Manhattan Real Estate Holdings, a Real-Time Social System, as of May 1, 1971,* Haacke's concept of the "system" of art meaning expanded to include the financial interests that supported and in some cases controlled museums themselves. It was this work, scheduled to be shown at the Guggenheim museum on April 30, 1971, and canceled on April 1, that elicited the following comments from Thomas Messer, director of the Guggenheims:

> To the degree to which an artist deliberately pursues aims that lie beyond art, his very concentration upon ulterior ends stands in conflict with the intrinsic nature of the work as an end in itself. The conclusion is that the sense of inappropriateness that was felt from the start toward Haacke's "social system" exhibit was due to an aesthetic weakness which interacted with a forcing of art boundaries. The tensions within this contradiction in the work itself transferred itself from it onto the museum environment and beyond it into society at large. Eventually, the choice was between the acceptance of or rejection of an alien substance that had entered the art museum organism.[23]

For Messer, Haacke had taken the transgressive power of the aesthetic a bit too far. His work had violated the implicit contract of social disengagement required by the tradition of aesthetic liberalism and could no longer be accorded the moral protection of the museum. His work had become "an alien substance."[24] While Haacke has, of course, gone on to produce a large body of

work, I am focusing on this moment in particular because it shows in the clearest way how the orientation of a transgressive aesthetic knowledge was defined and subsequently redefined to account for the social basis of aesthetic experience. Instead of Fried's mute "presence" (or even Robert Irwin's transcendental phenomenology), we have works that openly engage the audience in an interactive manner. Rather than presenting the viewer with a predetermined and immanent meaning, these projects, as Piper writes, only produce their meaning in a dialogical encounter between the viewer (understood as a socially specific subject) and the work.

In the preceding discussion I identified two key moments within the tradition of the modernist aesthetic. The first is the transgressive force of aesthetic knowledge. As in Kant's third *Critique* the aesthetic is that mode of knowledge that can overcome the boundaries of conventional thought (the opposition between reason and sense, or between subjective and objective judgment, for example). The aesthetic, as Derrida writes of the Kantian sublime, is the surplus that always threatens to exceed the frame of reason (even as it depends on the frame for its very existence).[25] The second is the moral/teleological dimension of aesthetic knowledge, which allows it to envision a more just and humane form of human society (even if it can only be evoked in the discrete encounter between the viewer and the work of art). These two dynamics combine to provide the aesthetic with the power to grasp the totality of social relations in a more systematic or comprehensive manner. It is this power that Haacke, Piper, and other artists claimed in their works during the early 1970s. These artists offered a radically new way in which to think of the transgressive function of the aesthetic.

This model was taken up by a number of artists and groups working throughout the '70s, '80s, and into the '90s, including The Guerrilla Art Action Group, Suzanne Lacy, Fred Lonidier, Martha Rosler, Alan Sekula, and Political Art Documentation and Distribution (PADD), among many others, and more recently by artists and collectives such as Group Material, Repo History, and the collaborative projects of David Avalos, Louis Hock, and Elizabeth Sisco. In these works an activist practice informed by conceptual art intersects with the activist, public, and community-based projects covered by *Afterimage* over the last fifteen years. For these artists the transgressive power of aesthetic knowledge is important precisely because it can be used to investigate the boundaries that are drawn between political and aesthetic experience, and political and cultural action. As Sisco noted in a discussion of the Art Rebate/Arte Reembolso project of 1995, "Art is about framing and re-framing things, and [David Avalos, Louis Hock, and I] think that the way that this issue [undocumented immigrant workers in Southern California] has been framed is a problem.[26] In other words, Sisco and her collaborators bring an aesthetic awareness of the function of framing (in which what is excluded is as important as what is

included) to their examination of the ways in which the mass media and politicians in Southern California have worked to construct a particular image of undocumented immigrant workers.[27]

Although questions of identity were increasingly central to art theory and practice during the last decade and a half, the broader terrain of cultural politics began to shift decisively. The period covered by these essays begins with Ronald Reagan's victory over Jimmy Carter in the 1980 presidential election and ends with the establishment of a Republican majority in both the House and the Senate following the 1994 congressional elections. This has been an era of profound political realignment in the United States, during which the liberal consensus of the Great Society was slowly but thoroughly dismantled, along with the social and cultural programs that were brought into existence by that consensus. Martha Rosler, in her "Theses on Defunding," provides one of the earliest accounts of a growing conservatism in corporate and public arts funding policy. The downward spiral that began with Reagan's first attempt to slash the National Endowment for the Arts' (NEA) budget in 1981 (and the successful elimination of funding for arts criticism in 1984) is now approaching its culmination in the threatened elimination of both the NEA and the National Endowment for the Humanities (NEH) by the Republican Congress.

Many of the essays in this anthology reflect the search among artists and critics for new strategies to challenge the now dominant conservative consensus. As conservatives have appropriated many of the tools and techniques of '50s civil rights and '60s student activists, albeit with access to a vast pool of corporate and foundation funding that was never available to either of these groups, progressive artists are faced with a number of troubling questions. How do artists position themselves within this complex and changing political climate? In particular, how do we understand art activism in this new context? What kinds of progressive or activist cultural practices will be most effective in challenging conservative power? What is the relationship between the form taken by an activist cultural practice and its goals? What relationships should artists establish with their audience, constituencies, or communities? What can we learn from past examples of art and cultural activism? Finally, how does the formulation of an activist art practice relate to the questions of difference and identity politics that are at the center of contemporary media and visual arts theory? One of the chief strategies the conservative movement has used to weld together an electoral consensus has been the creation of powerful images of pathologized Others (migrant workers, mothers on welfare, young black "criminals," etc.). Ioannis Mookas explores this process in his essay "Fault Lines: Homophobic Innovation in *Gay Rights, Special Rights*." Artists are skilled in the modulation of symbolic meaning. In this respect, they are ideally suited to engage, and subvert, the image politics of the conservative consensus. The projects of Avalos, Hock, and Sisco show just how essential a

representational politics is to the cultural work of the conservative consensus, and just how effective artists can be in challenging it.

One of the most promising directions for activist cultural practice today is suggested by a recent essay on movement politics by Frances Fox Piven and Richard A. Cloward. Piven and Cloward, who have been influential as analysts of, and participants in, progressive political movements for the past three decades, argue that movements emerge when the configuration of party-based political power no longer responds to the demands of existing constituencies and communities.[28] This is of course what happened during the late '60s and early '70s when the Democratic Party was forced to respond in some measure to movement-based demands for greater political power by women and people of color. Piven and Cloward offer a useful diagnosis of the rise of the conservative movement and its ability to weaken the Democratic Party's electoral base through an appeal to gender- and race-based conflicts within the American public. Whereas party politicians work to achieve consensus and to smother differences and conflicts, movements work to exacerbate those conflicts and provide a language that will bring them to the surface of existing political debate. Thus conservatives were able to offer formerly Democratic southern voters who were experiencing a real decline in their standard of living an explanatory narrative and a vivid set of images that would turn them against feminist and African American demands for greater equality and opportunity. As Piven and Cloward write: "The inflammatory rhetoric and dramatic representations of collective indignation associated with these tactics project new definitions of social reality, or definitions of the social reality of new groups, into public discourse. They change understandings not only of what is real but of what is possible and of what is just. As a result, grievances that are otherwise naturalized or submerged become political issues."[29] This is precisely what conservatives have done so effectively within the Republican Party by articulating (and amplifying) the political and cultural desires (and fears) of religious conservatives and a small but electorally crucial segment of "middle America." In the process they have fundamentally altered the political debate on welfare policy, racial inequality, poverty, and the role of the state. Conservatives have been able to provide working-class and lower-middle-class white voters with a convincing narrative that explains their declining standard of living not as a product of corporate decision making or global investment policies, but as the direct result of the parasitic moral depravity of young mothers on welfare, gay and lesbian artists, poor people of color, immigrant workers, and abortion doctors, overseen by a cabalistic liberal elite. By emphasizing the idea of a moral and cultural decay, and linking it with what Barbara Ehrenreich has called the "fear of falling," conservatives have been able to portray themselves as populists for perhaps the first time in the post–World War II era. This represents a singular ideological achievement, since the Republican Party has traditionally suffered among working-class and lower-

middle-class voters owing to its pro-corporate image. This shift has been brought about in large measure by the rapprochement between old-line fiscal conservatives and religious conservatives, who have been able to overcome the traditional resistance among southern voters, especially working-class and lower-middle-class voters, to the party of Lincoln.

How long can this strategy work? Clearly the "outsider" stance so favored by conservatives has already begun to lose its credibility. Along with their wholesale elimination of what remained of liberal social and cultural programs, this presents them with a dilemma that is at the heart of conservatism: how to build and sustain a political community without an enemy. Without liberalism to blame anymore, the conservative-fundamentalist coalition will be under increasing pressure to account for the persistence of the conditions it has so relentlessly associated with liberalism's pernicious influence (e.g., crime, poverty, declining American productivity, etc.). The shibboleth of cultural decay will only function for so long before people begin to ask questions, as they already have, about the morality of conservative economic policies that favor the rich and powerful and punish the poor and working class, and fundamentalist religious leaders who encourage hatred, and even violence, against nonbelievers. There is a growing discontent among the people and the communities that are treated by the conservative coalition merely as signifiers of difference and moral depravity, and that have been excluded from current political debate precisely because of the effectiveness of the political-cultural narratives and images promulgated by conservatives.

How can activist artists work with and through these communities? This is one of the most important questions facing critics, advocates, and practitioners of a politically engaged art practice today. I would argue that the current political moment demands an activist aesthetic based on performativity and localism, rather than on the immanence and universality that are the hallmarks of traditional aesthetics. Performativity is a concept that has emerged in a number of areas in recent cultural criticism to describe a practice that is adaptive and improvisational rather than originary and fixed.[30] Within this outlook the work of art is less a discrete object than it is a process of dialogue, exchange, and even collaboration that responds to the changing conditions and needs of both viewer and maker. Instead of an aesthetic centered on a "paradigm of consciousness" (the consciousness of the expressive artistic subject), an activist art is premised on what Habermas has defined as an intersubjective "communicative action."[31] Linked with performativity is the importance of localism. Artists recognize that the process of shared dialogue can proceed most effectively if they function not as privileged outsiders, but as coparticipants who are intimately involved in the concerns of the community or constituency with which they work. This "community" may be defined by such factors as geographic location, commitment to a specific political issue or movement, or identity based on race, gender, sexuality or class. In some of the most effective activist

projects, the tactical nuances allowed by performativity and localism are combined with the systematic comprehension and moral vision previously described as part of a refigured aesthetic discourse.

The projects of Avalos, Hock, and Sisco offer a useful example of how an activist aesthetic based on localism and performativity can play a direct role in "project[ing] new definitions of social reality" and new understandings of "what is possible . . . and just." All three have lived in San Diego for many years and as a result have developed a deep understanding of the complex interrelationships of economic and political power, and race-, class-, and gender-based violence and discrimination in the city. Their long commitment to the area has also allowed them to develop their own community, consisting of other artists, political activists, neighbors, neighborhood organizers, and sociologists and other academics concerned with the region. They are able to turn to this network for support, collaborative assistance, political and cultural information, and as a bridge to new communities. In the "Art Rebate/Arte Reembolso" project (1993), they distributed signed ten-dollar bills to undocumented workers as a symbolic recognition of their contribution to the Southern California economy. The work was developed to directly challenge conservative arguments that migrant workers constitute a negative drain on the state's resources. As Avalos, Hock, and Sisco discovered, undocumented workers make a substantial contribution to the economy, not merely through the profits they provide for their employers, but also through what they spend in the United States and the taxes that are deducted from their pay.

The symbolic gesture of the ten-dollar "rebate" had a much more effective resonance than it might otherwise have had because of the creative control that Avalos, Hock, and Sisco exercised over news coverage. Their handling of the individual performances was modulated in response to the kind of media attention that the project received. Upon discovering that U.S. news crews in particular were fixing on the image of the undocumented worker receiving money (which could be used to reinforce the very perception that they wished to contest), rather than on the contribution that the workers make to the U.S. economy, they prevented them from taping this part of the performance. Thus the "meaning" of the piece was not merely the signed bills, nor the act of distributing them, but also the subsequent coverage of the event by the media. Further, they collaborated with researchers, social service providers, and advocates for immigrants rights in developing the project, and involved them in the process of explaining the "performance" to each of the workers who received a ten-dollar bill. Their goal in the project was, as Sisco has noted, to "redefine community to include those who have been left out."[32] This work exemplifies a reinvented aesthetic that has effectively transformed the tools of conventional aesthetic knowledge. It is based on the utopian ability to imagine a better world, as well as the power to critically comprehend a broader social, cultural,

and economic "ecology." Within this process artists, as well as critics, must look both inward, to interrogate the internal conditions of their practice and their own role within that practice, and outward, to examine the systematic structures that influence the way in which their practice is actualized in the world. These two movements are represented in this anthology by the parallel concerns with patronage and funding, and with the pragmatics of an activist cultural practice.

Artists today are operating in an environment in which the formerly expansive umbrella of support for the arts is rapidly closing. The liberal consensus that had partially sheltered the NEA through so many controversies during the past decade and a half (the belief that art represents a socially and culturally valuable practice in and of itself, and that the state has a legitimate role in supporting its production) is very nearly exhausted. The assumption that the public *necessarily* values art making and the artist can no longer be sustained. As we move toward a society in which the buffering institutions of the liberal state gradually disappear, artists will be confronted with the difficult choice between quietism and withdrawal or renewed engagement. It is necessary, perhaps now more than ever, to think critically but constructively about what constitutes an effective activist art practice. The essays in this anthology offer one set of guideposts for this inquiry. We hope that it can act as both a record of this inquiry as it unfolded in the pages of *Afterimage* and as an incitement to carry it on into the future.

Notes

1 Alex Sweetman, "Everything Overlaps: There Are No Edges," *Afterimage* 1, no. 1 (March 1972): 2–3.

2 "As Mao said in 1937, 'All genuine knowledge originates in direct experience.' Why not join us?" Charles M. Hagen, "Editorial: A Position of Service," *Afterimage* 1, no. 1 (March 1972): 4.

3 This is a tendency that continues to the current day at the workshop. See the catalog for *From the Background to the Foreground: The Photo Backdrop and Cultural Expression,* published as *Afterimage* 24, no. 5 (March/April 1997). This exhibition was curated by James Wyman of the Visual Studies Workshop.

4 See Scott Heller, "Visual Images Replace Text as Focal Point for Many Scholars," *Chronicle of Higher Education,* 19 July 1996, A–15. See also "Questionnaire on Visual Culture," *October* 77 (summer 1996): 25–70.

5 Michael Lesy, "Review of Susan Sontag's *On Photography,*" *Afterimage* 5, no. 7 (January 1978): 5.

6 "Is there anything peculiarly 'photographic' about photography—something which sets it apart from all other ways of making pictures? If there is, how important is it to our understanding of photos? Are photographs so unlike other sorts of pictures as to require unique methods of interpretation and standards of evaluation?" Joel Snyder and Neil Walsh Allen, "Photography, Vision, and Representation," *Afterimage* 3, no. 7 (January 1976): 8.

7 As Jay writes, "The issue is this: a minority group of radical feminists/pseudo-Marxists

has, through a process of intimidation, gained a position of power in the medium which has distorted and subverted topics of critical and historical importance in the medium." Bill Jay, "Fascism of the Left," *Shots* 13 (January/February 1989): 22. See Catherine Lord's response: "Herstory, Their Story, and (Male) Hysteria," in *Afterimage* 18, no. 1 (summer 1990): 9–10. An *Afterimage* readers' survey, conducted in 1992, suggests the extent to which the "field" of the media and visual arts remains divided by deep cultural and political differences. Although the majority of respondents applauded coverage of film and video by women, gays, and people of color, a significant number also articulated a strong resentment of this work ("Enough already with the third world video; you've seen one, you've seen them all. More first person responses and reflections of artists and photographers.") The art world is clearly not immune to the same kinds of race- and gender-based antagonisms that have provided a foundation for the current anti–affirmative action backlash among conservative voters. "1992 *Afterimage* Readers' Survey," *Afterimage* 20, no. 2 (September 1992): 3.

8 These include Martha Gever's critique of the "canonization" of Nam June Paik, Sally Stein's revisionist account of the documentary photography of Jacob Riis, and Abigail Solomon-Godeau's investigation of the renewed interest in the work of Alfred Steiglitz during the mid-'80s. See Martha Gever, "The Canonization of Nam June Paik," *Afterimage* 10, no. 3 (October 1982); Sally Stein, "Making Connections with the Camera: Photography and Social Mobility in the Career of Jacob Riis," *Afterimage* 11, no. 10 (May 1983); and Abigail Solomon-Godeau, "Back to Basics: The Return of Steiglitz," *Afterimage* 12, no. 1 (summer 1984).

9 These include essays by Marita Sturken, "Feminist Video: Reiterating the Difference," *Afterimage* 13, no. 9 (April 1985); Patricia Mellencamp, "Uncanny Feminism: The Exquisite Corpses of Cecelia Condit," *Afterimage* 15, no. 2 (September 1987); Lauren Rabinovitz, "Video Cross-Dressing," *Afterimage* 16, no. 8 (March 1988); Nadine McGann, "Consuming Passions: Feminist Video and the Home Market," *Afterimage* 16, no. 1 (summer 1988); Chris Straayer, "Sexuality and Video Narrative," *Afterimage* 17, no. 10 (May 1989); and Liz Kotz, "Strip Tease East and West: Sexual Representation in Documentary Film," *Afterimage* 17, no. 3 (October 1989), among many others.

10 See David Trend, *Cultural Pedagogy: Art, Education, and Politics* (New York: Bergin and Garvey, 1992).

11 Owen Kelly, *Community, Art and the State: Storming the Citadels* (London: Comedia, 1984), 106–7.

12 See especially the special "Fundamentalist Media" issue of *Afterimage*, edited by managing editor Lynn Love, *Afterimage* 22, nos. 7/8 (February/March 1995).

13 See Dave Hickey, *The Invisible Dragon: Four Essays on Beauty* (Los Angeles: Art Issues Press, 1993). See also " 'B' Is for Beauty," special issue of *New Art Examiner* 21, no. 8 (April 1994); "The Return of Beauty," special issue of *Artweek* 27, no. 4 (April 1996); Richard Bolton, "Beauty Redefined: From Ideal Form to Experiential Meaning," *New Art Examiner* 21, no. 3 (November 1993): 27–31; and Wendy Steiner, *The Scandal of Pleasure* (Chicago: University of Chicago Press, 1995).

14 I have taken this term from Anthony Cascardi, who defines aesthetic liberalism in the following way: "The aesthetic moment in Kant replicates rather than resolves the tensions between the individual and the community that Kant elsewhere formulates as central to the position of the subject in the modern world. Whereas the Enlightenment reading of Kant [exemplified by Habermas] sees the third *Critique* as reflecting a development of the 'inner logic' of a self-contained aesthetic sphere, and tends to privilege the public discourse of taste over the experience of art itself, and whereas the Romantic response to Kant

tends to see the *Critique of Judgment* as a reintegrative and redemptive attempt to restore unity through the formation of what Schiller called an 'aesthetic state,' to a social totality that had been shattered by the disintegrative forces of capital, I would suggest that . . . Kant leads us to conclude that the foundations of the liberal ethic reside not in the cognitive powers of reason or understanding, but in the (transcendental) imagination which regrounds the liberal state as the unity of wills under the concept of an end which has subjective claim to universality." Anthony J. Cascardi, "Aesthetic Liberalism: Kant and the Ethics of Modernity," *Revue Internationale de Philosophie* 45, no. 176 (1991): 12–13.

15 See Carol Christ, "Victorian Masculinity and the Angel in the House," in *A Widening Sphere: Changing Roles of Victorian Women,* ed. Martha Vicinus (Bloomington: University of Indiana Press, 1977), 146–62.

16 Michael Fried, "Art and Objecthood," in *Art in Theory 1900–1990: An Anthology of Changing Ideas* ed. Charles Harrison and Paul Wood (Oxford: Blackwell, 1993), 822–34. This essay originally appeared in *Artforum* (summer 1967).

17 Clement Greenberg, "Avant-Garde and Kitsch," in *Art in Theory 1900–1990: An Anthology of Changing Ideas,* 531.

18 See Lucy Lippard, *Six Years: The Dematerialization of the Art Object from 1966–1972* (London: Studio Vista, 1973).

19 From Adrian Piper's essay in the catalog *26 Contemporary Women Artists* at the Aldrich Museum in April 1971. Cited in ibid., 235.

20 See Dan Graham, *Rock My Religion: Writings and Art Projects 1965–1990,* ed. Brian Wallis (Cambridge: MIT Press, 1993).

21 Hans Haacke, *Framing and Being Framed: 7 Works 1970–1975* (Halifax: The Press of the Nova Scotia College of Art and Design, 1975), 135.

22 See Maurice Berger's interview with Adrian Piper in the second part of this anthology.

23 *Framing and Being Framed,* 138.

24 See also Lucy Lippard's documentation of this event in *Six Years,* 122, 227, 229.

25 See "The Colossal," in *The Truth in Painting,* trans. Geoff Bennington and Ian McLeod (Chicago: University of Chicago Press), 119–47.

26 Elizabeth Sisco during the panel discussion "Production and Representation in Contemporary Art" at the Cranbrook Academy of Art (November 11, 1995).

27 For more information on the projects of Avalos, Hock, and Sisco, see Cylena Simonds, "Public Audit: An Interview with Elizabeth Sisco, Louis Hock and David Avalos," *Afterimage* 22, no. 1 (summer 1994): 8–11. On the Art Rebate/Arte Reembolso project, see John C. Welchman, "Bait or Tackle? An Assisted Commentary on Art Rebate/Arte Reembolso," *Art and Text* 48 (1994): 31–33, 86–87.

28 Richard A. Cloward and Frances Fox Piven, "Movements and Dissensus Politics," in *Cultural Politics and Social Movements,* ed. Marcy Darnovsky, Barbara Epstein, and Richard Flacks (Philadelphia: Temple University Press, 1995), 235–50.

29 Ibid., 239.

30 See Manthia Diawara, "Black Studies, Cultural Studies: Performative Acts," *Afterimage* 20, no. 3 (October 1992): 6–7. See also *Let's Get It On: The Politics of Black Performance,* ed. Catherine Ugwu (Seattle: Bay Press/London: ICA, 1995), and Judith Butler, *Gender Trouble: Feminism and the Subversion of Identity* (New York: Routledge, 1990).

31 See Jürgen Habermas, *The Philosophical Discourse of Modernity: Twelve Lectures,* trans. Frederick G. Lawrence (Cambridge: MIT Press, 1995).

32 See note 27 above.

The Politics of Patronage

Richard Bolton

Enlightened Self-Interest: The Avant-Garde in the '80s

> The whole thing about fun—I like to have fun. I think everyone wants to have fun. I think that having fun is being happy. I know it's not all fun, but maybe fun helps with the bad. I mean, you definitely cannot have too much fun. OK, it's like I want to have fun when I'm painting. And I want people to have fun looking at the paintings. When I think, What should I do next?, I think: more, newer, better, nower, funner.—Kenny Scharf, quoted by Gerald Marzorati, *ARTnews*

Over a decade ago, it was said that we stood on the brink of a new avant-garde, a postmodernist avant-garde, critically posed against dominant culture. This avant-garde seemed to offer radical new ways to intervene in the system of art production and in the construction of meaning and power beyond the art world. Since these days of promise, postmodernism's relationship to dominant culture has changed. Postmodernism has been embraced by the very institutions it sought to criticize, and many of the artists of the movement have won fame and, in some cases, fortune.

Over the last decade, we also witnessed profound changes in our economic and social life. The rise of conservatism has been accompanied by the centralization of power and the reassertion of inequality between classes. An aggressive, unregulated capitalism has been unleashed. Corporations have expanded their control nationally and internationally, while personal freedom has been diminished. From this perspective, the space of opposition seems to have grown much smaller.

Fame for critical artists, accompanied by diminished opportunities for change—how can we explain this contradiction? This article will attempt to answer this question by examining the effect the economic and political environment of conservatism has had upon art production. The impact that the art market, corporate patronage, commodity strategy, and the media have had on the function and meaning of recent art will be explored. It is hoped that this analysis will provide the reader with a sense of the *adaptability* of capitalism as it confronts challenge—with a sense of the way that power works through the cultural sphere to control dissent.

Inevitably, those with power in a society will strive to create a culture that reflects their interests and aims. It is also inevitable that there will be challenges to this power; the sustenance of power depends on the ruling classes' ability to anticipate and circumvent these challenges. In our society, challenges are not controlled through outright repression; instead, the ruling class works to establish hegemony—that is, it works to "frame alternatives and contain opportunities, *to win and shape consent,* so that the granting of legitimacy to the dominant classes appears not only 'spontaneous' but natural and normal."[1] A crucial part of this legitimacy is gained in the cultural sphere, for culture cloaks power with invisibility. Culture provides the ruling class with subtle opportunities to enter the public imagination, with ways to legitimate the agendas of the ruling class by associating them with the "universal" human spirit.

But culture is not so simple, and this consent is not easy to obtain. Our system is not monolithic—its many contradictions provide endless opportunities for critique. For these contradictions to go unnoticed, those in power must construct as seamless a reality as possible. To do this, power must be established in many different sectors of society; the successful engineering of consent depends upon coordination between these sectors. If we are to understand the role that art plays in the construction of consent, we must examine the range of institutional forces that act upon culture and discover the ways they work together.

The Art Market in an Age of Speculation

She is now 42 years old and supremely comfortable with success and money and luxury. . . . The artist is an . . . arresting figure. . . . Her attire can range from a tartan muumuu over bare feet to an Yves Saint Laurent suit and expensive spectator pumps. Her dinner parties are meticulously planned and catered. She is well read, well spoken, well educated at Mills College and Yale. Her work is in the collections of the Museum of Modern Art, the Metropolitan Museum of Art, the Whitney Museum of American Art, the Philadelphia Museum of Art and the Dallas Museum of Art.—Jennifer Bartlett, described by Nan Robertson, *ARTnews*

The art market has been transformed by American and transnational capitalism. The age of junk bonds has also been an age of fame and fortune for artists living and dead. Wall Street has not been the only site of wild profiteering—the art capitals of the world also have witnessed unprecedented speculation. This traffic in art mirrors the fervent trading of the stock exchange; investment indexes for art continue to climb; contemporary works of art are discussed like real estate investments; gallery owners trade artists and make deals in the style of corporate raiders.

As proof of the voraciousness of the art market, one need only examine the changes that have occurred in the "Million Dollar Club" over the last decade. During the 1979–80 auction season, only 14 paintings and drawings sold for prices of $1 million or more, but in 1987–88, an astonishing 121 paintings and drawings broke the $1 million figure. Ceiling prices have also skyrocketed. In 1980, *Turner's Juliet and Her Nurse* (ca. 1836) was sold for $6.4 million—the highest price of that season. In 1988, *Irises* (1889) by Van Gogh was honored with a price tag of $53.9 million.[2] In 1987–88, Sotheby's and Christie's—the two major auction houses—together recorded over $3 billion in sales. As *Newsweek* put it, "Sales by either house alone equal the gross national product of such countries as Fiji, Malta, and Burkina Faso."[3]

In such a time, it is not surprising that paintings by old masters and impressionists sell well or that new buyers, suddenly flush with cash, are attracted to these works. These works, after all, are the very embodiment of *quality* and are thus the most conspicuous and trustworthy kinds of investments. London art dealer Sir Hugh Leggatt has noted, with a trace of hauteur, that the new collectors "tend to treat art as a status symbol. With the nouveau riche who want to put dollar bills in a frame, the French impressionists appeal. They mean something."[4] However, more recent works have also done well in the marketplace. In the fall of 1988, Picasso's *Acrobat and Young Harlequin* (1905) was sold for $38.45 million, the highest price ever paid for a twentieth-century work. Weeks before this Picasso sale, *False Start* (1959) by Jasper Johns (a work that sold for $3,150 in 1960) was bought at auction for $17.1 million, a record for a living artist.

The "investment" is a site of excess, a collecting point for expanding income, and by all indicators art now serves this function more effectively than precious metals or even the stock market itself. According to the Sotheby's Art Index, the most trusted measure of worth, there has been a steady and unprecedented rise in the value of all forms of art and collectibles.[5] Salomon Brothers' annual report on compound annual rates of return shows that from June 1, 1983, to June 1, 1988, investment in old master paintings outperformed investments in coins, foreign exchange, treasury bills, diamonds, housing, gold, U.S. farmland, oil, and silver. The art market's strongest showing in fact came *after* the stock market crash of October 1987, when it outperformed all of the aforementioned assets as well as stocks and bonds. In times of economic difficulty, art is considered to be a wise shelter.[6]

The *Economist* has said this about the art market: "The source of the cash that makes current prices possible is plain to see. These are stirring times for capitalism."[7] The art boom is tied closely to new fortunes made in the stock markets in the United States and elsewhere. Exchange rates, and particularly the weak dollar, have also helped foreign investors, particularly the Japanese, who have been a major force in the art market of the '80s. As one collector puts

it, "The government killed real estate with the tax law, so collectibles are where it's at. Painting becomes stock. It becomes a global currency."[8] Or, to quote another rather frank collector: "There is so much liquidity sloshing around. After the really wealthy get their five houses, there's only one thing to do: collect art."[9] Art is considered such a mainstream form of investment that Sotheby's Holdings now makes loans secured by art, as does Citibank, which also provides "sophisticated financial services" and advisory assistance for its art-collecting clients.

Thus much of the boom is being driven by the ultrarich, who buy the most expensive paintings as speculative investments and as a way to create publicity. Leo Castelli has pointed out that "the meaning of these current prices is very clear. There are five to 20 collectors willing to pay $10 million or more for the masterpieces of this century. . . . They will not just buy anything."[10] And, in fact, auctions throughout the '80s were marked by a high percentage of lesser-quality works that remained unsold. But this is only part of the picture. For in the highly speculative art market of the '80s, the nature of collecting changed. Traditionally, collectors had behaved, well, like collectors, keeping a work for a generation or more. Today's collector often places the work back on the market as soon as a profit is glimpsed. Paintings at times never leave the warehouse. According to art adviser and Citicorp vice president Jeffrey Deitch, "[I]mportant paintings are being bought by investors who drop $5 million to $15 million at an auction, and sometimes they don't even bother to pick up the pictures."[11] In this atmosphere, twentieth-century art—even the work of emerging artists—has become a target for speculative acquisition. One can get into the contemporary market cheaply and, with rising prices, profit from the boom with little risk. The art market, it seems, is one successful case of trickle-down economics; a rising tide *has* lifted all boats.

A surprising number of the "hot" artists of the last decade have seen their work appear at auction far sooner than anyone expected. The first work by Julian Schnabel at auction was sold for $93,500 during the 1982–83 season. Works by David Salle appeared at auction in 1982–83 as well, and by 1986–87 a work by Salle commanded $60,500 at auction. Jennifer Bartlett's work appeared at auction in the early 1980s, and in 1985–86 a work of Bartlett's sold for $88,000. By the mid-1980s, even works by Jean-Michel Basquiat, Keith Haring, and Kenny Scharf were garnering respectable auction prices. In 1988, a painting by Ross Bleckner, painted and sold for $30,000 in 1986, brought $187,000 at auction. These auctions help establish the going rate for new work by these artists; high auction prices mean higher prices at the gallery as well. For postmodern artists who have not seen the value of their work established at auction, the expanding market has still meant increased gallery prices for their work. Recent works by Barbara Kruger can be purchased from Mary Boone for around $30,000; Sherrie Levine's latest paintings can be obtained from the

same dealer for $25,000 each. Levine's rephotographed "versions" of works by Alexander Rodchenko—early pieces praised for their challenge to beliefs about commodification and authorship—now sell for $2,000 each. Cindy Sherman's latest works are priced at $8,500 each and $15,000 for diptychs. Her early works, the "Untitled Film Stills," sell for $1,000 to $4,000, although some have been appraised for insurance purposes at $10,000. (When first shown, these works could be purchased for $50.) David Salle's most recent paintings range from $90,000 to $150,000. Julian Schnabel's gallery, Pace, will not provide prices of his recent work, but it has been reported that the artist earns $750,000 a year.[12]

As with many investments, art's worth is in part imaginary. Art has no natural value; this value must be constructed by the marketplace. As a result, this value is subject to change and collapse. "The price of art rests largely on your belief in it," claims art historian Souren Melikian, "so any kind of panic will inevitably affect art more than other kinds of investments."[13] Or as one gallery owner put it, "Is there any intrinsic value? No. It's all fantasy. Prices can go to $40 million [this spoken before Van Gogh sale in 1988], and so what? Why not higher? Any amount of money can be justified."[14] Or as Christie's Christopher Burge bluntly stated, prices are "driven by greed, desire, phobias, and, finally, whim."[15] Given this, an art market crash is a real possibility, and many investors feel that such a downturn is inevitable. Consequently, business magazines constantly warn their readers to exercise extreme caution when buying current art, lest they be caught with monstrous, unsalable works of art. A recent issue of *Barron's* offered this advice: "Collectors . . . need to be especially wary of buying at the top of a trend. Fashions in this field [art] are frequently short-lived. . . . Neo-expressionism, for example, was in vogue for roughly six years; now some say it's being replaced by a school they call 'Neo-geo.' . . . Second-tier neo-expressionists no longer sell."[16]

Establishing a value for a work of art helps to create control over the work, influencing how the work will function and who will see and own it. From this position of control, the market can be manipulated deliberately. Important collectors can change the status of the work of artists merely by shuffling their collections. Consider the habits of Charles Saatchi, certainly the best-known collector of the 1980s. Along with his brother Maurice, Charles has created the first "global" advertising firm, the largest in the world. Half of the world's five hundred largest corporations are clients, and in fiscal 1987 the firm's revenues equaled $1.36 billion.[17] Saatchi is said to spend more than $2 million a year on his collection. He has amassed over 500 contemporary artworks, collecting the work of single artists in depth—20 Salles, 32 Schnabels, 23 Kiefers, 21 LeWitts; he recently opened his own museum in north London to show these acquisitions (a museum, by the way, one-third the size of the Museum of Modern Art in New York City). His style of collecting allows him to have enormous impact

on the art market, and many collectors follow Saatchi's purchases closely, buying up other works of a given artist once Saatchi has demonstrated interest. There is concern about the damage Saatchi might wreak from this position of influence. In 1984 he sold off his Sandro Chia holdings, and this act appears to have significantly affected both Chia's reputation and the worldwide market for his work. Sperone Westwater, the artist's gallery, intervened, effecting a friendly buyout by repurchasing the paintings dumped by Saatchi, and so resuscitating the value of Chia's work. In a public letter to *ARTnews,* Chia complained about the possibility of "any one person accumulating my works in such number, thereby establishing a control and quasi-monopoly."[18] Given Saatchi's vast collection, there remains fear among galleries that other buyouts may be necessary in the future, that Saatchi may someday dump the work of other contemporary artists, encouraging other collectors to do the same, depressing the market and the artists involved.[19]

Corporate Support: "It Takes Art to Make a Company Great"

Business art is the step that comes after art. I started as a commercial artist, and I want to finish as a commercial artist. After I did the thing called "art" . . . I went into business art. . . . Making money is art and working is art and good business is the best art.—Andy Warhol, quoted by Jeffrey Deitch, *Art in America*

During the Reagan era, American business willingly provided the support to culture and human services that our government has refused to supply. In fact, corporate support for the arts has skyrocketed. In 1985, the last year for which detailed figures are available, U.S. business provided $698 million to the arts. During the same year, the government handed out about $163 million—just one-fourth the amount. The Business Committee for the Arts (BCA), an organization established to encourage such corporate support, estimates that corporations have contributed $5.4 billion to the arts over the last twenty years. Some have jokingly referred to the creation of an "artistic-industrial complex"; however, corporations donate even larger amounts to education and other social needs. Total corporate investment in all types of philanthropy has averaged $4.6 billion *annually* in recent years.[20]

Why should we worry about this? The reasons offered by corporations for their support are diverse, but all add up to the same result—a public realm brought under corporate control. Conservatism has extensively restructured cultural production. The corporation that performs as a good citizen doesn't really donate its capital, it *invests* it, developing a corporate culture and extending business's reach into all walks of life. The role of the corporation as a shadow government is strengthened. Citizens become accustomed to official art.

The arts have played an important role in marketing strategy since the beginning of the twentieth century. Artistic advances were incorporated into commodity design and advertising techniques; such contributions to *style* were a vital part of the rationalization of production and consumption.[21] Yet art can do even more for the corporation. During the 1980s, business has been introduced to the possibilities offered by art through a series of studies commissioned by the Philip Morris Companies. These studies, "Americans and the Arts," have shown that the typical member of the art audience is well off, educated, owns real estate, travels frequently, and often dines in restaurants. Members of the art audience, it seems, are "ideal consumers." This discovery has not been lost on corporations. According to Judith Jedlicka, president of the BCA, "The late '70s and early '80s . . . were difficult times for lots of businesses. One of the things that was reassessed was the philanthropic aspect of their operations. They realized, particularly with the arts, that those individuals interested in the arts were very often the consumer base the corporations needed for their products and services."[22]

"Why is business investing in the arts?" A recent BCA brochure offers this answer: "Business is investing its resources in the arts because it increases sales, attracts employees, enhances relations with employees and customers, helps develop new markets, broadens public awareness of business, and in some instances, increases property values."[23] Herbert Schmertz, director and vice president of Mobil Oil, is more blunt: "[Arts] patronage is merely another method to achieve the objective so starkly presented as 'corporate survival.' "[24] David Finn, CEO of Ruder Finn & Rotman (a public relations firm recognized as a pioneer in marketing with art), has also spoken of art's contribution to corporate power:

> Those in positions of authority in all societies have found it important to associate their activities with the most respectable values of their era. This has lent dignity and credibility to their actions and helped to establish a following for their leadership. It has enabled them to identify their policies and programs with a broad public good—thereby achieving one of the fundamental goals of sound public relations. The arts have often played a part in this process, since in every culture they function as expressions of that society's highest values.[25]

Of course, corporations claim to respect these larger human values. J. Burton Casey Sr., a partner of the Watson-Casey Companies, tells us that "in an increasingly mechanized and computerized world [a mechanization, of course, encouraged by the corporation], creative expression—the arts—afford the hungry, empty, desolate, and lonely side of each of us a measure of consolation, relaxation and reassurance we may not otherwise receive."[26] Artists are even seen as a crucial part of the battle for freedom—freedom, coincidentally, that is

in complete harmony with corporate ends. Winton M. Blount, an officer of Blount as well as of the BCA, reminded his audience of the many similarities between CEOs and painters in a speech entitled "The Arts and Business: Partners in Freedom":

> Art and commerce . . . each requires as much freedom as possible to survive and prosper. . . . There used to be artists who saw communism and socialism as the wave of the future. . . . There also used to be businessmen who saw government . . . as an ally of business and commerce. Time and experience have changed both perceptions. Are we [businessmen] instruments of the federal government? No, not willingly. We fight against it. So does the artist. . . . We depend on an environment of freedom to flourish and prosper. That environment is being persistently eroded everywhere by ill-advised and ill-conceived regulation, taxation, and other forms of government control. We live in an economy which is slowly assuming . . . the coloration of a socialistic society. . . . So we are engaged in an important work in furthering the arts. . . . We are helping to keep open those avenues of freedom along which art and commerce both travel.[27]

In corporatespeak, the relationship between art and business boils down to a single phrase: "enlightened self-interest." Everyone is said to benefit: culture is sustained, and the corporation reaches a new audience, presenting to that audience a sympathetic, human face. Conservative policy, corporate power, and the ambitions of the art world have all helped to establish an unlikely partnership; as a result, "whether we like it or not, American business is becoming a logical inheritor of America's social and cultural conscience."[28] This sentiment, offered by an American Express executive, indicates how far we have come. Although the increased role of business may not be "logical," it certainly is a fact. We cannot ignore the dramatic inroads business has made in our lives in recent years, nor can we ignore the consequences this influence has for critical cultural production.

The Arts as a Marketing Strategy
Once the importance of the arts is recognized, corporations must discover clever ways to put culture to work. Corporations put on few airs about their goals—most patronage is handled by the marketing department and comes out of the company's advertising budget, not its philanthropic account. These marketing departments must find ways to sell corporate agendas while benefiting artists and arts organizations. In the public relations world, this kind of approach is known as "strategic philanthropy." The arts have proven to be malleable vehicles for the projection of corporate personalities. A 1986 article in *Public Relations Journal* described the basic approaches: "Taking a risk [supporting controversial art] generally conveys that you . . . are progressive, ad-

venturesome, and concerned with the future. Alternatively, working with an established art form may imply a sense of concern for tradition and proven quality."[29] Those who have walked on the wild side include Philip Morris and AT&T, both sponsors of the Next Wave Festival at the Brooklyn Academy of Music; ARCO has also demonstrated its allegiance to progress through support of Los Angeles's "Temporary Contemporary" museum. Allstate lies at the other end of the spectrum, communicating a more "dependable" persona by supporting *Great Eastern Temple Treasures of Japanese Buddhist Art from Todai-ji* at the Art Institute of Chicago.

Such sponsorship usually goes beyond operating expenses. Corporations also provide important advertising and marketing support, for the impact of corporate generosity is lost unless consumers are reminded of the corporation's public spirit. Yet straightforward public relations gestures are not enough for some corporations, who must win political influence and curry favor for controversial profiteering. Mobil, for instance, happened to sponsor the exhibition *Te Maori: Maori Art from New Zealand Collections* just as it was opening a plant in New Zealand. Oil politics also lay behind Mobil's decision to fund the Islamic galleries at the Metropolitan Museum, as well as the exhibit *Unity of Islamic Art*. (Mobil calls this approach "affinity-of-purpose marketing.") United Technologies, among other things a well-known weapons manufacturer, concentrates on sponsoring the arts in Europe, Australia, and in other locations where there are strong disarmament movements.

Some companies have been able to realize more immediate cash returns on their investment in art. American Express allocates $3.5 million to the arts each year, favoring projects that "reflect the company's global outlook and concerns." According to Susan Bloom, AmEx's vice president for cultural affairs, art is an important marketing vehicle because it is "a universal language, reaching across borders and bringing people closer together"[30]—just like the American Express Card. The credit card business is extremely competitive, and companies do not stay long with marketing approaches that do not work. American Express has had so much success with its philanthropical strategy that it has named and registered it—*Cause-Related Marketing*[SM]. The company profits by tying donations directly to the growth of business. Take, for instance, AmEx's support of the renovation of the Statue of Liberty. Over a specified time, the company made donations to this project every time a transaction was made or a new card approved. By the end of the promotion, the company had contributed $1.7 million to the statue, increased transactions by 30 percent, and increased card applications by 45 percent. An example from the arts: In 1986, AmEx came to the rescue of Houston's Museum of Fine Arts by sponsoring *The Magic Mirror: French Portraiture, 1700–1900* during a time of economic depression for that city. The company gave free passes to area members who shopped with their card at Houston's Galleria mall; AmEx also marketed

the museum itself to local cardholders, thereby increasing museum membership to record numbers.

The arts have also been crucial to the public image of Philip Morris Companies, the well-known cigarette manufacturer. Philip Morris has enormous economic clout—Marlboro, its flagship brand, is not only the largest-selling cigarette in the world ($7 billion in annual sales) but also the best-selling packaged good of *any kind,* and accounts for one-fourth of all cigarettes sold in the United States.[31] Yet the public does not look kindly upon the cigarette industry these days, and sales are dropping; tobacco companies are even having trouble recruiting executives. Circumstances have called for extraordinary public relations work, and the arts have provided the means. According to chairman George Weissmann, the company likes to associate itself with "new ideas and innovative approaches . . . art forms and expressions that most strikingly challenge our creative imaginations."[32] Why? "We are in an unpopular industry. . . . Our support of the arts . . . has given us a better image in the financial and general community."[33] Under the slogan "It takes art to make a company great," Philip Morris has provided decades of support to arts organizations, offering corporate support to museums in the mid-1960s and recently opening a branch of the Whitney Museum in its Park Avenue headquarters. Philip Morris is particularly interested in supporting "avant-garde" work and is providing funds with "no strings attached."[34] For example, in 1987, Philip Morris made a two-year $500,000 grant to the aforementioned Next Wave Festival at the Brooklyn Academy of Music—the largest business grant ever received by the academy. The company also underwrote a national advertising campaign for the festival. The Next Wave provides Philip Morris with a perfect opportunity to present itself to (in the words of the *New York Times*) "a new constituency of young and trendy big spenders."[35]

In short, if the corporation can tolerate a degree of disruption, the work of art will serve the powerful as a warning sign, pointing out where midcourse corrections must be taken, steering the powerful away from the rocky shoals of their own contradictions. The work of art inoculates the powerful, protecting them against larger conflict.

The Corporation as Collector

It is estimated that over 60 percent of all Fortune 500 companies now collect art. Most of these collections are composed of contemporary work, which is less expensive and easier to obtain than other art. It is believed that these collections humanize the office, enhancing worker productivity. Collections are also felt to have great public relations value: companies often "have the added publicity angle of being able to boast (truthfully) that they are giving crucial work to lesser-known artists."[36] Lastly, of course, these collections *are* investments and expected to appreciate. Today's high prices have put art out of

the reach of many museums, and given the inaccessibility of most private collections, the corporate collection is fast becoming the public's main access to contemporary art. But these collections are not very accessible either. Artists might make a fast buck on a corporate sale, but their work is cut off from the audience—from an audience, that is, unencumbered by the constraints of the workplace. Since it is unlikely that art in a corporate collection will specifically address the conditions of labor or otherwise intervene in the workplace, corporate collections further the institutionalization of art *as a corporate activity.*

The greatest corporate collections can be found in the banking industry, and of these, the Chase Manhattan Bank, N.A., owns the largest and most established collection of contemporary art.[37] Started by David Rockefeller in 1959, the collection contains over 10,000 pieces and is valued at more than $17 million. (Rockefeller was also a major force in the formation of the Business Committee for the Arts.) Chase specializes in collecting the work of emerging artists, and the company has recently taken to exhibiting this work in an unusual way, utilizing its banking facility in SoHo as a gallery. Since this practice commenced, business at the bank has boomed; the SoHo location climbed from the one hundred eighty-fifth to the fourth busiest location. This new approach, however, seems to confuse some members of the audience. At the first opening in the bank, one attendee was overheard asking: "Is this a bank having a show called 'Art Gallery' or an art gallery having a show called 'Bank'?"[38]

Yet in spite of their desire to seem progressive, corporations still avoid purchasing work that is "sexually, politically, religiously, or morbidly explicit."[39] There are, however, pioneers of content as well. First Bank System of Minneapolis has established its reputation as a collector by filling its headquarters with "radical, unsettling" work by artists such as Enzo Cucchi and Gilbert and George. The bank's president wanted the collection to "reflect the changing dynamics of a banking business in the throes of deregulation"; Lynn Sowder, the bank's curator, echoes these sentiments, "Art is the most powerful visual symbol of this organization's commitment to change, which is why our collection upsets people."[40] The company hoped that the collection would help employees accept new ideas; at first employees were not so cooperative. The company worked to educate its employees through seminars, lengthy wall labels, and other means. According to the bank, this education reduced the number of complaining employees from 69 percent to 40 percent.[41]

Who would have guessed that work by contemporary artists would become so highly prized by business? Who would have guessed that Frito-Lay would one day purchase works by Julian Schnabel and Robert Longo? Who would have guessed that these artists would be embraced by the world they appeared to criticize? That works critical of the marketplace would become charged by excess capital? "Buy good art and you'll always get a return on your equity."[42] But for the corporation, good art is precisely that which *will* provide a return on

equity. Corporations may seem unlikely owners of critical art, but they have learned to work with increasing sophistication to incorporate critical culture into the management of capitalism. The corporation has used its enormous power to rob the arts of their role as a space of dissent, as a possible site of uncommodified experience. The museum becomes the site of affirmation of the corporation's project, and the corporation puts art to work inventing the future—larger markets and more power. We understand how advertising is used to define the public and establish support for power. Corporations merely extend this process into the cultural sphere, transforming art into a kind of advertising.

Thus art provides the corporation with a way to speak of the public good, even as the corporation furthers its self-interest. Art is used to normalize the power of the corporate class. To this end, corporations have taken over support of the arts from the government. Museums and arts organizations depend upon corporations for survival. Corporations have begun to set up their own satellite museums. The distance between corporate and cultural space grows smaller. What might the alternative be? The business magazine *Across the Board* has provided one answer to this question: "To those who still worry about the power of the corporate purse . . . there is one simple response: If not the corporation, who else?"[43]

Jacqueline Schnabel's five feet ten inches of compact curves and nonstop legs might have been custom-made for the erotic tailoring of Azzedine Alaïa, with whom—in an auspicious marriage of form and function—she has just gone into business. Belgian Jacqueline, wife of Julian, hopes to open Alaïa's first Manhattan boutique by the end of this winter. . . . Her introduction to Alaïa's clothes took place in Paris, where she and Julian arranged the nifty trade of a Schnabel painting on glass for a small Alaïa wardrobe, including a mink coat.[44]

We might see in art production—and cultural production generally—a means for understanding and affecting social experience. But such a use of art is at odds with the role it typically plays in our society. Art is instead thought to lie outside of everyday experience, in an ideal world removed from human needs and conflicts. Spiritual and material experience are divorced from one another. Herbert Marcuse explored this separation in a famous essay called "The Affirmative Character of Culture." Marcuse argued that culture typically addresses human needs in ways that reaffirm the power of those who control society. Marcuse pointed out that bourgeois rule had gained its strength from the promise of equality for everyone, but it could not fulfill this promise without bringing an end to its own rule. If power was to be sustained, the proletariat had to be held "at the stage of abstract freedom"; the ruling class had to develop ways to satisfy the needs of those ruled without giving up control. To achieve this, the bourgeoisie developed a "decisive answer: affirmative culture."[45] In affirmative culture, social conditions are examined abstractly; conflicts and contra-

dictions are cloaked in false universality and collectivism, obscured by apparent unity and apparent freedom. By distinguishing culture from civilization in this manner, culture could be removed from the social process. Crisis and conflict are displaced to an *imaginary realm,* and resolution is conceived only within this imaginary realm. By calling up and then subverting the desire for change, the existing system of power is strengthened (that is, affirmed).

For Marcuse, this co-optation of desire was achieved primarily through aestheticization. He explains that "the medium of beauty decontaminates truth and sets it apart from the present. What occurs in art occurs with no obligation. . . . It is deprived of concrete relevance by the magic of beauty." In this way, art pacifies rebellious desire. Individuals actually end up worse off, because their alienation begins to seem inescapable, universal, even spiritual. The desired world appears "realizable by every individual for himself [only] 'from within,' without any transformation of the state of fact."[46] Yet Marcuse hoped that art could be made a more integrated part of everyday life, for art seemed to offer the potential for productive change. It remained the site of desires unfulfilled by the conditions of everyday life.

The false relationships between cultural production, everyday life, and political change continue to inform our experience. Many present-day thinkers are revisiting Marcuse's argument as they attempt to understand the avant-garde, which was not specifically addressed by Marcuse in his essay. What relationship does oppositional practice have to affirmative culture? Under what conditions can oppositional practice exist? Peter Bürger has gone so far as to say that in the present, a truly progressive form of art production—one that reintegrates art into lived experience—is impossible. Echoing Marcuse, Bürger states that "art allows at least an imaginary satisfaction of individual needs that are repressed in daily praxis. . . . But because art is detached from daily life, this experience . . . cannot be integrated into that life." "Art as an institution neutralizes the political content of the individual work"; consequently, art in bourgeois society can only contribute "to the elaboration and stabilization of the subject." This condition is final, "true independently of the consciousness artists have of their activity. . . . It is the status of their products, not the consciousness artists have of their activity, that defines the social effect of works."[47]

Marcuse also recognized that much of the character of affirmative culture was derived from commodity logic: "As in material practice the product separates itself from the producers and becomes independent as the universal reified form of the 'commodity,' so in cultural practice a work and its content congeal into universally valid 'values.'"[48] Thomas Crow has addressed this issue with great clarity. In his essay "Modernism and Mass Culture in the Visual Arts," Crow describes how emerging modes of commodity production determined the character of the modernist avant-garde. He sees in the host of

competing practices within modernism an attempt to construct a critical medi-
ation of commodities:

> The society of consumption as a means of engineering political con-
> sent . . . was no simple or uncontested solution. . . . As it displaced resis-
> tant impulses, it also gave them a refuge in a relatively unregulated social
> sphere where contrary social definitions could survive, and occasionally
> flourish. . . . Managing consensus depends on a compensating balance
> between submission and negotiated resistance within leisure. . . . But
> once that zone of permitted "freedom" exists, it can be seized by groups
> which articulate for themselves a counter-consensual identity, an implicit
> message of rupture and discontinuity. . . . We can call [these groups] . . .
> resistant subcultures.[49]

The avant-garde tried to both respect and violate this zone of freedom,
switching between high and low culture, and so exploiting contradictions
within commodity culture; the avant-garde's "transformation of the commod-
ity must be activist and improvisatory: displacing . . . cultural goods into new
constellations of meaning."[50]

Yet Crow notes that this "pattern of alternating provocation and retreat" was
ultimately as productive for affirmative culture as it was for critical conscious-
ness. As consumption began to play a larger role in social relations, there was a
need to create expanded desires and sensibilities, and the artist had "the skills
required for an ever more intense marketing of sensual gratification." The artist
began to serve as a member of the research and development team of consumer
culture, as a "full-time leisure specialist, an aesthetic technician picturing and
prodding the sensual expectations of other, part-time consumers," establishing
a cycle marked by the "appropriation of oppositional practices upward, the
return of evacuated cultural goods downward."[51]

The commodity is presented by advertisers as a form of withdrawal—wealth,
luxury, and goods provide insulation from the world. In the public imagina-
tion, leisure-time detachment and art production are closely associated. Ad-
vertisers understand this and so utilize the arts in their marketing strategies.
The public sees the artist as a powerful outsider, and the mythology of artistic
withdrawal creates an illusion of nonconformity that will sell the product.
Artists have thus become prime candidates to endorse any number of com-
modities; the advertisement portrays art as the natural companion of mink
coats, makeup, and real estate.

Judging from contemporary advertisements, the commodity itself has be-
come a form of art. Products, juxtaposed with art objects, are proclaimed to be
"aesthetic statements," "masterpieces," works of the avant-garde, works of
nonconformity. Famous artists from the past return to endorse television sets,
copiers, and chocolates. Clothing and cigarettes are pictured in galleries. Ad-

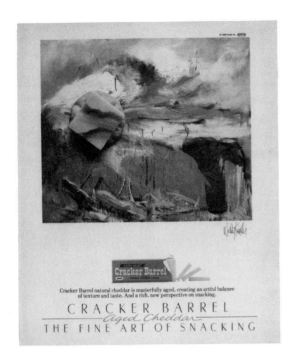

Cracker Barrel natural cheddar is masterfully aged, creating an artful balance
of texture and taste. And a rich, new perspective on snacking.

CRACKER BARREL
Aged Cheddar
THE FINE ART OF SNACKING

Advertisement for Cracker Barrel. Photo courtesy of Richard Bolton.

vertisements introduce us to "the art of dressing" and even "the fine art of snacking." The advertiser can make such extensive use of art precisely because art functions symbolically in our society as an ideal commodity. The advertiser hopes to call up the public's belief in art's permanence and universality, in art's utopian, compensatory role, and hopes to transfer these feelings to the product. But this would not be a believable strategy if art, as institutionalized, functioned in a radically different way than commodities do, or if art provided direct criticism of commodification. In fact, these advertisements demonstrate the harmonic convergence of art, the commodity, and advertising itself within affirmative culture.

It is not just the enshrined art of the past that is valuable to advertisers. Contemporary art, particularly work considered avant-garde, is also useful. Avant-garde marketing usually concentrates on the artist as a personality— a celebrity who speaks to a market of knowing consumers. Some people, it seems, will not buy Cutty Sark unless Philip Glass recommends it; thus we are treated to endorsements by Andy Warhol for Vidal Sassoon Natural Control Hairspray for Men, Keith Haring for Swatch, Warhol for the Drexel Burnham investment firm, Twyla Tharp for MasterCard, Michael Graves for Dexter shoes, and MoMA painting and sculpture director Kirk Varnedoe for Barney's of New York. Some manufacturers have even gone so far as to *create* an avant-garde specifically for their product. When Rose's Lime Juice wanted to "reposi-

Advertisement for Absolut Vodka. Photo courtesy of Richard Bolton.

tion" its 120-year-old product, it worked to reach a select audience that could spread news of the product by word of mouth. This audience turned out to be "gay men and single women in the eighteen-to-thirty-four-year-old range who live in major urban areas and who frequent bars," those who "read *Interview* and *Details.*"[52] To reach these consumers, the company chose "cutting-edge" creative people known to this audience but unknown to the larger population. The campaign would confirm the hipness of target audiences; those who could not identify the avant-garde endorsers of the product would, presumably, be curious enough to find out about the product. The ads included painter James Mathers; saxophonist, actor, and lounge lizard John Lurie; and fashion designer Carmel Johnson. Amaretto di Saronno liqueur utilized the same strategy in ads with *its* avant-garde, composed of Phoebe Legere (rock musician), Tama Janowitz (author), Tony Denison (actor), Victoria Jackson (comedian), and other trendy but obscure personalities.[53]

Carillon Importers was able to combine all of the above approaches in its promotion of Absolut Vodka. The company commissioned artists Warhol, Haring, Scharf, and Ed Ruscha to create painted ads for the product. The campaign not only utilized the reputation and painting style of each artist—it also capitalized on the market status of these painters. The company published litho-

graphic editions of the art created for each ad. Unsigned prints were offered to the public by mail order, signed prints were donated to museums, and the original paintings were added to the company's corporate collection. (A print from Absolut's Warhol edition is now in the collection of the Whitney Museum.) This campaign (along with others) helped Carillon increase sales to a respectable $200 million annually.[54]

Warhol is certainly the pivotal character in the establishment of "avant-gardism" as a marketing strategy. Once an important influence on the critical appropriation of mass culture, Warhol by the '80s had come to symbolize the ineffectiveness of such art, as well as the unprincipled and cynical sellout of art production. Warhol thus demonstrates the continued importance of the artist in the creation of commodity strategies. The Campbell's Soup Company helped drive this point home: an English ad by Saatchi and Saatchi used the sale of a Warhol Campbell soup can painting at Sotheby's to publicize the product itself. The auctioned painting was reproduced with this caption: "This copy sold at Sotheby's New York recently for almost £34,000. You can buy the original at your local supermarket for around 26p." In the United States, Warhol was commissioned by Campbell's Soup to make a promotional painting of a Campbell's dry-soup package. As pointed out by *Ad Age,* when Warhol painted Campbell's Soup labels in the '60s, he was "attempting to erase the boundaries between high culture and popular culture by fusing their elements. Now he's merely doing what Campbell's Soup Co. has done for more than a century. He's making lots of money."[55]

The Whims of Change: The Avant-Garde of the 1980s

Why wasn't she just printing posters? Why was she selling her work in commercial galleries? Kruger responds forcefully: "These were objects. I wasn't going to stick them on the wall with pushpins. I wanted them to enter the marketplace because I began to understand that outside the market there is nothing—not a piece of lint, a cardigan, a coffee table, a human being. That's what the frames were about: how to commodify them. It was the most effective packaging device. Signed, sealed and delivered."—Carol Squiers writing about Barbara Kruger, *ARTnews*

The artistic avant-garde is generally represented as a force outside of dominant reality—as a resistant subculture. We might consider this to be a false definition; after all, subcultural identity is usually rooted in racial or class differences, and the avant-garde typically does not define itself by such differences. Yet insofar as artists offer alternative understandings of reality, and insofar as these alternatives challenge the status quo, artists are considered to compose a kind of subculture. And when these challenges become most direct—in an

organized, "avant-garde" form—artists are brought into direct conflict with the same mechanisms of social control that affect more fundamental subcultures. Thus a discussion of subcultural politics can add much to our understanding of the current social role of art production.

Subcultures are articulated through representation. Members of subcultures create identity in part by constructing representations that stabilize their experience. The subculture may offer important challenges to dominant culture and significant possibilities for change. But change evolves from a preexisting world, and subcultures must compose their voices in part out of preexisting signs within dominant culture. In developed nations, a subculture comes to be understood through the media, by the way it appears in advertising, television programming, Hollywood films, mass-circulation magazines, and so forth. One might choose to see the relationship between the subculture and its image as a dialectical one. The subculture represents itself and its difference, the dominant culture plays back these differences through the media, the subculture revises its self-image, and society changes in the process. Such a model, however, is wishful thinking. The subculture is deprived of a dialectical relationship with dominant society precisely because it has little power over the organization of communication. As a result, no matter how dissident or subjective the experience of the subculture might be, and no matter how much this borrowed language is held up to criticism, it is almost impossible to completely subvert dominant ideology. Change must be built from the upended speech of the powerful, with dissent proceeding unevenly through dominant culture. The subculture creates incursions into dominant reality, critical spaces that are provisional and temporary.

In *Subculture: The Meaning of Style,* Dick Hebdige describes this battlefield and asks us to consider the range of opportunities for conflict and self-representation that style provides. Since "violations of the authorized codes through which the social order is organized and experienced have considerable power to provoke and disturb," resistant subcultures can politicize style, appropriating existing codes within dominant reality and turning them upside down. But as Hebdige also points out, these stylistic innovations attract the media's attention, and as the "subculture begins to strike its own eminently marketable pose," this dissent can be commodified and incorporated into the status quo.[56]

Radical new styles violate social norms, promising to alter the status quo through an exaggerated display of difference. In this way, fashion is said to give voice to resistance. But the protest of style also helps maintain the status quo by helping create a more stimulating commodity. That is, the status quo can adapt quickly to these stylistic challenges, while the subcultures can seldom confront deeper structures of production and consumption. The status quo can learn to be energized by these challenges; dissent and difference, articulated

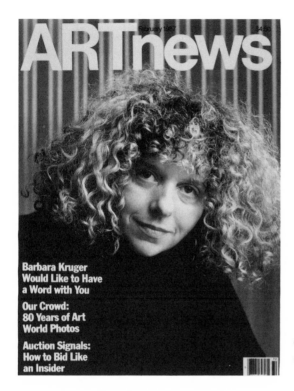

Cover of *Artnews*. Photo courtesy of Richard Bolton.

only as style, can be easily consumed as style. Again we discover the affirmative character of culture, moderating disruptions in the status quo. Alienation proves to be an effective marketing strategy; challenges to dominant reality become challenges to personal appearance, resolved by the purchase of commodities. Dissent is transformed into entertainment, compensating the public, fulfilling the need for change while ignoring the politics of that change. Stylish pseudochallenges to the boundaries of dominant culture only make those boundaries stronger. The consumption of products and images is presented to consumers as a form of resistance, with the "revolutionary" commodity replacing active social challenge.

How has the artistic subculture of the avant-garde been represented by the media? The art and entertainment press work to create a milieu of "famous" artists, an underground of difference that will aid magazine sales. This process blunts critical work by emphasizing individual artists over the collective issues that inform their work. Fame and success are important tools of affirmative culture; by casting achievement as an individual accomplishment, the artist is separated from the collective—the subculture—from which the work originally drew its power. This former power is replaced by the power of value and fame. "Genius" fills the void left by the elimination of work's social base.

The art and entertainment press has been essential in the management of '80s art production. Articles on the postmodern avant-garde have appeared with regularity in *Vanity Fair, Vogue,* and *Elle.* One example may be enough: In a picture essay entitled "Downtown style," *Vogue* (September 1988) chronicled the dressing habits of such trendies as Cindy Sherman, the Starn Twins, Annette Lemieux, and Jeff Koons. According to this article, "A conscious dishevelment was [once] an artist's mandatory style. . . . Today's . . . up-and-comers face a quite different reality: art as business . . . and art as public chic."[57] As participant Jon Kesser put it, "The role of the artist used to be as an outsider. You didn't want to meet your collector—and you dressed that way. Now, we all eat at the same restaurants, have our apartments photographed by the same magazines."[58] Sherman, by the way, modeled a Calvin Klein houndstooth sweater, a Shamask shirt, and Mizrahi evening pants.

ARTnews provides the best example of the marketing role played by art criticism; its "*People* magazine" approach is the best vehicle to certify the "arrival" (and thus the collectibility) of a new star. If one examines the magazine's demographics, one discovers that the average reader has an average household income of over $100,000 and an average net worth of over $1.1 million. These readers have art collections averaging over $80,000 in value, and collectively they purchased over $65 million of contemporary art in the last year.[59] Seen against these statistics, the presence of Kruger, Schnabel, and Levine on the cover of the magazine takes on new meaning. As the magazine itself points out in its media packet, "When the Morgan Guarantee Trust Company, America's fifth largest bank, wanted to advertise its private banking services to an audience in the top four-tenths of one percent of the population—those with portfolios of $5 million or more—it screened 80 magazines, selected 15 and chose one art magazine. *ARTnews.*"[60]

The Role of Critical Culture

In our (supposedly) postmodern, postindustrial society, capital is said to be generated through the manipulation of signs, information, and structure: through artificial intelligence, investment planning, corporate takeovers, media spectacles, advertising, communication. Of course, there is a real productive base, and these are real labor conflicts; the postindustrial illusion of their absence is part of the strategy. The success of the commodity depends upon its degree of detachment from reality, from labor. The de-skilling of labor, and the processes of design, marketing, and advertising, removes the presence of the individual. That is, the corporation replaces the individual as the author of the commodity. The object, abstracted, infused with aura, becomes a free-floating sign, and value becomes flexible, determined by manipulation of market.

The commodity of information undergoes the same processes. It is dissoci-

Advertisement for Rose's Lime Juice. Photo courtesy of Richard Bolton.

ated from its basis in production, and it, too, receives a manipulable value. Art can be considered to be an information commodity—in fact, art practice has come to play a central role in an "information" society. For who knows better than the artist how to manipulate signs? And how to generate capital through this manipulation? Just as art was used to develop commodity logic earlier in this century, art can be used to help construct the "postcommodity." Positioned within dominant culture, the avant-garde can help invent new commodity forms.

The modernist avant-garde, charged with such duties, eventually moved to the center of the status quo. This is now the case with postmodernism—this once promising critical practice, posed against the mass media, has become a media version of critical practice. The analysis of the politics of aestheticization has been transformed into an aestheticized version of politics. And the criticism of commodification has become an advanced form of this commodification—the "progressive" avant-garde has been brought into harmony with the "progressive" form of the commodity and the "progressive" structure of late capitalism.

Postmodernism was anything but a monolithic enterprise. There was, however, what we might consider an activist side and a more cynical, nihil-

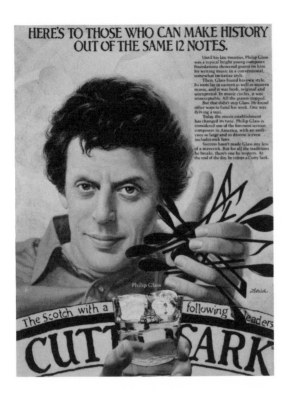

Advertisement for Cutty Sark scotch. Photo courtesy of Richard Bolton.

istic side. These two sides diverged at many points, taking very different approaches to the analysis of social codes, the subject, the art system, opposition, and praxis itself. One side of postmodernism pointed out the contingency of meaning, asking questions about the relationship between art and life, analyzing specific situations in which power created meaning. Another side rejoiced in the emptiness of the sign, assuming that there was no meaningful relationship between social experience and representation, mistaking the contingency of interpretation for the absence of meaning. Cynical postmodernism appears to have been easily commodified, and critical postmodernism followed thereafter. In the marketplace, these works do not exist as critical objects, but as commodities *styled* by criticism. Even works with apparent critical meaning can be brought under control by representing this criticality as something that can be "appreciated" and "valued" (rather than used). The work of the avantgarde grows removed from any real relationship to the struggles of the audience, and is instead joined to the rhythm of the marketplace and the planned obsolescence of ideas.

Critical artists must negotiate the space between high art and mass culture, between the elite audience and the general public, between rejection of the system and acceptance of it. As a result, most artworks have both critical and

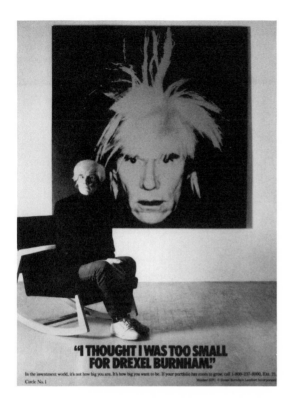

Advertisement for Drexel Burnham. Photo courtesy of Richard Bolton.

uncritical moments, times when they enlarge social possibility and times when they do not. Since interpretation depends upon social, economic, and political contexts, meaning can be altered by any significant change in these contexts. Shifting the context of interpretation has been used as a critical strategy, but it is also a strategy performed upon critical work by those who represent the interests of the status quo. As we have seen, critical work can be folded into the maelstrom of distraction and entertainment that marks our time.

Since the beginning of modernity, avant-garde artists have been thought of as pioneers of new forms of social experience, enlarging social possibility by challenging representation. In our time, the effectiveness of this task has depended upon the artist's ability to reconfigure signs borrowed from the media. But after negotiating the contradictions of these signs, these artists were presented with a new dilemma—the view of themselves in the media. Why is it that artists who have built their reputations criticizing the role of money, commodification, and fame in the production of art now refuse to analyze these forces in their own careers? It bears repeating that artists interested in social critique and change must consider and respond to the entire system that produces them and their work.

Capitalism constantly evolves, and critical approaches to it must constantly

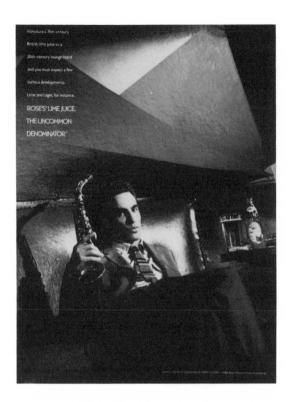

Advertisement for Rose's
Lime Juice. Photo courtesy
of Richard Bolton.

be reconsidered. As these artists are elevated to fame, it is the system that proves to be the master at appropriation and interruption, stealing back from these artists all that they have stolen. Postmodernism signified for many the end of the avant-garde (because of pluralism, or simulation, or the demise of the premises of modernism). But the avant-garde has been revived, at least in the marketplace and magazines. Avant-gardism, once based on critical resistance, finds its inversion in the current avant-garde, which lies at the forefront of culture precisely because its members refuse to resist. Still, a facade of resistance remains, for our system needs the illusion of liberty. The system must construct the very thing it denies—critical independence—precisely because there is a human need for this independence. Today's avant-garde provides the system with this needed simulation of independence. The audience is comforted by the mere presence of criticism and convinced of the magnanimity, openness, democracy, and pluralism of the patron class. This should disturb us a great deal, not only for what it tells us about the future of art, but for what it tells us about the future of all dissent. For if the artist—someone with a sophisticated understanding of the logic of representation—can be so completely subverted, what hope is there for other kinds of subcultural resistance, once this resistance encounters its image in the mass media?

If inequality is central to capitalism, then there will always be conflict stemming from this inequality. The successful maintenance of capitalism depends not on the elimination of dissent but on its institutionalization. Here then is the central problem of protest: it tries to break free of the system, of hegemonic constraints, to establish and hold a social space on its own terms, apart from patterns of conformity and commodification. At the same time, the dominant order works to incorporate dissent, institutionalize it, transform it in a way that confirms the status quo or that slows change to an acceptable, easily assimilated pace.

In a consumer society, commodities are looked to for the satisfaction of all needs. The need for critical understanding is affected by this—the artist is drawn into the traffic of commodities precisely because the audience expects commodities. But to conclude from this that there is nothing outside the marketplace, that there is no uncommodified experience or communication possible—this is just chic nihilism, a faux criticality that relieves artists of the responsibility for communication and change. Against this view, we should insist that there are times when possibility is created, when critical spaces are created that, while not outside the constraints of the present, still point to a different future. The marketplace is not automatically safe from challenge. Rather, the market must win consent; it does this by creating the belief that there is nothing outside the marketplace. Thus one can work to subvert the commodity, or one can choose to accept its limits. The former approach offers the possibility of constructing alternative experience and social change. The latter view cannot help but serve the status quo.

Notes

1 John Clark, Stuart Hall, Tony Jefferson, and Brian Roberts, "Subcultures, Cultures and Class," in *Resistance through Rituals: Youth Subcultures in Post-war Britain,* ed. Stuart Hall and Tony Jefferson (London: Hutchinson and CCCS, 1976), 38.

2 Prices come from the "Million Dollar Club," a list provided annually in the September issue of the magazine *Institutional Investor.*

3 Katrine Ames, Maggie Malone, and Donna Foote, "Sold! The Art Auction Boom," *Newsweek* 111, no. 16 (18 April 1988): 65.

4 Ibid., 72.

5 The Sotheby's index is a monthly gauge of the value of thirteen different sectors of the art market. The base of the index was fixed in September 1975, with the value of each area established at 100. By early 1984, old master paintings had climbed to 242, and by November 1988 old master works stood at 403 on the index. Impressionist works had climbed to 307 by the beginning of 1984 and were valued at 1,255 by November 1988. Modern paintings (from the first half of the twentieth century) were valued at 282 in 1984 and had jumped to 1,138 by the end of 1988. Contemporary art was added to the index in September 1987 (a certain sign of arrival for this form of art) and valued at 597. By November 1988, contemporary art had climbed to 856.

6 Compound annual rates of return reported in Salomon Brothers, "Long-Term Returns and Asset Allocation Decisions," *Stock Research: Investment Policy* (June 1988).

7 "More money than art," *Economist* 303 (23 May 1987): 95.

8 Martin Margulies, collector and real estate developer, quoted in Meg Cox, "Prices of Hottest Art Reach Stunning Levels as Boom Keeps Going," *Wall Street Journal,* 28 November 1988.

9 Leon Levy, collector and financier, quoted in Robert Lenzer, "Art prices mirror 'the age of plutography,' " *Boston Globe,* 30 November 1988.

10 Ibid.

11 Meg Cox, "Prices of Hottest Art."

12 Other artists have work sold so infrequently at auction that the price established by a sale may not be a reliable one. One interesting case: *On Social Grease* (1975), a work by the artist Hans Haacke, was sold during the 1986–87 season. This was the only work of Haacke's sold at auction this decade. Although Haacke is a well-known critic of the art market, and although this particular work takes a critical look at corporate and government opinions about art, *On Social Grease* sold at auction for $99,000.

13 Ames, Malone, and Foote, "Sold!" 72.

14 Klaus Perls, quoted in Maggie Mahar, "What Price Art? In an Overheated Auction Market, It's Whatever You'll Pay," *Barron's* 67 (29 June 1987): 6.

15 Ibid., 29.

16 Maggie Mahar, "A Fine Art: How to Become a Collector (It Isn't Easy)," *Barron's* 67 (6 July 1987): 15.

17 John Marcom Jr., "For Charles Saatchi, Ads Are His Business, Privacy His Passion," *Wall Street Journal,* 24 June 1988.

18 Sandro Chia, letter, *ARTnews* 84, no. 7 (September 1985): 9.

19 Tales of Saatchi can be found in Don Hawthorne, "Saatchi & Saatchi Go Public," *ARTnews* 84, no. 5 (May 1985): 72–81; Richard Walker, "The Saatchi Factor," *ARTnews* 86, no. 1 (January 1987): 117–21; and Anthony Haden-Guest, "Art Breaking," *Vanity Fair* 51, no. 8 (August 1988): 68–76.

20 See Dennis Farney, "What Is Art? Congress Appears Likely to Say It's Something to Protect from Budget Cutters," *Wall Street Journal,* February 4, 1985; Kathleen Teltsch, "Business Sees Aid to Schools As a Net Gain," *New York Times,* 4 December 1986. For a prediction of reduced corporate giving in the 1990s, see Meg Cox, "Corporate Giving Is Flat, and Future Looks Bleaker," *Wall Street Journal,* 17 October 1988. Finally, it is important to note that in terms of individual (rather than corporate) giving, a recent Gallup survey found that poorer households give a much larger percentage of their income to charity than do wealthy households. See Meg Cox, "Poorer Households Lead in Rate of Charitable Giving," *Wall Street Journal,* 19 October 1988.

21 Many key moments in this history are examined in the work of Stuart Ewen. See *Captains of Consciousness: Advertising and the Social Roots of Consumer Culture* (New York: McGraw-Hill, 1976), and *All Consuming Images: The Politics of Style in Contemporary Culture* (New York: Basic Books, 1988).

22 Jim Pettigrew Jr., "Corporations and Collecting," *Sky* (February 1986): 12.

23 "Make a Sound Investment," a brochure published by the Business Committee for the Arts in 1988. The brochure goes on to state: "Business, by using its resources, improves the quality of life in a community by enabling the arts to flourish. This helps retain and attract businesses, draws tourists and visitors—all of which adds to the economic vitality of a community."

 Art's effect on property values is obvious—artists are known as the vanguard of urban

48 Richard Bolton

development, the first sign that real estate values are soon to climb. This phenomenon is not restricted to the larger urban areas. To develop a large section of the downtown Austin, Texas, warehouse district, the Watson-Casey Company set aside a large amount of space that was rented to artists at a very low cost. (The expenses incurred in this move were absorbed by the company's promotion budget.) The move was successful, getting people "feeling that it was avant-garde/ cutting edge to locate in that part of the city rather than feeling as if they were moving to the slums." J. Burton Casey Sr., "The Arts and Business—Partners in Economic Growth," brochure, Executive Viewpoints series, Business Committee for the Arts, 1986.

24 Herbert Schmertz, "Patronage That Pays," brochure, Executive Viewpoints series, Business Committee for the Arts, 1987.

25 David Finn, "Involving the Arts in Public Relations—A Business Strategy," brochure, Business Committee for the Arts, 1986.

26 Casey, "The Arts and Business."

27 Winton M. Blount, "The Arts and Business: Partners in Freedom," brochure, Business Committee for the Arts, 1980.

28 Jerry C. Welsh, "Involving the Arts in Marketing—A Business Strategy," Business Committee for the Arts, 1986.

29 Judith A. Jedlicka, "How to Develop Partnerships with the Arts," *Public Relations Journal* (November 1986): 54.

30 Lorraine Glennon, "The New Patrons" *Art and Antiques* (May 1986): 98.

31 Christine Donahue, "PM to Add 2nd Global Brand?" *Adweek's Marketing Week* 28, no. 52 (9 November 1987): 1, 4.

32 George Weissmann, quoted in Glennon, 127.

33 George Weissmann, quoted in Robert Metz, "The Corporation as Art Patron: A Growth Stock," *ARTnews* 78, no. 5 (May 1979): 45.

34 See Alix Freedman, "Tobacco Firms, Pariahs to Many People, Still Are Angels to the Arts," *Wall Street Journal,* 8 June 1988.

35 Cathleen McGuigan, "The Avant-Garde Courts Corporations," *New York Times Magazine,* 2 November 1986.

36 Pettigrew, "Corporations and Collecting," 14.

37 This collection is but one aspect of Chase's interest in the arts. In 1987, Chase's national budget for culture was $1.8 million. Since 1957, the company has given more than $10 million to the arts. See "American Business and the Arts," special advertising supplement, *Forbes,* 13 July 1987. Chase was also the first U.S. corporation to list its art collection as a major asset, including it in its financial reports in 1982. See Ruth Berger, "The Corporation as Art Collector," *Across the Board* 20 (January 1987): 48.

38 Glennon, "New Patrons," 108.

39 Valerie F. Brooks, "Confessions of the Corporate Art Hunters," *ARTnews* 81, no. 6 (summer 1982): 110.

40 Adam Bartos, "The Big Payoff in Corporate Art," *Fortune* 115 (25 May 1987): 108.

41 Valerie F. Brooks, "Art and Business in the 80s: A Billion Dollar Merger," advertising supplement, *ARTnews* 86, no. 1 (January 1987): 36.

42 Berger, "The Corporation as Art Collector," 46.

43 Ibid., 50.

44 "Alaïa Alliance," *Vanity Fair* 50, no. 12 (December 1987): 106.

45 Herbert Marcuse, "The Affirmative Character of Culture" (1937), in *Negations: Essays in Critical Theory* (Boston: Beacon Press, 1968), 97, 98.

46 Ibid., 114, 95.

47 Peter Bürger, *Theory of the Avant-Garde* (Minneapolis: University of Minnesota Press, 1984), 12–13, 90, 96, 58.

48 Marcuse, "Affirmative Character of Culture," 94.

49 Thomas Crow, "Modernism and Mass Culture in the Visual Arts," in *Modernism and Modernity,* ed. Benjamin Buchloh, Serge Guilbaut, and David Sorkin (Halifax: Press of the Nova Scotia College of Art and Design, 1983), 233.

50 Ibid., 244.

51 Ibid., 251, 252, 225, 255.

52 Quotes taken from Richard Goodman, "Marketing for the Young and the Hip," *Vanity Fair* 48, no. 12 (December 1985): 48.

53 See Debbie Seaman, "On the Road with the 'In' Crowd," *Adweek's Marketing Week* 28, no. 29 (1 June 1987): 30.

54 See Brooks, "Art and Business"; also see (if you can find it) Michele Block Morse, "Absolut Truths," *Eastern* [Airlines] *Review* (December 1988; reprinted from *Success* magazine): 33, 48–51.

55 Kevin McManus, "Campbell Cooks as U.S. Soup Kitchen," *Advertising Age* 57, no. 5 (30 January 1986): 20.

56 Dick Hebdige, *Subculture: The Meaning of Style* (London: Methuen, 1979), 91, 93.

57 "Downtown style," *Vogue* 178, no. 9 (September 1988): 125–28.

58 Ibid., 127.

59 Figures derived from *ARTnews* 1988 media kit; based on 1987 survey by Mark Clements Research.

60 Untitled brochure in *ARTnews* 1988 media kit.

Darrell Moore

White Men Can't Program:
The Contradictions of Multiculturalism

Discussions of multiculturalism have become increasingly common in the wide-ranging community of media arts organizations, funders, teachers, distributors, exhibitors, artists, critics, and audiences. The term and concept of multiculturalism has risen out of the liberatory struggles of those whose identity has been defined in part by their difference from the so-called mainstream or general public. But the theoretical and material meaning of multiculturalism is continually negotiated and contested. As a result, multiculturalism raises, rather than answers, questions, including: Who is the audience of multiculturalism? Who gains from multicultural discourse and its consequences? And what are the rewards at stake?

This article presents an analysis of the concept of multiculturalism based on interviews conducted with individuals from Chicago's media arts community.[1] The interviews took place during a three-week period following the Women in the Director's Chair (WIDC) International Film Festival in March of 1992. The festival itself was "multicultural" in that it opened with a series of films by Native American women and highlighted recent films and videos by black women in a series titled "Mosaic in Black."

The discourse of multiculturalism includes a number of different perspectives, but most involve the belief that the mechanisms of critical recognition and funding in the arts should be more inclusive or should be restructured. In "independent" or "alternative" film and video, multiculturalism is part of a struggle to ensure media access to those who have been and continue to be excluded or marginalized from the for-profit (or "Hollywood") film world— people of color, women, queers, radicals—and to enable individuals to visually articulate their own identity. Many individuals and institutions that claim to be committed to multicultural practice also view it as part of a broader movement for progressive social change. Thus it is not surprising, given the social history of progressive politics, that the majority of Chicago's media arts institutions are run and staffed by white women and that some of the organizations, such as the Community Film Workshop (CFW) and the Community Television

Network (CTVN), serve primarily the black community and black and Latino youth, respectively.

While most components of the media arts community tend to support the general notion of multiculturalism, many are suspicious about the value of the term as an institutional practice. This shared skepticism often masks real differences in the ways individuals and organizations are thinking about issues of outreach and inclusion, critical dialogue, and funding sources. Most versions of multiculturalism recognize that there is a stark contrast between the problems and inequities within the independent media world and the ideas motivating conservative politicians and commentators who attack any work that benefits in some direct way from tax dollars and is produced by and for people they do not define as "the general public."[2] Yet censorship does exist in subtler forms, which include funding, curatorial, and distribution practices. As journalist and painter Margaret Spillane argues:

> It is easy to identify censorship when someone stands up in Congress and says that the creation of artistic works by certain sectors of the population will not be funded by the government. But no liberal defender of arts funding has seized this excellent opportunity to ask the most jarring questions of all: who gets to make art; who even gets to imagine that they might become an artist? And who gets to have their story told through art?[3]

The questions raised by Spillane suggest the need to expand the boundaries of what constitutes the media arts world and of what its corresponding responsibilities are. In this context, multiculturalism can function to critique and challenge the "status quo" in the conceptualization, funding, production, distribution, and exhibition of media work. As a form of critique, multiculturalism argues that the status quo effectively excludes people from diverse and marginalized cultural backgrounds from the system through which visual representations are produced and distributed. As a form of challenge, it explores ways to demystify media arts practice so that individuals can imagine themselves as producers as well as consumers of independent works.

Thus while multiculturalism theoretically critiques the whole gamut of traditional representations of cultural identities, it poses a particular challenge to those in positions of power in the independent media arts world. According to Ira Jeter, executive director of the Center for New Television (CNT), the issue of importance "is not as much access as it is advocacy." The independent media arts, Jeter says, have to address issues of funding, information sharing, and support in a field that is dominated by a white, mostly male, middle-class staff and constituency. According to filmmaker and professor Zeinabu irene Davis, there are "a lot of people who want to make the process of making media very, very mysterious. They do not want to teach that any Joe Blow or Josephine

Blow can pick up a camera and make a movie. They are intentionally closing the channels of expression and communication."[4]

Because the concept of multiculturalism involves blurry definitions of inclusion and control, people of color in Chicago's media arts community are less likely than whites to articulate a commitment to it. Many are loath to utilize the term because of its current buzzword status—it is supposed to indicate commitment to artists and audiences of color, but experience has shown that an institutional statement of multicultural purpose does not necessarily result in tangible changes in the institution's staffing or programming. Davis refrains from using the term because "it is confusing; there is no agreement on its meaning or what it's supposed to do." When pushed, Davis states that her understanding of multiculturalism as practiced is similar to that of video artist and teacher Maria Benfield. In her article " 'Feed-Back' Stimulates Alternative Visions," Benfield argues that multiculturalism seems to be expressed by the equation, "ANGLO+ africanamericanlatinoanativeamericanqueeramericanasianamericanmiddle-easternamericanfeministamericanradicalartists,ETC.,ETC.=MULTICULTURAL."[5]

Benfield argues that for most whites multiculturalism means a conversation among themselves enhanced by the participation of some individuals of color. Its additive character means that it obfuscates conversations among people of color, and continues to privilege the role of whites and relegate people of color to a secondary position. Such assumptions affect the ways in which media arts programming is constructed. Others argue further that as long as multiculturalism is defined primarily by white people, who use the "input"—experiences, opinions, and ideas—of people of color as a form of advice, it will fail to alter notions of criticism and of funding. When all is said and done, the resources, and the power to control them, whether at the level of funder or small organization, rest primarily with white people.

One of the central issues in the politics of multiculturalism is its ability to simultaneously recognize and disavow "difference" from the qualities that we have come to associate with whiteness.[6] Multiculturalism can force us to recognize difference by demanding that institutions perform outreach, seek diversity in their collections, staffing, users, and audiences. At the same time, multiculturalism can disavow difference by "diluting the thrust of self-determination and control of our voices and our stories," argues Abena Joan Brown, founder and director of ETA Creative Arts Theater. For Brown, who decided to make an exception to her normal refusal to discuss multiculturalism at a conference, "Where Do We Come From/Where Are We Going? A Conference on Multiculturalism in Chicago's Performing Arts,"[7] the real question is "Who is going to run the program?"

Issues of control can be obscured by talking as if all cultures were distinct and equal, like entrées on a menu. This interpretation of the relationship

among cultures disassociates power and control from whiteness. Many discussions of multiculturalism succumb to this. This was especially true of the panel discussions at "Where Are We Going?" On the opening night Robert Loescher, chair of the department of art history, theory, and criticism at the Art Institute of Chicago, gave a talk called "How I became a multicultural human being." Loescher interweaved elements of biography with a critique of education. In the 1950s, the Wisconsin State Board of Education required that the various cultures that make up Wisconsin be included in the curriculum. In the 1960s, the establishment of such institutions as the Peace Corps and the Fulbright Fellowship, the expansion of area studies programs, and his own trip to Spain made him more aware of the diversity of the world around him. After his talk, I asked myself several questions: Were Native Americans and African Americans included in his secondary school curriculum? Did he realize that area studies programs studied other cultures only as objects in cold-war power struggles? A seven-person panel titled "The Alternative Media: Necessary Voices" included one white woman and no people of color. The conversation sounded like passages from a 1950s anthropology text: Ken Davis, program director of WBEZ radio station, spoke of sending theater critics "on expeditions to theater performed in the periphery [to] bring it back to a mainstream audience"; Michael Lenehan, editor of *Chicago Reader,* noted that his weekly periodical is "not distributed in neighborhoods where the people don't read."

When challenged, the panel argued that the assertion of different ethnicities and forms of sexuality leads to social breakdown and atomization. Such outlooks allow whiteness to function at a level of invisibility such that, as Richard Dyer argues, it appears to possess no specific qualities at all. The power of whiteness lies in its ability to colonize the normal rather than to be superior.[8] When whiteness is identified as simply one ethnicity/culture among many, white power and domination are ignored.

One of the apparent benefits of the growing acceptance of the need for multiculturalism has resulted in its being required for admission to the system of funding that makes independent media work possible. To secure foundation support, organizations are increasingly called upon to demonstrate their multicultural credentials. They must be able to discuss outreach efforts, the content of their programs, and the makeup of their audience.[9] However, one of the results of the lack of a clear definition of multiculturalism itself is confusion over what is at stake in and who benefits from the use of multiculturalism as a signifier of institutional value.

As Denise Zaccardi, executive director of CTVN, who is white, notes, "Multiculturalism is not new. It's a notion many people in this field had over 20 years ago. What's new is the economic clout that now accompanies it." CTVN serves low-income black and Latino teenagers in alternative high schools. They produce a cable access show called *Hard Cover.* "The students use the cameras on

the first day of class; they choose the topics for the program and make up the assignments. I try to get funding," said Zaccardi. At another level, Zaccardi suggests, multiculturalism "is driven by advertising and money. Many organizations are forced to be more inclusive because they have exhausted their white audience."

In Chicago, the sorts of contradictions generated by foundation pressure on behalf of multiculturalism are most notably demonstrated by the MacArthur Foundation's $5 million commitment to support culture that reflects the diversity of the city's population, which is more than 60 percent people of color. Last spring the foundation released *The Arts in Chicago: A Report to the Community,* a yearlong study of the issues that concerned the arts community.[10] The report, conducted by the New York City–based Conservation Company, combined the company's sketchy national reviews of various arts disciplines with in-depth interviews with Chicago-based focus groups. Although the film/ video focus group's conclusions centered on the need for additional funding and a more cohesive community, the concept of multiculturalism played a pivotal role in the overall report. Almost every focus group identified the need for its constituency to present works that reflected the contribution of non-Western cultures, as well as the need for the arts community to undertake audience development to attract more people of color.

As a result of the report's recommendations, the foundation decided to continue to devote approximately three million of its five-million-dollar commitment to general operating support grants to cultural institutions that were at least three years old with annual budgets above $100,000, and to provide additional money to conduct marketing research, train arts administrators, develop art education programs, increase the cultural diversity of staff and audience, and develop affordable and appropriate performance spaces.[11] In this instance, however, the concern with multiculturalism had more to do with the survival of the city's major arts institutions than with the needs and desires of the city's many communities of people of color, not to mention of the white working-class communities on the city's north and southwest sides. The focus groups consisted of the executive directors of established arts organizations, and so reflected the needs of those organizations and their constituencies. Although there were people of color involved in the focus groups, they were few and did not represent emerging groups or developing constituencies.

What makes many—particularly people of color—skeptical about the report is that this funding strategy reifies present power relations. It does so by endorsing a notion of multiculturalism that is simplistic, if not thoughtless. It forces funded organizations to develop outreach programs that are unrelated to their primary mission; it undermines the ability of organizations to develop the track record necessary for intercommunity collaboration; and it commodifies the experience and culture of communities of color.

The exclusion of people of color from critical discussions about media work and its institutional support structures is seen as a continuing obstacle to multiculturalism in the field. Davis calls attention to the ways such structures are abused by people who consider themselves antiracist and multicultural. At the Thirtieth Ann Arbor Film Festival/Conference—a prestigious venue for experimental films—the twenty judges were chosen from a pool restricted to past judges and directors of prizewinning films. As a result, eleven white men, six white women, and three women of color were chosen as judges. According to Davis, this method of choosing, by relying on a sexist and racist past, impacts on the future: it closes off opportunities for people of color and women of all colors to speak. When confronted with this criticism at the festival's panel on multiculturalism, the festival organizers became defensive. Needless to say, when dialogue devolves into accusative and defensive posturing, the issues and concerns at hand are not addressed. However, Davis maintains that while it is not easy for liberal whites to be challenged, "it is necessary that these issues be discussed publicly because when [discussed] in private the concerns of people of color are not taken seriously."

Most individuals in Chicago's independent media arts community who are critical of the way the multicultural debate has been framed and suspicious of the ambiguity of the concept argue that "outreach"—bringing people who don't usually attend independent film and video events into the audience—is not the most significant issue. According to videomaker Nalani McClenden, "It doesn't take much work to get people to films." Outreach obscures the more difficult work of advocacy, and of sustaining an audience by attending to its concerns. In Chicago, "people of color realize that what they have to say about films and videos is not taken seriously." McClenden, who is working on a video about biracial youth, argues that young people of color are "well-versed in visual imagery and sophisticated about editing and narratives. They have a multitude of expertise in manipulating language, and they are adept at interacting with a whole range of expressions."

For many organizations, the version of multiculturalism to which they subscribe depends largely on how they interpret and implement their missions. Vera Davis, film historian and production instructor at CFW, states that CFW's "purpose is to bring training and support in 16 mm film production to mostly African American students." Davis states, "We require our students to take an aesthetics course and become a member of the network." She adds that many students drop the course because it is an intensive hands-on course that requires commitment. Those who stick it out find a supportive environment. For Davis multiculturalism is about "commitment to people of color." It is not about "stretching outreach activities to get funding."

WIDC's mission is to present "alternative visions by women from a variety of cultures." According to executive director Jeanne Kracher, WIDC has had some

success at fulfilling its mission. "Our relative success has depended in large part on the individuals who have dominated this diverse group at specific points over our 11 years." Kracher and artistic director Gretchen Elsner-Sommer stress that WIDC works collectively to balance out the fact that no one can know all there is to know about the field. Kracher states that "our festivals are supposed to reach out to people and to provide an opportunity for interested individuals to network and reach others. We also want to let women know that we are an available resource."

WIDC extended its collective approach in the programming of "Mosaic in Black," which was curated by a committee composed of some WIDC board members and volunteers. The majority of the women on the committee were black, and they networked in the community to find out what was available and what was going on. They struggled over questions of "diaspora," of how to frame the screenings of films by lesbians, and of what black women want to see. The success of this portion of the festival underscored, for Kracher, the significance of both the process and the individuals involved in putting together the "Mosaic" section. It also pointed out the distinctions between the strengths of WIDC staff, which is composed of seven white women, and of the volunteers, who were predominantly black.

One of the issues raised by multiculturalism in practice is the extent to which multiculturalism involves interculturalism. Jeter notes that focusing on a single group when doing outreach does not necessarily foster intercultural communication. CNT hosted a screening and discussion of Rea Tajiri's *History and Memory (for Akiko & Takashige)* (1991) that was attended by over fifty people, mostly Japanese, in the midst of a Chicago snowstorm. While hosting a mostly Japanese audience was certainly a positive use of CNT space, the event's outcome does raise the question of to whom outreach should be directed. Should events become categorized specifically as Japanese, Haitian, and the like? On the other hand, CNT, WIDC, and the Chicago Women AIDS Project sponsored a benefit screening of Ellen Spiro and Marina Alvarez's *(In)Visible Women* (1991) that drew an ethnically and racially mixed, mostly female, audience. It suggests that different organizations from different communities can and do work together.

One response of media artists of color to the increasing public discussion about multiculturalism has been to network among themselves and to begin to form organizations that operate from their impetus and respond directly to their needs. When artists of color invoke multiculturalism, they mean cultures of color, without whites. For them, multiculturalism arises out of a struggle for recognition initiated and peopled by "people of color." This struggle has been successful to the extent that the shared experiences of positive identity and of racism are openly acknowledged. An institutional assertion of a multicultural project by people of color is exemplified by the mission statement of the Na-

tional Coalition of Multicultural Media Arts (NCMMA), of which Margaret Caples, executive director of CFW, is a founding member:

> NCMMA is a national coalition of media professionals who share a common history of oppression based on their race including African Americans, Arab Americans, Asian Americans, Latino, Native Americans, and Pacific Islanders. This organization is dedicated to representing and serving the self-determined needs and concerns of these people of color in film and electronic media. The multicultural coalition will develop and engender leadership of people of color and represent constituencies which have been historically excluded, underserved and misrepresented by larger media industry and funding sources including Public Broadcasting, government agencies, corporations, and foundations.

The NCMMA is a response to decades of white domination in the media arts. It is a coalition of individuals of color with diverse histories who come together, as Stuart Hall argues, to recognize the common experience of racism and marginalization and to create a new politics of resistance and creation.[12] Similarly, Ayanna Udongo, videomaker and distribution manager at the Video Data Bank, states that there has been "a recent cohesiveness, a collective body that has been tightening around the need to find others like ourselves and to come together." She adds that this "collective body will facilitate our exposure to each other's work, styles, technique, and funding possibilities."

Many in the independent media arts community in Chicago are aware of and acknowledge their relative positions of power and the constitution of their organizations. While seeing this reality may be easy, changing it is another matter, because organizations and reward systems operate independent of specific individuals. Jeter argues that "the world is not as neat, clean, and slick as a Benetton ad. When there is a threat to one's survival, as there is in the media arts at the moment, it is difficult to successfully do what is necessary to be truly multicultural."

Notes

1 I talked with Zeinabu irene Davis, filmmaker and assistant professor of film at Northwestern University; Vera Davis, instructor at Community Film Workshop; Gretchen Elsner-Sommer, artistic director of Women in the Director's Chair (WIDC); Ira Jeter, executive director at the Center for New Television; Jeanne Kracher, executive director of Women in the Director's Chair; Nalani McClenden, videomaker; Ayanna Udongo, videomaker and distribution manager at Video Data Bank; Brenda Webb, executive director of Chicago Filmmakers; and Denise Zaccardi, executive director of Community Television Network. This article also benefited from conversations with concerned individuals, including Gabriel Gomez, Elspeth Kydd, Christine Minor, Arthur Stone, and the Black Graduate Student Roundtable at Northwestern University.

2 See Ioannis Mookas, "Culture in Contest: Public TV, Queer Expression, and the Radical Right," *Afterimage* 19, no. 9 (April 1992): 8–9; and Marlon T. Riggs, "Meet the New Willie Horton," *New York Times,* 6 March 1992, op-ed.

3 Margaret Spillane, "The Culture of Narcissism," *Nation,* 10 December 1990, 738.

4 Ann Filemyr, "Zeinabu irene Davis: Filmmaker, Teacher with a Powerful Mission" [interview], *Angles: Women Working in Film and Video* 1, no. 2 (winter 1992): 8.

5. Maria Benfield, " 'Feed-Back' Stimulates Alternative Visions," *Angles: Women Working in Video and Film,* 1, no. 2 (winter 1992): 3.

6 Homi K. Bhabha, "The Other Question: Difference, Discrimination, and the Discourse of Colonialism," *Out There: Marginalization and Contemporary Cultures* (New York: New Museum 1990), 71–87.

7 The seven-day conference was held at the Blue Rider Theatre in Chicago, March 23–29, 1992.

8 Richard Dyer, "White," *Screen* 29, no. 4 (autumn 1988): 44–45.

9 See Coco Fusco, "Fantasies of Oppositionality: Reflections on Recent Conferences in Boston and New York," *Screen* 29, no. 4 (autumn 1988): 80–93, and "Fantasies of Oppositionality," *Afterimage* 15, no. 5 (December 1988): 6–9.

10 Richard Mittenthal, *The Arts in Chicago: A Report to the Community* (New York: Conservation Company, 1991).

11 Cynthia Gehrig, "Art for Whose Sake? New Report Reflects Wide Debate," *Forum* 8, no. 4 (July/August 1991): 1–3.

12 Stuart Hall, "New Ethnicities," in *Race, Culture, and Difference,* ed. James Donald and Ali Rattansi (London: Sage, 1992), 252–59.

Coco Fusco

Fantasies of Oppositionality

To focus on the moment is to risk a degree of historical blind-
ness. I will therefore begin by admitting to certain assumptions about the con-
ditions of the present with regard to race and representation. First, the question
of race figures differently and to a much higher degree in current cultural
politics, particularly in media and visual arts, than it did at the beginning of
this decade. This phenomenon is directly related to the film and advertising
industries, where there has been an increased interest in "ethnic" audiences,
partly because of the success of black and Latino films in the marketplace. The
market power of ethnic groups is not only linked to the rise of ethnic middle
classes, but to the rate of growth of black and Latino populations in the United
States since World War II and shifts in immigration patterns that have added
hundreds of thousands of people of color to the United States. The impact of
these changes upon the United States is shown in the extent to which they are
transforming a sense of national and cultural identity. In the case of New York
City, for example, we are living in a moment in which the majority of the
population is nonwhite, though the distribution of wealth is disproportion-
ately concentrated among whites, as is the distribution of public funds for
cultural activities. New York has become a third-world city. Among the politi-
cal and sociological considerations that these changes have raised are tremen-
dous anxieties about the feasibility of strategies of social engineering. For every
"ethnic success story" trumpeted by the media there are countless instances of
racial violence, prejudicial deployment of immigration laws, depressing un-
employment and literacy statistics, and pervasive institutionalized racism. To-
gether these factors contribute to the shift in definition of group interests from
class and nation to identity categorizations based on sexuality, ethnicity, and
lifestyle. It is not only the agenda of cultural politics that is changing, but our
very concepts of culture and politics themselves.

For more than two decades, the Black Arts and other ethnically based artistic
movements have produced cultural events that have received varying degrees
of attention from the outside world. There have been moments marked by

crossovers of all sorts, from commercial success in the market to critical acclaim in the (white) art world, from official attempts at cultural integration to subcultural acts of appropriation. My particular concern in the context of the present is how the current multicultural interests interface with separatist projects. The sheer number of high-profile cultural events in New York City recently suggests that we are in the middle of a crisis of multiculturalism: these range from the Bronx Museum's *Latin American Spirit 1920–1970* exhibition sponsored by Philip Morris and several state and federal agencies; to the Rockefeller Foundation's reactivation of intercultural grants (and plans to develop worldwide distribution of film and video art with 70 percent producers being people of color and/or from the third world); to the Society for Photographic Education's conference "The Other/Voices: Issues in Representation"; to the New Museum's panels (and book project) titled "Ideology of the Margin," and the Dia Art Foundation's lecture series soliciting "subaltern" scholars. In addition, there are forthcoming multicultural arts projects that include the "Decade" show, a collaboration between the Studio Museum of Harlem, the Museum of Contemporary Hispanic Art, and the New Museum. Rather than attempting to address this trend in general terms, I prefer to focus on the role of the avant-garde sector in this conjuncture and examine its current interest in the so-called Other. Underlying the resurgent interest in otherness in the avant-garde is the legacy of its role as a broker between the mainstream and non-Western and vernacular cultures, and also its identification with the marginality it claims to share with disempowered groups. The avant-garde's current turn to the Other ambivalently affirms and questions its own marginality.

In the context of the alternative media sector that constitutes the contemporary avant-garde in the United States, the current focus on the Other comes at the end of a period in which deconstruction, psychoanalysis, and feminism have maintained hegemony, to a greater or lesser extent, over intellectual culture. The shift in attention and the debates over the implications of these theories suggest that certain operative categories can no longer hold as much weight as they have in cultural politics. Even the avant-garde is subject to market interests and pressures and is compelled to seek out new material for interpretation and exhibition. The avant-garde and socially conscious institutional engagement in discovery of the Other is also, however, an engagement in collective amnesia of past entanglements and, in more recent memory, of dismissive rejection. Although the promotional mechanisms would have it otherwise, there is nothing new about the so-called Other or its discovery. Western cultural institutions such as the avant-garde have a history of rejuvenating themselves through the exploitation of disempowered peoples and cultures.

Independent, alternative, and/or experimental films, videos, and exhibitions are dependent on public funds (even more so, perhaps, than the visual arts), and political arguments about accountability and proportionate repre-

sentation are especially powerful in this area of cultural production. It is crucial, therefore, to recognize that the blossoming of multicultural media events in a place such as New York City is in part attributable to institutional pressures expressed as arguments about the need for outreach, and the perceived need to redress the effective ethnic segregation of the art world. What is not always addressed in the policy discourse of multiculturalism is the segregated division of labor in which, more often than not, white arts institutions provide structures of control in which white intellectuals theorize about racism while ethnic film and video producers supply "experiential" materials in the form of testimony and documentary, or in which the white intelligentsia solicits token third-world intellectuals to theorize about the question—that is, the problem—of the Other for the white intelligentsia. These divisions contribute to the continuation of cultural apartheid regardless of the multicultural veneer. Given these problems, it should come as no surprise that fears exist within third-world organizations that the current multicultural impetus will ultimately hurt, not help them. Tokenism and lack of cooperation with third-world organizations, coupled with a rise in interest among white artists and intellectuals, signal for many the beginning of attrition in economic support for black, Latino, and Asian intermediaries. It will always be easier and more expedient for funders to participate in the consolidation or takeover of discrete entities than to support a number of small units.

I do not wish, nonetheless, to reduce the current surge in interest to an effect of market mechanisms and institutional anxieties, for this would be to neglect the existence and continuing emergence of challenging work by artists of color and to overlook the extraordinary influence that postcolonial studies, the "new ethnography," and black literary theory have had within the U.S. academy. The development of critical discourse on the postmodern condition and on counterhegemonic visual strategies of Third Cinema calls for further exploration of parallels in the logic and mechanisms of appropriation and syncretism between the Western avant-garde and its Other.

Much has already been said about postmodernism as a symptom of a crisis of identity in and of the first world. Yet we are only beginning to understand the points of intersection between these theories and the currents emerging from "other" sectors of critical theory. These include the reconceptualization of the third world as an effect of (post) modernity; the production and perpetuation of colonial fantasies, such as orientalism, and within these colonial discourses, the situation of the subaltern and the postcolonial subject. These currents in theory also include the critical revaluation of essentialist definitions of ethnicity, a rethinking of racial identity not as a fixed but a historicized, political category, and the study of dialectical patterns of assimilation and resistance in New World diasporic cultural phenomena as postmodernist gestures *avant la lettre*. Henry Louis Gates Jr.'s notions of U.S. black vernacular culture's poly-

valent "signifyin'"; Gerardo Mosquera's characterization of Cuban and Caribbean cultural experience as an ongoing encounter with different stages of social development; Roberto González Echevarría's vision of the modern Latin American literary project as the dismantling of ideologically fixed notions of identity and concepts of culture; Paul Gilroy's analysis of contemporary black popular music as an amalgam of Afrocentric traditions and modern technological sensibilities and apparatuses[1]—all are examples of cultural studies that have helped to further the understanding of third-world peoples' relations to modernity, the production of images, and the question of self-identity. Varied as these studies are, they signal a move away from celebration of ethnicity and presumption of ahistorical identity in critical discourses on third-world culture.

Unfortunately, the current state of affairs in public programming in the independent film and video sector barely allows for inquiry at this level of analysis. This is partly because of the nature of the models employed in public criticism and in the events in which critical dialogue takes place. The conservative demands of funding bodies and of the market obviously play a role, but these constraints are not entirely determinant. Problematic gestures come not only from the largely white avant-garde sector, but also from cultural nationalist tendencies in the third-world independent media sector. To illustrate some of the difficulties in furthering critical discourse on race and representation in this context, I want to focus in particular on two recent film conference/exhibition programs. Rather than reporting these events as such, I consider how the issues were presented, how the framing of the issues precluded addressing certain crucial questions, and what power relations are involved in the two models.

I should at this point acknowledge my own inability to engage in disinterested observation. As a woman of color and a participant in this sector as critic, curator/programmer, and program officer for a government-funded granting agency, it would be impossible for me to present an unbiased point of view. Within my own relatively short life, I have lived through the development of fictional categories to define my own ethnicity (Hispanic, a term for which there exists no concrete or geographical referent); I can remember when the same individuals and institutions that are now engaged in multicultural initiatives excluded questions of race and marshaled arguments about quality and complexity to maintain cultural apartheid; as a mixed-race individual of Afro-Caribbean descent, I can attest to the conceptual and material difficulties of separatism; and I have become extremely aware of how meager access to the means of production is conducive to competitive antagonism between third-world groups, and how these antagonisms facilitate the continuing hegemony of dominant institutions. But it is for such reasons that it is important to examine the difficulties in these two recent events.

The two conferences were the Celebration of Black Cinema (CBC), held in Boston, and Sexism, Colonialism, Misrepresentation: A Corrective Film Series, held in New York City, both in April 1988. The Boston event, presided over by Claire Andrade-Watkins (associate professor at Emerson College) and programmed by Pearl Bowswer and Institute for Contemporary Art film curator Julie Levinson, showcased black independent films from anglophone Africa, Britain, and the United States. It was run by a majority black (all but one), majority female (five out of seven) committee with public funds. It included two panel discussions with prominent black film scholars, one with visiting filmmakers, and a film program of eighteen titles. In addition, CBC, Inc., issued *Black Frames: Critical Perspectives on Black Independent Cinema*, a book intended to offer "a rare global and systematic examination of the particularities as well as the commonalities of the history, the context, and the aesthetics of black independent film practice in 'Anglophone' Africa, the United States and Britain."[2]

Although it is beyond the scope of this article to delve into extensive contextual detail, the Boston event cannot be fully understood without noting its place in the cultural environment of the East Coast art world. Since its inception in 1981, CBC has served as an important venue for black independent media, operating in an area of third-world film and video exhibition/distribution that has historically been one of the weakest and most problematic and underfunded. The development of noncommercial channels of exhibition, buttressed by critical discourse and educationally oriented research—all of which are served by CBC—has been crucial to the survival of the black independent media sector.

The three historical essays in *Black Frames* lay a groundwork for understanding the presence or absence, nature, context, and conditions of cinematic production in each area. The style each essayist takes is as indicative as the information, demonstrating a much-needed methodological flexibility to account for film production in the different regions of the diaspora. James Snead's survey reflects on the relativity of the term "independent," and relates the development of black U.S. independent film to the influences of structures in dominance, such as segregationist legislation, Hollywood stylistic codes, and racist stereotypes. His account also emphasizes technology—the potentials and disadvantages afforded by the postwar advent of 16 mm equipment—and the political imperatives regarding representation that gained currency with the civil rights movement. Manthia Diawara's study takes account of the dearth of films produced in anglophone Africa by foregrounding the economic impediments resulting from neocolonialist inequities and the relative lack of local government investment. Jim Pines's essay demystifies the apparent black British boom in independent productions in the 1980s by recounting its antecedents and the institutional shifts that have made current experiments possi-

ble.[3] The historical perspective in each of these essays gives a sense of how racial inequities play into black film development, thus eluding the presumption that racial identity is determinant in that development and recognizing the variety of styles, genres, and thematic concerns in and between each region.

Economic and political questions of independence in relation to cultural practice are also implicated in CBC as an organizational form. CBC is an exercise in cultural autonomy, an indication of the possibility of international cooperation between black organizations and, as such, a transformation of diaspora as dispersal into diaspora as transnational unity. And it is precisely within these structures that the specificity of black cultural experiences and practices can be examined, questioned, and understood. But CBC is not a disinterested learning experience; it is also a business, with "Inc." proudly displayed throughout its literature. It is consolidated through the legislation of exclusivity of rights, such as establishing exclusive rights to British Council support for the year 1988.

For all its positive contributions to the black independent media sector, CBC was also fraught with contradictions and conflicts symptomatic of the problematic status of critical discourse within this sector, especially when monolithic notions of black identity mask internal differences and occlude crucial agendas. Most evident was the all too familiar tension between the impetuses to claim all-inclusiveness or to disclaim it out of either unavoidable constraints or critical prerogative. This is not peculiar to black cultural events, but the tension underlies a chronic, unresolved debate in black cultural politics over the role of the producer in relation to the supposed community and the role of the critical intermediary in relation to the film practitioners' community. In the case of CBC, the book's editors claimed to provide an inclusive purview, while the film programmers opted for selectivity, and many filmmakers felt justified in admonishing participating critics for being selective in their treatment of material. At best, these tensions cause everyone to rethink their criteria for "quality." At worst, these imperatives turn the task of representation into a burden, impeding critical judgment and analysis and functioning ultimately to police all conflict, selection, and critique.

In the course of the CBC event, there was little scheduled opportunity to discuss films or do more than reiterate already published papers. The week-long program was, nevertheless, marked by a series of eruptions that made clear the differences within the community, particularly the British contingent (and these conflicts would probably have spread had more North Americans been present). The black British visitors are part of a black arts sector that has achieved unparalleled prominence in the '80s. At the center of this activity and debate are the London-based black workshops, each of which has produced work that has been found to be controversial for political and/or aesthetic

reasons. For outsiders, the dividing lines appeared to be between the theoretically oriented workshops and independent filmmakers in the documentary tradition. In the absence of opportunities for debate on political, aesthetic, and generational differences, the conflict was projected onto critics and reformulated as an argument over the legitimacy of the conventional social documentary and an insistence that criticism be compelled to legitimate it once again and concomitantly denigrate aesthetic issues from whatever angle possible. The closing panel, consisting of atomized presentations from the filmmakers present, only enforced the notion that celebration and critical debate are mutually exclusive. All these tensions seemed to point to a crucial, unanswered question—namely, can a conference celebrating black cinema address whether a black cinematic aesthetic can be identified at all?

If there was any consensus during CBC, it was that the question of aesthetics was at the root of the difficulties. This was apparent in the resistance to critical positions that foregrounded formal issues and in certain arguments, such as Clyde Taylor's rejection of the very concept of aesthetics. In his essay "We Don't Need Another Hero: Anti-Theses on Aesthetics,"[4] Taylor imputes diabolic intent to Western aesthetics in order to argue for its categorical rejection; however, such a view negates distinctions between aesthetic theories and the institutions and political entities that deploy them for specific ends. Taylor claims that Western aesthetic discourse, the inception of which he locates as coincidental with the Enlightenment and the rise of industrial capitalism, has functioned historically to uphold a depoliticizing formalism, which excludes any cultural work that does not conform to Eurocentric bourgeois aesthetic ideals.

Leaving aside the anachronisms involved in the interchangeable use of the terms "aesthetics" and "aestheticism," I would argue that in his conflation of Western aesthetics with "Aesthetics" ("all aesthetics are western"[5]), and the reduction of aesthetic philosophy to Kantianism, Taylor repeats the epistemic violence of dominant institutions by assuming that the official representation of aesthetics in the modern period reflects all aesthetic discourse in an all-inclusive manner. Such an undialectical approach, collapsing historiography and history, cannot account for the counterhegemonic tendencies within aesthetic discourse and practices themselves. I would not be the first to point out that not all aesthetics are Western, nor are they all Kantian, neo-Kantian, or formalist. Nor would I be the first, in light of decades of social historical research, to refuse to ignore the counterhegemonic impact of the cultural practices of disempowered groups on dominant aesthetics, as Mikhail Bakhtin's account of the influence of popular language and culture on the novel would suggest. Contrary to Taylor's assumptions, the Western bourgeoisie were not and are not the only group to marshal formal notions of beauty, as West African sculptures' highly refined, codified, nonrealist, symbolic renderings of the

figure would indicate; as they did, for example, to Picasso. Given the textual evidence of the philosophical and theological treatment of aesthetic issues prior to capitalism and the influence of those debates on aesthetic debates ever since, it seems highly problematic to place the rise of aesthetics in the eighteenth century, or to speak of a postaesthetic discourse in the present. To claim that a postaesthetic discourse is needed to undermine formalism negates a history of ethical and artistic debate that, at least since the development of Marxist aesthetics, has been concerned with the historical embeddedness of aesthetic forms and their evaluation. Unfortunate antecedents to such total dismissals of aesthetics coincide with the most repressive moments in revolutionary movements, when political imperatives and puritanical zeal lead to suspicion of formal inquiry and intellectual labor. Without aesthetics, and more specifically, without an approach to the formal properties of cultural works, we have no place from which to understand the specificity of art, a situation that only encourages facile and reductive slogans to be enumerated by "critics" and censors alike.

Given the economic realities of film production and the consequent dependence of filmmakers on institutions beyond their control, it is especially important that criticism account for the sociopolitical context of a work. Moreover, in light of the gross imbalance of access that third-world media production has to distribution and the chronic underrepresentation of third-world peoples in mainstream image production, any serious critical discourse on the third world must account for the influence of these factors on the nature of independent production, as does Julio Garcia Espinosa in his groundbreaking "For an Imperfect Cinema."[6] To couch valid assertions, however, in a racialized rhetoric of refusal neglects the hybrid experience of diasporic peoples, whose relation to the aesthetic, be it Western or non-Western, imposed, assimilated, creolized, or rejected, has nonetheless been a constant feature of modernity and should be understood as such.

Teshome Gabriel's "Thoughts on Nomadic Aesthetics and Black Independent Cinema" extends his search for symbols and structures to accommodate black experiences and black cinema from his previous work, *Third Cinema in the Third World*.[7] A collage of poems, reflections, diagrams, and graphics, the piece evokes nomadism in its style, but is confused by its literal interpretation of the nomadic metaphor—that since nomadism is originally from the third world, it can be applied to define cultural work of peoples originally from the third world. It is further weakened by its methodological inadequacy for the interpretation of more conventional black films, and its lack of explanation of the effects of material constraints on aesthetic choices. In his search for a non-Western model, Gabriel is left without the means to address an essentially industrial medium. More puzzling, however, is Gabriel's assertion that the nomad's story is necessarily a woman's story. Not unlike Taylor's claim that

"post-aesthetics" incorporates elements of feminist criticism, this gesture constitutes little more than lip service to sexual politics.

Perhaps what was most disturbing about these chivalrous gestures was that they were taking place in a virtual vacuum. The CBC conference and publication were marked by a lack of sensitivity to issues of sexuality and gender. Replicating an extremely traditional and even repressive hierarchy in its organization, CBC's division of labor consisted of a book in which the only female voice was that of the coeditor and all-male scholarly panels (with a female keynote address speaker, Toni Cade Bambara, whose paper was not published in the book). I found this particularly appalling in light of the enormous contributions made by U.S. black women filmmakers and cultural theorists to independent media, and even more disheartening given their cogent critiques of the masculinist underpinnings of cultural nationalism. Of the U.S. work in the program, the only example of an implicit critique of the politics of representation was Camille Billops's critique of stereotypes of femininity, beauty, and the love story genre in her film *Older Women and Love* (1987), though its transgression operates largely at the level of content.

The rejection of aesthetics, linked with resistance to the politics of representation, paved the way for wholesale misinterpretation of Kobena Mercer's analysis of dialogic and monologic tendencies in black British cinema. Contrary to the accusations levied by several independent documentarians, Mercer's article, "Diaspora Culture and the Dialogic Imagination," provides a sympathetic historical account of the relation of form and context in black independent cinema in Britain.[8] Rhetorical strategies, including those of the "tell it like it is" documentaries, Mercer argues, are a result of social and political imperatives and economic factors:

> The substantive concern with the politicizing experience of black youth in films such as *Pressure* (dir. Horace Ove, 1974) and *Step Forward Youth* (dir. Menelik Shabazz, 1977) demonstrates a counter-reply to the criminalising stereotypes generated and amplified by media-led moral panics in the '70s. . . . And as *Struggles for the Black Community* (dir. Colin Prescod, 1983) shows, the historical emphasis in this counter-discourse is an overdetermined necessity to counteract the dehistoricizing logic of racist ideology.[9]

Mercer then goes on to assert that the motives for and objectives of those formal choices do not dissolve their dependency on ideologically problematic forms, establishing the political, aesthetic, and generic distinctions within black film practice that continue to be a source of bitter debate. Realist methods, Mercer contends, operate within aesthetic values central to the dominant film and media culture; hence the black producers who use them must "redefine referential realities of race through the same codes and forms as the prevailing

film language whose discourse of racism it aims to contest."[10] While such films can offer an immediate source of alternative information, "such communicative efficacy in providing counter-information exhausts itself once the political terrain changes."[11] In addition, the tenet of authenticity is virtually incompatible with the strictures of narrative drama, since "typical" experiences are presumed to stand for every black person's perception of reality. Characterizing this mimetic conception of representation as monological, Mercer then contrasts it with semiotic approaches that "by intervening at the level of cinematic codes of communication . . . interrupt the ideological purpose of naturalist illusion and perform a critical function by liberating the imaginative and expressive dimension of the filmic signifier as a material reality in its own right."[12] Drawing on Bakhtinian theories of the carnivalesque and Edward Braithwaite's concepts of creolization and interculturation, Mercer offers a rationale and method for formal readings of films such as *Territories* (1985, by Sankofa Film and Video Collective) and *Handsworth Songs* (1986, by Black Audio Film Collective). Rather than refusing ideas from European artistic practices, Mercer writes, black cultural producers must direct their energies to evaluating how diasporic peoples are already inscribed within them, to discern and distinguish critical appropriation from imposition and/or assimilation.

Though not overtly stated, this argument allows for an awareness of how relations of power and control are important factors in processes of cultural appropriation and assimilation. This is particularly crucial, since the shift from essentialist to political categories of race, coupled with poststructuralist skepticism about identity and deconstructive relativism, could easily appear to be an abdication of any concern over who is actually engaged in critical debates. It is one thing to argue for delimiting and legitimating experiments in representational strategies, but it is quite another to call for a free-for-all in the political sphere of representation.

To return for a moment to Taylor's argument, if aestheticist tendencies have been instrumental in the exploitation of disempowered cultures, it has been precisely through their disavowal of the power relations involved in the formal appropriation of and subsequent capitalization on third-world culture. Indeed, arguments about the aesthetic "appreciateability" of Haitian painting were used by the surrealists, and about graffiti were used by many gallerists and critics in the early 1980s. And since the radical student groups of the 1960s adopted the symbols and rhetoric of third-world nationalist movements, an identification with the generically oppressed third-world Other has been the favored proof of a first-world artist/intellectual's political correctness. Yet the concern for abstract oppression abroad is not equivalent to the recognition of the problems within one's immediate environment—what the Black Panthers called domestic imperialism. More often than not, the avant-garde has balanced its fascination with foreign Others with miserly tokenism and/or dis-

avowal of the black and third-world artists within proximity, and people of color in general. The problems and dangers of the current phase of multi-culturalism lie in the apparent inability of many efforts to transcend this legacy of exploitation. To some extent, the institutional demands to justify public funding require the deployment of arguments that in themselves engender highly problematic, often racist, structures. For if black separatist organiza-tions are compelled to produce "celebrations" and bear the burden of represen-tation, the (white) avant-garde is equally compelled to propagate a curatorial discourse, with its rhetoric of discovery and retrieval, its mission to preserve hitherto unrecognized wonder from oblivion, and its implicit power to desig-nate art status to its objects.

The New York event, organized by French critic Bérénice Reynaud and white U.S. independent filmmaker Yvonne Rainer, took the form of an exten-sive series of documentaries, experimental short films, and independent fea-tures from the United States, Western Europe, Australia, Senegal, Tanzania, Mexico, Brazil, Nicaragua, the Philippines, and Taiwan. The majority of the works were produced by women—no works by white males were included, but a handful of films were made by black, Latino, and Asian men. Of the three panels, there were two in which media producers regarded as "people of color" predominated—Exclusionary Practices: Political Expediency and/or Social Necessity and The Responsibility of Representing the Other—and one in which white feminist theorists were in the majority—The Visualization of Sexual Difference. The event was not exclusively devoted to third-world films or to questions of race—in fact, the majority of films in the series were produced by white women from the first world. Although the very title of the conference implicitly assumes that sexism and colonialism can be addressed together as subsets of misrepresentation, the racial politics inscribed in the event were the source of the most heated debates. And as more than one participant was to point out, the event's locations—the Collective for Living Cinema and the Dia Art Foundation—were, until quite recently, bastions of overwhelmingly white avant-garde cultural practices.

Above all, the rhetoric of the compensatory gesture that underpinned the collective's "corrective" series was highly problematic—as if decades of racism and sexism could be overcome through a *single* event, rather than through a fundamental revamping of institutions and an ongoing critique of their selec-tion processes.

The fetishization of rarity in the avant-garde art world detracts from an in-quiry into the reasons for the relativity of that rarity in the first place. At no point during the Sexism, Colonialism conference was it clearly stated to whom this corrective was addressed, though the predominantly white, female art-world intelligentsia was the actual audience. If we look at the films in the program produced by people of color—Julie Dash's *Illusions* (1982), Charles

Burnett's *Killer of Sheep* (1978), Stanley Nelson's *Two Dollars and a Dream* (1987), or Sara Maldoror's *Sambizanga* (1972), for example—many of them are among the films most frequently shown in third-world exhibition circuits and festivals. Their "rarity" then relates to the white mainstream and white avant-garde venues and their exclusionary practices. On the other hand, the panels did not include critiques of white avant-garde and activist appropriation of people of color and the third world. These representations, it seemed, were not to be "corrected."

Since the early '70s, the reigning interpretation of Eurocentric film theory has led to the fetishization of formal complexity and the obsessive search for visual illustration of psychoanalytic "truths." This has encouraged institutionalized segregation and the blanket dismissal of cinema verité and activist documentary film and video. The recent multicultural events appear to be attempting to break down this segregation by including works, primarily documentary, by people of color, and by a renewed theoretical focus on the so-called Other. These events are, nonetheless, situated within a terrain that has been historically exclusionary. Endemic to this history are structured absences that function to maintain relations of power. To put it bluntly, no one has yet spoken of the Self implicit in the Other, or of the ones who are designating the Others. Power, veiled and silent, remains in place. The multicultural crisis of conscience, from the point of view of the empowered sector (relatively speaking, of course, since the avant-garde rarely perceives itself as empowered), has shifted political attention to the so-called margins of cultural productivity. Here the rediscovery of cultural work produced by people of color falls into a pattern of "othering" within film studies. As Ana Lopez has recently argued, "To a large extent, film scholarship's fascination with the identification of oppositional film practices—be they film noir, the woman's film, the structural avant-garde, or the New Latin American Cinema—must be seen as an effect of our interest in discontinuity as a progressive strategy that can be contrasted to an assumed standard, fixed and continuous history or institution—specifically Hollywood cinema."[13]

While identification of other cinemas presumes a fixed standard, the constitution of the Other around an absent center reaffirms that center, or rather it confirms the central role of those avant-garde institutions and the individuals who act as intermediaries in the current arts scene. In this context, the contemporary version of imperialism as social mission, or the curatorial rhetoric of saving films from oblivion, serves as necessary complement to the recentering of the avant-garde. The attention to the Others stresses otherness, reaffirming the role of the intellectual who interprets those experiences.[14] Not only does the institutional preference for ethnic testimony confirm the dependency of third-world artists on intellectual intermediaries, it also functions to create the illusion of authenticity—that "real" others are called to speak for the category

they represent, producing a spectacle of identity, atomized, stereotyped, and fetishized by the setting and structure of the events. But if the illusory presence of the Other serves to justify the intellectual's role, the absence of any interrogation of the identity and ethnicity of the implied Self transforms race into a problem of the Other. Racial identities are not only black, Latino, Asian, Native American, and so on; they are also white. To ignore white ethnicity is to redouble its hegemony by naturalizing it. Without specifically addressing white ethnicity, there can be no critical evaluation of the construction of the other.[15]

These structured absences in multicultural discourse took on a particular cast at the Sexism, Colonialism conference. While the majority of panelists were people of color, the organizing principles of the discussions were drawn from (largely French) feminist psychoanalysis. Throughout the conference there operated a Eurocentric presumption that sexual difference could be separated from other forms of difference and that the theoretical models that privilege gender-based sexual difference could be used to understand other differences. The first panel appeared to suggest that separatism was the province of nonwhite groups alone, for there was no representative of white, middle-class, first-world feminism or the overwhelmingly white avant-garde film community to speak on the political expediency of organizing without people of color. The second panel, in which feminist psychoanalysis and white critics predominated, did not officially include any interrogation of the Eurocentric prioritization of sexual difference, nor did it address the division of labor between white critics and nonwhite producers: at no point was there any discussion of the visualization of racial difference or of the third world in films such as Lizzie Borden's *Born in Flames* (1983), with its racialized divisions of "revolutionary" feminism, Ulrike Ottinger's work in China, or Deborah Schaffer's *Fire from the Mountain* (1987), about Sandinista leader Omar Cabezas.

Panelist bell hooks, in her commentary on her colleagues' presentations, pointed out that it was only within an exclusionary intellectual context such as the deployment of Eurocentric psychoanalytic theory that sexual difference could be extricated from other differences, such as race and class. Attempts were made to defend psychoanalysis from its detractors by insisting on its limitations, but at no point would the exponents of feminist psychoanalysis take on the deeper implications of the critique—that the problem lies not with psychoanalysis, which has been used in several contexts to account for the sexualization of racial difference,[16] but rather with the institutions and individuals who deploy it in exclusionary, fetishistic ways.

For reasons probably both personal and political, some of the so-called Others among the panelists chose to question the premises for their presence and questioned the label Other and/or "exclusionary practitioner." In the course of the first panel, Linda Mabalot and Isaac Julien were quick to point out that it was exclusion from white institutions that led to their opting for ethnically

and/or racially based organizations. Mari Carmen de Lara noted that the class differences between the middle-class Mexican women filmmakers in her group and the working-class female subjects of her films constituted a dichotomy within a single-sex organization as overdetermined, challenging, and even painful as any other differentiating paradigm. Julien, turning the question of expediency back to the institutions, indicated that accommodationist strategies only allow for a small space for the Others and create a situation in which tokenist gestures can take the form of grants and function as ideological payoffs. One of the few to critique paternalistic assumptions about third-world filmmakers' "responsibility," Julien unraveled the assumptions that relegate black cinema to a form of advocacy or social work.

The power dynamics generated by racial imbalance in the composition of the audience was the subject of hooks's introductory comments about the discrepancy between her anticipated and actual listeners and its effect on her speech. Trinh T. Minh-ha noted that the changeability of her "difference," depending on which context she addressed, might not be accounted for by a single term. Beni Matias rejected the perception of her as an Other before affirming her sense of mission, while Michele Wallace asserted in her opening comments to the final panel that intrinsic oppositionality could not be attributed to the so-called Other. This comment, passed over in the course of discussion, was an extremely significant one, for the claims to essential oppositionality are precisely the meeting point of the collective fantasy of cultural nationalism and the avant-garde's exoticizing fantasy of its other. To break with both marks the transition from essentialist fetish to political and critical dialogue.

Having described aspects of contestation to multicultural category politics, I realize that I risk creating the impression that counterhegemonic "truths" emanate exclusively from nonwhite speakers. But in the case of this conference the sole white participant with a long-standing commitment to the study of a third-world culture and its cinema, Catherine Benamou, was also the only one to suggest that the implications of genres might shift in a neocolonialist context and warned against the desire to project one's own version of oppositionality onto any situation.

Among the black and third-world participants in both events there were obvious political and aesthetic differences. There were those who unproblematically assumed the burden of responsibility, and others who refused such strictures. The important question, though, is why all these media producers must be thrown together without distinguishing the genres they work in when their white counterparts are not? Is it not condescending to presume that third-world filmmaking is so undifferentiated as to merit only one mode of categorization? One of the positive consequences of such distinctions might be to terminate the simplistic conflation of white, feminist, experimental cinema's

supposed oppositionality with that of almost any genre produced by a black or third-world filmmaker. As Hazel Carby notes, sexism and racism may be similar, but the institutions that engender them are not, nor are the forms of analysis they call for: any insistence on parallels via the reigning concept of patriarchy is ultimately a futile academic exercise.[17]

Multicultural and separatist media events will doubtless continue to take place in New York City and other areas of the United States: but what are the signs of salutary coexistence? It would seem that the current state of affairs bespeaks a lack of respect and recognition of third-world institutions, which translates into biases in funding and a dearth of genuine collaboration in decision making at the level of policy and practice. On the other hand, it is painful to realize that critical analysis of problems within third-world film production continues to be marginalized within the cultural nationalist context, and that virtually anything but celebratory explication or blanket attacks on abstract foreign agents is viewed with suspicion. The opening of critical dialogue within the "communities" of discursive dialogism in both sectors is badly needed if we are to break with the regime of oppositional fantasy. Such a move would not only be a sign of integration, but of integrity.

Notes

This article also appeared in *Screen* 29, no. 4 (fall 1988).

1 Henry Louis Gates Jr., *The Signifying Monkey: A Theory of Afro-American Literary Theory* (New York: Oxford University Press, 1988); Gerardo Mosquera, *Exploraciones en la Plastica Cubana* (Havana: Editorial Letras Cubanas, 1983); Roberto González Echevarría, *The Voice of the Masters: Writing and Authority in Modern Latin American Literature* (Austin: University of Texas Press, 1985); Paul Gilroy, *There Ain't No Black in the Union Jack: The Cultural Politics of Race and Nation* (London: Century Hutchinson, 1987).

2 Mbye B. Cham and Claire Andrade-Watkins, "Introduction," in *Black Frames: Critical Perspectives on Black Independent Cinema*, ed. Mbye B. Cham and Claire Andrade-Watkins (Cambridge: MIT Press, 1988), 9.

3 James A. Snead, "Images of Blacks in Black Independent Films: A Brief Survey," 16–25; Manthia Diawara, "Film in Anglophone Africa: A Brief Survey," 37–49; Jim Pines, "The Cultural Context of Black British Cinema," 26–36, in Cham and Andrade-Watkins, *Black Frames*.

4 Clyde Taylor, "We Don't Need Another Hero: Anti-Theses on Aesthetics," in Cham and Andrade-Watkins, *Black Frames*, 80–85.

5 Ibid., 81.

6 Julio Garcia Espinosa, "For an Imperfect Cinema," in *Communications and Class Struggle: 2. Liberation, Socialism*, ed. Armand Mattelart and Seth Singlaub (New York: International General, 1983).

7 Teshome Gabriel, "Thoughts on Nomadic Aesthetics and the Black Independent Cinema: Traces of a Journey," in Cham and Andrade-Watkins, *Black Frames*, 62–79; see also Gabriel, *Third Cinema in the Third World: The Aesthetics of Liberation* (Ann Arbor: UMI Research Press, 1982).

8 Kobena Mercer, "Diaspora Culture and the Dialogic Imagination," in Cham and Andrade-Watkins, *Black Frames*, 50–61.

9 Ibid., 52–53.

10 Ibid., 53.

11 Ibid.

12 Ibid., 54.

13 Ana Lopez, "An Other History: The New Latin American Cinema," *Radical History Review* 41 (April 1988): 98.

14 In her article "Can the Subaltern Speak?" Gayatri Chakravorty Spivak addresses this problem. See Cary Nelson and Lawrence Grossberg, eds., *Marxism and the Interpretation of Culture* (Urbana: University of Illinois Press, 1988), 271–313.

15 Hazel V. Carby addresses this issue in "White Women Listen! Black Feminism and the Boundaries of Sisterhood," in *The Empire Strikes Back: Race and Racism in Contemporary Britain* (London: Hutchinson, in association with the Center for Contemporary Cultural Studies, University of Birmingham, 1982), 212–35.

16 The work of Homi Bhabha and Franz Fanon are of particular importance on this issue.

17 Carby, "White Women Listen!" 214.

Charles A. Wright Jr.

The Mythology of Difference: Vulgar Identity Politics at the Whitney

1993 Whitney Biennial
Whitney Museum of American Art
New York, New York
March 5–June 13

Every two years art enthusiasts, critics, dealers, and artists relish the opportunity to pass judgment on the Whitney Museum of American Art's biannual exhibition of "significant" artwork produced during the previous two years. Critical sentiments run the gamut from simplistic accusations of trendiness on the part of the museum to condemnations of a virulent market system controlled by a handful of dealers, as well as to questions of quality leveled at exhibiting artists. These critical tendencies are, of course, not exclusively those of any single ideological camp. Rather, they straddle the boundaries set, on the one hand, by a conservative establishment that insists on traditional aesthetic values predicated on Enlightenment assumptions of taste, decorum, and quality, and, on the other, by a liberalist front dedicated to an embattled questioning of such culturally ingrained beliefs and committed to reconstructing historical understandings of aesthetic value through the achievements of cultural parity.

Not uncharacteristically, both extremes often remain decidedly reactionary, and as a consequence it is the work of the artists that is put on trial, at once the center of attention and yet peripherally situated as exemplars for propagandizing agendas—leaving the museum modestly poised as a disinterested progenitor of the field. Once the exhibition is removed from view and all have pronounced their verdict, it is the represented artists who bear the marks of validation or its obverse, while the agents and apparatuses that orchestrated or exacerbated the conflict proceed to conduct business as usual.

In the last ten years art historians and cultural critics have turned their attention to the museum or gallery as an ideologically charged site. Despite this, however, one need only survey much of the commentary leveled at this

year's exhibition (1993 Whitney Biennial, Whitney Museum of American Art, New York, New York, March 5–June 13) for evidence of the paucity of direct address of the Whitney's engagement of its own historical and philosophical status as a nexus in the contest of ideologies that subsumed this year's Biennial. Neither will one find any thoroughgoing examination of the pedagogical nature of curatorial practice as a medium for elucidating the museum's institutional alignments and interests. While reviewers were quick to praise or denounce, few questioned the underlying institutional impetus for the topical focus of the show (aside from accusations of "political correctness"), or sought to foreground the implications of the museum's relationship to the ideas and concerns it professed to "celebrate."[1] Can the mere fact of inclusion necessarily constitute a celebration of diversity? And how has the host of such a culturefest manufactured its own relation to the celebrants?

The fact that representation in any exhibition is predicated on necessary exclusions is rarely broached beyond evaluative pronouncements, but rather remains an untheorized given within the context of most art criticism. The role of the curator, therefore, takes on a kind of naturalized authority. Contrary to the benign assumptions that conceive curatorial practice as mere custodial stewardship, our contemporary setting requires an understanding of curatorship not as a kind of unmediated presentation but as a practice in which specific choices are made—determined by ideological interests, whether these be institutional or individual. To this end, it may prove more beneficial to acknowledge the absolute constructedness inherent in curatorial practice in general and to recognize that the careers and aspirations of artists hang in the balance. Since (at the time of this writing) the Biennial has closed, and its unprecedentedly text-heavy catalog remains the only surviving document, I have attempted to focus my comments on the operative textual ethos of the show rather than fully recount the merits of specific works and artists.[2]

Whether the exhibition is in the form of a survey or thematic presentation, we need to be reminded that within curatorial practice what is excluded is as profoundly instructive as what is included. This holds true not only for artists represented but also for the specific works selected. And in light of this, two points must be made from the start. First, unlike previous exhibitions, the 1993 Biennial is neither clearly a survey nor a thematic exhibition. Rather, this show offers a representative selection of works by previously marginalized artists loosely professing an interest in "questions of identity," while at the same time neglecting to address the identity of the inquiring institution. Second, as a result, this inquiry quite unproblematically installs the notion of cultural diversity as its curatorial objective in the absence of any thoroughgoing historical reflection. The exhibition refuses to address a fundamental, albeit reductive, homogenizing question that has plagued the museum since its founding: what is "American" in American art?

Concurrently with the 1987 Biennial, the exhibition *Guerrilla Girls Review the Whitney* at the Clocktower in New York City sought to expose what was American at the Whitney—and in its account "American" did not include women.[3] In the manner of many of the direct disclosures of art-world discrimination made by this anonymous collective, the exhibition was a stark, wryly humorous indictment of the historical record of the museum's historically conditioned notion of American Art—a tradition that clearly privileges white male artists. The exhibited series of charts and graphs provided statistics on issues of exhibition inclusion, curatorial sensitivity, and museum acquisition along gender and racial lines as reflected in Biennial presentations since 1973. Indeed, for the present discussion, 1973 constitutes a relevant marker in the Whitney's performance on the issue of cultural diversity. It is discernible from the Guerrilla Girls' report that the range of artists from various constituencies (women, blacks, Asians, Latinos/as and Native Americans) was at its peak in 1973, only to take a drastic downward turn in the years that followed.[4] That this abrupt acknowledgment of minority artists in 1973 was produced in the aftermath of the civil rights skirmishes of the 1960s as well as in response to pressure by underrepresented groups leveled at the museum is unquestionably plausible. However, as evidenced in the Clocktower show, whatever notion of Americanness was proffered by the 1973 Biennial, that floodgate closed almost as quickly as it opened. In a multiculturalist 1990s, exactly twenty years later, the Whitney once again takes up the gauntlet of American Art under the guise of cultural inclusion cum identity politics, this time feigning historical amnesia to suffuse that legacy of cultural indifference. Critical skeptics, I think, would ask whether or not this most recent effort of inclusion marks a significant reversal of that history or a conciliatory rehearsal of that twenty-year cycle.

In his introductory remarks, David Ross, the Whitney's recently installed director states:

> As a museum of American art, the idea of community is literally inscribed into our name. There is no single set of questions with more relevance at this moment, no set of shared concerns with more resonance *of* this moment than those raised by artists concerned with identity and community. If the act of questioning is an aggressive act or a demand, it is also a means of questioning the nature of control. (Emphasis in original)[5]

Ross at once states the obvious feature of the Whitney's pedigree. This skeletal framework for critical reflection assumes, however, that the museum's relationship to notions of Americanness and community is unproblematic. But while the concerns of many of the artists in the show speak to the urgency of issues affecting their lives, how are we to locate the museum's ideological investment in the matter as outlined by Ross? Furthermore, regardless of what Ross perceives as having "relevance for this moment," the concerns raised by

the exhibiting artists did not emerge yesterday, but are the product of historical and political conditions that have sustained the cultural marginalization of minorities and women in American society. Lastly, what agent of "control" is being interrogated? It is apparent that Ross does not recognize the museum's own role as such an agent and presumes it to be neutral.

Camouflaged by the ubiquitous nonsequitor "community," Ross remains firmly ensconced within a rhetoric that has informed the limited and limiting pantheon of mostly male, mostly white artists. Ross's melting-pot pronouncements aside, this year's exhibition wrestles with issues of cultural identity, opting for a splintered address of the elusive construction "Americanness" by way of what its curatorial staff understands—given the Whitney's exclusionary history—as not-American (for example, black, Latino/a, gay, etc.). Such a maneuver affects a kind of reparational gesture, presumably not drastically dissimilar from its curatorial position two decades before. However, it is not enough today to claim inclusion as an unqualified remedy to simple neglect. Rather, one must question the how and the why of that inclusion and distinguish it from other unsustained efforts to accomplish parity. Ross's conceptual sleight of hand posits an agenda that perceives the current cultural climate as one in which "the problems of identity and the representation of community extend well beyond the art world." "We are," he continues, "living in a time when the form and formation of self and community is tested daily. Communities are at war, both with and at their borders. Issues of nation and nationality, ethnic essentialism, cultural diversity, dissolution and the politics of identity hang heavy in the representation of community."[6]

It is no exaggeration that this war is being fought beyond Madison Avenue. Indeed, the selection of George Holidays's infamous eyewitness video of the Rodney King beating is probably the most poignant manifestation of the gravity of that national conflict. And the war that Ross refers to was restaged on the battlefield staked out on the five floors that housed the exhibition. More than a demonstration of generalized societal conflicts, the exhibition structurally alludes to political and philosophical collisions within the institution itself.

This year's presentation generated embattled criticisms that emphatically drew lines between art and politics as well as cultural inclusion and exclusion. The productive discursive value of the show was consumed in a proverbial cloud of smoke cast by the artillery of disparate camps and contending factions. In the name of diversity, the call to arms was raised and all combatants were readied to defeat their respective foe(s). One thing seems certain, however. The smoke was so thick that, in the end, it was impossible to see what you were shooting at. Who is the enemy and where is he/she to be found?

Popular media critics recognized the enemy and that enemy was themselves, a mythologically constructed "straight, white male"—the preeminent protector of culture. Recoiling with disgust, they dismissed the show, claiming that it,

sacrificed aesthetics in favor of collective political self-interest. These critics remained sternly reluctant to acknowledge that all forms of cultural production have historically embodied some relation to sociopolitical conditions: Serge Guilbaut's analysis of the role played by American abstraction of the 1950s as a reflection of prevalent assertions of American freedom after World War II is a relevant example.[7] Yet this form of inquiry was not afforded to any of the objects presented in the Whitney's galleries. Rather than privilege overarching nationalist claims, this year's Biennial revolved around the question of American freedom for whom?—the result of reigning anxieties within American national identity rather than a Cold War identity projection on an international scale.

With headlines as biting as "Culture War at the Whitney," "A Fiesta of Whining," and "Fade from White" gracing pages in the popular press, reviewers vehemently revealed a century-old Kantian trump card of aesthetic value, rather than rigorously examining the rancorous discomfort the exhibition produced. John Leo's review in *U.S. News and World Report* considered the exercise an irreverent meditation on political correctness with "occasional dollops of actual art and great helpings of trendy propaganda about victimization, imperialism, patriarchy and the dreadful stigma of white skin," while *Time* magazine's Robert Hughes dubbed it "a long-winded immersion course in marginality—the only cultural condition, as far as its reborn curators are concerned, that matters in the '90s." The art press, on the other hand, proved a bit more diverse in its assessment, preferring a more restrained, though pointed, consideration. *Artforum* went so far as to entrust not merely a single writer to discuss the show but eleven.[8] Jan Avgikos's contribution to this compendium of responses hauntingly articulates the intensity of the ideological casualties of this Biennial. Avgikos's article is an account of an exchange with a museum guard during one of the opening receptions for the exhibition, where, after he had refused to adjust the audio component of an installation work on view (Jack Pierson's *Diamond Life,* 1990), she heard him whisperingly retort, "Kill all white people," as he continued his rounds. In her review in *Art in America,* among the most glowing of the reports, Eleanor Heartney writes:

> Rejecting the frivolity of Biennials past, with their Day-Glo bathrooms [Kenny Scharf, 1985] and stainless steel bunnies [Jeff Koons, 1987], the 1993 Biennial declares itself as sober and instructive as the times demand. . . . Can this really be the same exhibition which the Guerrilla Girls targeted in 1987 for its longstanding practice of racial and sexual exclusion?[9]

This spectrum of opinions is evidence of the "war" Ross cites. The underlying commonality among these critics is that each contributes to a cacophonous set of victimized positions: on the one hand, a defensive hegemony perceiving

the threat of having to legitimate itself, and on the other, a persistent, multi-faceted and disparate coalition whose divergent motivations declare its right to be recognized and heeded. The reigning presumption, of course, is that either party will seize and impose power over the other. The material stakes in this argumentative exchange are so high that Michel Foucault's analysis of power as a field of contestation and negotiation would, presumably, be of little use. As a result, whether or not this Biennial proves to have offered an understanding of the art of our time, it instigated a discursive battle over claims of cultural rights on all sides. In fact, art making doesn't seem to be the issue at all but simply a pretext for acting on trenchant chauvinistic prejudices. Denunciatory and affirmative zealotries aside, as I have suggested, this very well may be, for all intents and purposes, the same exhibition that the Whitney mounted in 1973—a magnanimous but unrigorous multiculturalist web of institutional doublespeak in which the museum is haplessly entangled.

Having seemingly anticipated these various defensive stances, Ross and his curators staked a wide territory in the demarcation of the contested terrain:

> The art in the Biennial, like all art related to the important issues of our time—our identities, allegiances, environment, relationship to technology—must be considered with three important criteria in mind. First of all, despite a widespread belief to the contrary, art committed to ideas is not lacking in what are thought of as the traditional aesthetic qualities, for instance, sensuality, contradiction, visual pleasure, humor, ambiguity, desire or metaphor. . . . Second, works of art that are related to particular cultural positions are not unchanging. . . . [third, one must have] a willingness to redefine the art world in more realistic terms—not as a seamless, homogeneous entity but as a collectivity of cultures involved in a process of exchange and difference.[10]

But can such a field allow for a responsible address of issues of ethnicity, gender and sexuality and the multiple positions available to all subjects within these unspecified "realistic" terms? This apologetic realm appears too circumscribed and the options for the negotiation of subject positions too few. Having artists as representatives of specific cultural interests, the museum places itself in a double bind: the show's overdetermined emphasis on articulating difference in fact limits the possibility of exchange among its various agents. From a curatorial standpoint, the artists testify to the cultural constituencies they are said to represent. While certainly such conditions may inform their work, evidently black artists speak only for blacks, women speak only for women, and gays only for gays, bound as they are by a constrained notion of community. The conceptual thrust of the entire show relegates artists to cultural essences: regardless of the overall concerns specific to the production of any single artist exhibited, there is no acknowledgment of the actual possibility

that one could be black, gay, and female, for example. In addition, if cultural enfranchisement proved to be the motivating factor for the museum, the question of class stratification within American culture was thoroughly ignored.

Instead, the Biennial curators opted for what Paul Smith calls a "cerning" of subjects, a kind of discursive circumscription that limits the "definition of the human agent in order to be able to call him/her the 'subject' [rather than] argue that the human agent exceeds the 'subject' as it is constructed in and by much poststructuralist theory."[11] The consequence of this operative understanding of subjectivity is that it proffers singularly forced readings of the works on view in the exhibition. For example, Byron Kim's monochromatic canvases become specified as a commentary on race rather than an exegesis on the efficacy of contemporary abstraction; Lari Pittman's decadent allegories are confined to pronouncements on male homosexual ennui; Kiki Smith's metaphorical meditation on the female body stands as an indictment of patriarchy. This localization of meaning extends even to the contextual regulation of entire oeuvres. Robert Gober's altered newspaper bundles and the mock organizational banners of Mike Kelly are posited as illustrations of societal ills in deference to the more ironical twists that characterize their overall production. Through a suspension of the necessarily tenuous situatedness of individuals and the possibilities of negotiation and play in identity formation to foreground social urgency, the curators sacrificed the communicative resonance of much of the work on view. Herein lies the overall conceptual weakness of the exhibition. While Ross's metaphor of war may be apropos, the exhibition's curatorial conscription of the artist as cultural worker/warrior does not account for the particular complexity of the positions to which they address themselves. The decidedly imperative character of much of the work on view this year, from Pat Ward Williams's combative black males in *What You Lookn At?* (1992) to Sue Williams's pseudohysterical assaults on sexual dejection, foreground the negative impact of the issues they address. This is a battle, but what are the consequences of confining the various perspectives presented by the artists under a single institutional banner whose assumptions are couched in overdetermined liberalist ambitions of inclusion as a necessary criterion?

The ploy is twofold, to allow for the reinscription of an entrenched institutional model against a rarefied aesthetic complacency while attempting to accomplish this through a kind of divisive pigeonholing that diminishes the forcefulness of individuating discourses. The exhibition projects a mercenary gloss on issues of difference as its thematic impetus, incorporating "others" in an effort to idealize an alleged egalitarianism. What is surprising is that the implications of this strategy are not allowed to contribute to an overall understanding of the exhibition or the communities and issues it is supposedly attempting to serve. It is in this context that one recognizes the Whitney as the proverbial conservative sheep in liberal clothing: a strategy reminiscent of

Christopher Newfield's recent consideration of "flexible management" as a productive modus for conservative ascriptions of diversity within the humanities. Concerned with an address of institutional racism within university curricula, Newfield argues that

> the humanities as a search for ordered freedom has a couple of liabilities. It has tended to found its unity on exclusion, and there is little dispute at least about the basic facts of its history of celebrating universal reason even as it divides the cultural globe along lines of gender, race, nation, sexuality and so on. And it does not rise above the centralizing hierarchical aspect of management but retains and idealizes it. The conservative humanities might manage to pluralize itself by broadening its universals or reexamining previously rejected candidates for inclusion, but this would not prevent it from sustaining the comforts of authoritarian governance.[12]

In the name of diversity, I would argue that this Biennial is an exercise in rhetorical cultural management. Refusing to acknowledge its culpability as a bastion of internalized conservative values or to clearly articulate fundamental changes in its relation to underrecognized groups, the liberal press has grossly exaggerated any substantive distinction between Biennials of the past and this year's show. We may not accuse the Whitney of mere tokenism, but of an orchestrated conceptual obfuscation of an ingrained exclusionary history. This is the same show that the Guerrilla Girls vehemently criticized in 1987; although the terms and boundaries may have expanded, they continue to be operative.

By extension, the touted organizational structure for the exhibition begs some questioning as to the ambivalent institutional controls that permeate the show:

> Instead of selecting works by consensus vote among a curatorial team, this year's Biennial was determined by a group of curators led by a single curator-in-charge. The difference is more than symbolic. It reflects our desire to produce an exhibition that projects a personal curatorial perspective within an institutional framework—an organizational structure reflective of the issues of individual and community identity embedded in this Biennial.[13]

What does this convoluted statement really signify? And, in the institutionally reflective atmosphere of "exchange and difference," what form of power relation is invoked? This line of questioning is not meant to dismiss the logical relevance of the personal tastes of a single curator in building an exhibition. In fact, if a single curator had organized the show, such a query might be a nonissue. What is curious here is that this configuration prompts a hierarchical procedure that highlights Ross's conception of the liberal democratic processes

that underlie the institution's duplicitous reflection on cultural authority, enfranchisement, and diversity. For all that ailed previous Biennials, the consensus methodology allowed respective curators to vote their consciences, however contentious. Conversely, this extrasymbolic gesture prefigures a kind of auto-egalitarianism that underlies that Americanness embedded in the museum's very name: one is (artist and curator alike) permitted to speak and be heard only insofar as one is allowed. Again, profoundly "American." In addition, this authoritative trope is active in the curatorial dynamic of the exhibition itself.

Even while the diversity of opinions among the curatorial team may be tolerated within the organizational scope of the exhibition, these presumed subordinates are obliged to yield to a "curator-in-charge," who regimentally enforces the objectives and material limits of their activity. A transportation of this militaristic model, based on Newfield's assessment of flexible management, reveals a condition in which "differences are encouraged so long as basic rules and values circulate through the corporation's every subculture without impedance."

> Diversity does not subvert this general economy; in fact, the background uniformities of the general economy depend on a recognition of diversity in order to function, for they must encourage a sense of inclusion, individuality and participation. . . . flexible management guarantees that top-down authority, while it does not appear in the old form of sovereignty.[14]

This Biennial was, however, a group effort marshaled by Elizabeth Sussman, with a strike force (maintaining Ross's jargon) that included curator Lisa Phillips, associate curator Thelma Golden, and John Hanhardt, curator of film and video.[15] One is to assume that within this organizational scenario Sussman held veto power in the selection of artists and works—favoring individual curatorial sovereignty by auto-egalitarian means and thwarting consensus. However, where one hopes to locate the unified front, "the single curatorial perspective" advertised in the exhibition's press release, there is none to be found. A careful reading of the catalog reveals not one, but three shows. In effect, this document embodies a conceptual mutiny in which the respective curators assert their discursive autonomy. This is one of the most interesting as well as problematic aspects of the exhibition. Devoted to elucidating the discourse of difference, each of the curatorial texts included in the catalog constructs views on the machinations of identity politics from disparate perspectives. Each shares a concern for notions of community, but interpretive allegiances appear to end there. Any unifying coherence among the texts is clouded by a lack of a sustained critical vocabulary for addressing the issues raised by the work, and any thematic reconciliation is relegated to evacuated signifiers of diversity and community. Issues of context—for example, that the show is

presented by a museum dedicated to American art—again remain an unproblematic given. The result is a patchwork of often repetitively overlapping texts, with the curators selecting their favorite artists from the prescribed assortment, thereby staking some claim to curatorial individuality and authority.

Playing the consummate leader, Sussman attempts to delimit the scope of the exhibition by stating that "although sexual, ethnic, and gendered subjects motivate the content of recent art, these identities fragment but do not destroy the social fabric. Paradoxically, identities declare communities and produce a decentered whole that may have to be described as a community of communities."[16] Throughout, the operative concept of community is nowhere defined or analyzed and thus remains a floating signifier lacking critical bearing. There is, however more at stake in the above statement to which I take issue. First, Sussman's most glaring misrecognition is that the identities to which she refers are not to be configured as extraneous to the social fabric but are integrally interwoven into it. Such a presumption necessarily casts the artists within the very same frame that conservative critics assigned them—as social malcontents poised for assault. And if this threat is real, Sussman effectively abdicates responsibility to position herself within the discourse, either as a gendered subject or as a representative of the museum, a cultural authority within that presumed tapestry. Second, while the designations black, Chicano, gay, and so on connote a vulgar taxonomy of essentialized identities, such expedient partitioning is far from the complex reality of lives lived within and among these parties. While we may relish the eloquent turn of phrase, Sussman's "community of communities" more accurately resembles three rings and a tent—with lions, tigers, and bears awaiting the prodding of their trainer—than a genuine interrogation of difference.

A seasoned veteran of Whitney Biennials past, Phillips takes a patently art historical approach, distinguishing the style and outlook in recent art practice from the style and outlook in work considered in previous years. In contradistinction to Sussman's apologies for the works on display as "propaganda or agitprop," Phillips conceives a reasoned interpretation of the predominance of social concerns articulated in recent art practice:

> Now a new cry has arisen. The dictates of the [art] market are said to have been replaced by those of the political arena. . . . Today everybody's talking about gender, identity and power the way they talked about the grid in the late sixties. The issues of context and presentation are paramount and formal invention has taken a back seat to the interpretive function of art and the priorities of content.[17]

Rather than fixating on the activist impulses, Phillips is intent on an assessment of politically motivated artwork as another in a long line of significant artistic endeavors in American art. Phillips gives priority to artists' personal

interests with recourse to the recent ascription "patheticism," which "deliberately renounces success and power in favor of the degraded and the dysfunctional, transforming deficiencies into something positive. . . . we encounter a wasteland America, a bleak, chaotic, non-site of enervation, anomie, anger, confusion, poverty, frustration and abjection: dead zone, a no-man's land."[18] Uninterested in proposing agendas, Phillips's survey of the American cultural landscape approaches artists' works as though engaged in a process, rather than as static antagonistic incitements.

The most polemical curatorial essay is offered by Golden, who takes a position that is, by all accounts, a battle cry for artists of color. Golden squarely aims her sights within the terms set by Ross's notion of a cultural militia, and the exhibition's prodigious conflict. In fact, this essay articulates the flip side of the underlining peculiarities of the exhibition by naming its adversary in its very title: "What's White . . . ?"

Focused primarily on a number of artists of color included in the exhibition, the essay stakes out its culprit—"whiteness is a signifier of power." For Golden, this whiteness is posed in opposition to difference, which, quoting Cornel West, is concerned with "exterminism, empire, class, race, gender, sexual orientation, age, nation, nature, region" and, in Golden's words, "is positioned as different from whiteness, which as we enter this discourse, is almost impossible to define."[19] The quotation is culled from the introductory paragraph of West's essay, "The New Cultural Politics of Difference," and it is the aggressive spirit of these remarks that spur Golden on:

> The distinctive features of the new cultural politics of difference are to *trash* the monolithic and homogeneous in the name of diversity, multiplicity, and heterogeneity; to *reject* the abstract, general, and universal in light of the concrete, specific, and particular; and to *historicize, contextualize,* and *pluralize* by highlighting the contingent, provisional, variable, tentative, shifting and changing. (My emphasis)[20]

The first two infinitive clauses of the citation constitute the thrust of Golden's essay, an emphasis that I believe is misleading in the context of West's essay. Reading further in West's essay, he asserts that his politics

> are neither simply oppositional in contesting the mainstream (or *male-stream*) for inclusion, nor transgressive in the avant-gardist sense of shocking conventional bourgeois audiences. Rather, they are distinct articulations of talented (and usually privileged) contributors to culture who desire to align themselves with demoralized, demobilized, depoliticized, and disorganized people in order to empower and enable social action and if possible, to enlist collective insurgency for the expansion of freedom, democracy and individuality.[21]

There is a subtlety of argument here that suggests a much more sophisticated navigation than Golden is willing to admit. Political urgency here is tempered by a self-consciousness of its partisan adherents, whose ability to reclaim and redistribute cultural capital requires that they acknowledge the multivalence of their own positions within this process. As an enactment of West's program, however, this Biennial fails (1) at the level of contestation, (2) owing to the curatorial imposition of an asphyxiating binary framing of issues and artists, and (3) through its lack of any institutionally self-reflective address that might effect a substantive alteration of the overall philosophical, social, and economic status of the museum on the question of American diversity.

To this end, Golden's invocation of West's program is overly simplistic. What is, I think, emblematic in her argument is that "whiteness" stands as the necessary oppositional node, while difference is conceived of as an interactive combination of contending and complementary subject positions. But this strategy actually vitiates difference. As presented, such a curatorial perspective constructs an oppositional framing of subjects that encumbers the critical efficacy of much of the work presented and discussed. Meaning is circumscribed by an emphasis on, for example, race, gender, and sexual preference, each formidably in contrast to whiteness. The analogizing of whiteness with power assumes monolithic proportions, subsuming all that lies in its wake. How can such a reductive formulation benefit productive exchange among diverse subjects: not just people of color, but Caucasians as well?

While one cannot deny the weight of what is implied in Golden's essay, her argument allows no space for a negotiatory posture: no space for entry into the multivalent positions inscribed within the discourse of difference. In fact, while Golden's text admits that its project is "not simply about race," the question of race looms large not only throughout the catalog but in the exhibition as well. A critical formulation of race, though only one aspect within the spectrum of difference, is crucial to this year's Biennial. This is particularly the case since racial identity may be said to be intricately connected with other differential inscriptions: gender, class, sexual orientation, and so on. A recognition of the necessary interdependence of all positions and agents within the context of difference is not fully acknowledged or theorized by the curators of the exhibition, who insistently present difference as produced in opposition to, rather than as negotiated among, subjects.

While I might agree, in part, with Golden who cites cultural critic Lisa Jones's view that race "is really about hair texture," Barbara Jeanne Fields's assessment seems more to the point, particularly with regard to the issues of ethnic distinction touched on by the exhibition. In her essay "Slavery, Race, and Ideology in the United States of America," Fields, while tracing the discursive history of race, insists that "race is just the name assigned to the phenomenon, which it no more 'explains' than the judicial review 'explains' why the

United States Supreme Court can declare acts of Congress unconstitutional, or than the Civil War 'explains' why Americans fought each other between 1861 and 1865."[22]

In delineating a genealogy of slavery (both indentured and forced, white and black, respectively) in the United States since the early 1600s, Fields attempts to displace the common indictment of race as a founding premise for the abuses of servitude in America. Fields examines the status of slavery in colonial America as part of an evolving economic system informed by notions of American freedom legislatively based on property ownership. Pointing out that it was possible for both whites and blacks to become slaves in colonial America, she notes that the predicates for freedom "did not formally recognize the condition of perpetual slavery or systematically mark out servants of African descent for special treatment until 1661."[23] And it is, according to Fields, the institutionalization of slavery that produced the decisive entry of race as a discriminatory marker in the United States. Rather than rehearse this discourse in our contemporary setting, Fields suggests that race can be understood as a historically ritualized repetition of an ideology that sustains oppression through its distinctions:

If race lives today, it does not live on because we have inherited it from our forbears of the seventeenth century or the eighteenth century or nineteenth, but because we continue to create it today. Nothing handed down from the past could keep race alive if we did not constantly reinvent and re-ritualize it to fit our own terrain. If race lives on today, it can do so only because we continue to create and re-create it in our social life, continue to verify it, and thus continue to need a social vocabulary that will allow us to make sense, not of what our ancestors did then, but what we ourselves choose to do now.[24]

Fields here argues for a relinquishing of the bounds of such well-worn ideology, and for thinking of the history of race as a necessarily flawed construction that functions only to reinstitute an oppressive dialectic in which all actors are complicit. Refusing to conceive the ideology of race as a form of false-consciousness, but rather as a force shaping the real conditions of people's lives, Fields's comments on the subject implicate all who persist in invoking it: the restrictive imposition of race by oppressors as well as the oppressed's discursive imposition of their own oppression under the rubric of race.

With this in mind, Golden in like manner reinvents race through a conflation of this categorization with difference. I am not arguing here (and I do not believe Fields would either) for an out-of-hand dismissal of ethnic distinction within the political economy of difference; it's not a question of simply hoping that if one ignores them, the struggles of people of color within the United States will simply go away. However, Fields admits the absolute constructed-

ness of race and as a result alludes to a more delicate articulation that historicizes our perceptions of its limiting impact.

The matter of whiteness as a kind of master signifier within the theoretical framework of the Biennial does not end with Golden. In fact, it finds its most immediate, if not divisive, articulation in an interactive work (*Museum Tags: Second Movement [Overture] or Overture con Claque—Overture with Hired Audience Members*, 1993) by Daniel Martinez that sets the tone for the overall combative nature of the exhibition for every gallery visitor. Martinez has replaced the museum's insignia admission buttons with an inscription of his own. As enigmatic as Golden's query on race, Martinez's button activates the whiteness/power equation with the admonition "I can't imagine ever wanting to be white." The force of his pronouncement is undercut by this phrase being broken up and printed on successive admission tags so that viewers/wearers are required to reconstruct the phrase through a recognition of their fellow gallery visitors: each holding a piece to a charged word-puzzle that activates the multiplicity of subjective relations, again predicated on whiteness as a predominant signifier. But who is speaking here? Where do we find the "I" embedded in this denunciative act? Is this simply Martinez's own recalcitrant desideratum of racial distinction: an effort to prioritize, and thus foreground the innate value of his own cultural identity? Is this an institutional "I" of the museum whose exhibiting history has rarely acknowledged its lack of recognition of artists of color, ideologically distancing itself from that history by issuing blame to an unspecified, arbitrarily universalized white subject? Or does the distribution of the tags and the fact that we are required to wear them while viewing the exhibition signify an attempt to problematize racial specificity through implied accusation: invoking a kind of guilt by association? Certainly, this "I" identifies a variety of actors, all posited (whether affirmatively or negatively) against the qualifier "white" that is admittedly "unimaginable."

In her remarks on this work, Golden writes:

> This statement has radically different connotations depending on the wearer's race and attitude toward race. The button is an affirmative declaration that reverses decades of negativism about all that is not white. It also requires museum visitors to acknowledge the level of control inherent in museum practice and presentation and absolve themselves of some of the privilege of cultural imperialism.[25]

The piece, in these terms, attempts to enact a reversal in the position to which participants are assigned relative to a position of "otherness": "I," the determinant other of a white, imperialist power constituted as subject. An absolute reversal of the hegemony of whiteness as a defining category is sought. Again, the enemy is identified through a self-imposed imaginary otherness unable or unwilling to posit itself as an acting subject. The slippages are at the

crux of Golden's and Martinez's understanding of difference, in which one perceives oneself as thoroughly "other" and thus defers all agency to "whiteness" as an oppressing and oppressive subject position. While the lines of discursive opposition constructed in the Martinez work articulate specific boundaries between self and other, the combative nature of the address does not allow for communication between what Martinez conceives as not-white and the privileged position he assigns to whiteness. Indeed, the conceptual binds that constrict Martinez's work are not predicated on any form of exchange but instead enforce a binarism where all agents (or group of agents) misrecognize their necessary conditional codependence on the other for their own existence.

What I am interested in demonstrating through this analysis is that Ross's war metaphor, particularly as it permeates the very foundation of the Biennial exhibition, should not be understood as a call for mediation and celebration of difference, but rather as an exposition in comparative oppression studies. The dialectical form of address assumed within the context of the exhibition is so emphatically dependent on assigning artists and audience within specific frames of reference that it virtually presupposes conflict, rather than acknowledging the operative complexity of these positions. In this context, one is cast as a discretely black, Latino/a, straight, gay, female, male subject, and so on, in a way that denies the fluidity and dialogical relation that actually functions among these very markers.

Michael Holquist, elaborating on the nature of subject construction in *Dialogism: Bakhtin and His World* (1990), offers a particularly insightful discussion of the relation of self to other within a broad outline of the work of Mikhail Bakhtin. In his discussion, Holquist demonstrates what might be considered a differential encounter between speaking subjects in which all agents could be understood as successively and/or simultaneously occupying the roles of self and other. "Every human subject," he writes, "is not only highly conscious, but . . . that his or her cognitive space is coordinated by the same I/other distinctions that organize my own: there is in fact no way 'I' can be completely transgredient to another living subject, nor can he or she be completely transgredient to me."[26]

That instance of "transgredience," a position from which the subjects may perceive themselves as an object from the "outside," for Holquist via Bakhtin becomes a kind of barrier that marks the extreme tenuousness of intersubjective identification. And it is this condition that, with the exception of Phillips, the Biennial's meditation on difference chooses overwhelmingly to omit. The dialogical capacities of the subject positions presented in the exhibition are confined by a unidirectional discursive address that devolves into a malevolent contest of disparate cultural agents and entities. As a result, there is a

reification of subject positions in which an undifferentiated difference is pitted against a projected, imagined and otherwise unified (white) subject.

In "Beyond the Pale: Art in the Age of Multicultural Translation," Homi Bhabha offers a lucid, and often poetic, discussion of the ambivalent dynamics implicit in cross-cultural identification as presented in a number of works included in this year's Biennial. His discussion of nationalist discourses in an earlier work, "DissemiNation: Time, Narrative and the Margins of the Modern Nation," draws a distinction between what he calls the national subject's "double inscription as pedagogical objects and performative subjects" that is particularly germane to our present consideration of the differential politics portrayed in the exhibition. Curatorially, either through sheer arrogance or lack of conceptual diligence, no one appears concerned to functionally broach the subject of what it has historically meant to be an American subject or what that designation can mean within our multiculturalist present. What is even more surprising, however, is that a consideration seems crucial to the museum's capacity to equitably contribute to the national culture. Rather, the overall scope of the exhibition concentrates heavily on the first aspect of Bhabha's duality of subjective national identity: to address artworks, artists, and audience solely as rarefied objects and not as agents continuously engaged in negotiatory practices at all levels of the cultural spectrum. And it may be that this exhibition demonstrates that the realities of cultural identity and community are too complex to be adequately articulated in the convenient terms that the museum chose to present them in. With this in mind, we see that Bhabha's characterization posits the cultural other as an active agent in the construction of his or her identity beyond the scope of a totalizing national identity. Bhabha asserts that the nation as a collective identification is a "complex rhetorical strategy of social reference" in which the

claim to be representative provokes a crisis within the process of signification and discursive address. We then have a contested cultural territory where the people must be thought in a double time—the people are the historical objects of a nationalist pedagogy, giving the discourse an authority that is based on the pre-given or constituted historical origin or event; the people are also the subjects of a process of signification that must erase any prior or originary presence of the nation—people to demonstrate the prodigious living principle of the people as a continual process by which the national life is redeemed and signified as a repeating and reproductive process.[27]

It is this reproductive impulse that is sacrificed in much of the Biennial's ruminations on the nature of difference in general. If we allow Bhabha's formulation to stand in for the manner in which the historical specificity of white-

ness, and for that matter all subject positions manifested in the exhibition, participate in a perpetual relation, the field of debate among subjects is afforded productive efficacy. It is bounded by an impulse to cultural specificity while simultaneously in continuous dialogue and negotiation with it. The overdetermined subjective posturing assigned to the work of the artists in the exhibition by the curators become "paranoid projections 'outward' [that] return to haunt and split the place from which they are made. So long as a firm boundary is maintained between the territories, and the narcissistic wound is contained, the aggressivity will be projected onto the Other or the Outside."[28]

Golden's and Martinez's epithet "whiteness," for example, assumes a historically situated equivalence between whiteness and Americanness: as discursive markers of an oppressive agent. However, are we to understand this as a marker of racial distinction? What is the whiteness that is to be reviled? Certainly, the connective tissue here amounts to more than simply a matter of melanin ratios, but is instead a projection of socioeconomic casting cloaked in racial ideologies. More to the point, we are all (black, white, or otherwise) "othered" by this inscription. Metaphorically, Chris Burden's installation *Fist of Light* (1992–93) proved highly suggestive of the apparently real discursive destructiveness inherent in refusing to recognize the ramifications of this condition: one that emblematically infuses the rampant confusions, obfuscations, and inconsistencies that permeate this year's Whitney Biennial. The work itself was unassuming. It constituted a proposal for a sealed, air-conditioned chamber housing over one thousand 500-watt lightbulbs, the goal being "to totally saturate the entire space with light, attempting to remove all color in a visual analog of fission."[29] Sussman discussed the nuclear implications of this piece. Golden chose not to acknowledge it. However, this work embodied that concealed whiteness that she found "almost impossible to define." An intangible homogenizing force to which exposure would consume all "others" who entered: that is identity politics according to the Whitney Museum of American Art.

Notes

1 For an exception to this see Arthur Danto, "The 1993 Whitney Biennial," *Nation*, 19 April 1993, 533–36. Danto objects to the museum's institutional attribution of artistic value to George Holiday's Rodney King video footage.

2 *1993 Biennial Exhibition* (New York: Whitney Museum of American Art in association with Harry N. Abrams, 1993). Unlike previous Biennial publications, this document includes essays by each of the participating staff curators working on the exhibition: Thelma Golden, John Hanhardt, Lisa Phillips, Elizabeth Sussman, and Jeanette Vuocolo. In addition, critics were also invited to submit works for publication. They include Homi K. Bahbha, Coco Fusco, B. Ruby Rich, and Avital Ronell.

3 *Guerrilla Girls Review the Whitney*, the Clocktower, April 16–May 17, 1987.

4 The chart entitled "The Color Blind Test" relates that the cumulative number of nonwhite men included in the show since 1973 stood at 3 Asians, 17 Blacks, 8 Hispanics and 0 Native Americans, and of nonwhite women, 2 Asians, 0 blacks, 0 Hispanics, and 0 Native Americans.

5 David Ross, introduction, *1993 Biennial Exhibition*, 9.

6 Ibid.

7 See Serge Guilbaut, *How New York Stole the Idea of Modern Art: Abstract Expressionism, Freedom, and the Cold War* (Chicago: University of Chicago Press, 1983).

8 See John Leo, "Culture War at the Whitney," *U.S. News and World Report*, 22 March 1993; Robert Hughes, "A Fiesta of Whining," *Time*, 22 March 1993; and Peter Plagens, "Fade from White," *Newsweek*, 15 March 1993. Also see *Artforum* (May 1993). Coverage includes essays by Hilton Als, Glenn O'Brien, Bruce W. Ferguson, David Rimanelli, Jan Avgikos, Greg Tate, Dan Cameron, David Deitcher, Thomas McEvilley, Liz Kotz, and Lawrence Chua.

9 Eleanor Heartney, "Report from New York: Identity Politics at the Whitney," *Art in America* (May 1993): 43.

10 Elizabeth Sussman, "Coming Together in Parts: Positive Power in Art of the Nineties," in *1993 Biennial Exhibition*, 14–15.

11 Paul Smith, *Discerning the Subject* (Minneapolis: University of Minnesota Press, 1988), xxx.

12 Christopher Newfield, "What Was Political Correctness? Race, Right, and Managerial Democracy in the Humanities," *Critical Inquiry* (winter 1993): 329–30.

13 Ross, introduction, 10.

14 Newfield, "What Was Political Correctness?" 327.

15 Since this essay focuses primarily on the visual arts aspect of the exhibition, I have restricted my discussion to texts by curators whose predominant interests are in the visual arts: Sussman, Phillips, and Golden.

16 Sussman, "Coming Together," 11.

17 Lisa Phillips, "No Man's Land," in *1993 Biennial Exhibition*, 52.

18 Ibid., 54.

19 Thelma Golden, "What's White . . . ?" in *1993 Biennial Exhibition*, 26.

20 Ibid., 27. The West citation is from "The New Cultural Politics of Difference," in *Out There: Marginalization and Contemporary Cultures*, ed. Russell Ferguson, Martha Gever, Trinh T. Minh-ha, and Cornel West (New York: The New Museum of Contemporary Art: Cambridge: MIT Press, 1990).

21 Cornel West, "The New Cultural Politics of Difference," 19–20.

22 Barbara Jeanne Fields, "Slavery, Race and Ideology in the United States of America," *New Left Review* 181, (May–June 1990): 101.

23 Ibid., 104.

24 Ibid., 117.

25 Golden, "What's White . . . ?" 34–35.

26 Michael Holquist, *Dialogism: Bakhtin and His World* (London: Routledge, 1990), 33.

27 Homi K. Bhabha, "DissemiNation: Time, Narrative and the Margins of the Modern Nation," in *Nation and Narration*, ed. Homi K. Bhabha (London: Routledge, 1990), 297.

28 Ibid., 300.

29 Chris Burden, statement from *Study for Fist of Light* (1991), in *1993 Biennial Exhibition*, 125.

Martha Rosler

Theses on Defunding

1. The presence of monetary support for art cannot be viewed as neutral.

2. The source of monetary support cannot be viewed as neutral.

3. The presence and the source of funding have a systemic influence that is both economic and ideological.

3a. For the sake of the argument, the aesthetic is a subset of the ideological.

4. Government support, foundation support, and corporate support differ in their effects on the art system. The government, by ideological necessity, has had to adopt standards that seem disinterested and depoliticized—that is, that appear firmly aesthetic—and has supported work that satisfies criteria of *newness* and *experiment*. Nevertheless, those who do not share the associated assumptions about the meaning and direction of life—assumptions, say, of egalitarianism, cultural and personal pluralism, social progressivism or liberalism, and scientism—perceive the ideological character of art and reject the claim of sheer aesthetic worth.

4a. State granting agencies are idiosyncratic. They are likely to change quickly as they take up more of the burden of funding under the rubric of "the new federalism." State agencies are probably more prone than federal ones to bow to conservative tastes and right-wing pressure.

5. Foundations and, even more so, corporations, are not expected to be even-handed or even impartial in the way that government must seem to be. Rather, they are expected to stand on the bedrock of self-interest.

5a. Foundations vary in their policies, but many must now choose between supporting services to the poor that have been cut and supporting art. Several giant foundations have already announced policy shifts toward services to the poor, at the expense of a variety of other activities.

5b. Corporations are expected to maintain a monolithic public image that is anthropological to the extent that personality traits can be attributed to it. Thus, by lending an air of philanthropy and generosity, corporate benevolence can be used to defuse charges of wholesale theft, as in the case of Mobil or

Exxon. One required trait is good taste, which is assured only in aesthetic territory that is already known and ideologically encompassed, territory necessarily barren of present, "cutting edge" art, ideologically engaged art, or anything other than the safe. Most corporate money for art goes to the old, the safe, the arch, stuff that is above all redolent of status and spiritual transcendence, work that is more likely to be embalmed than alive.

5c. Many large and influential corporate funders are quite willing to congratulate themselves (before business audiences) for the public relations value of their contributions to culture.

6. In high times, when the economy has been strong, and large numbers of people have felt relatively secure about the future, the interest in personal well-being has risen beyond a survival level to an interest in personal happiness and cultural pursuits. Art is then accepted as important to society as a whole and therefore to its individual members.

6a. The latter part of the '70s saw corporations competing with each other to attract executives and other employees not only with economic lures but also with "quality of life" incentives, most of which involved the reclaiming of urban areas and especially the refurbishing of urban culture: that is, centrally, cultural outlets and activities.

7. In high times, art has been treated as the symbol and the vehicle of the spiritual treasure trove that is civilization and history. It is paradoxically both priceless, meaning irrespective of mere monetary valuation, and priceless, meaning terribly expensive. People think that art is a good thing even if they don't like, know, or care about what goes by that name—and nonbelievers are not given much of a hearing.

8. As the economy has skidded and recessions have come more and more frequently, economic considerations have taken precedence over most other aspects of collective and personal life.

8a. In the second meaning of priceless, that is, expensive, art is a speculative good, a store of monetary value. This side of art, art as investment, becomes more prominent in speculative times, when the social values that underlie a confident economy are in question and the future is uncertain. But art, as being above price, transcendent, bears social values. In speculative times, the opponents of *current,* unlegitimated art begin to gain a following because of that art's social uselessness in reinforcing traditional values. For those outside the close-in system of consumption and investment, art has appeared as a monetary drain as well as ideologically—morally and politically as well as aesthetically—suspect.

8b. The current [Reagan] administration's radical restructuring of American institutions includes an aggressive repoliticization of many aspects of culture. The shifting of constituencies to include a sector of the radical right wing and fundamentalist elements in working-class and middle-class strata has given

powerful encouragement and an official platform to the nonbelievers in the reigning paradigms of art and in the nonpolitical nature of art. In placing right-wing ideologues in policy positions, the National Endowment for the Arts has not been spared. Thus, even within the administration, the nature of art is under attack, though a muted one.

9. Corporations follow the lead of federal programs. During the 1970s, as government contributions to art increased, the contributions made by business increased dramatically. The withdrawal of government money is a signal to corporations to cut back their contributions as well, or to restrict them more closely to the most public relations–laden kind of art.

9a. The government follows the lead of corporations. Much of the government's giving, except for that to individuals, is done through matching grants: each government dollar must be matched by one from a private giver. The government will pay only as much as the private sector will match, no matter how far short of the original award that might fall.

9b. Many corporations will also only give on a match basis: without government funding, they will not give money. Such corporations as Exxon, ITT, and Aetna Life have declared themselves reluctant to replace the government in funding cultural activities.[1]

10. Policy shifts with ideology. As ruling elites restore the legitimacy of big business as well as its economic preeminence, corporate givers gain more credibility as policy sources and are able to influence the policy of grant-giving agencies. These agencies are now likely to be headed and staffed by pro-business people. Further, corporations gain more influence as givers as they take on an increasingly significant role in the funding of culture. By unofficially signaling their wish to give to certain individuals and projects, corporations reportedly have already managed to influence the government to match their contributions.

11. The government's policies aggressively favoring corporations and the rich affect funding. The 1982 tax act is projected to cause a drop in private giving to nonprofit institutions conservatively estimated to be above $18 billion in the next four years. According to the Urban Institute, an independent research and educational organization in Washington, D.C., such groups would lose at least $45 billion in combined funds from the government and private donors. Educational institutions, hospitals, and cultural activities were considered likely to be the most adversely affected.[2]

11a. The pattern of giving will likely be shifted by the new tax law from the rich (who are inclined to support educational and cultural institutions) to those earning under $25,000 (who are more likely to give to religious organizations).[3]

12. Many small, community-based, and community-oriented cultural organizations must have a steady income to stay in existence. A gap of even a couple of months would force many to fold. Yet the next few years are consid-

ered a transition period in which adequate money must be successfully solicited from the private sector to replace withdrawn federal money. Therefore many small organizations, especially those serving ethnic communities, will close.[4]

12a. Fewer ethnic- and community-oriented artists (including dancers, theater people, musicians, and so on) will be encouraged to continue their work. Consequently, we can expect their numbers to decline proportionally more than more mainstream-oriented artists. Cultural pluralism will fade as a reality as well as an ideal.

12b. Ideologically, cultural pluralism has already been tacitly discarded. We should be clear that ethnic arts have been targeted for defunding as being "divisive" and perhaps un-American, as well as (predictably) aesthetically inferior. (The Visual Arts section of the NEA was advertised a few years ago with a mass mailing of a poster in which "Visual Arts" was written on a wall as a graffito in Mexican-American barrio-style *placa* writing. We shall see nothing of the sort for at least the next few years.)

12c. The populist orientation of the Carter NEA has been discarded by the pseudopopulist Reagan administration, which is in this as in other policies intent on reestablishing the material signs and benefits of great wealth—in this case, an elite, restricted cultural practice.

13. Artists are as sensitive as anyone to changes in wind direction and as likely to adjust to them. The production of artists depends on conditions "in the field" of art as a sector of the economy as well as a sector of the ideological. There are more chances to enter and pursue a life of art making when there is more money devoted to art. There are more places in school and more jobs in education, more general attention to a broader range of art activities. As the climate favoring government support of art and art education darkens, and the amount of money available for things perceived as nonessential to personal and societal survival declines, fewer people are attracted to a life of art making. Fewer parents are likely to encourage nascent artists.

13a. Severe cuts in student aid will affect art and the humanities far more than business and engineering, and nonwhite and working-class students far more adversely than middle-class whites. Minority recruitment has also been de-emphasized under the new administration, as have affirmative-action hiring policies. Thus the conspicuous lack of nonwhite staff and staff of working-class backgrounds in museums and most other cultural services will probably become even more egregious.

14. Artists have been quick to bend to the replacement of the humane and generous social ideal of liberal administrations with an ideal of aggressive and cynical me-firstism. (The several reasons for this go beyond my scope here.) Although the image of the artist as predator or bohemian has gone in and out of favor, a questionnaire by a West Coast artist suggested that by the late '70s a

surprising number of artists, some quite well known, were calling themselves politically conservative and expressed the wish to make a lot of money. Artist landlords are now common. (Of course, the impulse to make money rather than reject a life of financial comfort can be traced to the monetary success of art making starting around 1960.)

15. Artists still vacillate between doing just what they want and developing a salable product. That is, their integration into the commercial system is not complete. The institutionalization of art and the replacement of the paradigm of self-oriented expression with that of art as a communicative act helped bring to art a uniformity of approach and a levelheaded interest in "success"—as well as the expectation of its accessibility.

15a. The current generation of artists sees art as a system and knows how to operate by its rules.

15b. Thus it is not a surprise that after the announcement of drastic funding cuts, especially in the National Endowment for the Arts, there was a disproportionate drop in the number of applications for fellowships. Next year will presumably bring a disproportionate rise, when word of the excessive timidity gets out. Equilibrium will eventually be reached, assuming that the Endowment survives, but meanwhile artists will adapt to the requirements of other kinds of monetary support (which is still likely to be a job outside art).

15c. The blurring of the line between commercial and fine-art production is most advanced in photography, which therefore may be the visual art most easily swayed by corporate backing—and most likely to attract it.

16. The "lower" end of the art system will continue to strangle, and the upper will swell and stretch as more of the money available from all sources will be concentrated in it. Soho will become more elite and exclusive. Artists who are serious about pursuing money will continue to seek it, and the rewards will perhaps be greater than they have been in the past. Superstars will be heavily promoted and highly rewarded while the absolute number of people calling themselves artists will shrink drastically.

16a. The restratification or perhaps bifurcation of the art system will continue, mirroring the labor-market segmentation in the economy as a whole.

16b. As artists' incomes shrink, except for those of the relative few, and as urban real estate in most cities continues to escalate in value, artists, who have functioned as pioneers in reclaiming decayed urban areas, will find themselves displaced, and the existence of artists' communities, so essential to the creation of art, will be seriously threatened. This is already occurring in New York.

16c. The policies of the present administration—such as the rewriting of tax law to greatly increase the safety of tax shelters, especially in real estate—as well as the moderation of inflation, and perhaps other factors as well have made the tangibles and collectibles market, a product of the rampant inflation

of the '70s, soften and fade, while the top of the art market is doing better than ever.[5] Sotheby Parke Bernet, the largest auction house in the world, which rode to the top of the collectibles wave, refused to announce its losses for 1981.[6] At least one dealer felt it necessary to advertise his continuing solvency and reliability.[7]

17. The nature of the alternative system will change. The smaller spaces will close, perhaps; the politically dissident centers will come and go, relying as they must on member artists' funds; the most bloated ones, such as P.S. 1 in New York and the Los Angeles Institute of Contemporary Art, which basically were products of the Endowment system, will become more and more indistinguishable from the junior museums they in fact are.

17a. New alternative spaces, perhaps most easily those for photography, will be financially supported by corporations and private dealers.

17b. Private dealers and, perhaps, corporate galleries will continue to tighten their grip on the exhibition system.

17c. The Museum Purchase Grant category has been eradicated. Private funds must now be sought for acquisition. Typically, foundations and fund-raising committees are inclined toward "historical" rather than current purchases, and toward physically large work—paintings or sculpture, say—rather than photography. Once again, the dealer's or collector's loan or gift of art will regain its former influence in determining what is shown in museums.

18. The number of institutional art jobs, from grade-school through college teaching, to administrative, curatorial, and other art-bureaucratic jobs, will drop steeply, so that artists will once again have to become petit-bourgeois entrepreneurs, attempting to make money through selling their work. They may seek financial support directly from corporations, perhaps photographic ones, so that their work will risk becoming, in effect, advertisements, like Marie Cosindas's work for Polaroid.

18a. Grant-getting agencies and agents, like the swollen few no-longer-alternative spaces, will see great expansion. Art promoters employed by art organizations are now being turned out by business schools, in programs that have existed for only the past few years. According to Valerie Putney's article in *Pace,* Piedmont Airlines' magazine,[8] the first such program was at Yale's drama school in 1965. At the State University of New York at Binghamton, the program aims to produce students able to "influence future policy regarding the appropriate role of the arts in a diverse technological free-enterprise society." These unashamed bottom-liners spout the language of fiscal account-ability while like-minded artists may also need to learn it to gain grants from cost-conscious corporations (and other sources, including the government). Or they may simply buy the services of agents themselves. (An old example of someone with grant moxie is Christo, whose career has depended on it.)

19. The parts of the system adjust to one another: artists learn the language of

the accountants, and their thinking becomes more like accountants' (or sales-persons') thinking. Art institutions and art makers adapt their offerings to the tastes of grant givers (that is, to the current ideological demands of the system). The new head of the Humanities Endowment has already disclaimed certain projects of the preceding head,[9] and the current head of the Arts Endowment has held up certain project grants. Will these kinds of grants now be curtailed?

20. Throughout the past decade, art organizations of all sorts had already begun adapting their offerings to the ideal of entertainment for a broad audience (partly a funding ploy). The reduction in funding has also spurred more and more of them to advertise for money and attendance in print media, on the radio, and on television. "Arts management seminars" teach ways to "target" audiences and get good returns for advertising dollars, as well as "how to identify and solicit the most receptive customers—through marketing surveys, direct mail, or whatever means has [sic] proven best."[10]

20a. In using the techniques of advertising, art organizations adapt their thinking and their offerings to the form of advertising. Increasingly, these appeals have been to pretentiousness, cultural ignorance, and money worship.

21. Because the pauperization of artists and others is connected to the reactionary policies of the current administration, while the absolute number of artists shrinks, proportionately more artists are likely to become social dissidents.

21a. The model of activism for artists and other cultural workers was slowly rebuilt during the Vietnam era, and that process will not have to be repeated today. Our society as a whole today is much more given to public display and political activism of every variety than it was for most of the period after World War II until Vietnam.

22. The conservative or reactionary artistic tastes of the corporate donors and private buyers will be prepotent, perhaps decisive, in their influence. But the *content* of their tastes cannot be assumed in advance: the ideologically reactionary work is not necessarily the most formally conservative, and we may find work that appears advanced formally backed by some political reactionaries. We may return to a kind of formalist modernism; artists, dealers, and their coteries will speak again of "quality" and mean "formal values," while other artists will expect only to make their living outside the high-art system and reject its values.

22a. If modernism is not restored, its formalist "investigations" may yet continue as part of a fragmented art scene, in which the present imagery expressing antirationalism, alienation, and uncertainty provides the theme.

22b. The next generation of artists will be part of a postinstitutionalized art system with a solidly restored hierarchy of glamour, wealth, and status. But the probably metaphysical high style it draws in its train may well be shot through

with the cynicism of a delegitimating vision—one that questions the authority of art and its forms as well as that of social institutions.

22c. The inevitable corollary will be that this smug display of wealth and ostentation, particularly if combined with flashy nihilism, will be a spur to the resurgence of a well-developed, socially engaged, and egalitarian art, such as has recurred in the industrialized world for over a century. Networks of artists who are interested in making such art have proliferated in the past few years.

Unlike many corporate donors who finance performances of established works such as "Swan Lake" and "Carmen," Philip Morris seeks out the experimental and avant-garde. In addition to Hopper and German Expressionism, there has been a Jasper Johns retrospective, shown at the Whitney and subsequently in Cologne, Paris, London and Tokyo. And there has been a photography show at the Museum of Modern Art. The company has also underwritten Michelangelo at the Morgan Library, North American Indian art at the Whitney and a traveling show of American folk art . . .

Philip Morris executives express a fundamental interest in helping to develop the arts and shape public taste.—Sandra Salmans, "Philip Morris and the Arts," *New York Times* (Business section), 11 November 1981.

"We believe that supporting the arts is one of the best investments NCR can make," says William S. Anderson, chairman and chief executive officer of the Dayton-based NCR Corporation and chairman of the Dayton Performing Arts Fund. "There is a high level of competition throughout the industry to hire the caliber of people we need. Dayton is not in the Sun Belt. It is neither on the East Coast nor on the West Coast. In fact, whether we like it or not, many people consider this part of the country just a step or two removed from the boondocks. When we recruit new employees, they want to know what they are getting into. This inevitably leads them to ask what the Dayton area has to offer in the arts and cultural activities."

A concentrated effort has been made to upgrade the cultural climate in the Dayton area in the past half-dozen years. The availability of new resources and some good artistic choices have made the job credible.—Paul Lane Jr., "Who Covers the Cost of Culture in Middle America?" *New York Times* (Arts and Leisure section), 28 March 1982.

Notes

1 *SVA* [School of Visual Arts] *Alumni Chronicle* (winter 1982).
2 *New York Times*, 28 August 1981.
3 Ibid.
4 See Harold C. Schonberg, "Cuts in Federal Arts Budgets to Hit Small Groups Hardest," *New York Times*, 19 February 1982.

5 See for example, Rita Reif, "Auction: Art Records Set in May," *New York Times,* 7 June 1981, "Auctions: A Low Volume but a High Yield," *New York Times,* 8 November 1981, "The Collectibles Market in Decline," *New York Times,* 3 January 1982; under the heading "Investing" (Business section), see H. J. Maidenberg, "Slack Days in the Tangibles Market," *New York Times,* 21 March 1982; and, under the heading "Personal Finance," see Deborah Rankin, "There's More Shelter Now in Real Estate," *New York Times,* 23 August 1981.

6 R. W. Apple Jr., "Sotheby Tries to overcome Business Problems," *New York Times,* 18 March 1982, and "Sotheby Troubles Shake Art World," *New York Times,* 21 March 1982.

7 Howard Beilin, Inc., *New York Times,* 28 March 1982; Sotheby's also ran a series of color ads in British magazines.

8 Valerie Putney, "More Than Talent, *Pace* (March/April 1982).

9 See Ivan Molotsky, "Humanities Chief Calls PBS Film Propaganda," *New York Times,* 9 April 1982.

10 Putney, "More Than Talent," 30.

Grant H. Kester

Rhetorical Questions: The Alternative
Arts Sector and the Imaginary Public

During the last several years contemporary art and contem-
porary artists have been at the center of a widely publicized controversy in-
volving the freedom of expression and the limits of state-sponsored culture.
This controversy was ignited by attacks on the National Endowment for the
Arts (NEA) by conservative politicians, commentators, and religious activists
such as Senator Jesse Helms (R-NC), Representative Dana Rohrabacher (R-CA),
Patrick Buchanan, and Rev. Donald E. Wildmon. In the course of the debate two
antagonistic positions have emerged. On the one hand conservatives argue that
individuals shouldn't be forced to pay (through their taxes) for art that offends
their religious, sexual, or political values. On the other hand, artists, arts ad-
ministrators, and sympathetic politicians argue that the selective denial of
funding for artworks simply because they offend particular social values or
beliefs constitutes a form of censorship.[1]

These two positions can usually be identified by the category of civil subject
invoked by the respective parties. Conservatives claim to be defending the
interests of "taxpayers," whose hard-earned income is being expropriated by
the state to fund the perversions of a depraved minority under the guise of
"art." Arts advocates, on the other hand, imagine a public that is, by and large,
more open and tolerant—a body of citizens dedicated to the collective good,
but cognizant of their own rich plurality. These terms represent two very dif-
ferent conceptions of the public sphere and the role of the state in adjudicating
between individual and collective interests.

The debate over publicly funded art has remained in a deadlock, owing in
part to the centrifugal force exerted by these two positions. A number of writers
have sought to position this debate within the context of the larger neoconser-
vative political agenda.[2] While these investigations have provided a fuller un-
derstanding of right-wing philosophies and tactics, they have at the same time
tended to forgo an extended analysis of the art world itself. In this essay I want
to introduce an analytic framework that is less concerned with reading the
extrinsic clash of values expressed in the art funding debate than with inves-

tigating the social and ideological positions taken up by artists and arts administrators within the institutions of public patronage.

As one reads through the various editorials, congressional statements, and tracts that have been generated by the "anti-NEA" forces, a central strategy emerges: the constant posing of the "art crowd," "an arrogant gang of parasites," "the art elite," "an elitist cabal," "the art cognoscenti," and "the amoral elite" against "the average American," "rubes," the "common man," "bricklayers," "taxpayers," and "the public." Dissolute artists have raised the "national ire" by "savaging" "one sacred symbol after another." The "11th-commandment" of the arts community is: "Thou shalt grant federal funds to art that's too intellectual for you to understand. . . . This keeps high-class art out of the hands of the rabble, who are too coarse to appreciate it and can't tell a Marcel Duchamp from a marcel wave."[3]

The dual-pronged characterization of artists as both amoral and elitist is at the center of conservative attacks on the NEA. Although the arts community spent much of its time arguing that the work of artists such as Andres Serrano and Robert Mapplethorpe actually performed a kind of moral therapy for society by providing an outlet for otherwise repressed forms of desire and cultural critique, the charge of elitism was harder to refute. As Richard Bolton points out in the introduction to *Culture Wars:* "[The argument over the NEA] became a battle for power between two segments of the intelligentsia: the cultural elite and the religious conservative elite. Both sides spoke for the larger public, but neither side seemed to have much connection to this public."[4] A number of writers have questioned the extent to which cultural conservatives such as Helms or Wildmon represent any broad popular opinion; what needs to be stressed, however, is that the relationship between Bolton's "cultural elite"—and the nonprofit, "alternative" art world in particular—and the public is no less complicated or contradictory.

It is worth noting that the influential direct-mail campaigns mobilized by both conservatives and artists to lobby Congress were orchestrated through a network of sympathetic organizations and individuals; in neither case did the letters represent the spontaneous outpouring of a "popular" sentiment. This is not to deny that people outside the domain of the arts support freedom of expression, but simply to point out the extent to which claims on either side of the debate to represent a broad base of public support should be viewed with some skepticism.

My analysis will begin with a discussion of the original arguments for public art funding promulgated during the establishment of the NEA in the mid-'60s. I will then examine the ways in which artists and administrators, in collaboration with NEA program staff, were able to make use of the (deliberately) vague principles contained in the Endowment's founding documents to fashion a fundamentally new, and in many ways progressive, model of arts funding pol-

icy. The institutional product of this model—the "artist-run space"—has functioned to buttress the autonomy of the alternative arts sector at the same time that it has provided a site largely insulated from direct political and economic (market) pressures within which a critical aesthetic discourse could take root. Yet ultimately this same insulation has mitigated the ability of arts organizations to develop a strong public constituency outside the alternative arts community itself. It is in part the lack of such a constituency that has made the alternative art sector particularly vulnerable to conservative charges of elitism.

The Origins of Endowment Funding

The establishment of the NEA by presidential order in 1965 represented the culmination of fifteen years of persistent lobbying by a number of committed arts advocates and politicians, including Senator Jacob Javits (D-NY), Representative John Lindsey (D-NY), Representative Frank Thompson (D-NJ), Senator Claiborne Pell (D-RI), Roger Stevens, Nancy Hanks, August Heckscher (President Kennedy's "arts consultant"), Barnaby Keeney (president of Brown University), Arthur Schlesinger, Jack Golodner, and many others.[5] Rather than being the product of a single compelling argument for arts funding, the final passage of the bill authorizing the Endowment was the result of a combination of political factors (including a democratic landslide in the 1964 congressional elections) and a loose ensemble of justifications accumulated over the preceding years.

In his book *The Reluctant Patron,* Gary Larson examines what he calls the "rationale-building process," by which arts advocates constructed various arguments to justify federal art funding:

> The rationale [for arts funding] . . . proceeded in a helter-skelter fashion, subject to the mood of Congress and the country, and passing through its various phases—the international prestige argument, the cultural dissemination argument, the economic argument, and, finally, the "American Civilization" argument—in a cumulative, snowballing fashion, gathering support along the way.[6]

The "international prestige" argument—a relic of what Larson describes as America's "nervous preoccupation with the Communist threat" during the late 1950s and early 1960s—suggested that the United States must subsidize the arts in order to demonstrate its cultural superiority to the rest of the world.[7] The "cultural dissemination" argument was based on the concern that the arts in the United States were only available to a narrow social and economic elite. The state must therefore intervene in order to make the arts accessible to a broad geographic and economic cross section of the American public. In 1963 President Kennedy, upon creating an informal presidential "arts commission,"

expressed his concern that "children are growing up who have never seen a professionally acted play."[8] The "economic argument" was fueled by the controversial "Goldberg decision" of 1961 in which Secretary of Labor Arthur Goldberg, called in to arbitrate a strike by the Metropolitan Opera's musicians' union, declared that "the question before the nation was how to restore the financial viability of cultural institutions," particularly large cultural institutions such as the Met, that were facing "rising costs and increased competition."[9] Finally, the "American Civilization" argument represented a melding of concerns about national prestige and the high-minded rhetoric of the Great Society, as expressed in this statement by Representative Torbert MacDonald (D-MA), during the floor debate over the original Endowment bill:

> With the passage of this legislation the United States will take a further step along the path which saw us, first a fledgling Nation [sic] groping for our bearings, next a young, vigorous people, flexing new-found muscles in a display of industrial strength and now, finally, a nation in its prime, combining raw physical strength and abundant energy with an active interest in developing our national interest.[10]

At its inception, arguments in support of the Endowment, particularly those designed to persuade and cajole skeptical congresspeople, were founded not on a definition of art as a public good in and of itself, but on its potential usefulness within the matrix of state policy and ideology. Significantly, in none of these early arguments are artists themselves considered to be the primary recipients or beneficiaries of government largesse. During the 1950s, art is seen as a cultural weapon in the Cold War. And during the 1960s it provides an additional justification for the expanding domain of state "responsibilities" within the Great Society. A key section of the Goldberg decision drafted by Goldberg's aide at the time, future New York senator Daniel Patrick Moynihan, asserts that "we must accept the arts as a new community responsibility. The arts must assume their place alongside the already accepted responsibilities for health, education, and welfare. Part of this new responsibility must fall to the Federal Government, for precisely the reasons that the nation has given it a role in similar undertakings."[11]

In fact the relationship between the Endowment and the Great Society would prove to be of considerable importance. Some Endowment advocates even justified public art funding on the basis of art's role in channeling social unrest and reintegrating the disenfranchised. According to then New York congressman Hugh Carey, speaking before Congress in the mid-'60s, "An outpouring of creativity (stimulated by the NEA) [would] . . . do far more than even the Civil Rights Act to bring them [the ghettos] into the mainstream of American culture."[12]

Although conventional histories often describe the Great Society programs

of Lyndon Johnson as the creation of a handful of committed politicians and administrators, their roots also lie in the specific political and economic context of the mid-1960s. According to historians Francis Fox Piven and Richard A. Cloward, the social legislation that constituted the core of the Great Society (for example, the creation of the Office of Economic Opportunity and projects such as Community Action Programs [caps] and Model Cities) was motivated in part by fundamental changes that were taking place in the electoral base of the Democratic Party during the 1950s and 1960s. In their study of welfare policy in the United States, *Regulating the Poor* (1971), Piven and Cloward analyze post–World War II demographic shifts and observe that with the increasing migration of southern blacks to the North, "blacks came to be located in states of the most strategic importance in presidential elections."[13] In response, the Democratic Party began to tentatively endorse pro–civil rights platforms and legislation during the mid-to-late 1950s. This response cost the party support among white southern Democrats, especially among conservative Democrats, or so-called Dixiecrats, who began to abandon the party. With the loss of votes in the South, the Democratic Party was increasingly reliant on the black vote concentrated in the urban centers of the Northeast and Midwest. Piven and Cloward argue that Great Society social programs were designed, in part, to consolidate and enfranchise increasingly militant black urban voters— to effectively bring them into the Democratic Party.

Great Society bureaucrats were worried that federal money meant for urban blacks would be absorbed by existing municipal political machines. "The problem was solved," as Piven and Cloward write, "by diverting a large portion of the new funds to a host of intermediaries other than local government, including private social agencies, universities, and new ghetto agencies."[14] In their attempt to reach the new urban constituency, Great Society programs developed the notion of "maximum feasible participation" (MFP), to involve inner city blacks directly in the process of deciding what to fund. Community Action Programs staff members spoke of "empowering" the urban poor and allowing for their "self-determination" through a form of "citizen participation."[15] However, from the point of view of government administrators, this strategy backfired, because "the federal programs channeled funds directly to groups forming in the ghettoes, and they in turn often used these monies to harass city agencies . . . the new agencies began to organize the poor to picket public welfare departments or boycott school systems.[16]

This experiment in "participatory democracy," although highly influential, was short-lived. The encouragement that MFP policies gave to urban political militancy soon brought the wrath of conservative congresspeople and city officials down on the Office of Economic Opportunity for supporting a process that Nathan Glazer described as "the government conducting guerrilla warfare against itself."[17]

With the election of Republican Richard Nixon in 1972, and the subsiding of widespread urban rebellion and property destruction, the constituency for Great Society social programs and urban reform lost its electoral value. A number of Great Society programs (Model Cities, CAPs, etc.) were either eliminated or severely curtailed under the Nixon administration's "New Federalism."[18] This dismantling of Great Society programs reached its apogee in the early years of the Reagan administration when massive cuts were made to income maintenance and social services programs whose initial impetus derived from the Johnson administration. By the mid-'80s the Great Society had become a highly charged symbol among resurgent conservatives of the perceived excesses and failures of liberal social policy.[19]

If the constituencies for CAPs and Model Cities were considered relatively insignificant by the Nixon administration, the same could not be said of the constituency for arts funding. The liberal aura surrounding the NEA was used to cultivate a decidedly different group of voters—not the urban black population, but liberal, upper-class whites. Thus the budget of the NEA (which Patrick Buchanan described as a "Great Society jewel" in his 1992 presidential campaign) increased exponentially under Nixon, from $8.3 million in 1970 to $80 million in 1975.[20] White House staffer Leonard Garment, in an influential memo to the president urging him to support increased Endowment spending, pointed to the electoral benefit that this gesture would provide:

> For an amount of money which is miniscule in terms of the total federal budget, you can demonstrate your commitment to "reordering national priorities to emphasize the quality of life in our society."
>
> The amount proposed . . . would have high impact among opinion formers. . . . Support for the arts is, increasingly, good politics. By providing substantially increased support for cultural activities, you will gain support from groups which have hitherto not been favorable to this administration.
>
> We are talking about the vast majority of the theater board members, symphony trustees, museum benefactors, and the like. . . . It is well for us to remember that these boards are made up, very largely, of business, corporate, and community interests.[21]

Support for arts funding provided Nixon with a rhetorical platform from which he could express his commitment to "reordering national priorities," for, as Elaine King remarks, "a small investment of political capital."[22] The liberal and humanitarian values associated with the Great Society (or what we might call the "aura" of Great Society policy) had, in effect, migrated from Johnson's (defunded) social programs to the Endowment and the principles of public art funding and cultural support. In the process they were detached from their original constituency and used to buttress Nixon's electoral base

among art patrons. This shift also accounts, in part, for the fact that the NEA's budget actually grew slightly during the early to mid-1980s when President Reagan was slashing food stamp programs, health care for the poor, and federal funding for school lunches. Both the political clout of the art establishment and the comparatively organized lobbying mechanism that it was able to mobilize—as compared with, say, working-class schoolchildren, the homeless, or welfare recipients—protected the Endowment's budget.

The value of art for the state is always related to art's capacity to generate or enable certain kinds of symbolic speech on the part of legislators and politicians acting within the highly circumscribed environment of public policy formation. Public policy debates are one of the central theaters within which the play of participatory democracy is acted out, and policy models or rationales are the scripts that are performed in this theater. They are a key part of the system by which the state generates consent for the expenditure of public funds. The advantage to thinking about debates over the Endowment in terms of their performative aspect is that it helps disabuse us of the notion that there is some necessary connection between the statements made by the various actors in these debates and the actions they might really take, their own relationship to the constituencies they claim to speak for, and the political, ideological, and material forces that actually impinge on their decision making.

There need be no direct relationship between the "signifiers" of political discourse and the actual behavior of politicians. Politicians and political managers, from Roger Ailes, who had Nixon's campaign staff reading extracts from Marshall McLuhan's *Understanding Media* (1964) during the 1968 presidential campaign, to the late Lee Atwater and George Bush, have labored under no delusions about the exercise of political power in this respect. Dan Quayle can excoriate the "cultural elite," even as his family owns a chain of newspapers, or attack Vietnam War draft dodgers, even as he waited out the war in the National Guard. Quite often in the recent debate over the Endowment, arts advocates have displayed a surprising degree of naïveté about this dimension of the political process. They devote an inordinate amount of time to logically refuting conservative attacks on the Endowment as a haven for deranged and immoral artists, without realizing that the more important task is to ask why these characterizations, as simplistic or illogical as they may appear, have been so effective; who listens to them and why? And what can be learned from them?

The Artists' Space Movement and the Discourse of Professionalism

The recent attacks on the NEA have been directed at a relatively small segment of the Endowment's budget devoted to small, "artist-run" visual arts and media

Nancy Hanks, director
(1969–77), National
Endowment for the Arts.
Photo courtesy National
Endowment for the Arts.

arts organizations and the artists they support—in particular, those funded under the visual arts, media arts, inter-arts, and theater programs. Examples of these organizations include Franklin Furnace, Los Angeles Contemporary Exhibitions (LACE), the Washington Project for the Arts (WPA), The Kitchen in New York City, NAME gallery in Chicago, the Southeastern Center for Contemporary Arts in Winston-Salem, North Carolina, and Installation gallery in San Diego, among many others. As opposed to the opera companies, symphonies, ballets, and major museums that receive the bulk of the Endowment's funding, most of these organizations either didn't exist prior to the establishment of the NEA, or would not have reached their present level of development without very large increases in Endowment spending during the 1970s.[23] During the tenure of NEA director Nancy Hanks, the NEA's budget grew from $11 million in 1969 to $114 million in 1977.[24] Under the influence of program directors who included artists Brian O'Doherty and Jim Melchert, as well as Henry Geldzahler, the NEA effectively enfranchised an entire network of exhibition spaces, media centers, presses, publications, and service organizations devoted to "alternative," nonmarket-oriented artists and artworks.

Although by the mid-'70s no one was naive (or opportunistic) enough to suggest that an artist-run exhibition space would prevent ghetto uprisings, the movement did, nevertheless, cloak itself with much of the rhetoric of the '60s in general, and the Great Society in particular. "The expansive idealism of the late '60s," according to the Washington Project for the Art's *Ten Year Document*

Brian O'Doherty, program
director, National
Endowment for the Arts.
Photo by Michael
Geissinger, courtesy
National Endowment for
the Arts.

(1986), "led to the climate of self-determination necessary to form the art-
ists organizations of the early and middle '70s."[25] And according to Brian
O'Doherty, one of the Endowment's first program directors, "A lot of radical
energies of the '60s fed into alternative spaces."[26] The Endowment's Workshop
Program, established in 1972, was instrumental in funding many of the early
artists' spaces. The NEA guideline booklet describes the Workshop Program
in terms of the importance of "artists' self-determination," and of the "non-
commercial, bare-walled, ripped-out, 'alternative space,' run by artists for
artists."[27]

This description evokes images of a virile, aggressive, bohemian avant garde:
bare-knuckled artists literally ripping a space for themselves out of the fabric of
the decaying metropolis as a refuge from a banal and indifferent art market.[28]
The bohemia conjured up in the Endowment's guidelines was in fact largely
populated by white, middle-class artists, and their "ripped-out spaces"—
at least those that survived—would, within the next decade, become well-
established and in some cases even well-funded venues, often located in the
midst of extremely valuable, "revitalizing" downtown neighborhoods. Fur-
ther, the "alternative" sector, far from rejecting the art market, would come to
function as a highly effective "farm team" system for the commercial sector,
with selected artists being called up to exhibit in the big leagues.[29]

If the alternative space movement represented an avant garde, it was a sin-
gularly institutionalized avant garde. The artist space movement developed its

own distinctive philosophies, professional etiquettes, communications networks, and hierarchies. The individuals who founded and ran these organizations were soon transformed from artists into artist/administrators or, in less flattering terms, artist/bureaucrats. This new managerial class rapidly assumed all the accoutrements of professionalism. They formed their own organizations dedicated to advancing the interests of the field (the National Association of Artists Organizations [NAAO], the National Alliance of Media Arts Centers [NAMAC], etc.), and, more important, they came to conceive of themselves as possessing special skills, and of their work as deserving professional respect.

Most attempts to understand the relationship of the alternative sector to the larger public culture focus primarily on the role of artists and artistic production. However, it is important to bear in mind the significance of the institutional network of the alternative sector and, more specifically, its status as a particular bureaucratic structure in the hands of a particular administrative class. When looked at in this light, it is possible to raise questions about the discourse of professionalism and issues of autonomy, not from the point of view of the artist as a vaguely defined (and highly mythologized) social type, but in the context of a more contingent and specifiable set of bureaucratic drives and rhetorics.

The position occupied by the artist/administrators of the alternative sector, both in terms of their administrative ideologies and in their relationship to forms of public and private patronage, can be more clearly understood through a comparison with the larger class of professional and managerial workers in the United States. This group, variously labeled the New Class (André Gorz, Alvin Gouldner), the Coordinator Class (Donald Stabile), and the Professional-Managerial Class (Barbara and John Ehrenreich), has been the subject of considerable study by historians and social scientists.[30] It encompasses a broad range of intellectual and cultural producers whose livelihood derives primarily from their ability to create and regulate a set of analytic or symbolic discourses—in fact, Robert B. Reich refers to this class as "symbolic analysts."[31] Barbara and John Ehrenreich trace the emergence, and subsequent growth, of the Professional-Managerial Class (PMC) to a combination of factors that began to plague the capitalist economy in the early twentieth century. First, the increasing technical complexity of industrial production required the supervision of a growing cadre of highly trained technicians, engineers, and scientists. At the same time, growing militancy and resistance on the part of industrial labor—in the form of highly disruptive strikes, unionization, and political organization—was posing a threat to the accumulation process. The PMC emerged, as the Ehrenreichs argue, "between" capital and labor. It was a mediating class whose role was, in effect, the "reproduction of capitalist culture and capitalist class relations."[32] PMC professions, from social work and advertising

to scientific management, were oriented around a "politically motivated penetration of working class community life," resulting in the "social atomization of the working class: the fragmentation of work . . . in the productive process, a withdrawal of aspirations from the work place into private goals, the disruption of indigenous networks of support and mutual aid, [and] the destruction of autonomous working-class culture."[33]

While the PMC, like the working class, was employed by capital, its relationship to the working class was, nevertheless, based on an "objective antagonism." As the Ehrenreichs express it, "Real life contacts between the two classes express directly, if sometimes benignly, the relation of control which is at the heart of the PMC—working class relation: teacher and student, manager and workers, social worker and client, etc."[34] At the same time, the PMC—especially during its initial consolidation as a class during the Progressive era—often expressed solidarity with labor. Its belief in a set of rational "solutions" to social problems led it into conflict with the capitalist class, whose interest in rationalization did not extend to any serious questioning of the larger social implications of the accumulation process.

Its ambivalent position between capital and labor, combined with its command of what it imagined were objective, scientific forms of knowledge, endowed the PMC with the belief that it spoke from a neutral or transcendent position within the social order. Its opinions and perspectives were assumed to represent neither of the two contending classes, but rather those of the "greater society." As the Ehrenreichs note, "The claim to high ethical standards represents the PMC's persistent reassurance that its class interests are identical to the interests of society at large."[35]

Despite its occasional alliances with labor during the Progressive era, the PMC realized that its survival depended in the last instance on its command of technical and analytic systems and bodies of knowledge. Thus, according to the Ehrenreichs, "The profession . . . was the characteristic form of self-organization of the PMC":

> The defining characteristics of professions . . . are, in brief: a) the existence of a specialized body of knowledge, accessible only by lengthy training; b) the existence of ethical standards which include a commitment to public service; and c) a measure of autonomy from outside interference in the practice of the profession (e.g., only members of the profession can judge the value of a fellow professional's work).[36]

A provisional inventory of those factors that characterize the PMC might include (1) a desire for professional status and autonomy (such that only other members of a given profession are capable of judging the performance of that profession); (2) a belief that the members of that profession are involved in an ethical mission to "reform" the larger social order, and further, that they oc-

cupy a class-transcendent position and thus speak from the perspective of society as a whole against the specific interests represented by other classes; (3) the ability to produce and regulate particular forms of symbolic and analytic discourse—as in the legal profession, engineering, advertising, and the like; and, finally, (4) a relationship to various disenfranchised constituencies that conceives of them as a mass to be variously regulated or empowered.

We can understand artist/administrators as a segment of the PMC. They are the managers of a particular form of cultural capital that is generated at the intersection of two discourses—the discourse of fine art, with its demand for freedom and autonomy, and the discourse of public funding, which imposes conditions of accountability and which requires the artist/administrator to take up a position in relation to "the public." The extent to which the characteristics of the PMC listed above correspond to the constitutive rhetorics of the alternative sector's administrative class is striking. The desire for professional status and autonomy (in which only artists are in a position to judge the work of other artists) is emblematic of the artists' space movement. The aspiration for professional status is usually expressed through comparisons with other fields. Charlotte R. Murphy, the executive director of the NAAO, testifying before the Congressional Subcommittee on Postsecondary Education, compares the "artistic laboratories" of the alternative arts sector with "laboratories for investigation within our nation's scientific and corporate communities. . . . Just as industry and science recognize their future success as dependent on a solid commitment to experimentation, and the accompanying possibility of failure, so must the arts."[37] And Karen Finley, in a statement following former NEA director John Frohnmayer's decision to withhold her Endowment grant in June 1990, insists: "Art is a profession and has experts, as do other areas."[38] Finally, Susan Wyatt, testifying on June 19, 1991, before the House subcommittee that oversees the Endowment, grounds her defense of professionalism in the arts with a comparison to opera, a rather unusual institutional model for the supposedly egalitarian artists space to aspire to:

> The notion that someone who has no expertise and knowledge of the arts can judge one proposed opera over another is absurd. In our society we acknowledge professionalism in many different fields, why not the arts? Who can truly argue they understand better than a qualified curator which paintings should be in a show or which organizational structure and long range plan suits a dance company better?
>
> Surely if we as taxpayers demand the best for our money we must insist that our dollars are spent by those best qualified to make such judgements.[39]

At the center of the alternative sector's concern with professionalism is a strong desire for autonomy from government interference, from the demands of

the art market, and from the limitations of consumer culture. As Stephen Kahn notes in "Communities of Faith, Communities of Interest," "The artists starting these spaces wanted the space to be a vehicle for *artists,* not dealers, collectors, critics, or audiences. To 'sell out' to any of these other constituencies would be to forfeit their autonomy as artists."[40]

The fact that alternative sector artist/administrators were actually able to achieve a high degree of operational autonomy—that is, to use Endowment funding more or less as they saw fit—was attributable to a combination of factors. Chief among these was their discursive skill, that is, their ability to create the ideological packaging necessary to justify the expenditure of state, and also private foundation, moneys on their activities. In effect, their survival depended on their capacity to construct narratives that positioned their own institutional activities in relation to a larger set of cultural goals associated with federal or private funding mandates. Second, the alternative sector, because of its relatively small size in relation to other areas of Endowment funding, was protected, or camouflaged, by the presence of highly visible and credentialed museums, operas, and ballet companies. And third, these artist/administrators were able to retain institutional independence because of their close involvement with the formulation of Endowment policies and practices through the peer panel and policy review panel system.

The discursive powers deployed by the alternative sector in its quest for autonomy are apparent in the process by which arts administrators worked to transform and negotiate the funding paradigms of the Endowment. Although, as I have noted, the initial justifications for the Endowment's existence were subject to a lengthy process of congressional debate and review, the actual purposes of the NEA, when finally codified into an act, were, according to Elaine King's unpublished dissertation on the NEA, "deliberately written very loosely."[41] In King's interview with Livingston Biddle, Claiborne Pell's aide (and a future director of the NEA) who drafted the language of the National Foundation on the Arts and Humanities Act, he observes, "We knew that there would be a lot of opposition and we knew there had to be a lot of freedom for the arts, the writing of this act had to be done carefully, allowing for broad interpretation of the arts on many levels."[42]

Thus, the act calls for only the most general goals—first, to make the arts more widely available; second, to strengthen cultural organizations; third, to preserve our cultural heritage for present and future generations; and fourth, to encourage the creative development of talented individuals—with very little idea of how these goals would be achieved or even defined. Owing to what King describes as the "open-endedness of the Act," considerable discretionary power would lie with the actual implementation of the NEA legislation through the specific procedures and guidelines governing the Endowment's daily operation.

As already mentioned, artist/administrators were able to play a crucial role in formulating these procedures and guidelines because of the Endowment's system of peer panels and policy review panels. Policy review panels for individual programs, which review changes in granting policy and program organization, are composed of program staff and artists. And the peer panels that make the actual selection of grantees and that recommend funding levels, were composed entirely of artists and arts administrators until the recent "lay person" provision. In line with the alternative sector's drive for professional autonomy, these panels are premised on the notion that only artists possess the necessary "expertise" to make informed decisions about arts funding. Although the decisions reached by both the policy review panels and the peer panels are subject to approval by the NEA's director and the National Council, until the recent controversies it was relatively unusual for their actions to be vetoed.

These mechanisms, which had been devised in order to insulate the NEA from congressional tampering, created a situation in which artist/administrators from the alternative arts sector, in conjunction with the NEA's program staff, became de facto policy makers. This is why the reassertion of the powers of the National Council over the peer panel system has been a major goal of conservative attacks. The report issued by President Bush's 1990 Independent Commission on the Endowment expressed "concern that the panels that make recommendations for grants had come to dominate NEA grant making" and advocated "sweeping reforms" in Endowment procedures to reinforce the role of the NEA's presidentially appointed director and National Council in making funding decisions.[43]

Through the mechanisms of NEA policy formation, the managerial class of artist/administrators and the NEA's staff transformed the relatively amorphous funding philosophy of the Endowment into a highly nuanced funding paradigm centered on the artists space and artist-run organizations. The artist-run space, as noted above, was intended to reject the banality of the market and provide support for a vital, alternative culture in which artists were responsible only to themselves and their own interests.

A key component of the institutional model of the artists space was the invention of a new civil subject—the "cultural worker." With the cultural worker model artist/administrators appropriated the existing language of Great Society programs that sought to "empower" the poor and working-class beneficiaries of government assistance by directly involving them in funding decisions. They performed a strategic substitution in which the artist became the disenfranchised citizen in need of "empowerment." Alternative sector artists were taken to constitute a special class of citizens who were being systematically exploited or ignored by the art market. Thus artists must "take over" the cultural apparatus that is founded on their own creative labor—they should

be on boards, make administrative decisions, form peer panels to dispense grants, and so on. Renny Pritikin, the director of New Langton Arts in San Francisco and a longtime figure on the alternative arts scene, is surprisingly frank about this appropriation:

> The objective [of the artists space movement] was self-determination. Artists took this rhetoric, originally intended to address disenfranchisement from political decision-making processes, and applied it to the microcosm of an art world that had effectively placed artists in a passive and victimized role, identifying that condition as a political one. As an alternative to such a condition, artists proposed to create their own ground for displaying their works both for their peers and any interested audience.[44]

In the second sentence of this statement, it is unclear just who was experiencing the "original disenfranchisement" that the rhetoric of participatory democracy sought to challenge. The rhetoric itself is disembodied and, conveniently, becomes available to artists. Thus artists "took" the political rhetoric that was "originally intended" to address the disenfranchisement of the poor and working class, and mobilized it to their own ends. Rather than the chronic unemployment and poverty faced by the urban poor, artists have to confront an uncaring art world that has "placed" them in a "passive and victimized role."

But the victimization of a fine artist by the art market is surely of a somewhat different order than, for example, the victimization of the rural poor by the processes of agricultural modernization under capitalism.[45] The experience of an artist whose work is rejected by the gallery system is simply not interchangeable with that of the poor or working class, whose relationship with the market economy has far more profound consequences. Taking up the position of an artist in our society has a great deal to do with acculturation and access. Thus one chooses to become an artist as a result of several related factors: having even the limited leisure time to pursue art, having access to various forms of art education—often graduate-level training—and coming from a social background that makes the idea of becoming an artist at least thinkable.

At the same moment that artists, like the PMC, want to identify with the working class and speak as "cultural workers," they also imagine that they are engaged in an ethical mission to reform society and speak not as artists per se, but as representatives of the "greater good." Being an artist provides one with a transcendent platform or identity from which to engage in moral rhetoric on behalf of a whole range of disenfranchised others. These two rhetorics—that of the artist as worker and the artist as transcendent subject (which I will explore in the final section of this essay)—oscillate together in the discourse of the alternative sector. A statement to John Frohnmayer by the NEA's 1990 "New Forms" panel suggests the ease with which artists and arts administrators identify themselves with various groups that experience social exclusion and op-

pression: "As committed arts professionals we hereby make common cause with all Americans—the poor, the old, the sick, the homeless, the unschooled and the unemployed—who are being systematically disempowered."[46]

This statement assumes, first, that "committed arts professionals" share some kind of implicit bond with the various groups that make up this veritable catalog of victimization, and second, that they can construct this bond through a simple declaration of solidarity. Why should someone who is living on the street necessarily have any more in common with an arts administrator than with an accountant? The issues that most preoccupy arts administrators, such as the expenditure of federal funding for the arts and debates over the freedom of expression, are of relatively little concern to someone who is without food, shelter, or a job. If there is a solidarity being experienced, it is largely on the side of the artists.

In fact, the objective social and economic position, and the cultural cachet, of artists often places them in direct conflict with the needs of poor or homeless people. Sharon Zukin's book *Loft Living: Culture and Capital in Urban Change* (1982) examines the extent to which artists, and a bohemian art culture, were integral components in the gentrification of lower Manhattan in the 1970s.[47] Exhibition spaces in urban centers such as New York City, Washington, D.C., and San Francisco played a key role in the cultural redefinition of "downtown" as a hip, cosmopolitan place for young professionals to live. In the case of Washington, the presence of cultural institutions such as Warner Theater and the Washington Project for the Arts, and a smattering of artists' studios in a formerly marginal area off Pennsylvania Avenue, provided the incentive for the packaging of a full-scale "Downtown Arts District," centered around the establishment of "arts-related retail" uses such as movie theaters, restaurants, and bookstores.[48] Alternative exhibition spaces, such as the Washington Project for the Arts, whose programming often took an adversarial stance toward the machinations of corporate capitalism, effectively functioned to facilitate this process by exchanging the "cultural capital" of their avant-garde status for reduced rents and other forms of "protection" from the skyrocketing property values brought about by the development process.

What is striking about the artists space funding model, as compared with discussions surrounding the formation of the Endowment, is the central role assigned to contemporary artists as the beneficiaries and constituency of public funds, and the relative indifference to the putative audience for publicly funded works. It is emblematic that in the Pritikin quote cited above the question of a potential audience, apart from other artists ("their peers"), is left unspecified. The tendency to elide the public in the calculations of the alternative arts sector is also evident in a widely circulated letter (dated January 31, 1992) to the NEA's National Council, written by Pritikin while he was the chair of the Visual Arts panel that approved grants to Franklin Furnace Archive in

New York City and Highways in Santa Monica that were subsequently denied by the council. In Pritikin's statement, the "arts community" is substituted for some larger public as the "constituency" of Endowment funding: "The Council's rejection of these two grants denies the validity of your own processes, work by dedicated professionals replaced by a whimsical irrationality which will alienate every applicant, *the very constituency of citizens you are meant to serve*" [my emphasis].[49]

Within the rhetoric of the artists space movement, artists seemed to believe that by rejecting market values they would effortlessly shed their own cultural privilege and operate in a utopian, state-funded, minipublic sphere, founded on "sweat equity" and collectivity. But the withdrawal from the elitist art market into a nonprofit enclave doesn't necessarily bring the artist any closer to various segments of the non-art public—nor does it allow artists to transcend their own class and cultural privilege. The empowering gesture of artistic self-determination tended to gloss over the very real schisms between the artist and society at large. One has only to look at alternative space exhibitions from the late '70s and early '80s such as Donald Newman's *The Nigger Drawings* exhibition at Artists Space in 1979 for an indication of the extent to which some members of the alternative sector felt that their self-evidently progressive cultural politics entitled them to employ virulently racist language to promote their work.[50]

Owing in part to the autonomy they were so anxious to achieve, alternative arts institutions were seldom called upon to question their own assumptions about audience and public perceptions of their "cultural work." An interesting example in this regard is the *Blues Aesthetic* exhibition held at the Washington Project for the Arts in fall 1989. The exhibition's curator was able to develop an art historical theme—involving an ostensibly inherent African American creative geist based in blues music—benign enough to attract generous sponsorship from a corporation (Ford Motor Company) that was anxious to overcome the bad press it was receiving for its poor treatment of black autoworkers.

As part of the exhibition, the WPA commissioned several "public art" projects that were sited in downtown Washington. Although the exhibit was heavily contextualized for an art audience, through an extensive series of lectures, film screenings, and publications, there was little or no attempt to create any context for the people who actually lived in, or traveled through, WPA's downtown neighborhood. One of the public projects was a billboardsize painting by New York artist David Hammons, showing Jesse Jackson in white face, blond hair, and blue eyes, with the slogan, "How Ya Like Me Now?" The painting referred to the difficulty Jackson was having, as an African American, in getting the Democratic Party to acknowledge the fact that he spoke for, and to, a significant bloc of potential voters through his Rainbow Coalition.

As the work was being installed, a number of young black men in the area

first confronted the installation crew, then left, and later returned with a sledgehammer to destroy the piece. Irony turns on a very fine axis; in the absence of any further explanation, and in the presence of an all-white installation crew, the "audience" for this work drew its own conclusions.[51] How do we account for the failure of what would appear to be an exemplary alternative space project involving a politically committed black artist? Hammons, because he was in Rome on a fellowship at the time wasn't present during the installation to provide any context. In addition, there was no real attempt at the kind of public education or community outreach before the piece was installed that might have given it some contextual foothold (for example, introducing Hammons's work and Hammons as an artist to people in the area before the installation was begun). I'm not trying to justify the destruction of Hammons's piece; I only wish to point out that the WPA saw its role in the production of a "public" artwork as being confined to the process of commissioning and installation. But a work whose meaning is apparent to an audience familiar with the artist and schooled in the ironic codes of the alternative sector may be quite oblique to passersby on the street outside.

The Hammons incident reflects the general condition of current public art that simply imposes highly coded gallery or alternative space works on a site occupied by an undifferentiated public, assuming that these works enjoy some kind of universalized capacity to communicate across cultural and institutional boundaries. In the absence of any developed theorization of this cultural gap, the alternative arts sector is by and large unwilling to acknowledge the contingency and the specificity of its own languages and modes of representation.[52]

The Rant Performance and the Implied Viewer

Throughout the 1970s and 1980s the constituency for alternative arts organizations such as Artists Space in New York, Los Angeles Contemporary Exhibitions, or the Washington Project for the Arts in Washington, D.C., was by and large not a local or regional community (aside from a local art community), but a national network composed of other alternative spaces, artists, and publications—and the funders and foundations that these spaces rely on for support.[53] With the recent controversy over the NEA, artworks that had been incubated and circulated within the alternative arts enclave for years were brought before a large public for the first time—in reproductions in *Time* and *Newsweek,* in exhibition catalogs waved on the floor of the U.S. Senate, on the evening news, and through the huge number of visitors that many of the embattled exhibition spaces received as a result of conservative attacks. According to Susan Wyatt, the former director of Artists Space in New York City, which organized the controversial *Witnesses: Against Our Vanishing* exhibition, "We had always

allowed ourselves to believe that the art we show speaks best to a particular audience, one which carefully follows the developments in the art world; in this sense our major audience was not a general audience. For the six week run of the Witnesses show, we had a general audience for the first time."[54]

I want to examine the implications of this statement for works produced in the alternative sector. How has the relative isolation of the alternative arts sector shaped the way in which these works "speak" to a "particular audience"? And how has it contributed to the ability (or failure) of these works to be legible beyond the alternative sector itself? In particular, I want to look at the specific rhetorical positions that these works take up in relationship to the viewer. It is my contention that many works produced in the alternative sector function not by directly addressing an alternative arts audience, but by speaking to an imaginary spectator whose (conservative) preconceptions are meant to be transformed by the experience of the artwork, and further, that the spectacle of this displaced rhetoric performs an explicitly therapeutic function for art-world audiences. By studying what we might call the "implied viewer" of these works, we can learn a great deal about how the alternative sector perceives the public and its relationship to this public. In particular, we can see how the partial and problematic autonomy of the alternative sector discussed above both enables and constrains this relationship.

There are a number of widely practiced modes or genres of alternative sector art. Two of the most prevalent are the "rant" performances of artists such as Karen Finley, Guillermo Gómez-Peña, Holly Hughes, and the late David Wojnarowicz, and the "moral/didactic" installation (MDI)—exemplified in the work of artists such as Group Material, Richard Bolton, and Martha Rosler. The MDI bombards the viewer with information about a particular issue or set of issues, such as homelessness, anti-Communism, corporate capitalism, censorship, U.S. foreign policy, and so on, usually in a highly dense and layered installation format combining video, audio, written material, and published articles.[55] In these installations the artist functions as the coordinator of an idealized mini public sphere in which controversial issues—normally suppressed by the mass media—can be openly engaged. The MDI attempts to encourage and contribute to a critical consciousness or attitude on the part of the audience.

The key elements of the rant include polemical statements, often with a direct address (for example, Finley's attack on President Bush in her recent Lincoln Center performance: "I want to see him suffer!" "I want to see him hurt!"), and a general excess of aggressive, highly affective language. The rant is usually theatrical and may include incantatory or cadenced delivery, chanting, and other spoken elements that owe as much to Beat-era poetry readings as to performance per se.

Although most often manifested as staged performances with minimal props

and costumes, the rhetoric of the rant also extends to written works—Wojnarowicz's catalog essay for the *Witnesses: Against Our Vanishing* show is a good example—and installations, such as Barbara Kruger's exhibit last year at Mary Boone gallery, which featured a floor-to-ceiling "barrage of moral provocation."[56]

Although the rant and the MDI employ two very different discursive strategies, in each case the relationship of the artist to the audience is that of a moral guide to the inequities of life under late capitalist patriarchy. The artist provides the audience with information or a perspective on social issues and experiences to which they are assumed not to have access. Further, the artist's relationship to this information or experience provides a kind of model (of sensitivity, of outrage, or of involvement) that the audience can emulate and take inspiration from. Thus what is "on display" in a Group Material installation is not simply information about a particular issue but also Group Material itself as an exemplary body of committed cultural activists. Although the MDI merits a much closer study, it has been the rant, thus far, that has gained most of the attention in the arts funding controversy. In addition, it offers what I feel is the most paradigmatic expression of the underlying cultural attitudes of the alternative sector.

A mythology circulates around the rant, promulgated by the artists themselves and by sympathetic critics, that purports to describe its effect on the viewer. This mythology describes an often aggressive process in which the artist literally forces the viewer to confront various forms of social oppression and discursive violence or misrepresentation experienced by women, people of color, gays and lesbians, the poor and working class, the homeless, immigrants, and others. The excess of affective language in the rant, for example, seems designed to overcome the indifference of the dominant culture to the issues of exploitation and oppression being explored by sheer rhetorical force.

Thus, Guillermo Gómez-Peña and Coco Fusco will "unleash the demons of [colonial] history," not in order to "scare" their "Anglo-European" audiences, but in order to "*force* them to begin a negotiation with these . . . demons that will lead to a pact of co-existence" (emphasis added).[57] The performances of John Malpede's Los Angeles Poverty Department (described in one review as a performance group made up of the homeless and the formerly homeless, founded by a "disillusioned New York performance artist") "*forced* the audience to see the consequences of street violence" (emphasis added). The criticisms directed in this performance against the objectification of the poor was "so thoroughly pounded in that one could only feel rage."[58] Karen Finley's performances deliver "an undeniable visceral punch." She "*pulls* the audience into one of her hell holes of life," and "she pulls us into her visions" (emphasis added).[59]

An influential prototype for this mythology can be found in critical readings

of Barbara Kruger's work during the early to mid-'80s. Although Kruger has for some time been comfortably ensconced in the art market, her earlier work was widely exhibited in the nonprofit sector (she was showing at Artists Space as early as 1974) and is clearly indebted to the cultural concerns of the alternative arts movement (Kruger's image as an "alternative" artist was paradoxically demonstrated by the uproar in the art world over her move from the comparatively low-profile Annina Nosei gallery to the rampantly commercial Mary Boone gallery in 1987).[60] Kruger's rise to art-world prominence in the mid-'80s was fueled in part by widespread critical endorsement from figures such as Craig Owens, Kate Linker, Hal Foster, Jane Weinstock, and others.

These critics described her work as a kind of ideological machine, capable of relentlessly "disrupting" the viewer's perceptions through the cunning deployment of "appropriated" images and personal pronouns. Her image/text pieces were endowed with the power to provoke the most remarkable kinds of transformations in the viewer's relationship to the mass media. According to Craig Owens, her work "forces the viewer to shift uncomfortably between inclusion and exclusion."[61] And in Jane Weinstock's view, Kruger's work "literally positions" the viewer, "you are positioned" and "linguistically placed."[62]

But this orthopedic aesthetic—in which the work seeks to "adjust" the viewer's subjectivity—assumes a singularly naive and ill-informed audience. The same hapless, usually male, viewer is incessantly "positioned" and "placed," and his preconceptions "disrupted" by the same static strategies and rhetoric. In addition, this critical interpretation overlooks the actual dynamics of art-world viewership. No one, certainly not in an alternative arts scene (where the visual and textual rhetorics employed in Kruger's work are most intelligible) that considers itself to be a bastion of nonconformity and progressive politics, would want to admit to being so ignorant of conditions of social oppression, or so complicitous with the representational discourses of patriarchal power. Ken Johnson, writing on Barbara Kruger's recent installation at Mary Boone gallery, observes:

> The curious question . . . is why, subjected as we were to such insulting, punitive, censorious and preachy rhetoric, was it so much fun? The answer, in part, is that it didn't feel as if Kruger were attacking us personally. Rather, the installation spoke to a fictive person, an imaginary someone who embodies the dark side of American society. That someone is, of course, a white male power figure. . . . We only wish that Jesse Helms had been there to share this experience.[63]

Johnson's observation is striking. The implied viewer for Kruger's work, as for the performances of Finley, Wojnarowicz, Gómez-Peña, or Hughes, is often a mythical father figure conjured up out of the artist's imagination in order to be shouted at, attacked, radicalized, or otherwise transformed by the work of

the performance. It is a viewer whose presence is presumed by the work's mode of address and whose outraged reaction is constantly solicited, but who, owing to the hermetism of the alternative sector, seldom arrives at the performance.

Thus the actual reception of these works has been largely rhetorical. The audience members for a performance by Finley or a Kruger installation knows that they aren't the real target of the outraged pronouncements on sexism or racial oppression. Rather, they consume the work simultaneously in the first person and the third person, imagining themselves as the intended viewer while at the same moment reassuring themselves of their own ideological superiority to this point of view. This kind of displaced, performative rhetoric provides viewers with the spectacle of moral outrage. Far from disrupting the viewer's perceptions of social violence, this spectacle can just as easily provide the opportunity for delectation—this is the "fun" provided by Kruger's ostensibly scorching social critique at Mary Boone. The potential for aesthetic consumption is in effect even in the case of an audience outside the alternative sector, which presumably might hold some of the conservative opinions the works seek to disrupt. Karen Finley's recent performance at Lincoln Center elicited this reaction from *New York Times* theater critic Stephen Holden:

> Her furious cry from the heart was so intense that it reduced the audience to a stunned silence, and it demonstrated that Ms. Finley has grown into a performer of spellbinding charisma. Her rants, with their repeated key phrases and incantatory rhythms echoing the more stentorian verses of Allen Ginsberg, are a powerful fusion of political rhetoric, poetry and shamanic outpouring. Even those who hate her ideas are likely to be shaken by the conviction of her performance.[64]

All the cornerstones of the rant mythology are here. Finley's "shamanic outpouring" "reduced the audience to a stunned silence." What is especially fortunate for Lincoln Center's theatergoers is that they can savor Finley's "spellbinding charisma" and leave the superfluous "ideas" behind. It is the experience of the performance that conveys her conviction, not any potentially disagreeable political message that might lie behind it. Finley will, as one *Newsweek* story has it, provide a "One-Woman Tour of Hell."[65] The use of the word "tour" is telling. In fact, it is the very basis of the way the rant functions for viewers who come to consume the spectacle of the committed artist.

Far from providing a shocking departure from conventional aesthetic modes, the rant actually recapitulates a very conventional relationship between the viewer and the artist, derived from Romanticism, in which the artist enjoys a privileged access to the truth of social oppression. In fact, the belief that it is the particular job of the contemporary artist to act as the conscience of society has become a commonplace in current debates over the function of the arts. Thus we find an organization as stalwartly bureaucratic as the National Assembly of

State Arts Agencies (NASAA) suggesting that "art, especially contemporary art, has a special capacity to touch a raw nerve in society. A work of contemporary art has the power to expose a community to a whole set of social, moral and ethical issues that might otherwise remain unexpressed or avoided."[66]

An extreme version of this model imagines the artist as a kind of transhistorical shaman. Performance artist Jeff McMahon, in a letter to the Senate Subcommittee on Education protesting content restrictions on Endowment funding, argues that "great civilizations have always realized that there are some people, artists, priests, medicine men and women, 'great speakers,' who are in touch with mysteries, languages, and experiences that are not comprehensible or palatable to one and all. The speaker may be Moses, it may be Vaclav Havel or David Wojnarowicz."[67]

At the center of the rant is the notion of the performance as a cathartic event in which artists become channels or mediums for the congealed residues of both their own and other people's experiences of social oppression. Thus "women, AIDS victims, and the homeless," according to a recent article on Karen Finley, "are all swept into the circle of her rage and despair."[68] "The only reason I feel comfortable around the broken, the inebriated, the drunken, and the addicted," according to Finley in her performance *A Suggestion of Madness* (1989), "is because it looks like what I feel inside."[69] And Gómez-Peña, in a transcript of a recent performance, enumerates the "sources" that infuse his performances:

> During my exorbitant journey beyond the limits of Western culture I learned quite a few things from quite respectable individuals. the Mexico City bums taught me to walk without leaving a foot-print. the Chamula Indians taught me to curse the divinity when necessary. . . . the Chicanos taught me to articulate my pain with maximum quality and minimum resources, my black colleagues taught me to detect the spiders of racism on the spot. my red colleagues taught me to remain still in the face of danger. my feminist comrades taught me to distrust men without visible weaknesses. Tonight I put all this knowledge on a plate and serve it to you with all my affection. But watch out! it might be poisonous to some of you.[70]

In this statement Gómez-Peña, whose work is very much concerned with the mechanisms of cultural appropriation, becomes something of a flaneur himself, journeying "beyond the limits of Western culture," collecting the experiences of his "feminist comrades," his "black colleagues," and "Mexico City bums," to be reprocessed into performance works and "served" to audiences at venues such as the Walker Art Center in Minneapolis, the Museum of Contemporary Art in Los Angeles, and the Brooklyn Academy of Music.

Painter and journalist Margaret Spillane, in her essay "The Culture of Narcissism," indicates the contradiction that exists between artists' privileged

social status and their ostensible identification with the poor and the dispossessed. Describing one of Karen Finley's performances, Spillane points out how this presumed identification founders on Finley's reductive notions of the "underclass." She goes on to note that "the individual victims she promised to evoke—the battered child, the exploited female service worker, the person with AIDS—turned out to be carelessly assembled amalgams of bourgeois Americans' cultural shorthand for those they believe exist beneath them."[71] As Spillane argues, "It's entirely possible to be a member of an oppressed minority and still participate in the privileges of the dominant culture."[72] Gómez-Peña, widely courted by the nonprofit art world, is the recipient of a MacArthur Fellowship with access to audiences and communications networks throughout the country. He has acquired a level of cultural capital that makes it increasingly difficult for him to identify himself unproblematically as a megaphone for the oppressed.

The artist has emerged in recent alternative sector works as the new universal subject, able to embody (or at least speak for) any number of subject positions and identities, simply by virtue of being an artist.[73] In this view, artists occupy a kind of transcendent position, from which they are empowered to make an unlimited range of moral judgments about the surrounding social order without having to account for their own cultural position and privilege. This "transcendence" is the product of two related ideological moments. The first is the displacement or mobilization of the artists' identity, brought about by the cultural-worker ideology discussed in the preceding section, and the second is the emergence in recent art world rhetoric of a vulgarized identity politics. This identity politics, especially evident in debates over multiculturalism, is premised on the belief that one's political or social position as an artist is constituted solely through essentialized categories of race, ethnicity, gender, or sexuality. It does not take into account the way in which other vectors of class or cultural privilege might contribute to, and complicate, the formation of the artist's identity.

These two moments coalesce in a figure like Andres Serrano, whose *Piss Christ* (1989) provided the pretext for Donald Wildmon's initial attack on the Endowment. The alternative arts sector has championed *Piss Christ* as a "disturbing and challenging artistic statement, [which] explores how spiritual belief has been exploited and spiritual values debased."[74] And Lucy Lippard has argued that Serrano's work "is part of the 'polyphonous discourse' many Third World scholars have been calling for; he challenges the boundaries formed by class and race, and between abstraction and representation, photography and painting, belief and disbelief."[75]

In images such as *Piss Christ* Serrano addresses issues of faith, desire, aesthetic beauty, and the body in a way that is both visceral and complex. Serrano himself has been anxious not to ascribe an overly literal "political" content to

these works, stressing instead their "ambiguity."[76] But this ambiguity can at times give way to works that replicate highly exploitative representational codes. For example, the large color photograph *Heaven or Hell* (1984) features Leon Golub, dressed as a cardinal, standing next to a naked, apparently beaten, woman hanging by her wrists, with "blood" splashed on her breasts. Even Lucy Lippard, who has long been sympathetic to Serrano's work, has raised some questions about this work, in which Serrano employs a blatantly exploitative image to ostensibly "criticize" the Catholic Church's attitude toward women. In a subsequent interview Serrano displays a striking level of unselfconsciousness about his creation of this image, choosing to simply ignore the possibility that he might need to rethink the ways in which he represents women in his work:

> I never thought of it [an "erotic" content] as far as that picture was concerned. Then my friends would see it and say 'she has nice breasts.' I never saw it that way. I've been looking at pornography since I was a kid, but to me that was not an erotic pose. . . . Sometimes it's hard to be politically correct and also be true to your own instincts, as far as sexuality is concerned.[77]

Serrano's sexual "instincts" just happen to express themselves in a conventionally exploitative image of a woman as the object of violence. Serrano fails to consider his own sexual or cultural privilege in manipulating existing representations of women or, in the case of a more recent body of work, the homeless. Serrano's discussion of this work, which involves making photographic "portraits" of New York City's homeless, is worth quoting at length:

> I've just completed a new series that refers to the portraits [Edward Curtis] did of American Indians. I went around and found homeless people in the subways, in the street, in the parks. I even found people looking through garbage. I was looking for the hard core homeless that sometimes even the homeless don't want to talk to. We set them up in subways in situations and took their portraits, studio portraits. . . . Basically, I gave them a fee to pose for me for 15 minutes, and had them sign model releases.
>
> I took pictures of one woman who I'm sure was a crackhead. She had problems focusing her eyes. Her head and eyes darted very quickly. But she's one of my favorite models. She's beautiful.[78]

While Serrano argues that these images resist dominant representations of homelessness ("I think you're talking about a certain prejudice if we think these pictures are bad because the homeless aren't being portrayed like they really are. What does that mean?"),[79] it's hard, based on comments such as the one above, to not view him as another kind of flaneur, wandering the streets of New York City, with studio lights and an assistant in tow, to produce what he

describes as "collaborative" portraits of people he "would never have looked at under different circumstances." What is even more remarkable about this project is that Serrano imagines that he is bestowing some kind of middle-class dignity on the homeless by taking their pictures: "Who says the homeless can't have studio portraits like everyone else?"

Serrano is a Hispanic American artist (in an art world where artists of color are systematically excluded) whose works openly challenge religious authority and transgress cultural boundaries, but he is, at the same moment, an artist who is remarkably oblivious to his own social power (as demonstrated by his patronizing attitudes toward his homeless subjects), and who is capable of producing works with openly sexist content. We can account for the apparent disparity between Serrano as an exemplary "multicultural" artist and his production of works that objectify women and aestheticize the homeless only by recognizing his own ambivalent position in relation to social power (in terms of class and gender as well as race) and cultural privilege.

Serrano's works and his opinions are frequently solicited and circulated within the art world. He enjoys a fairly privileged relationship to the institutions of high culture, such as gallery and museum exhibitions and public and foundation grants. In short, he simply does not speak from a position that is directly exchangeable with that of the homeless, or of women. The solution to the inconsistencies in Serrano's work isn't to attack him on the basis of a fanatic belief in some thoroughly integrated and contradiction-free artwork or to argue that artists of color must produce unambiguously political works. But neither is it to simply ignore or avoid the contradictions that do exist in his work and his outlook as a cultural producer.

The limitation of the art world's vulgar identity politics lies precisely in the fact that it overlooks these contradictions. The social and cultural positions that we occupy are far more complicated than monolithic categories of race or sexuality are able to describe. Robert Mapplethorpe was gay, but he could also objectify black men in a way that was disturbing to many people of color. Struggles against racism have sometimes employed sexist and homophobic rhetoric, struggles against economic oppression have sometimes overlooked entirely the labor of women and people of color, and struggles against sexism have sometimes ignored the needs of working-class women and women of color. The point is that we are differentially positioned in relation to oppression. Obviously this differential is highly biased, and continually reconstructed around certain central racial, sexual, and economic categories. But this doesn't absolve us of the responsibility of interrogating our own connection to specific modes of social power—especially for participants in an arena such as the art world in which the most revolutionary rhetoric mixes unashamedly with the most blatant displays of cultural and economic privilege.

Identity theory, in its more complex and enabling form, teaches us that forms

of oppression are highly imbricated and adaptable. It is entirely possible to be Hispanic and still harbor bourgeois attitudes about the homeless, or to be a lesbian and also a cultural conservative, like Anne-Imelda Radice, the former director of the NEA. In this respect the right wing in the United States is far more sophisticated than many in the art world when it comes to recognizing, and exploiting, the complexity of multideterminant identities, as Bush's appointment of Clarence Thomas suggests. Kobena Mercer makes this point in his essay " '1968': Periodizing Politics and Identity":

> The challenge of radical pluralism demands a relational and dialogic response which brings us to a perspectival view of what antagonistic movements have in common, namely that *no one has a monopoly on oppositional identity.* The new social movements structured around race, gender, and sexuality are neither inherently progressive or reactionary. . . . Just like everyday people, women, black people, lesbian and gay people, and people who worry about social justice, nuclear power, or ecology can be interpellated into positions on the right just as much as they can be articulated into positions on the left.[80]

It is this "relational and dialogic" perspective that we need to bear in mind when considering the position of the "committed arts professional" who would make common cause with the homeless. Alternative sector artists can't transcend their cultural privilege simply through an act of good faith. Their production is, by and large, not rooted in the representational needs of a non–art audience or community. Rather, their "community" is too often limited to the alternative arts sector itself. Even though they often make claims to speak for, or to work with, a given community—particularly in forms such as the moral-didactic installation—these alliances and collaborations are almost always temporary. The artist moves on to another issue, another site or another constituency, while the community remains behind—touched or transformed in some way, one hopes, by the artists' presence or by their particular discursive skills.

No matter how sensitive artists might be, the situation that they place themselves in in relation to a non–art community is constrained by the same problems of paternalism and benign domination that structure the relationship between PMC social workers and their working-class clients. Tim Rollins, whose Kids of Survival (KOS) is considered by many to offer an exemplary case of community-based art, was accused last fall by former KOS members of misallocating funds from the sales of their works and intimidating group members with "favoritism and threats."[81] Although Rollins has vehemently denied the charges, it seems clear that in projects such as this the experience of empowerment and collaboration on the part of artists and their non-art constituencies is bound to differ.

The relationship between "community" artists and the "communities" they seek to work with is inevitably implicated in the larger symbolic economy of American politics. The poor and the oppressed in our country are often being spoken for. Their rage and their oppression are frequently appropriated by politicians and policy-makers for their own ends. Thus the same Great Society aura that allowed Richard Nixon to court the liberal establishment through increases in NEA funding also allowed the alternative arts sector to reinvent itself as a legitimate beneficiary of public funding by appropriating the empowerment rhetoric of the late '60s.

The rootlessness of the alternative artist is emblematic of the position occupied by the majority of intellectuals and artists in the United States today. This rootlessness is neither good nor bad per se; it simply is the defining condition under which much oppositional cultural production takes place (certainly most forms of state-funded community or public art). The problems of speaking for others, of cultural privilege, and of intellectual tourism, are the central problems facing the publicly funded alternative arts sector today. There is no simple solution except to acknowledge them and begin a dialogue on how to work through them. What is striking, however, is the almost total refusal in the alternative sector to acknowledge that these problems exist, and the unquestioned belief that simply calling oneself an artist is a sufficient precondition for engaging in highly theatrical forms of moral rhetoric on behalf of the disenfranchised.

The unstated assumption behind the arts funding paradigm that has existed in the United States for the past quarter century has been that contemporary art production is a self-evident public good, deserving of taxpayer support. The cultural worker and artists space models stressed the importance of autonomy for the contemporary artist and led to the creation of a network of state-funded laboratories engaged in various forms of cultural experimentation. This model is no longer sufficient—not because, as conservatives argue, artists are producing blasphemous or anti-American works, but because this very autonomy has prevented artists and arts administrators from developing and administering models of cultural production in which the needs of the public are taken seriously.

Although there have been victories along the way in the arts funding battle—primarily in the courts—it is important to realize just what the conservatives have been able to accomplish. Frohnmayer's replacement, Anne-Imelda Radice (who will herself be replaced by the incoming Clinton administration), was more than willing to implement a conservative cultural agenda under the guise of concerns over artistic quality. The NEA's National Council, after twelve years of Republican appointments, is almost entirely conservative and now has the power to override both the peer panels and the NEA's director. Although many members of the Endowment's staff are trying to maintain as much of the pre-

viously existing infrastructure as possible, it is clear that the NEA as it was only a few years ago has ceased to exist. At the same time, economic cutbacks at the state and federal level have eroded what little funding for the arts existed in the first place. If current trends continue, many state arts councils won't even exist in a few years' time.

It seems apparent that the paradigms used to justify public arts funding in the United States are going to change. Whether this change will come in response to conservative demands for a museumified "high culture" or will respond to calls for a more truly popular and democratic culture remains to be seen. A great deal depends on the ability of the art world to reformulate the relationship between publicly funded artists and the publics they hope to represent. In articulating this relationship, it will be necessary to discard the old, comfortable truths of the artists space and artistic autonomy. This process must begin with a frank and critical appraisal of the art world's own practices and presuppositions regarding various strata of the American public. There are an enormous number of constituencies, movements, and communities within the American public whom artists can work with and learn from—not as the shock therapists of some imaginary middle class, but as collaborators and participants in the daily struggles of life under an increasingly oppressive and divisive economic regime. This is the argument that has to be made when conservatives have the audacity to wrap themselves in some presumed public outrage. But it can't be made convincingly so long as artists' relationship to these publics remains one of moral censure, shamanistic arrogance, or pedagogical superiority.

Notes

1 The following statement is taken from a declaration developed by the Jacob's Pillow Presenter's Conference in Becket, Mass.: "Some politicians argue that it is not censorship to deny public money to controversial projects because in these instances artists can pursue other sources. This argument is fallacious for the following reasons: 1) it denies the artist the right to public funds even when the work is of recognized quality, and 2) it defines excellence according to values which are not artistic." Quoted in the *National Association of Artists Organizations Bulletin* (spring 1990): 7.

2 See Carole S. Vance, "The War on Culture," *Art in America* (September 1989): 39–45. See also Richard Bolton, "The Cultural Contradictions of Conservativism," *New Art Examiner* 17, no. 10 (June 1990): 24–29. Both articles are included in Richard Bolton, ed., *Culture Wars: Documents from the Recent Controversies in the Arts* (New York: New Press, 1992).

3 These phrases were taken from a random selection of editorials and press releases contained in *Culture Wars*.

4 *Culture Wars*, 23.

5 For accounts of the formation of the Endowment, see Milton C. Cummings Jr., "Government and the Arts: An Overview," in *Public Money and the Muse: Essays on Government*

Funding for the Arts, ed. Stephen Benedict (New York: W. W. Norton, 1991), 46–52; Dick Netzer, *The Subsidized Muse: Public Support for the Arts in the United States* (Cambridge: Cambridge University Press, 1978), 59–74; and Gary O. Larson, *The Reluctant Patron: The United States Government and the Arts 1943–1965* (Philadelphia: University of Pennsylvania Press, 1983), 152–218.

6 Larson, *The Reluctant Patron,* 222.

7 Ibid., 160.

8 Edward C. Banfield, *The Democratic Muse: Visual Arts and the Public Interest* (New York: Basic Books, 1984), 59.

9 Ibid., 47.

10 Larson, *The Reluctant Patron,* 194.

11 Ibid., 161.

12 Banfield, *Democratic Muse,* 60.

13 Frances Fox Piven and Richard A. Cloward, *Regulating the Poor: The Functions of Public Welfare* (New York: Vintage, 1971), 251.

14 Piven and Cloward, *Regulating the Poor,* 262.

15 See David Stoloff, "The Short Unhappy History of Community Action Programs," in *The Great Society Reader: The Failure of American Liberalism,* ed. Marvin E. Gettleman and David Mermelstein (New York: Vintage, 1967), 231–39.

16 Piven and Cloward, *Regulating the Poor,* 266.

17 Stoloff, *The Great Society Reader,* 177.

18 On the impact of New Federalism on federal urban policy, see Susan S. and Norman I. Fainstein, "Economic Change, National Policy, and the System of Cities," in *Restructuring the City: The Political Economy of Urban Development,* rev. ed., ed. Susan S. Fainstein et al. (New York: Longman Press, 1986).

19 See Charles Murray, *Losing Ground: American Social Policy 1950–1980* (New York: Basic Books, 1984).

20 Cummings, "Government and the Arts," 55.

21 Elaine King, *Pluralism in the Visual Arts in the United States 1965–1978: The National Endowment for the Arts, an Influential Force* (unpublished Ph.D. diss., Northwestern University, Field of Interdepartmental Studies, in speech, June 1986), 139.

22 Ibid.

23 In fiscal year 1991, artist-run exhibition spaces, media centers, and publications received less than 15 percent of the NEA's total programming support. Most of the first-generation alternative spaces were founded in the early to mid-1970s (e.g., Franklin Furnace in 1976, The Kitchen in 1971, the Washington Project for the Arts in Washington, D.C., in 1975, and the Visual Studies Workshop in Rochester, N.Y., in 1969 [it received its first NEA funding in 1972]).

24 See King, "Pluralism in the Visual Arts," 94. Even though NEA funding may make up a relatively small proportion of an organization's total budget (often as little as 15 to 20 percent), the organization is still reliant on the leverage that NEA recognition provides for other funding sources.

25 *Washington Project for the Arts Document,* ed. Helen M. Brunner and Donald H. Russell (Washington, D.C.: Washington Project for the Arts, 1986), 1.

26 King, "Pluralism in the Visual Arts," 153.

27 Ibid.

28 Ibid., 153–55.

29 As Derek Guthrie notes in an article in the *New Art Examiner* on the Washington Project for the Arts, "The 'farm-system' of artists spaces would never have come into existence

without the passionate support of Brian O'Doherty." Derek Guthrie, "WPA: Dinosaur or Phoenix?" *New Art Examiner* 14, no. 7 (March 1987): 21.

30 See André Gorz, *Farewell to the Working Class: An Essay on Post-Industrial Socialism* (Boston: South End Press, 1982); Alvin W. Gouldner, *The Future of Intellectuals and the Rise of the New Class* (New York: Seabury Press, 1979); Donald Stabile, *Prophets of Order: The Rise of the New Class, Technocracy, and Socialism in America* (Boston: South End Press, 1984); and Barbara and John Ehrenreich, "The Professional-Managerial Class," in *Between Labor and Capital,* ed. Pat Walker (Boston: South End Press, 1979), 5–45.

31 Robert B. Reich, *The Work of Nations* (New York: Vintage, 1991).

32 Barbara and John Ehrenreich, "Between Labor and Capital," 12.

33 Ibid., 16.

34 Ibid., 17.

35 Ibid., 26.

36 Ibid.

37 Testimony by Charlotte R. Murphy before the Committee on Education and Labor; Subcommittee on Postsecondary Education, March 21, 1990. Printed in *NAAO Bulletin* (spring 1990): 6.

38 Karen Finley, statement made June 29, 1990; printed in the *NAAO Bulletin* (July 1990): 1.

39 "Statement of Susan Wyatt, Executive Director of Artists Space," reprinted in the *NAAO Bulletin* (July 1991): 11.

40 Stephen Kahn, "Communities of Faith, Communities of Interest," in "The Visual Artists' Organization: Past, Present, Future," in *Afterimage* 14, no. 3 (October 1986): 13.

41 King, "Pluralism in the Visual Arts," 63.

42 Ibid.

43 The Independent Commission was cochaired by John Brademas, president of New York University, and attorney Leonard Garment, the man who gave Richard Nixon such revealing advice about the political value of supporting increased arts funding. These comments are taken from a summary of the commission's report, released in September 1990.

44 Renny Pritikin, "The Port Huron Statement and the Origin of Artists' Organizations," in *New Writing in Arts Criticism: 1986 Journal,* ed. Anne Marie MacDonald, Kathy Brew, Peter Saidel, and Maureen Keefe (San Francisco: San Francisco Artspace, 1988), 37.

45 In his discussion of the "negative identification" that existed between avant-garde artists and workers during the late nineteenth century, in his essay "The Politics of the Avant-Garde," Raymond Williams notes that early "alternative and opposition groups formed by artists based themselves on the premise that artists, like workers, were being 'practically exploited' by the market system." Raymond Williams, "The Politics of the Avant-Garde," in *Vision and Blueprints,* ed. Edward Timms and Peter Collier (Manchester: Manchester University Press, 1988), 6–7. A more recent example of this identification is provided by the publication this spring of a list of "our country's cultural working class" by Jeff Gates and ArtFBI (Artists for a Better Image). Developed as a response to Vice-President Dan Quayle's attacks on the "cultural elite," the ArtFBI list includes a hundred artists "who have evoked [the power to effect change] and, more importantly, have developed creative ways to pass that potential on to others."

46 NEA Artists' Projects: New Forms Panel, statement, May 25, 1990; cited in *Culture Wars,* 213.

47 Sharon Zukin, *Loft Living: Culture and Capital in Urban Change* (Baltimore: Johns Hopkins University Press, 1982).

48 See *Arts Space,* the Report of the Mayor's Blue Ribbon Committee for Promotion of the Arts and Economic Development (1988), which was funded and coordinated by the Dis-

trict of Columbia Office of Business and Economic Development. Also see "Editorial," *New Art Examiner* (May 1988): 5.

49 Renny Pritikin, statement to the National Council, January 31, 1992, printed in *NAAO Bulletin* (February 1992): 2.

50 See Howardena Pindell, "Breaking the Silence," *New Art Examiner* (October 1990): 32–36.

51 For coverage of this event, see "Angry Group Knocks Down Jackson Portrait," *Washington Post* 30 November 1989, B1, and Courtland Milloy, "Thinking with a Club," *Washington Post* 3 December 1989, B3.

52 For another perspective on the question of coding in visual artworks, see Grant H. Kester, "Pragmatics of Public Art: An Interview with Stephen Willats," *Afterimage* 19, no. 10 (May 1992): 8–12.

53 Although the *audiences* for these spaces included a large number of local artists, the artists shown were as likely to be from New York or Los Angeles as from the local community. The programmers of these spaces were content to take up what writer and former *Art Papers* editor Laura Lieberman has termed the "missionary position"—trying to introduce the "locals" to progressive alternative arts models. Many of these spaces were, in fact, criticized precisely for their failure to respond to the needs of local artists. Writing on the infighting between former Washington Project for the Arts director Jock Reynolds and several prominent Washington artists and WPA board members, Derek Guthrie comments, "At the heart of the issue was who could control the exhibition program. In terms of simple rhetoric, it was local artists versus outside artists." Guthrie, "WPA: Dinosaur or Phoenix?" 22.

54 Statement by Susan Wyatt before the House Subcommittee on Government Activities and Transportation, June 19, 1991; printed in *NAAO Bulletin* (July 1991): 8.

55 Examples include Martha Rosler's *If You Lived Here . . .* and Group Material's *Democracy* projects, which were presented at the Dia Art Foundation's exhibition space in Manhattan and later published in book form by Bay Press. These projects included self-described "Town Meetings," intended—as the name suggests—to create a utopian mini public sphere in which artists, activists, and members of the public could engage in free and open debate. See *If You Lived Here: The City in Art, Theory, and Social Activism*, A Project by Martha Rosler, ed. Brian Wallis (Seattle: Bay Press, 1991). See also Richard Bolton's recent project on male violence, which was shown at the Capp Street Project in San Francisco in the spring of 1992.

56 Ken Johnson, "Theater of Dissent," *Art in America* (March 1991): 131.

57 Kim Sawchuk, "Unleashing the Demons of History: An Interview with Coco Fusco and Guillermo Gómez-Peña," *Parachute 67*, 25.

58 Charles Wilmoth, review of Los Angeles Poverty Department's *Jupiter 35*, in *High Performance* 46 (summer 1989): 57.

59 Charles Wilmoth, review of Karen Finley's *We Keep Our Victims Ready*, in *High Performance* 46 (summer 1989): 57.

60 See Andy Grundberg, "When Outs Are In, What's Up?" *New York Times* (Sunday, 26 July 1987), sec. H, 30, 32.

61 Craig Owens, "The Medusa Effect; or, The Spectacular Ruse," in *We Won't Play Nature to Your Culture: Works by Barbara Kruger* (London: Institute of Contemporary Arts, 1983), 6.

62 Jane Weinstock, "What she means, to you," in *We Won't Play Nature*, 12–16.

63 Johnson, "Theater of Dissent," 131.

64 Stephen Holden, "The Stark Oratory Of a Wild Karen Finley," *New York Times*, 23 July 1992, C17.

65 Laura Shapiro, "A One-Woman Tour of Hell," *Newsweek*, 6 August 1990, 60–61.

66 Tom Birch, "Government and the Arts: A Manipulated Debate," *Art View: The Quarterly Journal of the National Assembly of State Arts Agencies* 11, no. 4 (1991): 4.

67 *Culture Wars*, 254.

68 Shapiro, "One-Woman Tour," 60.

69 Barry Kapke, review of *A Suggestion of Madness*, in *High Performance* 45 (spring 1989): 55.

70 Guillermo Gómez-Peña, "A Poem for the Program," from *1992: A Performance chronicle of the re-discovery of America, by the Warrior for Gringostroica*, in *White Walls* 30 (When World's Collide) (1992): 14.

71 Margaret Spillane, "The Culture of Narcissism," *Culture Wars*, 571.

72 Ibid., 573.

73 *Culture Wars*, 34. Bolton warns of the danger of the artist posing as a "Christ-like stand-in for all oppressed people."

74 Statement by Ted Potter, director of the Southeastern Center for Contemporary Art, May 19, 1989.

75 Lucy R. Lippard, "Andres Serrano: The Spirit and the Letter," *Art in America* (April 1990): 239.

76 When asked how he felt about the "strong political interpretation of [his] work," in an interview with Christian Walker, Serrano replied, "I can't really fight that or complain about it because the work is meant to be open to interpretation, as I always say it is. I have to take it both ways, the good with the bad." Christian Walker, "An Interview with Andres Serrano," *Art Papers* (September–October 1990): 38.

77 Walker, "Interview with Serrano," 39.

78 Ibid., 41.

79 This and the remaining Serrano quotes are all from the Walker interview, 41.

80 Kobena Mercer, "'1968': Periodizing Politics and Identity," in *Cultural Studies*, ed. Lawrence Grossberg, Cary Nelson, and Paula A. Treichler (New York: Routledge, 1992), 426.

81 See Robin Cembalest and Seonaidh Davenport, "Spectrum," *Artnews* (September 1991): 23.

Mable Haddock and Chiquita Mullins Lee

Whose Multiculturalism? PBS, the Public, and Privilege

"Elitist," "highbrow," and "alternative" are terms used to de-
scribe public television fare and hint that only the privileged few need view it.
Lately, a new term has been added to these adjectives: multicultural. Multi-
culturalism and its professed agenda of inclusion has brought a new focus to
the Public Broadcasting System (PBS), and potentially greater access for people
of color. However, the reality of public television has seldom lived up to its
potential. In a recent article, Pat Aufderheide describes public television as a
haven for freedom of expression and wide-ranging creative opportunities.
Aufderheide writes: "Television viewers value its First Amendment functions;
they rate the service a highly valuable community institution . . . and rank it
higher than commercial television as a source for understanding important
issues."[1] People desire and expect great things from public TV, but many seg-
ments of the audience remain outsiders and are powerless to take full advan-
tage of it. In this essay we will look at the ways in which institutional privilege
operates in the public television programming arena and how the multicul-
tural agenda works in practice.

All phases of public television programming, from production to distribu-
tion, rely on funding accessibility. Who receives this privilege? Generally, not
people of color. In the last five years, there has been an increase in programs by
African Americans, Native Americans, Pacific Islanders, Latinos, and Asians
on PBS. With the increase in programs and the ideological shift toward multi-
culturalism, one would assume that people of color had acquired institutional
privilege. Our research offers evidence to the contrary. We also offer funding
and programming strategies that, in practice, could allow for a more accurate
portrayal of cultural diversity on public television.

A stale rumor circulating within the media arts community insists that un-
less you're one of the minorities, you can't get funding for cultural program-
ming. After years of invisibility, producers of color, through a programmatic
shift toward multiculturalism, can allegedly have their projects broadcast on
public television virtually at will. Many white producers have cried foul, feel-

ing that most programming funds have gone to minority producers because the issue of multiculturalism is at the top of the agenda of the foundations and corporations that support media, art, and culture. Those who cry foul are deceived. Recent history tells a contrasting story of grant dissemination. The rumor of institutional privilege for people of color is propelled by those outside communities of color—in practice multicultural producers aren't being fully or fairly funded.

So who gets the money? In PBS, most of the major grants go to series done by producers who are not people of color. Ken Burns, after his triumphant *Civil War*, is planning a new series on baseball. Bill Moyers can usually expect support. The Major Strand Series—*Frontline, NOVA, American Playhouse, American Experience, P.O.V., Great Performances*—are the vehicles for the majority of prime time public television programming and have long experienced the benevolence of PBS. Of these major programs and series, none has a multicultural focus. The Strands might offer one or two programs by minorities, but the majority of the money, and the control of the money, still goes to people who are outside the communities of color. Greater corporate and foundation support may be available today for people of color compared with five years ago; some producers of multicultural programming have benefited from this priority shift. Still, most of the money, the administration of that money, and the values the money promotes are not multiculturally directed and therefore the primary interest of producers or audiences outside of the cultural mainstream seldom benefits from them.

Yet the myth of heavily financed multicultural programming persists. White producers who get no money or less than they want propagate this myth most fiercely. It's perhaps a natural tendency to blame others when we fail to receive what we think is our equal share. Amid the promotion surrounding multiculturalism, outsiders easily point the finger at the producers of color and say, "We're not getting money because they're getting it," instead of looking at the real picture.

A random examination of corporate and foundation philanthropy reveals a shallow commitment to multicultural interests. The 1992 edition of *Corporate Foundation Profiles* reveals some trends. For example, Capital Cities/ABC Foundation gave $192,500 in the area of Arts and Culture. Of that amount, the Museum of Broadcasting received $90,000; the Lincoln Center for the Performing Arts received $75,000; and Dance Theatre of Harlem received $10,000. Ameritech Foundation granted $694,451 to Arts and Culture, with $249,451 to WETA-TV to underwrite a documentary entitled *The Congress;* Ameritech granted $10,000 to the NAACP Special Contribution Fund for programs to eliminate discrimination. Fannie Mae Foundation awarded $192,750 to Arts and culture, of which WETA received $17,000; KCET-TV received $2,500, and the Arts Festival of Atlanta, an organization committed to African American culture,

received $250.[2] Either African American organizations consistently request smaller grants or a conflicting value system is at work. The biggest money is still going to major white institutions.

The mythmaking and blame shifting is detrimental to all producers, especially producers of color who suffer the double-edged sword disadvantage of underfinancing and resentment from white producers. For multiculturalism to become a reality in cultural programming, rather than an empty slogan there must be a shift in power. Neither arts councils, nor the heads of the Corporation for Public Broadcasting (CPB), PBS, and corporations are committed to sharing the power to make funding decisions with those outside their immediate purview. Were they to share power equitably with people of color, there would be substantial changes. The number of black males in public broadcasting, as well as all people of color in decision-making positions, would increase and facilitate the fulfillment of long-unmet programming goals. A complete value shift might occur with positive consequences for the African American community. In the past, a foundation might grant $70,000 to a predominantly white organization to curate an African film festival. With a new emphasis on power sharing, foundations, well staffed by people of color, might be willing to put faith in distribution agencies like Pearl Bowser's African and Diaspora Images or Haile Gerima's Mydepuh Films. These organizations and individuals have performed curatorial functions for the past twenty years. The large pots of money available for projects that strengthen minority programs generally go to major institutions like New York University (NYU), and others that may not be fully responsive to multicultural communities. These institutions seem to embrace the cause of multiculturalism but aren't fully commited to it. It's time to support people and organizations like Pearl Bowser, Haile Gerima, and Third World Newsreel, who have worked directly with filmmakers, artists, and producers but don't get large shares of money. Over the past five years, the number of grants to multicultural organizations has increased, but the dollar amount of the grants remain comparatively small. There's a big gap between what NYU or Lincoln Center receives compared to what is received by Mydepuh Films or African and Diaspora Images.

According to Linda Gibson of California Newsreel, a film and video distributor of works by independent producers, PBS programmers exert institutional privilege to determine which series or individual programs we see on the air. Gibson says, "What's the likelihood of getting airtime for a program by a producer with a multicultural perspective? PBS gatekeepers and programmers tend to take the path of least resistance. The result is mediocre, middle-of-the-road programming, oriented to white, middle-class viewers. Programs that truly challenge viewers appear rarely."[3] "But," she continues, "we're talking about European culture here. I'm not saying it shouldn't be done. It should be on the air along with everything else. William Buckley should be balanced by pro-

grams that offer an alternative point of view."[4] Current programs needn't be eliminated and replaced by a full spate of offerings by independents. This is a call for a significant, wider-ranging representation of American culture. Gibson contends, "Maybe the different program offerings would impact membership drives. An increase of membership dollars flowing in would reflect the shift toward meeting the programming needs of a wider audience."[5]

As a distributor, California Newsreel operates as a for-profit entity and depends on earned income, although occasionally it receives foundation funding for special projects like the African Film Collection. Gibson is concerned about securing distribution rights for programs that promote an African American perspective. But PBS, because of its institutional privilege, can afford to buy its rights from producers by tying production funds to distribution rights. The distributor ends up fighting PBS over the rights for a program but is unable to afford these rights and loses out. Such losses ultimately jeopardize a distributor's bottom line. PBS emerges victorious over the smaller distribution entities and, in turn, faces stiffer competition when fighting commercial TV's ability to purchase distribution rights in perpetuity. Despite experiencing such lopsided opposition to its own interests from commercial television, PBS seems slow to empathize with or act in the interest of the small distributor.

Gibson asks, "Is the mandate for PBS to become a self-supporting entity? Their mandate is broadcasting, not acquisition and distribution rights."[6] With public support, PBS is establishing itself as a distribution entity and threatening the survival of small distributors. It has ignored complaints from small distributors and advocated openness and a competitive atmosphere. This cavalier attitude toward the plight of the small distributor typifies the bully who wins the struggle based entirely on size—in this case, financial size.

Like many distributors, California Newsreel has some financial resources but not enough to invest in production. Originally formed in the 1960s as a production collective, California Newsreel has focused on distribution. But as a result of current economic pressures brought on by a paucity of programs available for acquisition, it has reconsidered returning to its roots as a producer of original programming that it could distribute itself.

To cure the inequity, artists and funders must make major strides in each other's direction for the sake of change. Black organizations and producers are not necessarily to blame for their own underfunding. They are as competent, as creative, as visionary as anyone else. Filmmakers like Julie Dash and Charles Burnett have displayed tremendous talent, insight, and perseverance. They've constructed their own cinematic vision in the face of tremendous odds at each stage of project development, production, and distribution. The problem is caused as much by the devaluation of African American artistic pursuits as it is by human nature. It can boil down to a bias that is subtle but all too common. People are biased in favor of the familiar. People give money to artists they

know and trust. African Americans haven't had a history of access to a pool of investors. The challenge facing African American producers today is to develop a relationship with corporations and foundations that administer large sources of money.

For funders to truly commit to multiculturalism, they must acknowledge and respond to some fundamental cross-cultural conflicts. They must be willing to take some risks, that is, be willing to work with an individual or organization who although talented and creative, might be unknown to them. Many options are available to funders approached by talented unknowns. For example, a funder could support a planning grant to assess the organization's ability or readiness to develop a specific project. Another option might be for a funder to conduct research to identify prospective organizations and producers. If producers are insufficiently trained, money can go directly to helping them acquire work experience in fund-raising, negotiation, proposal preparation, resource management, and other relevant areas, to increase their likelihood of success during subsequent funding rounds. These recommendations place the onus on foundations and corporations to initiate a proactive approach to supporting multiculturalism. If producers and arts organizations submit less than perfect proposals that, despite having worthwhile ideas, fall short of expectations, funders could provide assistance in redrafting the proposals as an investment in the projects' development. A subsequent phase of funding could then support the project's completion.

The idea of developing such relationships is a potential win-win proposition. But few African American producers have the support of an organization or the financial resources necessary to sustain them while they court funders for five years in the hope of eventual support. So these producers choose an alternate, more familiar route. They run through a cycle of submission, rejection, and resubmission, soliciting one funder after another rather than developing a long-term relationship with one or more funders. Henry Hampton is one producer whose persistence did reap success. As president of Blackside, Inc., founded in 1968, Hampton worked in the film and video production industry for nearly twenty years before *Eyes on the Prize* had its mid-1980s premiere on PBS. To his advantage, he had the support of an organization and resources to maintain himself as he focused on the *Eyes on the Prize* series. Most producers and artists of color lack the resources and support systems necessary to nourish persistence in the face of steady rejection.

The nature of proposed projects also influences a producer's odds. Hampton, even with his long record of rejections, nonetheless had a distinct edge. *Eyes on the Prize* examined an issue that was well known, fairly palatable, and crossed boundaries of age, geography, and race. European Americans, African Americans, women, children, conservatives, liberals, the left wing, the right wing—everybody was involved in and impacted by the civil rights movement.

In many respects, *Eyes on the Prize* may have been seen as a model for a truly multicultural program, since it embraced and united such a broad cultural spectrum of humanity. Yet *Eyes on the Prize* is only one example. Other programs shouldn't be penalized because of their culturally specific representation of community issues. For example, *Frontline* recently examined the 1983 clash between the activist organization MOVE and the Philadelphia police in a program entitled *The Bombing of West Philly*. The program aired in prime time and received the affirmative promotion that is standard for that series. Louis Massiah, an African American documentary producer and founder of Scribe Video Center in Philadelphia, also covered MOVE in a documentary entitled *The Burning of Osage Avenue*. Massiah's award-winning program was broadcast late at night (at 10:00 P.M.) and never received the endorsement of PBS. Representation of a race-specific point of view worked to deny Massiah the privilege that PBS, in its commitment to diversity, purportedly grants to producers who present an alternative view.

A producer's chances narrow when personal background and project content clash with funder priorities. Controversial projects are proposed and rejected by funders with regularity. Aufderheide, noting how corporations shy away from controversy, writes: "Corporations have no interest in attaching their names to something controversial or low-rated." When funders are approached about such programs, they've been known to say, "We'll pass, thank you. . . . We don't think our customers would like this show."[7] Faced with such skittishness, should producers conform to funders' tastes and make their projects more palatable? Is the onus only on the producer? What can producers do when confronted with a funder that has promulgated a philosophy of multiculturalism, grassroots activism, and community empowerment that is in practice narrow, limited, and spurious?

Neither party should be required to shoulder the entire responsibility. Funders, if they are to truly promote a multicultural agenda, must take a broad look at issues and understand that they don't have all the answers about what's important to multicultural communities. Corporations and foundations need to help producers shape proposals so finished projects maintain their power and integrity. Rather than dilute a project, producers can develop it into one the funders are comfortable funding. It's a two-way street, a process of negotiation in which each party educates the other. In the real world, people of color are denied institutional privilege primarily because of their status as media outsiders who have no influence over media managers' decisions.

In an ideal world, people of color would be able to submit proposals to institutions of color that know the producers, trust in their competence, and share a vested interest in funding their projects. In the real world, this scenario is rare or nonexistent. With the exception of the United Negro College Fund, whose resources flow from white philanthropy and community contributions,

few pro-community, issue-sensitive funding bodies exist in the African American community. With a paucity of our own institutions, it's important for multicultural communities to use their people, resources, and organizing powers to develop relationships that facilitate positive, consistent outreach from outside institutions. Because of its stated commitment to multiculturalism, PBS is the kind of institution with which African Americans could forge an alliance.

PBS has identified health, community empowerment, education, and several other pertinent issues as top programming priorities for the upcoming year. Now that these broad issues are defined, the next step should be to address a specific issue such as community empowerment in a way that combines television programming initiatives with solutions to issues of empowerment within the community itself. In this respect, programming proceeds beyond issues addressed on television to influencing life in the real world.

Equally important is the task of defining our terminology. How does a corporate funder's definition of community empowerment differ from a Latino, Native American, Asian, or African American filmmaker's definition? The definitions of health or education of funders and producers might contrast sharply. The challenge is to listen to all these voices and find the shared truth. Corporations and foundations have diligently researched and identified the broad issues that they feel might strengthen the community at large. They enjoy the privilege, however, of allowing the process of policy implementation to filter from the top down, with little grassroots input into programming decisions that ultimately impact on viewers. The way we define, project, visualize, implement, and interact with community mandates might differ vastly from the way foundations define those issues and the way they expect their money to effect change.

Producers of color and the organizations that support them must begin to organize and vocalize their concerns. We have to speak up loudly and clearly about setting an agenda and transforming it into policy. At that point, policy becomes an established method for defining needs and actualizing change, an empty set of rules with limited impact. Gibson agrees that communities must empower themselves to address programming, broadcasting, and distribution issues. Community empowerment and film distribution intersect in the process of making work available. The responsibility of distributors is to manage the business successfully and pay the producers they represent. At the same time, distributors can balance their business interests with a commitment to community empowerment and provide film and video materials at an affordable cost. Distributors like California Newsreel make a concerted effort to uphold the producers' financial interests, since "they come from the communities we're trying to empower."[8]

The multicultural community must channel its dissatisfaction with insensitive institutions into rational initiatives and work with the guardians of

media and broadcast outlets. Communities must learn how to get a broadcast station's attention, negotiate effectively, rally support from other media organizations, develop consistent feedback, and hold community leaders accountable. "There is so much that you're able to do, if you know how to do it," Gibson says.[9]

In the last ten years, with the exception of the Urban League's *State of Black America* report—an esoteric, academic document useful primarily for research purposes—no concerted effort has been made to establish a solid broadcasting agenda. Contemporary programming initiatives must be oriented toward community building and empowerment. They must not be directed solely toward African Americans in their own little corner of the world, or Latinos or Asians or other people of color similarly fractured and separated from major institutions and communities. Rather, they must address all of us, and make all of us accountable to each other within a positive, dynamic activity that affords us privileges long denied. It's our responsibility to express our visions and voices, both creatively and in administering resources to establish an agenda for contemporary programming. It's up to the community to say that education is important. Education, for some communities, might be more than *Sesame Street,* although it's an important program. Education extends far beyond one highly effective children's TV show to encompass antidrug, anti-illiteracy, parenting, and relationship-building initiatives that expand options for communities approaching these obstacles and opportunities.

Empowerment initiatives could likewise be implemented in a variety of formats. A range of options might include a community center in each neighborhood where people attend hands-on production workshops; video purchases or rentals relevant to community needs; a series broadcast daily; informational tips inserted into public or commercial television programs. Regardless of the format, the efforts should reach out to people where they are.

In many respects, multiculturalism should serve as the philosophical basis of these outreach initiatives. The term "multicultural" is composed of the word "culture," suggesting culturally specific programs, which, in turn, suggests race-specific issues, and the prefix "multi," which affirms the variety of perspectives that characterize our society. What is needed is an honest interpretation and treatment of this concept. PBS's definition of multiculturalism lumps all cultural groups together and de-emphasizes the distinctions inherent in each group. For example, the current series *Dance in America* devotes one hour each week to examining dance from different cultures. But PBS has yet to dedicate an entire series to an exploration of dance from a specific cultural viewpoint. To truly appreciate the scope of a culture and its people, it's necessary to examine the subtleties and variations within that culture, to delve beneath surface expressions, and discover how the people define reality for themselves.

An African American definition of multiculturalism is more specific to cultural and racial concerns than mainstream versions and thereby problematic for many. In this country, we should put away the fear of examining race and race-specific issues. The formation of this country was based on racially exclusive institutions, and the country's present state of economic and social decline can be attributed to those institutions. Why not have a race-specific agenda for black producers and programmers in public television? Economic, social, cultural, and political issues impacting African Americans are different from those affecting gays, women, and physically or mentally challenged people. We are justified in claiming such a race-specific agenda, and we should be able to know that multiculturalism in public broadcasting is designed to serve those needs.

In the past twelve years, since the inception of the National Black Programming Consortium (NBPC), we've been told that as an organization supportive of a race-specific agenda we're narrow-minded, regressive, nostalgic for the '60s. We've been told that it's not savvy to continue to discuss the issue of race unless we include all people. But our aim is not to exclude anyone. Multiculturalism was designed in response to community needs and problems. We've observed the ills within our communities—such as illiteracy, drug abuse, teenage pregnancy, unemployment, deteriorating schools, and the murder and imprisonment of young black men. More young African American men are in jail than in college. Multiculturalism, as a proposed antidote to discrimination and its effects, can address these issues by acknowledging the decay in our communities and the need to establish policies of reconstruction. That's what multiculturalism should do. But PBS's definition and approach blurs the distinctions between all Americans and dilutes the power that a multicultural agenda might exert. PBS's middle-of-the-road definition of multiculturalism is characteristic of its highly politicized posture that compels it to be many different things to many different kinds of people. Despite some of its tremendous programming initiatives, many of PBS's actions are tied to politics. Membership dollars, few of which come from minority communities, supply 40 percent of PBS station operating expenses. PBS stations, in an effort to serve their members, exert pressure on PBS in Washington and expect a response to their concerns.

It may be a political risk for PBS to deal with multiculturalism in a race-specific manner, so it has applied an integration model. In order to minimize the risk and not ghettoize race-specific, issue-oriented programs, PBS underplays the need for or usefulness of programming that is specific to African American needs in the form of news, public affairs, or drama. Instead it finds it useful to encourage African Americans, Asian Americans, Native Americans, and other groups to participate and enter the dialogue by integrating their concerns into the programming structures currently in place.

But integration is only one approach out of many, and it may not be the most

effective one. We've seen what integration has done to the black community. There's been a decrease in the number of successful African American businesses. African American families have moved away from historic black communities and left these neighborhoods disjointed and isolated. The availability and power of role models for children in African American schools were diluted as many African American teachers were displaced. Integration has engendered some positive changes as well, and new options and opportunities have arisen, but it needn't be the ultimate solution for public broadcasting.

If PBS programmed a multicultural series—representing African Americans, Asians, and Latinos—it would draw a more consistent audience and ultimately receive solid support from communities of color. If, on Tuesday evenings at 7:30, it scheduled, for example, African American News, it would eventually build an audience for that time slot. This programming policy could more effectively build audiences than the policy of a random integration of programs into the schedule.

Recent research by the CPB supports this contention. At a focus group meeting four African American communities were asked whether they watched public television and if not, why not? The respondents expressed high satisfaction with PBS programming but complained that programs were often hard to find. The conclusion from this study was that African Americans generally don't watch PBS because they don't know when issue-sensitive programs are scheduled. When a program airs, people expect to find it the following week, but when it's gone, they change the channel. *Eyes on the Prize,* for instance, built a consistent African American audience because people knew what time to expect it.

Both approaches together, integration and culture-specific programming, would be ideal, but neither is fully exploited. In the current PBS lineup there are no series from minority communities. At no time can we turn to PBS and know that people of color will get their fair share of information. *Frontline, P.O.V., American Experience,* or *American Playhouse* don't consistently attract a multicultural audience. When these series feature a culture-specific topic, viewers of color often miss it, because, as research indicated, they don't know when to expect to see multicultural programming. Again, people support those they know and trust, whether with money or viewing time. Relationships are built on reliability.

The development of a relationship and feedback mechanism between PBS and the multicultural community might help PBS examine the weaknesses of its approach. PBS believes that its inclusive and integrative definition of multiculturalism works. Many in the African American community disagree. An honest dialogue could facilitate mutual understanding. An increase in managers of color could strengthen the dialogue. Out of the 347 local PBS television stations, systemwide, there are only 7 minorities in upper management and 15

who serve as either program managers, programming hybrids (people who serve in a dual capacity such as general manager and program manager), or programming personnel who ultimately report to station managers.[10] Even fewer stations managers and general managers of color exist within that system. Thus few of the managers (the majority of whom are white) are likely to place an African American series at the center of their programming agendas. At the Major Strand series, no persons of color work as executive producers. At CPB, no person of color sits on the board of directors. PBS can boast eight people of color out of thirty-five on its board of directors. At foundations and corporations, the top three executives are not likely to be people of color.

This reality points to an imbalance at the upper levels of programming and decision making and discourages dialogue with underserved communities. Programmers understand that they must do something, and on one level that's what they do: "something." If a multicultural program is accepted as part of PBS's core schedule, local PBS stations understand they need to air it, but there may be no commitment to build a promotional or outreach initiative around it. Such an effort could yield an increase in similar programs and in viewers. It seems that this approach would ultimately expand their bottom line by attracting new audiences and new kinds of support for PBS stations. In many respects, the support already exists. Beyond membership dollars, public television stations are financed through a combination of PBS community service grants and funds from city and state governments or university systems. Although communities of color are outside the system, we have a direct financial stake in it as taxpayers and owners of the airwaves over which programs are broadcast.

We realize we have a philosophical stake in PBS's long-standing claim to diversity and innovation. Independent producer Austin Allen argues, "Public television belongs to the diverse communities of this country. The importance of that . . . is a reclaiming of those institutions that belong to us."[11] Since this institution is ours, we have the responsibility to protect and shape it. National black organizations in different parts of the country can help set an agenda for culturally diverse media programming and then enforce that agenda through negotiation, interaction, and accountability, with the aim to persuade program managers to consider the perspective of the underserved multicultural community.

An atmosphere of near-debilitating fear has characterized the past twelve years. Many voices have been silenced. Some of the most distinct and powerful collective voices we hear are those of rappers in the black community promoting positive values. The rappers, most notably those who profess a progressive, responsible message, address what's happening in the community today. And they do it loudly. We would be wise to listen to their interpretation of mainstream issues. Their lyrics also proclaim their lack of trust in an African American leadership that they describe as only self-interested and unable to save the

community they're politically connected to. The issues these rappers raise deserve our attention and commitment and should spur us to action.

As Linda Gibson states, "As long as multicultural programming is made inaccessible to television audiences, there will always be a group of people who will know nothing but mainstream art. Until television presents black dance, art, salsa, jazz with the same regularity as mainstream programs, specific segments of the population won't think about it. They'll continue to minimize minority issues and consider them unworthy of serious attention."[12]

Until African Americans, Latinos, Asians, and Native Americans become more proactive and collectively vocal, our programming will be marginalized and our communities will remain underserved. We need to recognize we're all in this together; we should sit down at the table collectively and collaborate to find a bottom-up and top-down approach to project funding and support. Otherwise, the institutionally privileged will continue to find their needs met and the rest of us will remain outsiders, separated from benefits that are rightfully ours. Until barriers crumble and philosophies change, the privileged few will continue to conceive of and profess their perspective as being the only one. Not only do the nonprivileged suffer because of misrepresentation or no representation at all, but the privileged, likewise, suffer. A narrow-minded, insular perspective separates them from real-world issues that, despite their denial, gravely shape their lives and the world around them.

Notes

1 Pat Aufderheide, "A Funny Thing Is Happening to TV's Public Forum," *Columbia Journalism Review* 30 (November/December 1991): 60–63.
2 *Corporate Foundation Profiles,* 7th ed. (New York: Foundation Center, 1992), 125, 35, 230–231.
3 Telephone interview with Linda Gibson of California Newsreel, San Francisco, March 26, 1993.
4 Ibid.
5 Ibid.
6 Ibid.
7 Aufderheide, "A Funny Thing," 60–63.
8 Gibson interview.
9 Ibid.
10 *1992 Statistical Report* for CPB Office of Industry Research.
11 Statement by Austin Allen during August 1992 African American Programming Summit, Boston.
12 Gibson interview.

Brian Goldfarb

Video Activism and Critical Pedagogy: Sexuality at the End of the Rainbow Curriculum

An understanding of virtually any aspect of Western culture must be, not merely incomplete, but damaged in its central substance to the degree that it does not incorporate a critical analysis of modern homo/heterosexual definition.—Eve Kosofsky Sedgwick, *Epistemology of the Closet*

The 1992–93 New York City school year has been a tumultuous one not only for students and educators, but also for media activists. Just prior to the start of the school year (that is, during the summer, while teachers were away) the city's Central School Board instituted a ban on curricular materials (including videotapes) dealing with AIDS that do not privilege abstinence as a means of AIDS prevention—a measure that came to be known as "the gag rule." The gag rule was introduced in part to counter the anticipated release of a document that had long been in the works: a multicultural curricular development guideline under production by the Office of the Chancellor of New York City public schools. Called the "Children of the Rainbow Curriculum," this guideline to the development of a first-grade multicultural curriculum was implemented in the fall of 1992. Generally advocating acceptance of cultural diversity, the guideline included six pages that became the center of a national controversy. These pages urged teachers to recognize and discuss diverse family structures, including gay-headed households, and to teach general recognition and acceptance of sexual diversity. The curriculum guide was slammed by conservative parents, religious organizations, and school board members, who condemned the document on the basis of the material on gay sexuality that was included on these six pages. The attack on the curriculum, mounted primarily by members of one vocal Queens, New York district, received a tremendous amount of media coverage. While the guide was not ultimately revoked, several local school boards refuse to use it. Further, the controversy has had critical repercussions in school board politics. In February, the Central School Board failed to renew the contract of Joseph Fernandez, the New York City schools chancellor whose office produced the curricular guide. And while the gag rule was

It Is What It Is (1992) by
Gregg Bordowitz. Frame
capture by Brian Goldfarb.

revoked just days before the decision on Fernandez was announced, the Rainbow Curriculum continues to be evoked in conservative backlash in educational and religious institutions around the country.

The key role played by heteronormativity in the very structure of our educational institutions has made the issue of sexual identity a volatile component of multicultural programs. In what follows I will lay out some of the background to the Rainbow Curriculum conflict. I will also examine a shift in critical discourses on sexuality that posits same-sex desire as an integral part of all sexual identities rather than defining homosexual identity as exclusive and biologically predetermined. I will focus on analyzing two videotapes produced by gay advocacy and AIDS outreach groups—works that situate AIDS and sexual practices within a range of cultural identities. The first, *It Is What It Is* (1992) by Gregg Bordowitz for Gay Men's Health Crisis,[1] is an example of work developed by a nonprofit gay advocacy and AIDS/HIV support organization in direct dialogue with public school administrators.[2] The second tape, *AIDS, Not Us* (1989) by Sandra Elkin in collaboration with the HIV Center for Clinical and Behavioral Studies,[3] is an example of media produced by a nonprofit research organization concerned with AIDS prevention in inner-city communities. These tapes are examples of kinds of work that are crucial to future curricula. Educators faced with the challenge of the social, cultural, and life-sustaining needs of their student communities must confront the interrelationship of sexual and cultural identities that has been at the core of conflicts over the Rainbow Curriculum. I will continue with a brief look back to the way differing sexualities have been handled in U.S. curricula and an analysis of a videotape produced in response to the way sexuality has been handled in the British educational system.

The Rainbow Curriculum document is basically a systemwide reference manual for individual teachers' selective development of a broad multicultural first-grade curriculum. Addressed directly to teachers (not students), it sug-

gests ways of introducing students to thinking about a broad range of cultures, ethnicities, identities, and social practices. The stated aim of the text is to foster "respect and appreciation for diversity of lifestyles, cultures, and languages."[4] The Rainbow Curriculum project was motivated in part by the idea that instituting dialogue on cultural diversity at the earliest possible point in the educational process might help to circumvent the conditions that are contributing to the recent rise in bias incidents (gay bashing, police violence against blacks and Latinos) and the escalation of these incidents into small-scale intercommunity wars (such as the Hasidic/African American conflicts in Bensonhurst, Crown Heights, and elsewhere).

Controversy over the Rainbow Curriculum centers on some school board members' objection to the text's brief mention of diversity in sexual orientation. Contained in a few sentences that, as previously mentioned, appear in 6 of the text's 443 pages, the passages in question include a section in which it is suggested that children should be taught to acknowledge the positive aspects of diverse types of households. This suggestion follows a notation that family structures vary and "may include gay or lesbian parents" as well as the suggestion that educators should foster sensitivity to "differences in sexual orientation" in order to minimize the stigmatization that can lead to ostracism, conflict, and loss of self-esteem, all of which are mentioned as known factors contributing to the high rates of homelessness and suicide among gay and lesbian teens.[5] Fixating on these passages, several members of the New York City School Board and a few local community boards condemned the entire text, with one member characterizing it as "dangerously misleading lesbian/homosexual propaganda" that promotes ideas about sexuality that are "as big a lie as any concocted by Hitler or Stalin."[6]

At the height of the conflict over the Rainbow Curriculum the Central School Board decided to terminate Fernandez's contract. Ultimately, sensational misrepresentation of the contents and institutional role of the Rainbow Curriculum by members of the Central School Board and by vocal members of local school boards and the religious right was the key factor in the chancellor's termination.[7] The media represented this controversy as a power struggle between Fernandez and certain school board members, although this struggle is only one part of a larger ongoing national controversy surrounding the status of normative ideas about sexuality in school curricula. The controversy has included, for example, equally crucial debates over current guidelines for condom distribution in New York City high schools (included in the "HIV/AIDS Program Implementation Guidelines") and over the official sanctioning of media and texts in HIV/AIDS curricula that address the real diversity of sexual practices among youth.[8]

Historically, gay sexuality has been represented as abnormal or pathological in the institutions of mental health and education.[9] This treatment of gay and

lesbian desire as illness has posed an immediate threat to the health and welfare of gay youth. New York City's Hetrick-Martin Institute estimates that gay youth in the United States are two to three times more likely to attempt suicide than heterosexual young people. Moreover, a quarter of gay youth are forced to leave home. The exceedingly high rate of suicide and homelessness among gay youth is attributable in no small part to the effects of institutional practices that ostracize them, in the effort to "correct" or punish an already marginalized population.[10] In order to counter these stigmatizing and pathologizing measures, some progressive educators assert that homosexuality is an inherent condition that is behaviorally in place before school age in certain individuals.[11] Since the '70s, a behavioral model that naturalizes sexuality has been used to intervene in policies supporting the use of disciplinary or "corrective" measures against students identified as gay. Theorist Eve Kosofsky Sedgwick has described the situation as one in which the discourse of a naturalized gay identity has gained a privileged status through its effectiveness in countering supposedly therapeutic, corrective, or punitive practices aimed at eradicating "perverse" desires and practices.[12] She calls this approach "minoritizing," because it strategically defines homosexuality quantitatively (a group of individuals occupying biologically homosexual bodies) instead of qualitatively (a form of behavior that is aberrant in relation to the heterosexual norm, yet a potentially significant aspect of sexual identity in all people).

In education what Sedgwick calls the minoritizing approach has been helpful as an important counter to those who would appeal to the authority of the institutionalized discourses of medicine and science to grant heterosexuality a normative status. Minoritizing arguments have been used with some success both to defend the right of gay educators to teach (because it is biologically inherent, homosexuality cannot be learned or contracted) and to protect lesbian, gay, and bisexual students from institutional attempts to change or discipline their desire (an inherent condition cannot be corrected). But these arguments have been less helpful in implementing a historical understanding of sexuality in all its cultural complexity, and in situating same-sex desire as an integral and positive part of all sexual identities. In opposition to minoritizing views, Sedgwick proposes a category of social constructionist approaches to sexuality, which she designates "universalizing views." According to these views, same-sex desire is not a mode that is attached only to particular bodies or identities, but rather it informs a diverse range of sexual practices, including those designated heterosexual. Sedgwick concludes, however, that in the context of Western discourses on sexuality, both frameworks for understanding homosexuality are tainted by a pervasive and potentially eugenic homophobia. Thus advocates of gay-affirming education must come to terms with a critical dilemma ominously voiced in this assessment: "There currently exists no framework to talk about the origins or development of individual gay identity

that is not already structured by an implicit, trans-individual Western project or fantasy of eradicating that identity."[13]

A barely concealed subtext of the Rainbow Curriculum controversy is the conservative anxiety over the increased authority and legitimation of gay and gay-affirming organizations and educators in conjunction with the institution of an HIV/AIDS curriculum. In part, critics of the Rainbow Curriculum are responding to the new institutional status of educators and activists who, themselves educated by their work and experience with a decadelong struggle against HIV/AIDS, have become leaders in the production of youth-focused educational materials that acknowledge and foreground the critical fact of diversity in sexuality and the culturally situated nature of sexuality. The discourses on sexuality represented in HIV/AIDS curricular material produced by activists and progressive organizations emphasize the fact that AIDS transmission occurs not on the basis of who you are (your sexual identity), but on the basis of what you do (how you practice whatever it is you practice). This message assumes at least two conditions that conservatives would like to deny: First, AIDS in the West has been most effectively confronted by gay activists and organizations, because gay communities initially were hit the hardest. This has placed gay men and others who have worked with AIDS organizations supported by the gay community in a position of expertise with regard to AIDS education, not only for gay youth but for all youth. Recent legislation aimed against gays and a gay-affirming curriculum in education thus can be seen as a reaction to the increasingly visible presence of gay educators in the field, owing in part to pedagogical qualifications linked to sexuality. Second, diverse modes of sexual practice have in common specific acts and methods (both gays and heterosexuals practice anal intercourse); thus it makes sense to educate all youth about a diverse range of safer sex practices, regardless of their stated sexual orientation.

Organizations such as Gay Men's Health Crisis (GMHC) and AIDS Coalition To Unleash Power (ACT UP) were among the first to recognize the need for HIV/AIDS education among youth and to begin producing media for school curricula—media that addresses not only the informational needs of gay students, but the needs of students coming to terms with a range of sexual identities and practices. The media produced by these groups has been part of the curricular material that supports the pedagogical strategies and approaches recommended by the Rainbow Curriculum—the pedagogy opposed by religious groups and conservative constituents within the school system.[14] Strikingly absent from most sex education curricula, the subject of homosexuality was generally raised as a specter or stigma in contexts ranging from academics or sports to disciplinary harangues (not only among students but also between teachers and students) in the lunchroom and schoolyard. Implicitly or explicitly, heterosexuality has been granted the status of a normative standard in

It Is What It Is (1992) by
Gregg Bordowitz. Frame
capture by Brian Goldfarb.

the disciplinary practice of educational institutions, a standard that is enacted
not only through the literal disciplining of students by teachers and admin-
istrators, but in the very structure of the curriculum as it intersects with family
life, youth culture, and sexuality.

Two tapes produced in recent years specifically for HIV/AIDS education in
U.S. urban high schools present views of lesbian, gay, bi-, and heterosexualities
situated in the context of HIV/AIDS education and urban youth culture. In *It Is
What It Is,* by AIDS media educator and activist Gregg Bordowitz for GMHC, gay,
lesbian, bi- and heterosexual youth are the voices of authority on a range of
sexual practices and cultural identities—not only their own, but also those of
their peers. By encouraging viewer identification with characters who embody
a range of sexualities, ethnicities, and class positions, *It Is What It Is* provides
positive identificatory models for gay, straight, and bisexual youth while prob-
lematizing for all viewers binary, adult/youth models of pedagogical authority.
Binary and hierarchical models of gay/straight sexuality that continue to be
offered in other texts and contexts are implicitly challenged. Bordowitz's tape
is an excellent example of work that grounds issues of sexuality in the Rainbow
Curriculum and its surrounding controversy.

The tape is comprised of three segments that address identity, homophobia,
and safer sex respectively. Each segment is composed of a number of short
vignettes in which narrative, role playing, farcical "person on the street" inter-
views, and scripted faux-documentary discussions are used to address each
topic. These vignettes are performed by a group of actors—about a dozen Asian
American, Latino/a, African American, and white young men and women. The
tape explicitly problematizes the easy labeling of sexual identities among the
group. In the first section, which focuses on sexual identity, one youth informs
viewers that the sexualities and HIV status of group members are "none of your
business." However, sexual identities are articulated individually by some of

the characters through the performance of narrative skits based on personal experience (about coming out, for example).

Bordowitz's use of reflexive dialogue reminds viewers that this is not simply documentary but partly dramatization. This strategy fosters a productive ambiguity between the performed identities and the lived sexualities and HIV status of the performers. The ambiguity allows the tape to negotiate two contradictory positions associated with minoritizing and universalizing positions: on the one hand, it provides positive models of immutable gay identity, and on the other, it allows for identification across sexual identities. Drawing upon the '70s developmental, minoritizing view, one youth asserts that "researchers have found [that gay] feelings are either set at birth or at the very latest within the first year or two of life." Another states that "[being gay] is not a choice." While the minoritizing position is reinforced at moments by the affirmative association of same-sex desire with gay identity, it is contradicted by the obvious fact that these identities are being performed and enjoyed by the actors. This is followed by an indication that two unspecified nongay actors are playing the parts of gay youth—a hint that problematizes the viewing game of categorizing cultural signifiers (e.g., clothing, body type) while also suggesting a subtext of relationships that are not acted out: closeted hetero/homo relationships. Minoritizing arguments that relieve gay youth of guilt and responsibility for same-sex desire (sexuality is what it is, you are what you are) are combined with more universalizing, social constructionist positions that posit same-sex desire in terms of a whole range of cultural practices (e.g., family relationships, friendship, ethnic and gender identity). Behind the apparent provision of role models for a range of sexualities are less explicit, more complicated models of identification in which straight and gay youth may perform (and perhaps encourage viewers to "perform," identify, and empathize with people of) other sexualities. Making fixed sexual identities problematic is underlined by the safer sex section of the tape, where the entire cast lines up to pass a kiss from one to the other and back again. This game, which is meant to illustrate the fact that HIV is not transmitted through kissing, also serves to defuse anxieties around same-sex and straight-gay physical contact and pleasure.

In the institutional context, Bordowitz's tape is especially remarkable for its use of universalizing strategies to frame sexuality in terms that affirm gay desire. Traditionally, administrative support for sex education and an alternative family curriculum has been carried out through negative mandates concerning the purported need to "control" perceived problems around sexuality—for example, the need to control teen pregnancy or HIV transmission, or the need to curb homophobia in the classroom in order to curtail students' loss of self-esteem and to curb suicide among gay youth. Much institutionally endorsed sex education curricula has tended to target adolescent women (who almost invariably are presented as victims of heterosexual male youth); to

It Is What It Is (1992) by
Gregg Bordowitz. Frame
capture by Brian Goldfarb.

define sexuality in terms of the mechanics of procreative biology; and to pre-
sent gay sexuality as a danger to mental health, in the few cases where it is
considered at all. As a result, desire—and particularly the desire of straight
women and gay, lesbian, and bisexual youth—disappears from the sex educa-
tion picture. As educational theorist Michelle Fine has noted, sex education
that avoids a discourse of desire further marginalizes the students whose de-
sire is already typically denied: "The absence of a discourse of desire, com-
bined with a lack of analysis of the language of victimization, may actually
retard the development of sexual subjectivity and responsibility in students.
The most 'at risk' of victimization through pregnancy, disease, violence, or
harassment—all female students, low income females in particular, and non-
heterosexual males—are those most likely to be victimized by the absence of
critical conversation in public schools."[15]

An implicit message of It Is What It Is is that it is impossible to address sexual
desire without addressing the real diversity of practices through which it is
expressed in youth culture. This is a point addressed by Fernandez's staff in
developing the HIV/AIDS curriculum, which, for example, suggested discussing
anal and oral sex among other practices with fourth- and fifth-grade students.[16]
Fernandez's office seemed to be acknowledging what AIDS organizations and
activists have been saying all along: you can't expect to educate students about
how to avoid transmission if you don't explain how it occurs, and how to
prevent it. Realistically, this means moving beyond a biologistic approach that
names the danger of exchanging bodily fluids to an approach that names spe-
cific practices associated with desire. It Is What It Is does exactly this by first
validating desire and then discussing at length both the mechanics and the
social/emotional aspects of dealing with a range of sexual feelings through
safer practices.

It Is What It Is was among the first curricular aids officially produced to
speak to high school students about sexual diversity, desire, and safer sex

Video Activism and Critical Pedagogy 155

practices. Completed just before the Rainbow Curriculum was distributed, the tape was released at precisely the time that a major capitulation to conservative demands took place within the school board. In the summer of 1992, the school board ruled that educators addressing the issue of HIV/AIDS in the classroom must sign an oath requiring that "substantially more time and attention be devoted to abstinence than to other methods of prevention [of HIV infection]."[17] This ruling applied not only to teachers' speech, but to media used in the classroom. Because it does not advocate abstinence quantitatively more than other safer sex practices, *It Is What It Is* became officially barred from classroom use despite support by the chancellor's office for the project throughout its production. In previous stages, the HIV/AIDS Program Implementation Guidelines instituted progressive developments such as the approval of condom distribution and the teaching of needle cleaning and practicing safer anal and oral sex. But modification of these guidelines brought some serious pedagogical restrictions, such as the elimination of the subjects of anal and oral sex in the elementary school curriculum, and the institution of this "oath of abstinence" across the curriculum. According to later drafts of the guidelines, all educators who teach HIV/AIDS prevention must take a standardized teacher training course and follow restrictive official mandates regarding the teaching of safer sex practices. Much of the information provided by the teacher training program is useful, and guidelines are helpful in ensuring the transmission of accurate information and enforcing the need for confidentiality with regard to student HIV infection. However, teachers already beleaguered by institutional demands are often unable to take the course, and thus are not allowed to address the issue of AIDS without repercussions. Systemwide attention to the issue has led to increased surveillance of individual teachers' classroom activities. This situation escalated to the point that the New York Civil Liberties Union filed a suit against the board on behalf of teachers, claiming that the guidelines "violate teachers' freedom of expression in the classroom."[18]

Videotapes, pamphlets, and instructional materials produced by social service organizations have been the main source of up-to-date, frank information that is unavailable in commercially produced textbooks. With the gag rule in place, these all had to be approved by a review committee at the Central Board to verify that they met abstinence-centered requirements. This mandate resulted in the effective censorship of *It Is What It Is*. However, educators willing to risk challenging the board's rules continued to employ censored material in many New York City classrooms.

Although *AIDS, Not Us,* a tape produced by Sandra Elkin for the HIV Center for Clinical and Behavioral Studies in New York City, is equally implicated in a discourse on desire and sexual diversity, it has not been subject to the same degree of school board censorship as *It Is What It Is*. This is not because the school board has given the tape its stamp of approval. By keeping a low profile

AIDS, Not Us (1989) by
Sandra Elkin. Frame
capture by Brian Goldfarb.

with respect to larger school board and administrative controversies, the HIV Center has been able to gain wide distribution of the tape throughout New York City public schools while the gag rule was in effect, even though it didn't meet abstinence-priority regulations. For example, many educational health care and correctional facilities receive the tape through the New York State Department of Health. The success of the tape in reaching an inner-city public school audience can be attributed in part to the producer's ability to enlist the support and input of a range of community organizations and cultural producers working in the margins of the school system. With music written and performed by rap stars Heavy D and the Boyz and a first-person voice-over narration spoken by a teen character within the narrative, the tape's authority, like that of It Is What It Is, is located within urban youth culture itself—a factor that is more likely to make it a popular tape.[19] But the tape's position on sexuality and desire may be another possible reason for its relative success during the period of the "oath of abstinence."

AIDS, Not Us provides safer sex information through a dramatic narrative about a group of five African American and Latino male teens. AIDS is framed among crime, drugs, and drug-related violence as one of several life-threatening conditions of inner-city life. Produced in 1989, a year that educational authorities were just beginning to recognize the need to dispel the myth of AIDS being a gay disease, AIDS, Not Us takes a step toward countering associations of AIDS with homosexuality while still acknowledging the presence of gay youth in urban youth communities. The tape presents a gay youth—a teen who is not HIV-positive—as a voice of authority, someone with information about safer sex who can educate his straight friends. While this is not the only, or the central, narrative of the tape (we see a range of possible sexual scenarios as well as one character's idolized brother, a PWA who has been infected through needle use), AIDS, Not Us does indicate the work of gay individuals in establishing educational networks. Chris is confronted by Miguel, his closest friend in the group,

AIDS, Not Us (1989) by
Sandra Elkin. Frame
capture by Brian Goldfarb.

who derides him for associating with "a faggot." When Chris responds by
coming out to him, Miguel reacts violently. Later, the two manage to mend their
friendship when Miguel decides to accept his friend's sexuality, "even if [he]
may never understand it." Although Chris attempts to educate Miguel on
modes of transmission, the tape concludes by informing the viewer that "Chris
won a basketball scholarship to college and went on to medical school; Miguel
attended trade school until he became ill. He died of AIDS in his twenties."

Because *AIDS, Not Us* represents straight relationships in much more depth
than *It Is What It Is,* the tape is more likely to be accepted in the public school
context. In addition, straight desire is not exactly embraced in its various
modes of expression: Miguel's unwillingness to limit his partners is associated
with his unwillingness to use condoms—his death reads, in part, as punish-
ment for his promiscuity. And while the topic of abstinence is never broached
in the tape, the gay-sex narrative of Chris and the straight-sex narratives of his
friends are all framed to imply that monogamy, combined with condom use, is
the way to go. *It Is What It Is,* a tape that takes no single stand on monogamy
versus promiscuity but advocates a range of sexual choices and experiences
even within straight culture is less likely than *AIDS, Not Us* to be accepted
even in some more liberal public school classrooms.

The positions taken by these tapes are representative of strategies for ad-
vocating a pedagogy of sexual diversity informed by a dynamic and adversarial
relation to the strategies of conservative constituents within the politics of
education. Opposition to gay rights in U.S. education has a long legislative
history. In 1978, freshly inspired by Anita Bryant's successful campaign to
challenge gay rights legislation in Florida (a campaign that he actively sup-
ported), California state senator John Briggs authored an initiative for a similar
referendum in his own state. Proposition 6, as it was called, would have re-
quired the firing of any school employee who was "advocating, soliciting,

AIDS, Not Us (1989) by
Sandra Elkin. Frame
capture by Brian Goldfarb.

imposing, encouraging or promoting private or public homosexual activity directed at or likely to come to the attention of schoolchildren and/or other employees."[20] The idea behind this legislation is that gays may be tolerated so long as they remain closeted—an implicit proviso that becomes confused by the legislation's inevitable blurring of distinctions between what constitutes "public" and "private" behavior. From the standpoint of this legislation, is public display of any form of intimacy with a person of the same sex a proscribed pedagogical act on the part of an educational professional? What the Briggs initiative implied was that any public signifying of, or participation in, gay culture (within or outside the classroom) constituted pedagogical "advocacy," "solicitation," or even "imposition" of gay culture in the classroom.

Until three months before it was voted upon, polls indicated that the Briggs initiative would pass. The press billed it as a done deal. However, thanks in part to gay activists' vocal opposition, Proposition 6 ultimately was defeated. But this was a partial victory for gay activists at best, not only because the margin of defeat was frail and indicated that there was still strong support for homophobic legislation, nor simply because the entire contest placed the rights of gay educators in a defensive position. Certain arguments posed against the legislation embodied a different manifestation of homophobia that would have to be confronted in the years after 1978. This position is voiced in the following passage from the speech of former Governor Ronald Reagan—a single speech to which Briggs himself attributed the defeat of his bill. Reagan takes the ironically liberal position that "[Proposition 6 presents] the potential for real mischief. . . . Innocent lives could be ruined. . . . Whatever else it is, homosexuality is not a contagious disease like measles. Prevailing scientific opinion is that an individual's sexuality is determined at a very early age and that a child's teachers do not really influence this."[21]

In her historical account of gay-related educational law, lawyer and educa-

tional theorist Karen Harbeck notes that the potentially ruined innocent lives referred to in Reagan's speech were not those of gay educators, but those of educators presumed to be straight who, under Proposition 6, could be rail-roaded out of the profession on the basis of a possible "mistaken" interpreta-tion of their behavior as homosexual. The seeming defense of gay educators in the passage above illuminates the complexities to be negotiated in the post–Briggs initiative struggle with discourses of sexuality in educational insti-tutions. Reagan's partial exoneration of gay sexuality ("Whatever else it is, homosexuality is not . . . ") does little to hide the fact that he is disappointed in medical science's inability to control, or correct, homosexual desire and behavior. Eve Kosofsky Sedgwick notes that the American Psychiatric Associa-tion removed homosexuality as a disease in 1973, only to reinstate the trans-gression of heterosexual norms in youth as "gender identity disorder of child-hood."[22] Following these shifts in medical terminology, Reagan and others may not have regarded homosexuality as a contagious disease, but they certainly viewed it as a disorder.

Reagan's apparent defense of gay educators makes it clear that in 1978 popu-lar debates had not even begun to address the issue of the need for the inclusion of material on gay identity and culture in curricula. Political opposition to the Briggs initiative was formed on the basis of a problematic view that homosex-uality is innate and not culturally informed after an early developmental stage, and therefore homosexual behavior can be neither "caught" nor "taught" in the classroom. While the position Reagan gave voice to did contest the idea that gay educators are implicitly involved in recruitment to gay culture, it side-stepped the volatile anxiety resonating in the Briggs initiative around the un-stable, ambiguous nature of cultural signs associated with all modes of sexual-ity—an anxiety about the fact that straight-identified individuals might "act" gay, that gay-identified individuals might "act" straight, or that the cultures of sexualities—and sexual identity itself—might be unstable and ambiguous.

The degree to which this anxiety persists is evident in the passage in England a decade later of legislation very similar to the Briggs initiative. Like Proposi-tion 6's attempt to snuff out perceived classroom advocacy of homosexuality, England's Section 28 prohibits its "promotion." The 1988 British Act states that "a local authority shall not a) intentionally promote homosexuality or publish material with the intent of promoting homosexuality; [or] b) promote the teaching in any maintained school of the acceptability of homosexuality as a pretended [sic] family relationship."[23]

Simon Watney makes clear the degree to which, for Section 28's supporters, "promotion" is a euphemism for seduction. According to Watney, Section 28 gives voice to conservative fears of the vulnerability of heterosexuals to homo-sexual desire, and fantasies that the gay educator is so powerfully seductive that students will be recruited into gay culture through his or her presence

Pedagogue (1988) by Stuart Marshall. Frame capture by Brian Goldfarb.

alone. On the one hand, these fantasies provide an overtly sexualized script for the barely veiled narratives of sexual desire that for centuries have informed the popular conception of the (primarily man-boy) pedagogical power relation. On the other hand, they fuel the statistically disproved, yet tenaciously persistent, identification of pederasty with male gay educators. The degree to which these fantasies are based on repression, desire, and denial is the subject of Stuart Marshall's satirical video *Pedagogue,* a 1988 tape that was produced in direct response to the passage of Section 28.[24]

Using the conventions of the mock documentary or "mockumentary," this ten-minute video centers on a scripted and staged interview with an art school professor, Neil Bartlett. The male interviewer, who never appears on camera, interrogates Bartlett with questions ranging from the seemingly inane (what's your favorite color?) to the overtly directed and accusatory (are you a homosexual?). While answers to questions that are not "loaded" are coded as possible "clues" to sexual identity (Bartlett names the feminine-coded pink as his favorite color), answers to questions framed to elicit a confession throw up roadblocks (Bartlett asserts—twice and vehemently—that he is "absolutely not" a homosexual). As Bartlett's talking head spouts his disdain for liberal educational values, the camera is drawn down, as if against its will, to more erotogenic areas of Bartlett's body, regions that might reveal signs of a verbally disavowed sexual identity. It fixates on an exposed bit of chest hair framed by his open black leather jacket; on safety-pin jewelry (inscribed with the word "care") hanging from his leather jacket's breast pocket—a zipper pocket, of course; and on the crotch of his snugly fitting jeans.

The camera's fascination with Bartlett's body and its gay-coded accoutrements articulates the conservative fantasy/fear that is so unconvincingly disavowed in the speech that Bartlett mouths; the very presence of the gay educator holds the pleasurable threat of seduction, "promotion," and recruitment

into homosexuality, even for die-hard conservatives. Voicing ideals about proper dress and "old-fashioned" educational standards like paternalistic authority and disciplinary standards, Bartlett makes overt the link between conservative, neo-Victorian disciplinary practices and their own simultaneous repression and production of the "deviant" sexual scenarios stereotypically associated with gay culture, effectively revealing the institutionalization of deviance within the mainstream pedagogical practices that inform Britain's Section 28.

The tape concludes with comically absurd testimony by a number of Bartlett's students about the highly contagious nature of his gay identity. These young men and women who up until the arrival of Professor Bartlett had been enjoying perfectly "normal" heterosexual lives suddenly realize that they themselves are gay. The simple presence of Bartlett for a day unleashes an epidemic of homosexual desire that infects not only these students but their parents, roommates, and pets.

Inadvertently, Marshall's tape can be read as implicitly evoking Reagan's argument against the Briggs initiative; of course one does not "catch" homosexuality by way of contact with gay teachers. But paradoxically, the conservative fear mocked by Marshall—the idea that sexuality is coded even in seemingly neutral areas of identity and culture (in color preference, for example) and can be acquired—acknowledges the social constructionist position that supports a gay-affirming curriculum like that represented in the controversial six pages of the New York City public school system's Rainbow document. Reagan's argument that homosexuality is behaviorally in place after a certain age (and is therefore unlearnable at school) is one counter to the incredibly retrograde discourse of Section 28, but this dissociation of sexuality from pedagogy, as it is evoked implicitly and in a different way by *Pedagogue,* leaves unconsidered the issue of the cultural practices of homosexuality vis-à-vis other areas of ideology, culture, and desire. What the Rainbow Curriculum implies is that homosexuality is constituted within a complex of ideologies—is articulated through cultural practices both inside and outside of gay culture—and is lived by gays *and others* through cultural elements that can (and must) be "taught" through gay-inclusive and gay-affirming curricula. As Simon Watney has noted, anti-gay educational laws like Section 28 "paradoxically . . . draw attention to the fact that fundamental definitions of sexual identity and sexual morality are historically [that is, ideologically] contingent and by no means 'natural.' "[25] Contesting homophobic laws like Section 28 has sometimes made it strategically necessary for pro-gay legislators, educators, and activists to recall, implicitly or explicitly, developmental models that circumvent the plausibility of contamination-by-education theories, but this strategy leaves unexamined dominant assumptions about the mechanisms through which gay, straight, or other cultural practices are learned and carried out. By focusing precisely on

gay culture as it is lived in and through other cultural institutions (like the family), the six controversial pages of the Rainbow Curriculum begin to problematize the nexus of ideology, cultural practice, and education that is at the heart of both Section 28 and the Briggs initiative. The Rainbow Curriculum represents a broad institutional shift in the United States from the question of *who may teach* to the question of *what is taught*—that is, from the right of gay educators to teach to the institution of gay-inclusive material across the curriculum.

Generally, the conservative legislative backlash of the past twenty years represented by Proposition 6 and current opposition to the Rainbow Curriculum can be seen as a response to visible, institutionalized shifts in educational policy toward support for gay teachers and curricula.[26] While two decades ago, antigay measures in education were largely directed at individual teachers identified as gay, today conservative forces more frequently focus their attack on the range of gay-inclusive and safer-sex curricula. Harbeck cites gay educators' widespread success in attaining legal and financial backing from teachers' unions across the nation during the seventies as a key explanation for the diminished frequency of conservative legal initiatives against individual teachers in more recent years.[27] But the nexus of the battle has shifted to the curricular terrain, which is being structurally transformed (though only in some places and in small degrees) to include material on gay culture, history, and sexuality. The ongoing struggle between New York City schools chancellor Joseph Fernandez and opposing school board members over the Rainbow Curriculum is one highly publicized moment in this shift. But an equally critical intervention has come in the form of curricular media produced by educators such as Bordowitz and Elkin who work on the margins of the school system. They are now, paradoxically, compromised by the very mechanism of institutional acceptance (as was the case with the "gag rule").

Another group who are potentially compromised are students from high schools throughout New York City who are involved in video production programs such as Rise and Shine Productions and the Educational Video Center (EVC). In their productions, these students are encouraged to take up issues of direct concern to them and their peers but that schools fail to address adequately. In Rise and Shine's narrative production *Blind Alley* (1992), a male youth who participates in a gay-bashing incident learns a hard lesson about his own sexual anxieties when the victim of the bashing turns out to be a close friend of a young woman with whom he wants to get involved. The tape underscores the elusive nature of the boundaries that divide heterosexual and gay cultural realms.[28] EVC's *Free to Be Me* is a student-produced documentary that includes candid interviews with lesbian and gay youth who relate stories about the confusion, fear, relief, and pride associated with coming out.[29] Through the process of peer education, these tapes allow students to occupy roles of pedagogical authority. Clearly this sort of pedagogy doesn't happen spontaneously,

especially with respect to fighting homophobia—an issue that is often violently silenced. Essential support for this type of production has come from organizations such as the Hetrick-Martin Institute, a social service organization for gay youth that runs the Harvey Milk High School in New York City and conducts workshops on homophobia and other issues in high schools throughout the city. Students from Rise and Shine and EVC participated in workshops run by the Hetrick-Martin Institute prior to producing the tapes described above, and institute staff and Harvey Milk High School graduates worked with both Bordowitz and Elkin on their tapes as well. Clearly, interorganizational support is critical not only for the circulation of these tapes but for their production.

In the aftermath of the Rainbow Curriculum controversy, this network across progressive education, social service, and media activism is critical to continued production and distribution of the kind of tapes discussed here. The controversy obviously has important ramifications nationally not only for educators but also for media activists. As I have tried to show, the Program Implementation Guidelines for mandated HIV/AIDS education placed limits on what could be taught in the classroom, putting progressive educators under surveillance and creating official channels for the censorship of intra-institutional media production as well as teachers' classroom media choices. It is important at this moment to attempt to work against these institutional blockades while finding ways to make tapes that challenge curricular mandates from the margins—a project that may require working with youth from sites outside the public school system. Media organizations like GMHC Audio-Visual, the Educational Video Center, and Rise and Shine will continue to play a critical role in this project.

Notes

1 Gregg Bordowitz, *It Is What It Is,* videotape (New York: Gay Men's Health Crisis, 1992). Distributed by Gay Men's Health Crisis (GMHC) Dept. of Education, (212) 337-3559, 129 W. 20th St., New York, N.Y. 10011.

2 As a member of the GMHC audiovisual staff, Greg Bordowitz produced the tape in consultation with the New York City schools' chancellor's office—specifically, with Fernandez's materials review committee. Well informed on concurrent developments within the public school system, Bordowitz saw the tape as an opportunity to push the limits of the authorized high school sexuality curriculum.

3 Sandra Elkin, *AIDS, Not Us,* videotape (New York: HIV Center for Clinical and Behavioral Studies, 1989). Distributed by the HIV Center for Clinical and Behavioral Studies, (212) 740-0046, 722 W. 168th St., New York, N.Y. 10032.

4 *Children of the Rainbow* (New York City Public Schools: Office of the Chancellor, 1992), xii.

5 Ibid., 372, 399, 400, 402–3.

6 The quote, by Mary A. Cummins, president of District 24's school board, is cited in Steven Lee Myers, "How a 'Rainbow' Curriculum Turned into Fighting Words," *New York Times,*

13 December 1992, 6. See also Steven Lee Myers, "Board in Queens Is Suspended in Battle over Gay Curriculum," *New York Times*, 2 December 1992, 1.

7 As already indicated, the general guidelines of the Rainbow Curriculum are meant to aid individual teachers and schools in developing a curriculum that advocates the acceptance of diversity. They do not constitute a specific or mandatory set of lessons. However, many on the religious right erroneously claim that the attention the Fernandez administration has given to the social issues represented by the Rainbow Curriculum has been at the expense of "academics."

8 As this article was being prepared for publication, New Yorkers faced heated school board battles in many of the city's thirty-two districts. Led by groups like Pat Robertson's Christian Coalition and armed with more money than registered voters, the religious right had begun targeting local elections that normally have a low voter turnout (as low as 4 to 7 percent). As threatening as this "grassroots" backlash may seem, defeating the religious right on its chosen ground of local electoral politics requires only a relatively small oppositional voting block. Indeed, groups such as People about Change in Education (PACE), the Gay and Lesbian Emergency Media Campaign, and the Campaign for Inclusive Multicultural Education had already begun to mount a broad-based opposition.

9 For further discussion of this subject, see Jeffrey Weeks, *Against Nature* (London: Routledge, 1991), and Michel Foucault, *The History of Sexuality,* vol. 1, *An Introduction,* trans. Robert Hurley (New York: Vintage Books, 1980).

10 See Eve Kosofsky Sedgwick, "How to Bring Your Kids Up Gay," *Social Text* 29 (fall 1991): U.S. Department of Health and Human Services, *Report of the Secretary's Task Force on Youth Suicide* (Washington, D.C.: U.S. Government Printing Office, 1989); Friends of Project 10, *Project 10 Handbook: Addressing Lesbian and Gay Issues in Our Schools* (Los Angeles: Friends of Project 10, 1991), 11–16; and Hetrick-Martin Institute, *Factfile: Lesbian, Gay and Bisexual Youth* (New York: Hetrick-Martin Institute, 1992).

11 These strategies have been used by prominent groups such as Project 10 in Los Angeles and the Hetrick-Martin Institute.

12 Eve Kosofsky Sedgwick, *Epistemology of the Closet* (Berkeley: University of California Press, 1990), 1.

13 Ibid., 41.

14 The fact that there is a dire need for AIDS educational media that situates the problem in terms of diverse sexual practices and identities was driven home to me in my experience as a teacher (and a straight, white, male teacher at that) in New York City elementary and junior high schools during the late '80s.

15 Michelle Fine, "Sexuality, Schooling, and Adolescent Females," *Harvard Educational Review* 58, no. 1 (February 1988): 49–50.

16 "Teaching of Sexual Concepts Stirs a Heated Debate among Officials," *New York Times,* 17 June 1992, B1, B2. Note: The curriculum was later revised, under pressure by conservative members of the city school board, to omit the mention of oral and anal sex, references implying gay relationships among youth, and the cleaning of hypodermic needles. See Joseph Berger, "Board Agrees on Teaching about AIDS," *New York Times,* 25 June 1992, B-1, B-4.

17 *Resolution #33 of the NYC Board of Education,* as noted in a school board public relations document titled "HIV/AIDS including Condom Availability in NYC High Schools and Selected Special Education Programs: Commonly Asked Questions and Answers," October 1992, 3.

18 James Dao, "Critics Decry New AIDS Education Rules as Censorship," *New York Times,* 29 May 1992, B-3.

19 An important lesson learned from the widening struggle to develop effective AIDS preven-
 tion material has been the necessity of addressing explicitly the diversity of sexual prac-
 tices in terms that are specific to all communities, and particularly those being hit hardest
 by the AIDS epidemic. This means that organizations originally set up by and for gay
 communities are narrowcasting videos to straight and gay Latino/a and black urban com-
 munities (which are currently experiencing higher HIV infection rates) and to (primarily
 urban) youth. As a result, AIDS educational material produced by these organizations has
 begun to address sexuality as it is constituted within and across ethnic, class, and regional
 communities. In the context of public school institutions, these approaches represent a
 radical departure from curricula that have generally denied the centrality of sexual desire
 and sexual cultures as they are expressed through other cultural discourses.

20 Karen Harbeck, "Gay and Lesbian Educators: Past History/Future Prospects," in Karen
 Harbeck ed., *Coming Out of the Classroom Closet* (New York: Routledge, 1991), 130.

21 Ronald Reagan, quoted in Harbeck, 129.

22 Eve Kosofsky Sedgwick "How to Bring Your Kids Up Gay," *Social Text 29* (fall 1991): 20.
 Sedgwick points out that this designated disorder is in fact highly differentiated between
 boys and girls: while boys may be given this label if they display a marked desire to
 participate in female-stereotyped activity or practice cross-dressing, it is applied to a girl
 only if she insists that she is anatomically male.

23 Quoted in Simon Watney, "School's Out," in *Inside/Out: Lesbian Theories, Gay Theories*
 (New York: Routledge, 1991), 388.

24 Stuart Marshall, *Pedagogue*, videotape (London, 1988). Distributed by Video Data Bank,
 (800) 634-8544, 37 South Wabash Ave., Chicago, Ill. 60603.

25 Watney, "School's Out," 300.

26 Nonetheless, progressive pedagogical work retains the often contradictory nature of the
 political struggles that inform it. Thus educators need to marshal both minoritizing and
 universalizing claims for use in sexuality curricula. While the notion of an innate or im-
 mutable sexuality may be necessary to protect some youth, without a curriculum that
 begins to break down the simple binary opposition between hetero/homo identities, edu-
 cators cannot begin to dismantle the disciplinary mechanisms that reinforce homophobia.

27 Harbeck, "Gay and Lesbian Educators," 130.

28 *Blind Alley* and *The Real Deal: Multicultural Education,* videotapes (New York: Rise and
 Shine Productions, 1992). Rise and Shine Productions, (212) 265-5909, 300 W. 43rd St.,
 New York, N.Y. 10036.

29 *Free to Be Me*, videotape (New York: Educational Video Center [EVC], 1992). Distributed by
 EVC, (212) 254-2848, 60 East 13th St., New York, N.Y. 10003.

Activism and Oppositionality

David Trend

Cultural Struggle and Educational Activism

In recent months cultural politics has entered the public con-
sciousness as never before. Politicians, bureaucrats, and reporters have cred-
ited creative endeavors with the capacity to influence matters ranging from
public morality to national productivity. As a result, bizarre pressures are
being placed on an already strained nonprofit cultural mechanism. The diffi-
cult task of fund-raising for the arts has become increasingly politicized by
legislators and special-interest groups. The very architecture of public pa-
tronage may consequently soon change. Ironically, this is all occurring at a
time of great possibility for the cultural Left. Nationally, the atmosphere seems
ripe for a new era of coalition politics, and activist cultural workers are ideally
situated to assist the movement. But to do so we must restrategize our cultural
practice. We need to think about popularizing its forms. We need to think about
education.

The national economy is partly to blame for the current fiscal dilemma. No
one needs to be reminded of the damage done to public patronage by supply-
side economics. A recent article in the *New York Times* noted that the arts are
facing a triple threat, as contributions from corporate, government, and indi-
vidual donors decline simultaneously.[1] A combination of economic down-
turns, spending freezes, and tax-law revisions has resulted in philanthropic
cutbacks that have many arts administrators and public officials in a panic. In
real dollars, the budget of the National Endowment for the Arts has declined by
27 percent since 1981; private contributions to the arts have decreased nearly
that much in the last two years. As a consequence, arts institutions have gone
out of business by the dozens, while those that have survived have been
obliged to reduce their services and cut their staffs.

Money hasn't been the only problem. With the Reagan revolution came a
calculated strategy to change the shape of government through the introduc-
tion of "private sector initiatives" and "public/private partnerships." This
meant the wholesale transfer of many formerly publicly administered func-
tions—from health care to education to culture—into the hands of corporate

America. As social services were reoriented along lines of profitability, the government's ability to correct economic inequities declined. The growing privatization exacerbated divisive hierarchies of work (professions) and study (disciplines) that stratify human activities in disproportion to their community function. This prevented large segments of the population from receiving social services and from participating in democratic decision making, increasing the extent to which the United States is becoming a class-divided society.

In the art world, modernism's institutional stronghold made matters worse. One of the major disputes of '80s cultural politics has involved the segregation of art from other social relations. Despite its egalitarian origins, modernism eventually limited the constituency for cultural practice. What was once proposed as a democratic practice of "pure seeing" accessible to every citizen was gradually transformed into an elite academicism. The resulting ghettoization of culture has allowed radical efforts to be easily contained. Such attitudes have been materially reinforced by conservative curators and art historians (who tend to hold the institutional purse strings) and by granting agencies like the National Endowment for the Arts (that privilege aesthetic quality over social benefit).

Regrettably, avant-gardists have often exacerbated this dilemma by choosing to work outside the system. Although such practices provide temporary (and at times necessary) solace, ultimately they are misplaced in their refusal to engage the institutions that utilize and reproduce state power. Such beliefs reinforce the social alienation that artists have inflicted upon themselves for decades.

These factors have gradually transformed the character of cultural organizations and the constituencies they serve. As a consequence, alternative spaces are now obliged to consider the star status of the artists they exhibit, museums must cater to wealthy patrons, and the value of art itself is measured on the auction block. At the same time, competition for patronage has considerably eroded cooperation among artists and their organizations. Gradually the movement toward privatization is returning art and culture to the domain of the market—and ultimately of the wealthy. Marx would label this an inevitable consequence of a system premised on profits rather than social utility. And indeed the logic of most conservative policy makers would confirm that analysis. As Vermont Republican congressman Jim Jeffords crassly joked in a recent interview, "The arts are the soul of this country, and there is no better way to promote the country than to sell its soul."[2] Is it any wonder that in such an environment popular support for culture has begun to dwindle?

Seen in this light, the arts funding crisis of the 1980s is but one symptom of broader civic dissolution. In a stratified public sphere, citizens no longer feel confident that their efforts make a difference. Conservative claims persist that a mythical "mainstream" should determine standards of community behavior.

But this actually represents a mechanism for naturalizing social hierarchies. As such, the Right's program masks a profoundly anti-egalitarian strategy for the deligitimization of dissent. Differences among people are framed as obstacles to be ameliorated in the interest of the common culture.

Indeed, the cultural funding crisis has taken a stridently political turn, as congressional ideologues have launched direct legislative attempts to silence opposition. Normally the doings of the $171 million National Endowment for the Arts attract little attention on Capitol Hill. However, the publicity generated around this fall's quadrennial endowment reauthorization hearings has yielded the proceedings currency as a symbol of conservative determination.

Andres Serrano and Robert Mapplethorpe were easily cast as antithetical to the imaginary mainstream. Despite its transparency, this strategy effectively capitalized on the specialized production of the avant-garde to push progressives into civic alienation. Conservatives assert that a nonrepresentative leftist minority has infiltrated the cultural nexus as it did the university decades ago. Patrick Buchanan is not alone in claiming that "while the right has been busy winning primaries and elections, cutting taxes, and funding anticommunist guerrillas abroad, the left has been quietly seizing all the commanding heights of American art and culture."[3] It is ironic that just when many liberals are protesting the "politicization" of the arts by feminists, gays, and people of color, conservatives are quickly mustering forces to impose their own agenda.

Without a doubt, these recent controversies will have a lasting impact on the way culture is supported in this country. The National Endowment for the Arts is already bowing to pressure from conservative lawmakers to change its granting procedures. But beyond the hoopla about free speech and censorship lie broader debates involving the character of intellectual life. Those on both sides of the ideological fence have recognized the importance of art in shaping opinions and values.

Practical Strategies

In the cultural realm conservatives are seeking to gain the upper hand with the same tactics they used to win the White House. With a program of moral traditionalism, the Right has seized upon popular symbols to put the Left on the defensive. As a result, progressives find themselves in a reactive position in which the very terms of their antagonisms are defined by the other side. With a continual battle being waged against this or that conservative motion to censor or defund, a positive agenda has become difficult to formulate. And without this positive articulation, the Left dooms itself to a position of marginality. Ernesto Laclau and Chantal Mouffe argue that "if the demands of a subordinated group are presented purely as negative demands subversive of a certain order, without being linked to any viable project for the reconstruction of spe-

cific areas of society, their [sic] capacity to act hegemonically will be excluded from the outset."[4] Framed in this manner, the solipsistic nihilism of much avant-garde practice is both defensive and counterproductive. We need a positive plan.

At the heart of the struggle must lie a message through which cultural activists can broaden their reach. We must popularize a pair of concepts that conservatism seems unable to reconcile: difference and egalitarianism. Accomplishing this on a popular level will mean reclaiming many icons and values that conservatives have appropriated. Why, for example, have we allowed the definition of such concepts as patriotism and the family to be set by the Right? If deconstruction has taught us anything, it is that the meanings of cultural signs are unstable. As Carole S. Vance points out, it is through the false recontextualization of Mapplethorpe and Serrano as *negative* symbols that the Right made its recent congressional gains.[5] Cultural activists can work to unmask the methods of conservative image manipulation, while at the same time forging a positive iconography. What matters is the framework in which a particular idea is placed. Therefore contexts of transmission and reception become vital components in this struggle. In other words, signification becomes a matter of political strategizing.

Of course, the task ahead involves more than simply seizing popular symbols. It requires a political imaginary that is as yet unrealized in our history. The common shortcoming of all hegemonic regimes (including utopian ones) is their implication of totalizing ideology or subjectivity. To Samuel Bowles and Herbert Gintis this problem becomes particularly evident within conventional liberalism. Although frequently presented as a pathway to emancipation, the liberal ethos perpetuates distinctions between historical subjects and objects: those who act and those who are acted upon. It seeks to make surface corrections to a structurally flawed system without interrogating its underlying economic inequities.[6]

In contrast, a radical democracy defines itself on all levels in pluralistic terms. There is no single set of attitudes or social group to which all others must conform. Instead, the unifying ethos is one of decentered authority.[7] For obvious reasons, such a scheme seems dangerously unstable to many neoconservatives, who warn of the "threat" of unbounded egalitarianism.

To put these theories into practice, activists need to develop the mutually supportive character of their struggles. This presents a challenge to the cooperative tolerances and communicative capacities of the interests involved. Groups defined by gender, sexuality, ethnicity, nationality, or occupation need to recognize their unique roles in the social totality. To encourage this coalescence, boundaries (and the hierarchies often implied) must be diminished that separate groups via such distinctions as amateur/professional or mass/elite. We should work toward a worldview that is horizontal rather than vertical.

The moral dimensions of this struggle cannot be overstated. The concept of guaranteed equal rights carries enormous popular appeal, as revealed last year in the advances of Jesse Jackson and the Rainbow Coalition. The Jackson phenomenon demonstrated the willingness of large numbers of people with different interests to coalesce around the issue of their common estrangement from power. This was accomplished despite a biased and xenophobic press.

In a similar fashion, artists and media producers can help shape a discourse of solidarity by reaching beyond single causes or issues (important as they are). The task entails working to create a discursive space for activism on many levels. In addition to creating unifying texts, this means strategizing in legislative and institutional arenas. As Fred Glass recently wrote of labor media, "If 'Union Yes' shows up on your car radio, in your living room, on a billboard you pass, etc., then unionism can become a part of the background of our daily lives. Thus naturalized, the spots can disarm a direct message at your anti-union workplace that unions are hostile and Other."[8]

Cultural workers have an important role to play in demonstrating the interconnectedness of various struggles. Both the conservative political apparatus and the news media simplify social problems by representing them as isolated phenomena. In this way public attention is diverted from the actual causes of human misery and inequity. For instance, the nation's drug dilemma has been characterized as a monolithic war, with seemingly no relationship to the forces of economic imperialism, racism, and structural poverty (not to mention the wholesale marketing of various forms of "legal" intoxication) that lie beneath it.

To combat such propagandizing, artists can fashion representations that illustrate such conditions in their full contexts, difficult as that may be. In his photographic installation *Geography Lesson: Canadian Notes* (1986–87), Allan Sekula approached a task no less daunting than an analysis of Canadian civic subjectivity. He accomplished this with photographs showing homes, workplaces, union halls, shopping centers, banks, and museums—interspersed with texts and accompanied by an explanatory essay. A passage about money reads in part:

> The Bank of Canada whispers to the Canadian bourgeoisie in two voices. A nostalgic voice recalls the immensity of Canada's natural wealth. The bourgeoisie hears the whisper absent-mindedly, it knows that this wealth may not even be Canadian. A second whisper is more insistent: "Invest abroad, trade freely, you citizens of the world." Working-class Canadians are encouraged to hear only the first voice, to accept their relative comfort in the world of nations, this wealth that is theirs only in the imagination.[9]

The resulting work reveals the way people arrive in their social circumstances. Awareness of such factors is a prerequisite of meaningful change.

In a similar, yet somewhat more dramatic vein, the film *Fighting Ministers* (1988) by Bill Jersey and Richard Wormser demonstrates the tenacity with which the corporate state seeks to sustain social fragmentation. The film describes the efforts of clergy near Pittsburgh in confronting steel companies and banks over plant shutdowns. Its narrative centers on a confrontation between the corporate-controlled Lutheran Council and a group of renegade pastors over whether the pastors should meddle in secular affairs. Insisting that they must remain involved with the workers' struggle, the ministers are eventually defrocked and jailed. *Fighting Ministers* is a story about coalition building—about the joining of two movements for a broader cause. As such it provides a lesson in the construction of a democratic imaginary and in the difficulty of creating one in our culture.

Similar messages were conveyed by last year's Democracy project by Group Material and Concrete Crisis, organized by Political Art Distribution/Documentation the year before. Both actions integrated works in many forms by makers from across the social spectrum. The September 1988 Education and Democracy component of the Group Material project included writing, photographs, video, painting, and sculpture by students, art teachers, professional artists, hobbyists, hospital patients, journalists, children in day care, and political activists. Though somewhat cacophonous (and occasionally self-contradictory), the assemblage demonstrated that a concern for education is inseparable from issues of geography, race, gender, family, income, law—a myriad of social and political concerns that are often considered irrelevant to the classroom.

"Concrete Crisis" was presented in three formats—an exhibition, a magazine, and a series of street posters—to reach audiences both inside and outside the art world. It demonstrated that the urban quandary facing New York City comprises such overlapping problems as gentrification, political corruption, and racial bigotry. But beyond that, "Concrete Crisis" also broached the difficult topic of the way artists themselves are implicated in these conditions. As Greg Sholette wrote in the show's catalog, cultural workers find themselves in a contradiction "between social and moral criticism on one hand, and on the other hand, the economic reality that the institutions of the artworld in which we participate are sometimes responsible for those social problems."[10]

Thus beyond individualized works or actions, cultural workers need to address the institutional structures that frame their practice. It may involve creating new organizations for mutual support. In the prewar years of the 1930s, a coalition momentarily came together under the umbrella of antifascism. Brought together in 1936 under the auspices of the American Artists Congress in New York City were groups and individuals with such diverse concerns as racial inequality, poverty, government censorship, unemployment, global armament, and unfair working conditions for artists. The initial call for participation in the congress read in part:

This Call is to those artists, who, conscious of the need for action, realize the necessity of collective discussion and planning, with the objective of the preservation and development of our cultural heritage. It is for those artists who realize that the cultural crisis is but a reflection of a world economic crisis and not an isolated phenomenon. . . . Dealers, museums, and private patrons have long ceased to suply the meager support they once gave. Government, State, and Municipally sponsored Art Projects are giving only temporary employment—to a small fraction of the artists. . . . Oaths of allegiance of teachers, investigations of colleges for radicalism, sedition bills aimed at the suppression of civil liberties, discrimination against the foreign born, against Negroes, the reactionary Liberty League and similar organizations, Hearst journalism, etc., are daily reminders of the fascist growth in the United States.[11]

For five years the congress initiated exhibitions, demonstrations, and other actions linking artistic production to other social concerns. Ultimately the group fell apart owing to the political fallout from Stalinist policies abroad and anticommunist sentiments at home. Yet the American Artists Congress demonstrated, if only for a brief period, the potential of a national cultural alliance.

In recent decades we have witnessed similar efforts: the Art Workers Coalition, the Alliance for Cultural Democracy, the Union for Democratic Communication. On the whole these groups have failed to garner the economic resources or membership support necessary to have much impact. In part this has been a factor of their inability to coherently convey their own messages; in part it has resulted from self-containment within the arts community.

Pedagogical Imperatives

Establishing a coalition requires, first of all, a belief in its possibility. We should recognize the pedagogical character of our task. Antonio Gramsci wrote that "every relationship of 'hegemony' is necessarily an educational relationship." In this context he was not simply referring to the form of teaching that one commonly associates with the classroom. Gramsci was describing the larger process through which citizens are socialized to recognize and validate power. This process infuses all components of the social apparatus: the office, the church, the museum, and particularly the school. If we think of these institutions as sites of political persuasion, then Gramsci's theory of education becomes significant. Obviously, we are always in a process of learning. Therefore pedagogy encompasses such diverse activities as parenting, filmmaking, architecture, and storytelling.[12]

Following Paolo Freire, Henry Giroux and Roger Simon have used the term "critical pedagogy" to add a self-reflexive dimension to this broadened notion of learning. Critical pedagogy "is a concept which draws attention to the pro-

cess through which knowledge is produced."[13] By extension this includes an analysis of what kinds of thinking are legitimated in teaching, as well as the discursive relations and power configurations that enable the process. In other words, critical pedagogy seeks to help people locate themselves socially and politically. One might describe this as a framework for political organizing. As such it can be practiced by cultural workers on many levels, from legislative activism to institutional intervention to the creation of specific artworks. Moreover, it can be used as a means of helping people to decode the mendacity of the mass media so that they can make informed decisions—whether at the grocery store or in the voting booth.

But enacting this critical pedagogy requires material and institutional support. A measure of political organizing is needed to obtain these resources. The basic tool of democracy is the ballot. Through voting and lobbying we can enact public policy to mitigate social inequities. In this respect the task of motivating both voters and legislators is also an educational one. The market has shown that it cannot be counted on to represent the interests of all citizens equally. Government must create the means to do so. Cultural workers need to convey this to politicians and their constituencies. Beyond articulating specific grievances, the message should contain concrete proposals for structural change. Recently Don Adams and Arlene Goldbard called for the reinstatement of such federal programs as the Roosevelt era Federal One project (which incorporated the Federal Theater Project, the Federal Writers Project, and similar publicly supported programs in all arts) or the cultural components of the more contemporary Comprehensive Employment and Training Act (CETA) program.[14] Such entities could function as corollaries to the Independent Production Service (IPS), the newly created $6 million federal program that provides support for innovative work in film and video. The IPS was developed after producers demonstrated to Congress that the Corporation for Public Broadcasting was not filling the needs of independents and minority constituencies. That the IPS could be brought into being is evidence that such structural revision is indeed possible.

On an institutional level, cultural workers should identify sites of maximum tactical value. Conventional school itself is one of them. For many years artists' residencies provided ready access to classrooms. Unfortunately, in recent years opportunities for residencies have become fewer and fewer as conservative policy makers stress the primacy of "professional" teaching. On the other hand, the conservative educational reform movement has called for a reorientation of certification along lines of subject matter expertise (rather than educational training), making it easier for artists with BFA or MFA degrees to become teachers.

For those inside the system the task is often difficult. Conventional schooling begins the process of depersonalization and control by fragmenting knowl-

edge into categories and units of measurement. Not only are the relationships between different kinds of knowledge removed, but learning is conceived as something that occurs only in a school and at a specific point in one's life. In these and other ways schooling interpellates teachers and students within what might be termed "official culture." Students are expected to respect this major instrument of socialization, even though it often denies the legitimacy of their own desire, knowledge, and cultural heritage. From secondary to postsecondary years the emphasis shifts slightly to occupational training and credentialing. Still, there is a normative path of full-time study at accredited colleges or trade schools for those with the inclination and financial wherewithal. Older students, part-time students, working students, or students in nondegree programs feel a subtle (or sometimes not so subtle) stigmatization.

Although college and university instructors encounter some of the same restrictions as their colleagues in grade school and high school, they generally suffer less curricular scrutiny and are more able to implement change. If they teach art or writing, they are also more likely to have contact with other practitioners. Unfortunately these instructors are bound by a greater emphasis on vocational preparation, for either the commercial sector, the art world, or the academy itself. In addition, this system has its own set of debilitating rules. Teachers in virtually all formal settings are limited by the bureaucratic controls of increased standardization, performance rating, and advancement regimens.

As with other cultural workers, the most critical problem facing activist teachers in the arts is the lack of a viable structure of mutual support. This is the reason radicalism is often localized within individual classrooms. Organizations like the National Art Education Association (NAEA) and the National Education Association (NEA) are unable to formulate coherent policies because of the size and complexity of their memberships. Although they appear to provide forums for divergent viewpoints at various national and regional meetings, their overarching function is the homogenization of interests into a generalized position of advocacy. They act as pseudocoalitions that neutralize activism and difference. The College Art Association, Society for Photographic Education, Society for Cinema Studies, University Film/Video Association, and other organizations for teachers in colleges and universities suffer many of the same shortcomings.

A classic example of this leveling approach can be found in *Focus on the Arts: Visual Arts,* a newly issued publication from the NEA and NAEA, which attempts the paradoxical task of reconciling liberal and conservative curricular theories. Author Don L. Brigham initially offers a critique of discipline-based art education, arguing that it "would unintentionally reduce or eliminate the essential quality of art while attempting to vivify, strengthen, and extend it in our schools."[15] As a remedy Brigham would reintroduce notions of experiment and play, but only in the context of a byzantine quantification procedure (i.e., a

twenty-point evaluation form scoring the way each student "detects and depicts an object's major gestalt form," "depicts analogous/metaphoric memory imagery," etc.).[16] He rationalizes this as an inevitable response to school board empiricism. As a result, students continue to be measured and ranked, while broader problems of art education go unchallenged.

Given the difficulty within the mechanisms of formal education, it is fortunate that a broad range of options exist. These fall under the rubric of popular education. More a generalized category than a specific type of schooling, popular education encompasses the range of informal social formations that have replaced the clubs and coffeehouses that nurtured grassroots learning in past centuries. Some contemporary antecedents include community centers, local history societies, participatory research groups, health collectives, worker study programs, camera clubs, media access facilities, and other educational entities that people engage in after their formal schooling. Considered as a whole they form a very important social and political resource. Moreover, "student" participation is generally voluntary and without direct economic motivation. This is exactly the type of organization in which genuine culture can develop.

Worldwide, many linkages of political movements have developed through popular education in the modern era. Examples include the folk high school movement in Denmark, the Gaelic League in Ireland at the turn of the century, the Antigonism movement of the 1930s in Nova Scotia, and, more recently, the Highlander Folk School in Tennessee.[17] During the last two decades Highlander has become an international focal point of popular education, providing a range of national and regional workshops on such topics as community organizing, literacy development, environmental activism, and cultural production. The axioms of Highlander are to "learn from the people and start education where they are" by educating "people away from the dead end of individualism into the freedom that grows from cooperation and collective solutions."[18]

Rather than seeking simply to relieve the suffering of the Appalachian poor, Highlander's goal is to harness their potential capabilities. Although Highlander was instrumental in bringing the trade union movement to Tennessee in the 1930s and the civil rights movement several decades later, the organization eschews a single ideology. As Tom Lovett explains, Highlander was deliberately vague in articulating its governing concepts: democracy, mutuality, and concerted community action. It allowed "time and the people to define them more precisely. It quickly learnt that ideology, no matter how firmly grounded in objective reality, was of no value if it was separated from a social movement of struggling people."[19]

Due to the dynamic quality of these social movements, the content as well as the form of education changes in the popular context. Philip Wexler explains:

A mass educational politics implies, if not a single, unitary movement, then a popular articulation that directs attention to the fact that the common practices of these movements are what we now historically mean by education. Any popular educational movement now requires collective work to press toward articulation and realization. Not only will new sites of social communication need to develop, but even the goal of universal enlightenment will be historically redefined. The meaning of literacy in an information, semiotic society is not only that the artefacts (television, microcomputers, telecommunications) are new, but that the social relations to the artefacts also change. A new enlightenment aim of contemporary popular educational movements is consciously to appropriate and use various knowledge practices for collective aims.[20]

The labor movement has long recognized the importance of education both as a tool for membership development and as a way to improve the quality of workers' lives. As Wexler suggests, labor has also learned that in the technocratic era of multinational capitalism it must reach beyond traditional definitions of "workers'" issues. One of the most visible of these programs is the Bread and Roses Cultural Project of Local 1199 (the 100,000-member Drug, Hospital, and Health Care Employees Union). Bread and Roses uses artists and artwork to promote a broad range of issues of both direct and indirect relevance to working people. In 1986 the organization sponsored the nationally touring exhibition *Disarming Images: Art for Nuclear Disarmament* of paintings, prints, and photographs made to protest the arms race. In addition to providing a much-needed venue for political artists and a positive publicity vehicle for Local 1199, the exhibition demonstrated the interrelationship of two movements often considered separate. By combining activism for both peace and labor, the exhibition exemplified the sort of coalition that progressives need to consider.

Recently Bread and Roses issued a videotape based on a musical review performed for health care workers and patients in the New York City area. The script for *Take Care* (1989) evolved from workshops at which 1199 members discussed their lives and jobs. This material was then crafted into songs and sketches and performed during lunch breaks at hospitals and nursing homes. Like the *Disarming Images* project, *Take Care* is not a direct exercise in union advocacy. Rather than preaching the benefits of organizing, the tape presents a collage of overlapping concerns ranging from job burnout to AIDS education. As such it fashions an image of a complex subjectivity in which commitment to various social issues exists simultaneously. Without privileging any one position, *Take Care* says that one can be a leftist, a humanist, a feminist, a person of color, and a worker at the same time. This is the essence of coalition politics.

It should go without saying that cultural workers have another pedagogical resource waiting to be activated in nearly every city. The national network of

over four hundred visual artists' organizations and media centers holds dramatic potential for popular education. In the current fiscal climate, these organizations are often under considerable financial strain and in need of invigorating programs. Unfortunately, those who run artists' spaces have been reluctant to become involved in education, partly because the National Endowment for the Arts discourages it. A similar prohibition against "amateur" activities has stymied community involvement. (The NEA visual arts and media arts programs consider their mandate to be the service of "professional" artists and producers.)

Nevertheless a few groups have circumvented this prohibition by either disguising their educational projects or funding them through other sources. The well-received exhibition *Out of the Studio: Social Education through Art* at Brooklyn's Minor Injury Gallery this year demonstrated the elegance with which student projects might grace an artists' space. Comprising the collaborative efforts of over two hundred children from fifteen New York art classrooms, the exhibition allowed young people to voice their own concerns about poverty, crime, and homelessness. More important, it also demonstrated the ability of youngsters to work together in a process of social critique. One notable project resulted in a book entitled *Why We Do and Don't Learn* (1988), in which the students of Brooklyn junior high school teacher Maria Asaro discussed their own relationships with institutional learning. According to Asaro, since "the book served as a vehicle for the students to make a critical statement about themselves and their school, afterwards it was important for them to realize they had a responsibility to both."[21]

Ultimately, this is where the processes of cultural production, education, and democracy intersect: where citizens recognize their own involvement in formations of power. This is not a realization that comes easily, because so many elements conspire to frustrate the process. The corporate consolidation of the mass media and the alienation people feel from government promote a belief in the intractability of the status quo. The task for cultural activists, as always, is to convince citizens that this isn't so. Many of the tools we need to accomplish this mission (such as popular educational venues) are already at our disposal; we are in danger of losing others (like artists' organizations and media centers); still others (conventional schools) are waiting to be appropriated and transformed. Forging this vision is simply a matter of faith.

Notes

1 William H. Honan, "Arts Dollars: Pinched as Never Before," *New York Times,* 28 May 1989, sec. 2, 1.
2 Ibid.
3 Patrick J. Buchanan, "In the War for America's Culture, the 'Right' Side Is Losing," *Richmond News Leader,* 24 June 1989.

4 Ernesto Laclau and Chantal Mouffe, *Hegemony and Socialist Strategy: Towards a Radical Democratic Politics,* trans. Winston Moore and Paul Cammack (London: Verso, 1985), 189.

5 Carole S. Vance, "The War on Culture," *Art in America* (September 1989): 39–45.

6 Samuel Bowles and Herbert Gintis, *Schooling in Capitalist America: Educational Reform and the Contradictions of Economic Life* (New York: Basic Books, 1976), 20–26.

7 Laclau and Mouffe, *Hegemony,* 190.

8 Fred Glass, "Toward a Morphology of Labor Video," *Afterimage* 17, no. 2 (September 1989): 12.

9 Allan Sekula, quoted in Richard Bolton, "Notes on 'Canadian Notes,' " *Afterimage* 15, no. 7 (February 1988): 13.

10 Greg Sholette, "The New Angst: For George Grosz," *Upfront* 12/13 (winter 1986–87): xxxviii.

11 Matthew Baigell and Julia Williams, eds., *Artists against War and Fascism: Papers of the First American Artists' Congress* (New Brunswick: Rutgers University Press, 1986), 47.

12 Henry A. Giroux and Roger Simon, "Popular Culture and Critical Pedagogy: Everyday Life as a Basis for Curriculum Knowledge," *Boston University Journal of Education* 170, no. 1 (1988). Reprinted in Henry A. Giroux and Peter McLaren, eds., *Critical Pedagogy, the State, and Cultural Struggle* (Albany: State University of New York Press, 1989), 236–53.

13 Ibid.

14 Don Adams and Arlene Goldbard, "Social Studies: Public Policy and Media Literacy," *Independent* 12, no. 7 (August/September 1989): 36–38.

15 Don L. Brigham, *Focus on the Arts: Visual Arts* (Washington, D.C.: National Education Association, 1989), 13. Discipline-based art education is an approach to teaching introduced by the Getty Center for Education in the Arts. It seeks to legitimize the place for art within elementary and secondary school curricula by stressing measurable methods of art appreciation and technical imitation. It was first outlined in *Beyond Creating: The Place for Art in America's Schools* (Los Angeles: Getty Center for Education in the Arts, 1985).

16 Ibid.

17 Tom Lovett, "The Challenge of Community Education in Social and Political Change," *Convergence* 2, no. 1 (1978): 47–48.

18 Ibid.

19 Ibid.

20 Philip Wexler, *Social Analysis of Education: After the New Sociology* (New York: Routledge and Kegan Paul, 1988), 183.

21 Maria Asaro, quoted in David Trend, "Multiple Choice," *Afterimage* 17, no. 1 (summer 1989): 19.

Ann Cvetkovich

Video, AIDS, and Activism

Some of the most persuasive claims for the transformative possibilities of cultural politics have come from theorists and activists (many of whom function as both) involved in combating the AIDS crisis. Of central importance in the struggle against AIDS has been the insistence that, because AIDS is not simply a medical or scientific problem but also involves a crisis of representation, it demands not only political activism but what Douglas Crimp has called "cultural activism."[1] In its simplest sense "cultural activism" refers to the work of gathering and disseminating information—in this case drawing attention to the inadequacies of government and medical policies and educating people about the prevention and treatment of AIDS. In the absence of a cure for AIDS, the dissemination of information is one of the only ways to save lives. But the term "cultural activism" also makes a stronger claim about culture's role in political activism, challenging the assumption that issues of representation or discourse are secondary to the problem of finding a medical cure or changing government policies.

Cultural activism includes books like Simon Watney's *Policing Desire: Pornography, AIDS, and the Media* (1987), which shows how responses to AIDS have been mediated by the cultural construction of sexuality, and especially of homosexuality.[2] Watney argues that the government's failure to respond to the health crisis is inextricably bound up with institutional structures that enable the scapegoating of certain groups, such as homosexuals, people of color (especially those in the third world), prostitutes, and IV drug users. Therefore, transforming ideologies that enable this scapegoating is just as important as transforming the health care system.

Cultural activism also includes the analysis and critique of representations of AIDS. Such work is carried out in books like *Policing Desire* and Douglas Crimp's collection *AIDS: Cultural Analysis/Cultural Activism* (1988), Cindy Patton's *Inventing AIDS* (1990), and in videos like Pratibha Parmar's *Reframing AIDS* (1988), in which Watney and others discuss how homophobia and racism affect images of and responses to AIDS.[3] This work examines why AIDS activism

attends to sexual politics and contends that the sex-positive imagery that has been produced by ACT UP and other groups, far from being a pleasurable luxury, is central to the job of addressing the cultural assumptions that have resulted in an inadequate response to AIDS.

To talk about cultural activism, then, is to expand and redefine definitions of politics and activism. Strategies for cultural activism go beyond simply providing information; they include the analysis and critique of how representations and information are produced and attention to the form in which information is presented, not just to its content. Much of the safer-sex information distributed by mainstream organizations, even when it is accurate, is very clinical, or implicitly condemns "promiscuity" and promotes monogamy, or emphasizes heterosexual practices to the exclusion of the particular needs of gays and lesbians. In contrast, for example, Gay Men's Health Crisis' Safer Sex Shorts (1990–) not only provide information about safer sex but eroticize it, acknowledging that telling people to use condoms may be useless if the presentation doesn't address the fear that safer sex interferes with sexual pleasure. AIDS activism thus questions not only whether the truth is represented but how truth is represented, and suggests that to be effective information must be both true and persuasive to its audience.

AIDS Demo Graphics (1990), Douglas Crimp and Adam Ralston's compilation of the graphics that appeared in conjunction with ACT UP's first three years of activity, amply demonstrates the complexity and importance of cultural production.[4] To ACT UP, demonstrations are not only "direct actions" but forums for theater and performance. Understanding AIDS as a crisis of representation, ACT UP intervenes in the media both by seeking and getting mainstream media attention and by producing its own alternative media. Crimp and Ralston refer to *AIDS Demo Graphics* itself as an instance of cultural activism, introducing the book as follows: "This book is intended as a demonstration, in both senses of the word. It is meant as direct action, putting the power of representation in the hands of as many people as possible. And it is presented as a do-it-yourself manual, showing how to make propaganda work in the fight against AIDS." They claim authority to speak about ACT UP's graphics not as critics but as activists who are part of the movement that they chronicle. Furthermore, they stress the fact that the images reproduced in the book must be understood within the context of their use; the accompanying commentary thus documents the history of the demonstrations in which the materials were used, rather than, for example, locating the material within a history of art.

Crimp and Ralston also argue that the graphics are complicated signs that condense information into effective slogans and images. They expand the term "direct action" further by using it for the work of explicating images and slogans that appear on ACT UP's buttons, posters, and T-shirts. Describing the famous "Silence = Death" logo, for example, they suggest that its power con-

sists in its ability to provoke questions about its meaning rather than in the clarity or fixity of one meaning.[5] "And it is the answers we are constantly called upon to give to others—small, everyday direct actions—that make Silence = Death signify beyond a community of lesbians and gay cognoscenti."

AIDS *Demo Graphics* also makes clear that if the notion of cultural activism involves a redefinition of the political, it also requires that culture be redefined. Crimp and Ralston emphasize that the value of AIDS activist graphics resides not in their aesthetic power or formal complexity but in their effectiveness as part of the political movement to combat AIDS. Displaying material about AIDS within a museum or gallery is not the same thing as reproducing text and images on T-shirts, buttons, and posters. Very few of the images that appear in AIDS *Demo Graphics* first appeared in galleries or conventional art institutions. Success within the art world is not the primary goal of artists working within the context of AIDS activism, and communicating only to an art audience is a limited accomplishment. Thus, cultural activism involves rethinking the identity of the artist as well as the role of production, distribution, and audience in determining a work's significance.

In the interest of looking more closely at the complex meanings and manifestations of cultural activism, I want to consider how the videos in the series *Video against* AIDS (1989) and the work of ACT UP's DIVA-TV (Damned Interfering Video Activist Television) function as means to a variety of ends, as tools that must be understood within the context of their uses. Organized by John Greyson and Bill Horrigan for Video Data Bank, *Video against* AIDS is a compilation of a vast array of videos produced between 1985 and 1989. The collection makes the work relatively cheap and accessible. It reflects the broad variety of responses to AIDS, drawing together documentaries and formally innovative works and chronicling organized protests and personal reactions. The tapes address a variety of audiences, such as gays, lesbians, people of color, and women—audiences that may or may not overlap, need different information, and respond to different formal strategies. Acknowledging the fact that AIDS is a multifaceted problem, the series does not assume that all of the videos serve every audience.

The organizers of *Video against* AIDS designed the series to be used as a form of activism. They arranged the videos under topics such as Discrimination, AIDS and Women, Mourning, and PWA Power, and the pamphlet they distribute with the series encourages those showing the tapes to experiment with other combinations according to the needs of each audience. Assuming that the videos will be shown selectively, the pamphlet authors recommend a total viewing time of about an hour and suggest that programs be limited to four or five videos in order not to strain the audience's attention span. The pamphlet also suggests topics for follow-up discussion, emphasizing that this activity is as important as watching the videos, and it stresses the need to encourage

audiences to act on the information they receive by getting involved in AIDS organizations. The success of the series, then, is seen to depend on the audience developing an active relation to the material rather than simply on consuming it passively.

My discussion below focuses as much on the process of showing selections from Video against AIDS to specific audiences as on the videos themselves, in an effort to examine how screening tapes as a form of activism works in practice. It is easy enough for me in my capacity as "cultural critic" to deconstruct the opposition between culture and politics, but it is another matter entirely to follow through on that gesture in practice. Despite elaborate explications in many arenas of the complex relationship between culture and politics, the mainstream art world still sees itself as transcending political interests while the scientific community and government institutions are reluctant to consider how ideology and discourse mediate their discovery and representation of the "facts." Within activist groups such as ACT UP the distinction between culture and politics reemerges whenever cultural work is seen as secondary to the work of "real" politics or "direct action." And, as I will elaborate further, even audiences aware in theory of the inseparability of culture and politics tend to distinguish between documentary and nondocumentary films by claiming that the former are politically engaged while the latter are less immediately activist.

Drawing from my own experience with the Video against AIDS series, as well as with DIVA-TV's *Target City Hall* (1989) and *Like a Prayer* (1991), and the Safer Sex Shorts produced by Gay Men's Health Crisis, I'd like to consider four different kinds of video activism: (1) the use of video within educational institutions such as classrooms and academic conferences; (2) the use of video within activist groups, such as ACT UP; (3) the use of video and visual materials within mainstream cultural institutions, such as museums and galleries; and (4) the use of video as a form of alternative cultural institution or site of alternative representations. Broadly speaking, the first two strategies involve a redefinition of politics, bringing activism into the university and bringing educational and cultural materials into activism; the second two strategies involve a redefinition of culture, transforming existing cultural institutions in order to make them more activist, and enabling cultural production outside of institutional contexts. Used in a classroom or gallery, AIDS videos can turn a cultural event into a political event. Used within conventional political circles, visual materials can make it possible to turn political events into cultural events.

My experience with using AIDS videos as a form of activism began over a year ago. Armed with copies of Video against AIDS and DIVA-TV's *Target City Hall,* I arrived at the Institute on Culture and Society, an annual weeklong conference organized by the Marxist Literary Group, held in 1990 at the University of Delaware. Most of the conference participants are graduate students and faculty members in the humanities with an interest in cultural theory and a com-

Still from *They are lost to vision altogether* (1989) by Tom Kalin. Courtesy of Video Data Bank, Chicago.

mitment to Left politics. The topic for 1990 was cultural activism, and I had arranged to lead a session on AIDS activism, with the aim of prompting discussion about the connections and differences between AIDS activism and other forms of political organizing with which the conference participants might be more familiar. I was also interested in introducing the issue of AIDS, gay and lesbian politics, and the politics of sexuality into a forum that tends to focus on political economy and class to the exclusion of other categories of political and cultural analysis.

I showed the group *Target City Hall,* which focuses on ACT UP/New York's March 1989 demonstration at City Hall, in order to provide an example of ACT UP's direct action tactics and its alternative media production. To address the role of sexual politics and gay and lesbian politics in AIDS activism as well as of avant-garde or formally innovative cultural practices, I also screened John Greyson's *The AIDS Epidemic* (1987), Isaac Julien's *This Is Not an AIDS Advertisement* (1987), and Tom Kalin's *They are lost to vision altogether* (1989).

The response to *Target City Hall* was generally positive, but the other videos proved much more controversial. Criticism of the latter group of films generally took the form of complaints that the films were inaccessible either because they were too formally difficult or obscure or because they were too narrowly directed at a gay and lesbian audience. Both of these criticisms are based on the assumption that a video that works only for a specific audience, whether defined in terms of cultural literacy or in terms of sexual identity, is limited or flawed. Faults found with *Target City Hall* similarly focused on specificity: ACT UP was too white, too middle-class, and too urban, so its demonstration tactics appealed only to a particular group. Whereas I had expected the discussion to focus around the tactics particular to lesbian and gay AIDS activists, I found myself persuading people that the videos might be instructive for *them* and that they were so by means of a politics of representation.

The uneasiness produced in particular by Julien's and Kalin's work seems to me to emerge from a subtle but nonetheless quite real homophobia, which takes the form of a displacement onto other audiences. By invoking a hypothetical straight and potentially homophobic "mainstream," audience viewers were able to claim that while they themselves were not disturbed by the videos' overt representations of homosexuality, others might be alienated. Both at this screening and at a discussion of the same videos after a screening at a graduate student conference on cultural studies at the University of Texas, the audience of progressive academics and activists assumed that they were not the intended audience for the videos because they were already informed about the issues they raised. I think this perception is problematic, since it reproduces an elitist distinction between those who are in the know and those who are not, and it ignores the possibility that a screening of such films within an academic context is itself a "real" political or cultural event.

The viewers were reluctant to position themselves as straight viewers of a gay-identified video and to explore the specific ways in which the videos were inaccessible. A potentially interesting discussion of how images of gay male sexuality are threatening to straight audiences was foreclosed by the assumption that because the videos depended on a discourse that privileges the gay viewer, they were not relevant to nongay audiences. The relative inaccessibility of a work designed for a particular audience to individuals outside of that audience is just as likely a symptom of homophobia as it is a sign of the work's failure. To assume that a video that treats gay and lesbian sexuality openly will not speak to heterosexual audiences is to assume that heterosexuality functions independently of homosexuality and that homosexuality is only of importance to gay audiences.

While professional academics see themselves as already informed and thus tend to speak on behalf of some putative audience other than themselves, college students often respond more directly about their own perceptions of the videos. This spring, in a course on feminism and mass culture, I showed students *Doctors, Liars and Women* (1988), Jean Carlomusto's and Maria Maggenti's documentation of the ACT UP/New York women's protest against *Cosmopolitan* for printing an article with misleading information about heterosexual women and HIV transmission, followed by *They are lost to vision altogether.* I showed the videos in conjunction with a unit on women's fashion magazines, intending to foster a discussion about feminist responses to mainstream media. The students found the documentary engaging and instructive (many of them knew very little about AIDS and almost nothing about AIDS activism), and none of them seemed disturbed by the fact that many of the activists in the video were openly lesbian. Once again, though, *They are lost to vision altogether* proved more problematic; not only did students argue that

Still from *They are lost to vision altogether* (1989) by Tom Kalin. Courtesy of Video Data Bank, Chicago.

the film was too gay and thus not appealing to straight audiences, but some disliked what they saw as the MTV-style editing, because they thought it made the video too trendy or too superficial.

These cases demonstrate the difficulty that many audiences have with politically engaged video that is not documentary. Furthermore, documentary is assumed to provide a transparent account of information and facts; all of the audiences seemed confident that the message of videos such as *Target City Hall* and *Doctors, Liars and Women* was self-evident and not really subject to differing interpretations. Rather than needing to "read" the videos, they assumed that they could talk about the videos' content without worrying about how the information was mediated by the form.

This assumption played a role in the responses to videos that appeared to be more formally complex, such as *This Is Not an AIDS Advertisement* and *They are lost to vision altogether.* By conflating accessibility and truth and assigning a positive value to them, viewers could resist the work of interpretation that Kalin's and Julien's formal choices highlight. What these audiences failed to see is that the politics of Julien's and Kalin's projects in part depend on the rejection of traditional documentary style. Both seek to address the loss and grief experience by the gay community in the context of AIDS and to reconstruct and maintain the possibility of desire and sexuality in the face of the homophobia so exacerbated by the AIDS crisis.

In *This Is Not an AIDS Advertisement,* the repeated images of water, of gravestones, and of two men holding flowers provide a moving and lyrical acknowledgment of death and loss. In the second half of the video, the words "Feel no guilt in your desire" appear as text on the screen and as the refrain of the lyrics on the soundtrack, juxtaposed with images of men altogether. The video creates an emotional mood, seeking to stimulate fantasy and desire as powers that can combat death and homophobia. *They are lost to vision altogether* contrasts documentary representations of AIDS from the mainstream

188 Ann Cvetkovich

media with more lyrical and erotic images of gay male sexuality, as if to revive and celebrate the desires rendered invisible by the homophobia of the mainstream media. Both videos treat desire and fantasy as central to the politics of AIDS and use nondocumentary forms to provide pleasure.

One way to encourage audiences to read the form as well as the content of video is to challenge their assumption that documentary is a "truthful" form. For example, DIVA-TV's documentaries challenge the form they mimic by reframing mainstream media representations. Both *Target City Hall* and *Like a Prayer* incorporate footage from news coverage of the protests they document in order to demonstrate the biases and omissions in the media's accounts. Thus, in addition to providing alternative information, the videos critique not only mainstream representations of AIDS and activism but representation itself. Furthermore, part of the power of the DIVA-TV documentaries is their ability to convey the emotional and libidinal appeal of a demonstration. Raw footage of demonstrations is carefully edited and accompanied by a musical sound track that enables the video to reproduce some of the emotional power and immediacy of the event itself. These videos are not simply documentaries; borrowing from the techniques of music videos, they work as a kind of advertisement for activism, chronicling the planning of the demonstration and its aftermath in ways that are seductive as well as instructive.

There is, then, less distinction than there might first appear to be between the AIDS videos that use the documentary form and those that seem more formally complex. There is as much to be learned from *They are lost to vision altogether* as from a more conventional documentary, especially because it questions the apparent truthfulness of images. For example, superimposed over an image of two men fucking is text that reads, "Why only white bodies?" forcing the viewer to question not only what is shown but what isn't. "Avant-garde" films like *They are lost to vision altogether* must be seen as political, not merely as artistic statements, if the political and cultural issues related to AIDS are to be fully understood.

The difficulty of "reading" nondocumentary videos and the complexity to be found in documentary and activist images suggest that the materials cultural activism produces can play a crucial role within as well as outside of the political movement that generates them. Videos and other texts can be used for self-criticism and analysis, providing examples of the multiple perspectives and approaches people bring to fighting the AIDS crisis. Videos can educate activists with the group about the politics of representation; screenings can effectively address issues that are difficult to raise without seeming too theoretical or too analytical. Video can serve as a vehicle for the kind of analysis for which there is often little time within the context of planning demonstrations and actions. Thus culture is an intimate part of political struggle, not merely the theory that describes it from above.

Video is also a crucial means of direct action. It can be enormously useful to carry a camera as a nonviolent but nonetheless potent "weapon" during a demonstration to document or to fend off violence or harassment. This spring, for example, ACT UP/Austin used a video camera to document committee hearings about AIDS bills being proposed in the Texas state legislature. The committee members were visibly unsettled by the camera's presence, which seemed to register opposition and surveillance more powerfully than the presence of protesters did.

Videos like those of DIVA-TV extend the life of a demonstration beyond the attention of those who were present at the event. They also make it possible for activists to share resources. In Austin, for example, ACT UP/Austin has screened the DIVA-TV videos and GMHC's Safer Sex Shorts at events such as the March on Austin for Lesbian and Gay Rights and at benefit parties. Video helps to draw attention to the local ACT UP group's activities as well as to inform and engage its audiences. In some places video activism substitutes for collective activism; in Eugene, Oregon, where there is no activist organization, Michael Kroetch decided to use a Fisher-Price® camera to make a fifteen-minute AIDS education tape, *This Is Not a Condom* (1990).

Video and print cultural activism also plays an important role in providing forms of intervention within traditional cultural institutions. In some ways, the more "arty" videos may work better than documentaries for cultural events that are not explicitly political. In the Video Drive-In evenings organized by Kate Horsfield in Central Park in the summer of 1990, Julien's *This Is Not an AIDS Advertisement,* Kalin's *They are lost to vision altogether,* Ellen Spiro's *DiAna's Hair Ego* (1989), and Gran Fury's *Kissing Doesn't Kill* (1990) spots were shown along with videos without an overt political message. Because of the visual characteristics of the AIDS videos, they meshed well with the other works on the program, at the same time presenting important information. Like the videos, *AIDS Demo Graphics* both serves an important function for activists, providing a historical account of ACT UP/New York's activities, and accommodates those interested in art by presenting ACT UP's graphics as examples of visual design.

The work of questioning the distinctions between culture and politics and between documentary and nondocumentary political video also involves questioning the tendency to evaluate different political goals according to their relative urgency or priority. My desire to investigate the complex questions involved in defining cultural activism stems in part from my experience of how divisive AIDS activism can become when people disagree about what constitutes direct and indirect action or long-term and short-term goals. Most AIDS activists agree that no single response to the AIDS crisis can work on its own; a variety of tactics that address a variety of communities must be used. In practice, however, when decisions must be made, distinctions such as those

between politics and culture often reappear—and often give priority to the former.

Such dichotomies are at present proliferating among groups like ACT UP, whose members are feeling pressure to choose between gay and lesbian politics as opposed to AIDS activism, or between the concerns of gay white men as opposed to issues specific to women or people of color. One of the most significant transformations for gay and lesbian AIDS activism within the last year has been the proliferation of Queer Nation groups across the country, inspired by an affinity group within ACT UP/New York that quickly grew large enough to function as an autonomous organization. Queer Nation's agenda is to focus more directly than ACT UP does on gay and lesbian politics, although its style, direct-action tactics, and membership owe a great deal to ACT UP. It is not coincidental that Queer Nation appeared at the same time that ACT UP groups were experiencing serious divisions over issues of race and gender, conflicts that raised questions about the limitations and specificity of ACT UP's focus on AIDS and/or the concerns of white gay men. Such conflicts also led ACT UP/San Francisco to split into two groups, with the newly formed ACT UP/Golden Gate focusing on AIDS treatment and data issues and the original group combating AIDS within the context of a coalition politics that addresses concerns about race, gender, and sexuality. At stake in these tensions are different conceptions of what constitutes primary and secondary issues, narrow and broad agendas, and direct and indirect tactics.

These divisions, which often result in an apparent dwindling of numbers and financial resources, have received various interpretations from activists involved. In May, in an open letter declaring the group to be in crisis, Peter Staley cited as the reason for ACT UP/New York's difficulties its inability to sustain internal criticism and tensions, caused by well-meaning but misguided activists interested in turning ACT UP into an "ideal grassroots social movement." Staley suggested that a caucus within ACT UP interested in linking the AIDS crisis to the war in the Gulf was spreading the group's energies too thin and claimed that the urgency of the AIDS crisis precluded giving attention to certain long-term goals. He argued that "defeating racism, sexism, and homophobia will take decades at best, and become a never-ending fight at worst. Successfully countering the anti-abortionists or America's imperialist tendencies will take more time than people with AIDS have."[6]

ACT UP, like any direct-action group, must always contend with the need to both focus energies on specific targets and combat the many-faceted AIDS crisis on a variety of fronts. Yet attempts to claim that one issue is more urgent than another are problematic. Staley's analysis of ACT UP's tensions assumes that those members who have AIDS or are HIV-positive have different goals and motives than those who are not. Citing a "rift . . . between those of us who joined as a matter of survival and those who joined seeking a power base from

which their social activism could be advanced," he implies that the pressure on ACT UP to attend to "broader" issues of race and gender or U.S. foreign policy comes largely from those members who are less immediately affected by AIDS and thus less invested in treatment and data issues. Such distinctions, however, cannot be easily made. Staley's letter suggests the importance of not only acknowledging but examining the specificity of ACT UP's agenda and membership. For example, just as the fact that the majority of the group's members are white, middle-class, male, and gay need not mean that its concerns are necessarily narrow or exclusionist, at the same time neither does it mean that ACT UP can relieve itself of the necessity of examining and struggling against structures of racism, sexism, and homophobia.

In a recent article in the *Village Voice,* Robin Hardy asks whether AIDS activism is forgetting gay men in its rush to tackle the problem of other social groups hard hit by AIDS. He cites as problematic the "de-gaying" of ACT UP/New York, for which he finds evidence in negative responses within the group to using the pink triangle in the AIDS demonstration against President Bush last summer and to the "I Hate Straights" manifesto distributed during the Gay Pride March last year.[7] Hardy problematically pits gay politics against race and gender politics, claiming that the latter issues emerge and take over when ACT UP seeks to address heterosexual women and people of color affected by AIDS. He neglects to consider that these issues might well be emerging from within ACT UP's gay membership itself, whether from lesbians or from gay men of color. As Cindy Patton has suggested, the failure on the part of AIDS activism to form successful coalitions between gay and lesbian groups and organizations of people of color is cause for concern. The links between AIDS and other issues, whether gay and lesbian politics or race and gender, will never disappear, and the close ties between gay and lesbian politics and AIDS activism within ACT UP might well be taken as a positive and productive connection rather than as a potential distraction.

In fact, the strongest evidence against Staley's and Hardy's belief that ACT UP must renounce certain struggles in order to devote its attention more specifically to AIDS might well be the work of lesbian activists, who have been a crucial presence within ACT UP from its inception but whose intimate connection to the struggle against AIDS has not necessarily been motivated by concern for their own physical health. This work is exemplified by the book *Women, AIDS, and Activism* (1990), produced by the ACT UP/New York Women and AIDS Book Group.[8] Like *Video against AIDS* and *AIDS Demo Graphics,* the book not only describes activism but performs it, aiming to reach both other activists and those who seek information about women and AIDS. The variety of material about women and AIDS fills a previous huge gap in available AIDS information, which has all too often lacked any consideration of gender difference.

The book implicitly addresses the issue of women activists' participation

in ACT UP and also addresses the particular concerns of prostitutes, women of color, women in prison, and IV drug users. Some of the essays articulate personal experiences of women with AIDS, who must become the "experts" about their position, given the lack of information available from institutional sources. Articles by the women in ACT UP suggest that even when they are not addressing AIDS as people with AIDS (PWAs), AIDS may still have a profound impact on their experience. Their commitment to AIDS activism suggests that they share multiple and overdetermined affinities that in specific instances reach across differences of race, class, gender, and sexuality. In her essay "AIDS and Politics: Transformation of Our Movement," Maxine Wolfe discusses ACT UP's presence for her as a vehicle for political action. Her comments echo Ann Northrop's unapologetic claim, in *Target City Hall,* that if she has been guilty as a lesbian of "exploiting AIDS," it has been in order to use AIDS activism to combat homophobia, empower women, and legitimize lesbianism. Other essays consider the relations between feminist politics and ACT UP, making it possible to link ACT UP's activities to other political interventions against the health care system.

The variety of audiences and concerns addressed by *Women, AIDS, and Activism* suggests that ACT UP's lesbian activists are often acting simultaneously on behalf of themselves and on behalf of groups other than themselves. Rather than their choosing one issue over another, their commitment to lesbian and gay politics likens them to gay men and their commitment to feminism links them to other women. Their contributions to ACT UP complicate the easy distinctions that Staley and others make between gay men or PWA activists and those who act in solidarity with them. Furthermore, the information the book provides about safer-sex practices specifically for lesbians should not be considered less urgent than information for other groups, just because the number of reported AIDS cases among lesbians has been lower. The equation of safer-sex practices with condoms assumes that all sexual activity is focused around penises, whereas information about dental dams, so frequently absent from safer-sex material, should presumably be of interest to heterosexuals as well as lesbians. Preventing lesbian invisibility is not strictly a lesbian concern; it also guards against the assumption that AIDS is a problem specific to any one group.

By emphasizing the integral role of women in ACT UP, *Women, AIDS, and Activism* makes it difficult to be reductive about the identity of the group or its activities. Similarly, the tapes in Video against AIDS are necessarily not unified in any straightforward way, and thus exemplify and enable coalition politics. Just as the distinction between culture and politics should be challenged, so too must simplistic distinctions between direct and indirect action and long- and short-term goals be resisted, since as the relations between, for example, gay and lesbian politics and AIDS activism suggest, it may not be possible to distinguish between primary and secondary goals or between more and less

important activists. To dismiss certain cultural products or certain groups as less than central is to prescribe in advance the nature of a political movement that must always adapt to change.[9]

Notes

1 See Douglas Crimp, "AIDS: Cultural Analysis/Cultural Activism," in *AIDS: Cultural Analysis/Cultural Activism* (Cambridge: MIT Press, 1988), 3–16.

2 See Simon Watney, *Policing Desire: Pornography, AIDS, and the Media* (Minneapolis: University of Minnesota Press, 1987).

3 See Cindy Patton, *Inventing AIDS* (New York: Routledge, 1990).

4 See Douglas Crimp and Adam Ralston, *AIDS Demo Graphics* (Seattle: Bay Press, 1990).

5 See also Douglas Crimp, "Mourning and Militancy," *October* 51 (winter 1989): 3–18; Lee Edelman, "The Plague of Discourse: Politics, Literary Theory, and AIDS," *South Atlantic Quarterly* 88, no. 1 (winter 1989): 313–14.

6 Peter Staley, "ACT UP: Past, Present and Future." Letter distributed at ACT UP/New York meeting, May 27, 1991.

7 Robin Hardy, "Die Harder: AIDS Activism Is Abandoning Gay Men," *Village Voice* 36, no. 27 (2 July 1991): 33–34.

8 ACT UP/New York Women and AIDS Book Group, *Women, AIDS, and Activism* (Boston: South End Press, 1990).

9 Video Against AIDS is distributed by Video Data Bank, School of the Art Institute of Chicago, 37 S. Wabash Ave., Chicago, Ill. 60603. *Target City Hall* and *Like a Prayer* are distributed by DIVA-TV, ACT UP/New York, 135 W. 29th St., New York, N.Y. 10011. Safer Sex Shorts are distributed by Gay Men's Health Crisis, 129 W. 20th St., New York, N.Y. 10011.

Dateline 1996: This Is Not the End

I'm happy to see this article reprinted precisely because of its inevitable datedness. Only five years after its original publication, it marks what is already the past, a time when the sick friend for whom it was written was still alive and when AIDS activist culture was flourishing. In that moment of crisis, it was urgently important to document not only those dying but a rapidly evolving political movement in order to satisfy both activist and psychic needs, which, as Douglas Crimp has eloquently argued, shouldn't be mutually exclusive.[1] It is hard to believe that when this publication appears, we will be marking the tenth anniversary of the founding of ACT UP. My article has retroactively come to signify a period of activist intensity whose end I could not then foresee.

Some things haven't changed, though. I still teach the materials that I wrote about in 1991, and if their lessons constantly evolve in relation to the circumstances of the present, then my original argument that activist video's meanings are contextual continues to be confirmed. In 1996, for example, DIVA-TV's videos serve as a document of an activism that is not part of my undergraduate students' lived experience. Sending them to ACT UP meetings and demonstra-

tions (in Austin at least) is no longer one of my pedagogical goals. This spring, one of my most accomplished students studied most of the material discussed in this article for an independent course about the culture of AIDS. In addition to being well versed in cultural theory, she had activist experience with Austin's Lesbian Avengers. I was surprised to discover, however, that she had almost no previous familiarity with the cultural legacy of ACT UP. I have to remember that a twenty-one-year-old is unlikely to know about activism that took place when she was sixteen, and even if documentation exists, it only continues to circulate through ongoing activist efforts. For this reason alone, I continue to teach *AIDS Demo Graphics* (1990), *Target City Hall* (1989), *Like a Prayer* (1991), *They are lost to vision altogether* (1989), and Crimp's "Mourning and Militancy" in courses ranging from The Politics of Sexuality to Introduction to Literary Criticism. This spring, students in the latter course made a point of telling me that they were grateful to have the problem of AIDS become part of their classroom experience.

Along with the materials discussed in my 1991 article, I have recently been teaching Gregg Bordowitz's video *Fast Trip, Long Drop* (1994), which challenges the documentary form from the vantage point of a post-activist HIV-positive aesthetic of depression.[2] Crimp's claim that we should not overlook the work of mourning in our zeal for militancy is not lost on Bordowitz, who insists on his right to be cranky and depressed and refuses to be a heroic role model. The activists of the late 1980s are now reckoning with the existential dilemma of confronting activism's limits; it has not provided a cure for AIDS, nor has it staved off the grief caused by the death of friends or, in Bordowitz's case, his own prospective death. As Jean Carlomusto points out in the video, the activist documentaries of an earlier period have taken on new meanings, as the footage that once offered proud testimony of a robust and angry resistance becomes a memorial that depicts the dead. AIDS activist video has become our archive.

Activist video is intended primarily for the present; it incites and sustains activism, providing an audience of its peers with the information and inspiration needed to get out into the streets, the classroom, and the dominant media. Video activism is so new that we are only now in a position to see how it can be used to create an activist archive, which is often a difficult task because of the ephemeral nature of activist materials. The challenge is to ensure that activist history never becomes dead history; it must be actively integrated into the lives of its audience. The history of activism offers testimony that because activism has happened before, it can happen again. I am literally a child of the 1960s, someone whose conception of that decade's activism was profoundly idealistic because I was too young to participate in it directly. It was only many years later, during the college campus South African divestment activism of the mid-1980s, that I realized that the demonstrations and marches I had attended

in my adolescence weren't simply some pale imitation of the past, and that the present was as real as it gets. Although for some people AIDS activism provided a first heady experience of grassroots power, for me it was a forceful reminder that new forms of activism always arise. At a recent conference on feminism, Angela Davis urged the younger women in the audience not to be nostalgic for past generations of resistance and not to be daunted by failure.[3] Just as breaking up with your lover doesn't mean that you'll never fall in love again, she argued, the end of a movement, however bitter and divisive it might be, shouldn't mean that you reject all forms of activism. The links between love and activism are painfully real for many AIDS activists, who, faced with the deaths of so many friends and lovers, have found the energy for falling in love and the energy for protest equally difficult to sustain.

Even when their members aren't dying, activist groups come and go, reaching a peak for a few years and then mutating into other forms. ACT UP has inspired many other groups, including Queer Nation, Women's Action Coalition (WAC), and the Lesbian Avengers, each of which has waxed and waned (and sometimes waxed again) in many different locations, each with its own complex and specific history.[4] A history also remains to be written about how participation in ACT UP and AIDS activism has influenced an entire generation of cultural workers, whose work continues to blur the boundaries between art and activism, even when it is produced individually rather than collectively. From some of the most interesting artists represented in the Video against AIDS series—Tom Kalin, Isaac Julien, Pratibha Parmar, and John Greyson—have come works such as *Swoon* (1992), *Young Soul Rebels* (1991) and *The Darker Side of Black* (1993), *Khush* (1991), and *Zero Patience* (1993). The women and lesbians whose AIDS activism is documented in *Women, AIDS, and Activism* and *Video against AIDS* continue to be a powerful force. It is important to understand the ongoing influence of AIDS and activism on the work of artists such as Ellen Spiro, Catherine Saalfield, Jocelyn Taylor, Maria Maggenti, Sarah Schulman, and Jean Carlomusto, to name just a few.[5] At the same time, we must live with the fact that indispensable projects such as David Wojnarowicz's *Close to the Knives* (1991) and Marlon Riggs's *Black Is, Black Ain't* (1994) will not be part of an ongoing body of work.

The story of how the late 1980s and early 1990s came to constitute a crucial moment in the history of U.S. queer cultures is beginning to be told. The 1993 Whitney Biennial included an AIDS time line, and the 1995 New York Lesbian and Gay Film Festival featured a three-part program of AIDS media produced between 1985 and 1990 (curated by Cynthia Chris with Peter Bowen) that included many of the videos discussed in this article. Alexandra Juhasz's recently published *AIDS TV* (1995) provides an invaluable history of AIDS activist video, especially because Juhasz herself was directly involved with the scene she chronicled and because she understands the need to analyze activist

video in terms of its production, distribution, and reception.[6] Video Data Bank continues to market Video against AIDS, a compilation that represents a key period in AIDS activist history and whose accessible format is even more of an asset as time goes by.

I wrote this article as one way to do something useful during a time when my life was structured around daily visits with my friend Skip in the hospital. It's a piece I wrote for him as a way of resisting, in both the good and bad senses, his death, and I was happy that it was published quickly enough that it didn't have to carry that familiar "in memory of" acknowledgment. I was glad that he liked the article and that he helped it to reach a nonacademic audience (including the night nurse at the hospital who Skip was convinced had a secret crush on me). So many of us now have works that are inextricably intertwined with the deaths of our friends and lovers. They are not a transcendent legacy but a testimony to the presence of death in our lives. In *Rat Bohemia*, Sarah Schulman writes that "AIDS is not a transforming experience. . . . There is nothing to be learned by staring death in the face every day of your life. AIDS is just fucking sad. It's a burden. There's nothing redeeming about it."[7] I understand the danger of fictions of redemption, but I also know that the experience of death has transformed me because it has profoundly affected me. Those of us who do not die of AIDS will continue to serve as witnesses.

Along with its value for activism, the material about which I wrote continues to have pedagogical purposes in the university, even for those students who may never become members of any grassroots cause. One activist lesson I've learned is not to underestimate what may appear to be modest gains; ACT UP's ubiquitous Silence-Death logo provides endless room for class discussion, not least because there are always some students who have never seen any kind of pink triangle before. We do not have enough tools to transmit even the very recent past when it is not part of an official history, and the invaluable documents provided by *AIDS Demo Graphics, Women, AIDS, and Activism,* and Video against AIDS make it easier to keep activist history alive. It is not dead memory, but memory that I teach in order to inform the present. Whether I am inspired or depressed, and I know these cycles of feeling well by now, this archive helps me to locate myself in relation to a history that is not past as long as AIDS continues to mark us.

June 1996

Notes

1 Douglas Crimp, "Mourning and Militancy," *October* 51 (winter 1989): 3–18.
2 *Fast Trip, Long Drop* is available from Drift Distribution, (212) 254-4118, 611 Broadway, no. 742, New York, N.Y. 10012. For more on the video, see Gregg Bordowitz, "Boat Trip," *American Imago,* 51, no. 1 (spring 1994): 105–25, and Cynthia Chris, "Documents and Counter-Documents," *Afterimage* 22, no. 4 (November 1994): 6–8.

3 Conference on Feminist Family Values, organized by the Foundation for a Compassionate Society, Austin, Tex., May 10, 1996.

4 For an account of the Lesbian Avengers' history, see Sarah Schulman, *My American History* (New York: Routledge, 1994).

5 A partial list of works would include the videos *Greetings from out Here* (1993, Spiro), *L Is for the Way You Look* (1991, Carlomusto), and *Bodily Functions* (1995, Taylor); *Positive: Life with HIV* (1995, Saalfield); the feature film *The Incredibly True Adventures of Two Girls in Love* (1995, Maggenti); and Sarah Schulman's books *People in Trouble* (1990), *My American History* (1994), and *Rat Bohemia* (1995).

6 Alexandra Juhasz, *AIDS TV: Identity, Community, and Alternative Video* (Durham: Duke University Press, 1995). The book includes a valuable videography assembled by Catherine Saalfield.

7 Sarah Schulman, *Rat Bohemia* (New York: Dutton, 1996), 52.

Michael Renov

Early Newsreel: The Construction of a Political Imaginary for the Left

In his introduction to *The Archaeology of Knowledge* (1972), Michel Foucault explores with customary elegance the epistemological foundations of what (in France in 1969) he termed a "new history"; that is, a field of discourse, a historical problematic, constituted not by the divination of continuity, the single horizon line of ideas and traditions, but by a semiosis of discontinuity and its principal parts—threshold, rupture, break, mutation, transformation. Indeed, Foucault's own work devotes itself to the detection and rigorous elaboration of just such interruptions in the surface of a globalized historical narration. For if Foucault's grand project remained the analysis of the regulated and legitimated forms of power, the general mechanisms through which these forms operate, and their continual effects, the locus of analysis was fixed precisely at those points at which power became "capillary" or localized. The object of such microanalysis was the overthrow of history as a distillation of a single will or governing animus in favor of a process of discovery—of a series of subject positions progressively and materially constituted within a concretely differentiated play of psychic and social forces.[1]

To shift the terms of the argument toward the terrain of classical Marxist criticism, Foucault's call for a new history entails a reordering of emphasis from overall determination and the construction of a totalizing model to the play of difference within the historiographic field. The emphasis on rupture and transformation can thus be cast as an act of affirmation, a measured deconstruction of a false metaphysics. Foucault writes:

Continuous history is the indispensable correlative of the founding function of the subject: the guarantee that everything that has eluded him [sic] may be restored to him; the certainty that time will disperse nothing without restoring it in a reconstituted unity; the promise that one day the subject—in the form of historical consciousness—will once again be able to appropriate, to bring back under his sway, all those things that are kept at a distance by difference, and find in them what might be called his abode.[2]

The interrogation of dyadic or rigidly determinist systems of thought, whose structuring and conceptualizing of terms deny their interpenetration and thus their mutually constitutive character, is by no means the exclusive province of the poststructuralist or deconstructive critic. One particularly fruitful direction of such study, generated within a Marxist framework, has developed the Gramscian notion of the hegemonic, that reciprocally confirming yet always contested realm of ideas and values that reinforces the relations of domination and subordination within society. Gramsci's formulation and its elaboration by such critics as Raymond Williams and Stuart Hall, in theorizing a process, a series of articulations within ideology through which class rule becomes internalized while remaining all the while susceptible to contestation, has endowed the traditional Marxist binarism—ruler/ruled—with a suppleness and fluidity adequate to the contradictions of social life. Williams, for his part, has urged an adjectival usage—the "hegemonic"—as an active inscription of the transformational character of power relations experienced in cultural terms. Writing in *Marxism and Literature* (1977), Williams seems to echo Foucault's abjuration of static or seamless modes of analysis in favor of a critical method that "instead of reducing works to finished products, and activities to fixed positions, is capable of discerning, in good faith, the finite but significant openness of many actual initiatives and contributions."[3] If, as Williams maintains, hegemony can never be singular but is instead "a realized complex of experiences, relationships, and activities, with specific and changing pressures and limits,"[4] informed cultural analysis must seek to comprehend the dynamic, ever-shifting conditions of signification without enthroning process itself as a mystifying continuity.

It is within this framework of debate over the appropriate methods for writing the history of culture that I situate the following examination of a particular variant of political filmmaking that spoke a new language of contestation for the American New Left, as characterized by the film production and distribution organization known as Newsreel. For indeed, the outpouring of radical documentary filmmaking during the last half of the 1960s was only one manifestation of an upsurge of cultural activism in the United States after nearly three decades of retreat. This or any examination of collective efforts to reshape society through cultural intervention during the '60s must take into account the superheated currents of thought and commitment that animated the decade. Such an inquiry is particularly timely given the resurgence of popular and scholarly interest in a decade grown curiously remote despite its storied volatility.

How many of us educators in U.S. universities have encountered, to our boundless dismay, a sea of empty faces when the lecture topic or classroom discussion has turned to the Vietnam War or the mass demonstrations required to stem the tide of institutionalized racism, events of our recent national past?

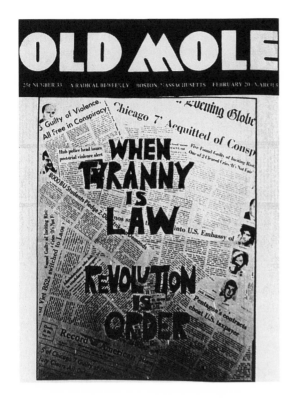

The cover of *Old Mole,*
a 1960s underground
newspaper. Courtesy
of Michael Renov.

Despite the erosion of popular memory and the evacuation of meaning at-
tached to '60s activism, the decade remains a watershed of consciousness for
the post–World War II United States, as evidenced by the recent publication of
an admirable collection of essays and reminiscences entitled *The Sixties with-
out Apology.*[5] The hermeneutic tension that title invokes—namely, what *were*
the '60s and why should we apologize for them—is one that should animate
this discussion.

The references to the privileging of discursive discontinuity and of the the-
orizing of the dynamic of contestation within the hegemonic in contemporary
criticism serve as the preface for my discussion. Instead of investigating the
fertile fields of cultural and textual overdetermination we call Hollywood, I
have chosen to test the outermost edges of the hegemonic through an analysis
of a constellation of oppositional practices circulating around the name News-
reel.[6] The word "Newsreel," like the logo/image that houses it, is assaultive.
Shorn of all qualifiers, it asserts an inaugurating refusal of history or referen-
tiality as its prior, constitutive field. The alternation of logo and black leader, in
conjunction with the audible staccato of machine-gun fire on the sound track,
announces a militancy of filmic intention; the stripped-down trace of author-
ship—Newsreel—stakes a claim for "truth" as a generic ingredient. It is my

intention here to chart the terms of Newsreel's oppositional trajectory during the first two years of its existence, from late 1967 through 1969, by an interrogation of its conditions of existence, a brief analysis of two exemplary texts, and a positioning of its shifting functions within the culture of resistance it helped to forge. For despite the tremendous flux of membership within the groups in question, the geographical separations,[7] and the ideological splits that the singular form, Newsreel, masks and elides, I claim that Newsreel, taken as an ensemble of cultural practices and effects, functioned as a consistent source of projective imagination and psychic legitimation for an isolated movement. In a sense that I will demonstrate, Newsreel occupied a crucial position in the largely unconscious construction of a political imaginary for the New Left.[8]

The development of the productive forces beyond their capitalist organization suggests the possibility of freedom *within* the realm of necessity. The quantitative reduction of necessary labor could turn into quality (freedom). . . . But the construction of such a society presupposes a type of man [*sic*] with a different sensitivity as well as consciousness: men who would speak a different language, have different gestures, follow different impulses. . . . The imagination of such men and women would fashion their reason and tend to make the process of production a process of creation.—Herbert Marcuse, *An Essay on Liberation*

Many times the films of Newsreel, the movement's only organized film producers . . . give us a sense of action taking place, involving us rather than forcing us to involve ourselves; these films make viable situations out of last-ditch, too-late efforts.—John Hunt, *Leviathan*

By 1968, Herbert Marcuse's diligent hopes for the emergence of an "aesthetic ethos"—a new Reality Principle that would invalidate the historic oppositions between imagination and reason, higher and lower faculties, poetic and scientific thought—had been dramatically renewed. Although *An Essay on Liberation* appeared in print in 1969, the book's preface assures us that this distillation of Marcuse's ruminations on freedom predates the protean events of May 1968. Theorizing from within the precincts of late capitalism, Marcuse had come to distinguish between two fundamentally opposed conditions of the working class as the historical agent of social change: the objective element of Marxist orthodoxy whereby labor remained the potential revolutionary class, and its negation, the subjective element, indicative of labor's imbrication within a system of high productive yield and the concomitant satisfaction of the worker's instinctual needs. Given the conservative dynamic of production and exchange, dependent on the exploitation of a marginalized underclass and the satellite states of the third world, Marcuse postulated that the sources of that Great Refusal, which alone could diminish the self-sustaining momentum of the one-dimensional society, were the subcultural elements burrowing from

A radical version of a Bank of America bank draft. Courtesy of Michael Renov.

within. Now the vanguard of oppositional activity was no longer the industrial working class but rather the militant minorities—the urban black, the white middle-class student activist, the hippie, the radical feminist. For Marcuse, the exigencies of the contemporary conjuncture had necessitated an inversion of the traditional Marxist paradigm: material conditions produce consciousness. In this transitional phase of late capitalism, Marcuse could claim: "Under these circumstances, radical change in consciousness is the beginning, the first step in changing social existence: emergence of the new Subject."[9]

Whether or not these countercultural or oppositional groups were in any way "conscious elements" in the revolutionary scenario envisioned by Marcuse, the construction of the "new Subject" was everywhere apparent.[10] A partial chronology of '60s oppositional culture offers a sense of the snowballing of cultural resistance by mid-decade through organizational tactics (sit-ins, demonstrations, peace vigils) and emergent expressive forms (the be-in, the happening, guerrilla theater, the underground press, free-form radio). It was through the agency of the latter grouping—the forms of the "new culture" in efflorescence from 1966 to 1972—that an embryonic subjecthood began to form. Such a fictional unity was the font of identity for a constituency whose cultural dispossession was, for the most part, self-willed. (It has become a sociological commonplace that the leadership of the New Left was comprised primarily of the children of privilege. Among the major campuses that experienced occupations, only San Francisco State departed from the model of the elite educational institution, falling out of step with the overseers of the future, e.g., Columbia, Berkeley, Harvard, and Cornell.) This resistance culture

sounded a call to arms; like Newsreel, these avatars of the new consciousness embraced negation. Note, for example, the frequency of conventionally repellent appellations as the stance of militant self-exclusion by the underground newspapers *The Old Mole, The Berkeley Barb, The Carbuncle Review, Rat;* the New York anarchist action group Up Against the Wall, Motherfuckers; the radical feminist Women's International Terrorist Conspiracy from Hell (WITCH).

Here we can distinguish that sense of joyful self-discovery present in every revolutionary moment's seizure of language and the selective appropriation of preexisting forms. The essential mode of nascent revolutionary discourse remains bricolage, a heterogeneous blend of *ursprache* and linguistic elements recruited through inversion or whimsy. For example, one of WITCH's earliest public pronouncements, appearing in *Rat* (15–28 November 1968), took the form of the conjuration of a sacred matriarchy: "In the Holiest Names of Hecate, Isis, Astarte, Hester Prinn and Bonnie Parker, we *shall* return."[11] A 1969 wall calendar created by the Students for a Democratic Society (SDS), advertised in the pages of *Rat,* evinces nothing less than a reinscription of the historical canon; annotated dates of particular interest included January 1 ("Victory of Cuban Revolution—1958"), February 4 ("Black student sit-in movement began, Greensboro, North Carolina—1960"), April 29 ("Columbia University shutdown—1968"), and October 12 ("Indians discover Columbus—1492"). In the words of the SDS ad: "The rest are a surprise."[12] As advertised in the *Village Voice* in the first half of 1968, the program of Newsreel films to be screened each Saturday night at 10:00 at the Film-Makers' Cinematheque included guerrilla newsreels and actualities, the latter a term certain to evoke the Brothers Lumière and their founding efforts in the predawn of cinema. Again, one detects the impulse toward a transvaluation figured through the reinscription of history and the cultural practices embedded within it.

In her 1965 essay, "One Culture and the New Sensibility," Susan Sontag describes the function of all modernist art as "shock therapy for both confounding and unclosing our senses," a corrective to what she calls the "massive sensory anaesthesia" of the postindustrial age.[13] By the late '60s, significant splits within the new sensibility were evident, with the more politicized factions engaging in confrontational art activities. Some political art-warriors devoted their talents to heightening the implicit contradictions of commercial art beyond the limits of containment. An anonymous art collective known only as the Eyemakers produced a form of political super-graffiti based on the principles of photomontage. By juxtaposing shocking or invasive imagery of ravaged Vietnamese women and children or tear gas–bearing troops with advertising images familiar from the visual repertoire of consumer culture, the Eyemakers forced the glossy promotional appeals to self-destruct beneath the weight of a viscerally experienced disjunction. This was guerrilla art to suit the Marcusean

injunction: "Every person an artist!" In a do-it-yourself explanation appearing in a March 1968 *Rat,* the Eyemakers encouraged mass replication of their own art act: "For a couple of cents invested in some old magazines, you have available to you all the resources which cost Madison Avenue millions of dollars and years of research to produce." In clear violation of copyright and trademark laws, the Eyemakers' posters were available only by mail or, for a time, at the New Yorker Bookshop in Manhattan. Never daunted, the Eyemakers expressed in their manifesto the revolutionary zeal and street slyness of the late-'60s cultural guerrilla: "They'd have to stop producing ads, they'd have to stop printing magazines; there'd have to be no scissors left in the land to stop collages."[14] The militant art maker of the late '60s shared the confrontational rhetoric of the political leadership, choosing to overthrow the structure-in-dominance or self-destruct in the process. In the words of *Rat* editor Jeff Shero, used as a voice-over commentary in Newsreel's film *Summer '68:* "If we do our job right, we're going to either be put out of business by the cops or go under financially. That's what it should be all about. That's guerrilla journalism." In all, this was how Jonas Mekas summed up Newsreel in 1968: "February: First screening of newsreels produced by the Newsreel group (organized late in December 1967)—the most important new development in the American cinema."[15]

Such acts of cultural intervention as those of the Eyemakers were active and intended as participatory. For its part, *Rat* printed a special "Chicago" edition (August 1968) intended as a manual for the well-informed street fighter; a year later, its preview of the Woodstock festival included directions on how to transform one's own copy of *Rat* into a rain hat via a few simple folds. I would argue, however, that, insofar as representational rather than "live" or face-to-face modes of interaction were concerned, the new subjectivity was most dramatically shaped and galvanized within the visual regime most conducive to the complex plays of projection, introjection, and identification—that is, the cinema. Judging by the prevalence and enthusiasm of film reviews appearing in the major organs of the underground press in these years, the movement population never lost its Hollywood habit, while remaining true to the art cinema of its bourgeois intellectual roots. The same newspaper that featured a column called "Blows against the Empire," chronicling the latest minor victories in the heartlands of America, was perfectly capable of running a serious review of *The Detective* (1968), a Frank Sinatra cops-and-robbers vehicle. It was no simple matter to reeducate the radical intellectuals, to wean them from visual pleasure to agitation and propaganda. Thus, the earliest mentions of Newsreel in the underground press are clearly marked as "hard news" rather than as coverage of the cultural scene.

Indeed, the original statement of purpose published by Newsreel speaks of

the need for a radical news service as an alternative to television news. The founding mandate called for low-profile reportage and analysis collectively assembled from the fieldwork of committed young filmmakers. A certain naïveté prevails in early Newsreel's "production for use" ethos, as evidenced by the pronouncements promising the distribution of films within a week of their completion. In fact, three types of news films were to be made: short newsreels for weekly release; longer, more analytic documentaries; and informational or tactical films.[16] Yet there was from the first an unformulated ambivalence with regard to questions of mediation or principles of filmic construction. Clearly, there was a perceived need for immediate coverage of events from a left perspective, but the call for an alternative to "the limited and biased coverage" of the mass media offered no programmatic principles that could contribute to a reconceptualization of standard film and television practices. The very effects that broadcast television had traditionally celebrated as its claim to journalistic superiority over the print media—immediacy, emotional impact, and accessibility—were to be recycled, in unreconstructed form, to serve radical aims.

Bill Nichols, a preeminent authority on early Newsreel by virtue of both a master's thesis and dissertation on the subject, has posited a barometric rather than vanguard relationship between the film collective and the movement it served.[17] The New Left in its organizational incarnations tended toward an uneasy vacillation between anarchic pluralism and ultraleft elitism; in neither climate were normalizing working principles likely to emerge. Despite its rhetoric, Newsreel remained, at least until the early to mid-'70s and the emergence of two stable production bases in New York and San Francisco, subject to the personal and political preoccupations of its ever-changing membership. Indeed, a film shot and edited by Newsreel personnel in 1968–69 only received the organizational imprimatur upon completion, subject to consensus approval by the collective. A film, nominally approved yet at odds with prevailing political sentiments, could languish in distributional limbo with few prints struck. This was the case with Norm Fruchter and John Douglas's *Summer '68* (1969), which was judged "too cerebral" by the Newsreel majority in the summer of 1969.[18]

The political current of the late '60s dictated a concerted self-effacement of authorship, which we see in the collectivized anonymity of such sister organizations as the Eyemakers, the San Francisco Mime Troupe, or Newsreel. Indeed, it is only in recent years that early Newsreel members have acknowledged primary responsibility for films that were intended as "authorless texts," the New Left mythic equivalents of the emanations of the Lévi-Straussian "*pensée sauvage.*" But strong rifts appeared within the New York membership, in particular over the uneven distribution of craft skills and experience, with previously established independent filmmakers like Robert Kramer, Marvin Fishman, Norm Fruchter, Robert Machover, John Douglas, David Stone, and

Peter Gessner—all well-educated white males—finding themselves progressively at odds with a younger, more working class–inflected faction, often feminist or third world in composition. By 1970, the first-generation filmmakers had left New York Newsreel amid the debates concerning correct political lines to be adopted in the wake of accelerating factionalism within the New Left characterized by the dissolution of SDS, the formation of the Weather Underground, and the heightened militance of feminists within movement organizations. By this time, the interpersonal dynamic within the Newsreel collectives in New York and San Francisco paralleled the crisis state to be found elsewhere within oppositional cultural groups; *Rat,* always a Newsreel fellow traveler, had, by January 1970, been purged of its original leadership by militant feminists.[19]

A substantive contradiction is discernible, then, between early Newsreel's stated concern for the conditions of reception, the immediacy and political utility of product, and the relative disregard accorded the conscious theorizing of its filmmaking practices, the engendering of a viable aesthetic consistent with the political aims of the group. The early Newsreel self-conception was, instead, embedded within a thoroughgoing "romanticism of the barricades" evident around the world during 1968 and 1969. Here was an exuberant militancy that envisioned cameras as machine guns and Newsreelers as *Marvel Comic* heroes, slamming celluloid bullets into the belly of the beast. In a legendary turn of phrase appearing in a 1969 *Film Quarterly* interview, Newsreel's Robert Kramer spoke of the need for films that "explode like grenades in people's faces or open minds up like a good can opener."[20]

The Newsreel approach constituted a conscious inversion of the Hollywood paradigm in which millions are invested in production values with no regard given to establishing a context for informed spectatorship or structured response. The entertainment film, paragon of the disposable culture, was thus the antithesis of Newsreel's socialist utopian vision: "Films made by the Newsreel are not to be seen once and forgotten. Once a print goes out, it becomes a tool to be used by others in their own work, to serve as a basis for their own definition and analysis of the society."[21] But for all the sober talk of the films as tools for analysis, Newsreel and its mythic auto-construction provided the occasion for forays into revolutionary imagination. From *Rat*'s 1969 coverage of an evening of Newsreel's work at the State University of New York at Buffalo we read: "At the end of the second film, with no discussion, five hundred members of the audience arose and made their way to the University ROTC building. They proceeded to smash windows, tear up furniture and destroy machines until the office was a total wreck; and then they burned the remaining paper and flammable parts of the structure to charcoal."[22] Newsreel, by this account, was less a tool for analysis than an engine of war, fueled by spontaneous combustion.

Judging from the available evidence, Newsreel was, from the moment of its inception, a site of symbolic condensation, a kind of tabula rasa for projections of diverse character. One early and ardent supporter of the Newsreel project was Jonas Mekas, who was instrumental in providing a structured screening outlet and testing ground for new work via the Saturday late-night slot at the Film-Makers' Cinematheque. Newsreel was, in early 1968, sufficiently embryonic in form and political agenda to support Mekas's own utopian aspirations for an avant-garde newsreel expressed in his column in the *Village Voice*. Mekas's pronouncements are worth quoting at length as proof of Newsreel's hold on a broad spectrum of the late '60s creative imagination and of the specifiable overlaps within normally adjacent communities of thought and activity—that of the overtly politicized fabricators of culture and of the artistic avant-garde.

> It is too early to predict where the Newsreel will go. One thing is clear, the newsreel has been for a long time one of the most neglected forms of cinema. Which means that one area of life had been neglected by the filmmakers. I hope that by the time the Newsreel reaches its twentieth issue, it will begin to discover its own contemporary style, technique, form, it will begin to escape the established conceptions of the newsreel— which means, it will begin to escape the established content. I am waiting for the avant-garde newsreel. I see no difference between avant-garde film and avant-garde newsreel, because a real newsreel, a newsreel which could help man [sic] to get out of where he is, must be an avant-garde newsreel, must be in the avant-garde of humanity, must contain and be guided by the highest and most advanced dreams of man.[23]

Indeed, the 1968–69 period, particularly within the hyperactive confines of New York City, was a moment of cultural fusion, a time for reaffirming ties across a range of broadly adversarial idioms of expression. In addition to the Film-Makers' Cinematheque screenings, Newsreel films played at the New York Theater, the New Cinema Playhouse, and the Bleecker Street Cinema during the first half of 1968. The Newsreel logo was visible at venues far and wide, with the films frequently paired with live music for movement fundraisers such as a benefit for the New York High School Student Union at the Bitter End Cafe in February 1969, also featuring the Fugs. Newsreel attended Woodstock, with continuous screenings at the campgrounds adjoining the festival site. *Windflower* (1968), Adolfas Mekas's film about a draft dodger, shared billing with Newsreels #2 and #4 at the 42nd Street Playhouse in February 1968. The temporary fusion of oppositional forms postulated here is graphically figured in an ad that appeared in the *Village Voice* (21 March 1968) announcing a midnight festival of films at the New Yorker Theater to benefit the community-sponsored radio station WBAI-FM. The publicity referred to the

event as a festival of avant-garde and antiwar films, the coordinating conjunction *and* bridging a division all too frequently maintained in less-explosive times.

Such patterns of distribution and exhibition helped reinforce a sense of shared cultural identity, while intensifying political conflicts around the world served to polarize public opinion. The culture of protest was at its confrontational zenith; there could be no middle ground. Louis Althusser, in theorizing the notion of interpellation, has provided us with a valuable tool for analysis; modes of discourse, he tells us, operating within a framing ideological ensemble, mobilize a hailing or beckoning power, a mechanism of psychic identification. The explosion of poster art and related forms of mass image production via the underground press of the period strained toward a culture-wide effect of suture, by discursive strategies such as the use of the first-person plural, the recovery of certain avatars of revolutionary struggle by an act of joyful historical revisionism, or by an emphatic reiteration of shared gesture or bodily linkage—the embrace of arms, the fist raised in solidarity.

Columbia Revolt, Newsreel #14 (1968), was the first authentic success for the film collective; in its first month of release, at least fifty prints were struck of this chronicle of the series of student strikes and building occupations at Columbia University in the spring of 1968.[24] Like so many other Newsreel successes since 1968, *Columbia Revolt* was the right film at the right moment. After repeated viewings, the film still creates the impression of a rapidly assembled, rough-hewn object perfectly suited to its purpose, as though a band of settlers had thrown up a rude battlement in a single night. There is no syncsound in its fifty minutes; indeed, the panoply of voice-overs becomes both the axiom of narration and the orchestrator of tonal values. The strength of the film lies in its sense of an urgency forthrightly conveyed and in its heterogeneity. This is a heterogeneity of voice; of human visage, with the faces of angry young men and women, black and white, the formerly anonymous ones, locked in combat with the powerful men who ruled Columbia and dictated public opinion—the Arthur Hays Sulzbergers and the William S. Paleys; and of visual materials—still photographs mingled with variously lit film footage often bearing traces of physical duress.

But *Columbia Revolt* is also a film of celebration capable of evoking the spirit of a utopian communality. Every activity of life is raised to ritual status inside the occupied buildings: sharing the food that has broken through the line of siege, transforming Low Library into a pleasure zone through music and dance. But the quintessence of this transvaluation is the candlelit wedding of two young strikers, Andrea and Richard, who tell us in voice-over that they had "wanted to be married at home with our family." The ceremony culminates with a benediction that binds together all who, in Marcusean terms, share the will to freedom within the realm of necessity: "I now pronounce that Andrea

and Richard are children of the New Age." At such moments, *Columbia Revolt* beckons toward an imaginary fullness, a cultural plenitude offered as reward for future struggle and as the visible legitimation of present action.

Columbia Revolt performed a dual function—as a self-generated document of struggle and as a source of inspirational renewal. Without question, it succeeded in reinforcing ties of psychic identification and group solidarity for its movement audience; its power to persuade or reeducate an audience beyond the bounds of its prescribed community remained less evident. Norm Fruchter and John Douglas's *Summer '68*, shot during the anxious months of planning and preparation that culminated in the actions at the Chicago Democratic Convention (August 1968) and released the following summer, is a film of radically divergent intent and formal structure. Unlike *Columbia Revolt, Summer '68* never found its audience. An unfavorable response from Newsreel members limited its availability, as did the filmmakers' unwillingness or inability to promote the film on their own.[25]

At a time when the collective was accelerating community outreach toward the previously unorganized and unconvinced—high school students, the working class, third-world peoples—*Summer '68*, a demanding, densely organized self-examination of the movement within the realm of ideas, was a political tool ill suited to the moment. During its fifty-plus minutes, the film explores a series of crises endemic to the movement by the summer of 1968—those of political tactics and alliances, as well as those of organizational structure and leadership roles. But the key to *Summer '68* is its unremitting will to self-scrutiny, its need to probe beneath the facade of the New Left, constructed through an uneasy interplay of mass media distortions and movement self-promotion, to begin to deconstruct the imaginary ensemble of images and ideas that had *become* the movement, arguably to its tangible detriment, and to advance in its stead, through an act of consciousness, a substantive effort toward self-knowledge.

If the film can be deemed a primary text within a New Left discourse entitled "The Politics of Identity," no accusation of solipsism or vain self-indulgence is intended. Rather, *Summer '68* evidences a sophistication of discursive strategy that operates on a principle of separation. Word is often disengaged from image. While a Newsreel-typical blending of participant voices and their multiple perspectives is used to narrate events, black-leadered segments punctuate the image track to underscore the primacy of analysis, that is, to narrate ideas. Moreover, the deployment of narrating voices is a complex one, with at least three distinct levels and usages of voice-over occurring. In the first instance, there are the voices of character-participants within the diegetic frame, the draft-resistance organizers and underground-press editors whose activities illustrate the breadth and seriousness of movement goals. Sometimes these voice-overs exposit or elaborate on the pro-filmic; at other points they offer self-critique or comment on the visual track. When draft-resistance organizer

Frame enlargement of North Vietnamese schoolchildren from Santiago Alvarez's *79 Springtimes of Ho Chi Minh* (1969). Courtesy of Michael Renov.

Vernon Grizzard is invited to go to North Vietnam with other antiwar activists to facilitate the release of captured American pilots, the decision is made to exploit media attention to enhance the prestige of the movement and to offer public proof of its effectiveness. Instead, the role of the movement is effectively annulled by media coverage. Amid the first flush of victory at a bustling JFK Airport upon the pilots' return, press-conference organizers choose to exclude Newsreel from the proceedings. The hoped-for bolstering of movement legitimacy is called into question. Grizzard's voice-over offers a critique of a performance we witness in the cinema verité–style footage of a media encounter shortly after his return: "I was afraid to cross the boundaries of legitimacy. There's no way to be both legitimate and outraged today in America in front of news media. To get up and talk about murder and the death of children and young men—you can't say that." As in this instance, voice-over commentaries of diegetic participants repeatedly reexamine actions and strategies, questioning their limits and utility. One effect of such a secondarizing of the pro-filmic is the dampening of an easy identification.

The second category of vocal narration is comprised of the voices of other unseen activists who comment on the choices and actions of the visible protagonists. A contrapuntal effect is achieved as two separate voices interrupt the sync-sound continuity of Grizzard's press conference with intermittent critical salvos as the image track remains continuous. The first voice says: "You came

on, I thought, very, very cautious, sort of like 'I'm a red, white, and blue all-American boy; I'm not very political. I'm just an organizer in a draft resistance group which has a disagreement with American policy at this point.' " A second voice intervenes moments later, disrupting the predictable rhythm of the media event: "Did it ever occur to you that you oughta say: 'Look, mother-fuckers, this is what I saw in North Vietnam and you're gonna have to kill everybody there before they quit?' " These sound elements illustrate in condensed form the climate of contestation and exchange that enveloped every tactical decision or public gesture.

Finally, there is a level of what could be termed "master narration," achieved through the use of a single, flatly intoned voice—the filmmaker's own. The film does not evince a "Voice of God" authority, an unquestioned omniscience for this level of narration in the manner of standard documentary exposés (note, for example, the use of the voice of the ethical guarantor—Edward R. Murrow, Chet Huntley, Charles Kuralt—in the network-television documentaries of the '60s liberal tradition such as *Harvest of Shame* [1960], *Sit-In* [1961], *Hunger in America* [1968]). Rather, this narrational element achieves its position of mastery by virtue of the greater weight of knowledge and analysis it brings to bear on the issues raised. The classical Newsreel style dictates abrupt, untitled beginnings, often in medias res. In *Summer '68,* the essential terms of the film's problematic are addressed from the very outset through the inauguration of a hermeneutic element that traverses the text. It is the master or metadiscursive voice that presses the interrogation in terms that will evolve in conjunction with the events imaged: how to define the "we" of the movement, how to insure the legitimacy of actions taken in the name of "the people," how to use the lessons of defeat and compromise to make meaningful change in a complex society.

All of this analysis suggests a primacy of the sound track in *Summer '68.* It is therefore important to add that the special attention accorded acoustic elements in no way impedes the development of an image track that, in terms of its diversity of sources and immediacy of impact, is the equal of any of its better-known Newsreel cousins. But it is the layering of commentary and the relationship of sound elements to the structuring principles of the text that make *Summer '68* a richly textured work too long ignored. Norm Fruchter, who recorded sound and codirected, had been a writer of some note before his turn to cinema, both as a novelist and as a member of the editorial boards of such arbiters of contemporary Marxist thought as *New Left Review* and *Studies on the Left.* Although one hesitates to isolate individual contributions within collective endeavors, the sophistication of Fruchter's thought and political insights permeate the text. The final moments of the film offer a dramatic illustration of the potency of effect achieved through the interpretation of word and image: Robert Kramer addresses a crowd of demonstrators on the streets of

Chicago as the end of four days of political engagement draws near. The sudden appearance of troop carriers on Michigan Avenue signals the apogee of confrontational drama. As the camera turns from Kramer to the parade of occupational forces, a kind of visual epiphany or radical defamiliarization occurs. The film becomes, for the moment, a directly transmitted witnessing of history. Refusing the appeal of the unmediated moment, the film returns for the last time to the ceaseless interrogation of historical acts and the meaning they bear for the promulgators of social change.

As the voice-over commentary concludes:

> Once the troops were called out, we thought we'd won. But won what? All we'd managed was a disruption. But we'd fought for days and so many people had joined us that we felt much more than ourselves. For once, we thought we *were* the people. [Sound of communal singing, "This Land Is Your Land"] . . . When we left Chicago to go back to our own communities, our sense of triumph quickly became a memory. What we went back to was the tough, day-to-day work of building a revolutionary movement. And what Chicago finally came to, for us, was the feeling of what it might be like after making that revolution, when anyone could say: "We *are* the people!"

Notes

An earlier version of this essay was delivered as a paper at the conference Hollywood in Progress: The Years of Transition, Ancona, Italy, November 1984.

1 Michel Foucault, *Power/Knowledge: Selected Interviews and Other Writings—1972–1977* (New York: Pantheon Books, 1980), 96–97.

2 Michel Foucault, *The Archaeology of Knowledge* (New York: Harper and Row, 1972), 12.

3 Raymond Williams, *Marxism and Literature* (Oxford: Oxford University Press, 1977), 114.

4 Ibid., 112.

5 Sohnya Sayers et al., eds., *The Sixties without Apology* (Minneapolis: University of Minnesota Press, 1984).

6 With its twentieth anniversary fast approaching (December 1987), Newsreel, despite its many transformations of political strategy and personnel, has remained a fixture of the left-wing film community since its beginnings. The precise itinerary and various incarnations of Newsreel remain the subject for further inquiry; at present, two functioning entities carry on the political activism of the founding movement. California Newsreel (630 Natoma, San Francisco, Calif. 94103) produces and distributes films on work and the changing character of the workplace (including its own *Controlling Interest*, 1978, and *The Business of America*, 1984), in addition to administering the Southern Africa Media Center, featuring the world's largest collection of films on apartheid. Despite its history of privileging distribution over production, Cal Newsreel has begun developing an ambitious new project—an extended critique of media within U.S. society—intended for public broadcast. Third World Newsreel (335 W. 38th St., 5th floor, New York, N.Y. 10018) is a collective that has focused on producing films that "give voice to the voiceless." Since the early '70s, the leadership of Third World Newsreel has been provided by filmmakers of color (mostly women) whose work has offered representations of the struggles of the exploited and the marginalized (battered women, Chinese garment-district workers, Viet-

namese refugees, to name only a few). More recent Third World Newsreel projects have included a series of traveling film exhibitions featuring the work of African, black American, and Asian American cineastes as well as the organization of the Minority Media Development Program, intended as a comprehensive study of the crisis in media production among minority practitioners in New York State.

7 At the height of its oppositional powers in the late '60s, Newsreel could boast offices in New York, Boston, San Francisco, Los Angeles, Detroit, Chicago, and Atlanta; there was a degree of communication and strong familial ties with groups in London, Paris, and Tokyo. Newsreel's film vaults contain at least one film sent from Japan, during the peak period of confrontation, that has never yet been translated or titled.

8 The Imaginary, in its Lacanian usage, is one of the three essential orders of the psychoanalytic field: the Real, the Symbolic, the Imaginary. The latter term refers to a type of apprehension in which the subject constructs a false and, in Lacan's system, a founding unity between self and other, based on some factor of resemblance or homeomorphism. According to Laplanche and Pontalis, the Imaginary implies "a sort of coalescence of the signifier with the signified," a collapsing of difference in favor of a deceptive identification. J. Laplanche and J.-B. Pontalis, *The Language of Psycho-Analysis* (W. W. Norton, 1973), 210.

9 Herbert Marcuse, *An Essay on Liberation* (Boston: Beacon Press, 1969), 53.

10 It should be added that all wholesale labels—the movement, the counterculture, the New Left—are concatenations of disparate elements and tendencies that threaten to self-destruct at every moment. These terms are necessary but inadequate ones; each requires a considerable degree of qualification impossible to offer here. For a valuable discussion and clarification of this problem, see Todd Gitlin, *The Whole World Is Watching: Mass Media in the Making and Unmaking of the New Left* (Berkeley: University of California Press, 1980), 293–96.

11 *Rat* 1, no. 20 (15–28 November 1968): 3.

12 *Rat* 1, no. 21 (3 December 1968–2 January 1969): 15.

13 Susan Sontag, "One Culture and the New Sensibility," *Against Interpretation* (New York: Dell, 1966), 302.

14 *Rat* 1, no. 2 (22 March–4 April 1968): 8.

15 Jonas Mekas, *Movie Journal: The Rise of the New American Cinema—1959–1971* (New York: Collier Books, 1972), 326.

16 Ibid., 306.

17 Bill Nichols, "Newsreel: Film and Revolution" (master's thesis, University of California, Los Angeles, 1972), 73.

18 Norm Fruchter, telephone interview by author, November 3, 1984. According to Fruchter, a founding member of Newsreel, prints were routinely rented to political groups until they failed to return the third film. California Newsreel's present collection contains a major gap owing to the hasty departure of an Iranian student group after the 1978 revolution, with Newsreel films in tow.

19 David Armstrong, *A Trumpet to Arms: Alternative Media in America* (Los Angeles: J. P. Tarcher, 1981), 375.

20 Robert Kramer, "Newsreel," *Film Quarterly* 21, no. 2 (winter 1968–69): 46.

21 Mekas, *Movie Journal*, 306.

22 *Rat* (29 October–12 November 1969): 8.

23 Jonas Mekas, "Movie Journal," *Village Voice* (29 February 1968): 40.

24 Norm Fruchter, telephone interview by author.

25 Ibid.

Maurice Berger

Interview with Adrian Piper

For more than twenty years Adrian Piper has used philoso-
phy and art to interrogate the categories of self and other. Her academic studies
and writings explore the theoretical implications of such categories, while her
artwork forces her audience to recognize how xenophobia distorts them.
Piper sometimes uses her own experience as a catalyst for this critical pro-
cess. In the "Mythic Being" series (1973–75), Piper confounded her own racial,
gender, and class identity, becoming, for example, a working-class black man
in *The Mythic Being: Cruising White Women* (1975). Other works mimic au-
diences' stereotypical reactions to situations involving race. The installation
Four Intruders plus Alarm Systems (1980) places the viewer in a black-walled
booth with four photographs of angry-looking young black men, while Piper's
voice recites responses to the work by "whites," from hostile redneck to whiny,
well-meaning liberal to politics-has-no-place-in-art conservative. The well-
known *My Calling (Card) #1* (1986) is a business card that confronts people
who, not realizing that Piper (or whoever uses the card) is black, make racist
remarks. The desire to help people learn, which animates all Piper's work, is
overt in the 1983 *Funk Lessons.* In this performance Piper invited her audience
to participate in an evening of funk dancing, coaching them in the basic move-
ments and giving a short history of the black American musicians who laid the
groundwork for white rock 'n' roll.
 While studying philosophy at the City College of New York, Harvard, and the
University of Heidelberg, Piper participated in the conceptual art movement of
the late '60s and early '70s. She has taught philosophy at the University of
Michigan, Georgetown University, Harvard, Stanford, the University of Cal-
ifornia at San Diego, and Wellesley College, where she is now a full professor of
philosophy, while continuing to publish, exhibit, and perform internationally.
She has received two fellowships from the National Endowment for the Arts
and, most recently, a Guggenheim Fellowship. Her retrospective curated by the
Alternative Museum in New York City, *Adrian Piper: Reflections 1967–1987,*
has been touring the United States and will be at the College of Wooster Art

Adrian Piper, *Cornered* (1988). Video (produced by Bob Boilen), table, lighting, birth certificate. Photo courtesy of John Weber Gallery, New York.

Museum in Wooster, Ohio, this October. She also had a solo exhibition at John Weber Gallery in New York this September and at Exit Art in New York this October. Her video installation *Out of the Corner* (1990) will be at the Whitney Museum of American Art from October 9 to November 11.—Laura U. Marks

This interview was conducted in Washington, D.C., in May 1990 and subsequently expanded.

MAURICE BERGER: Your most recent work confrontationally, albeit politely, positions its white audience into a process of self-inquiry. An installation like *Cornered* (1988), for example, powerfully suggests to the white spectator that he or she—given the history of miscegenation in America—is, in all probability, black. Through what emotional and intellectual mechanisms do these installations and performances direct the viewer into a constructive self-examination of his or her own racism, sexism, and classism?

ADRIAN PIPER: *Cornered* challenges the white viewer to transcend that deeply entrenched, carefully concealed sense of privilege, specialness, and personal superiority that comes from identifying oneself with society's most privileged group. If we are ever going to move toward a resolution of the problem of

racism, not only in this country but internationally, we've got to overcome the divisive illusion of otherness, the illusion that each of us is defined not just by our individual uniqueness but by our racial uniqueness. The ideology of otherness is a pernicious symptom of the inability to gain self-worth except by differentiating oneself from others implicitly viewed as inferior. It's a false ideology, based on invalid inductive generalizations with a low probability of truth.

In *Cornered* I try to undercut this ideology by exploding the myth of racial separation. Like many works of mine, *Cornered* confronts the viewer with the facts in a way that mirrors any confrontational interaction between people. Since my work establishes a relation between a person and an object, some differences obviously exist. In *Cornered*—where I'm speaking to the viewer from a video monitor—the difference is minimized. The confrontation in these works tends to be difficult for the spectator, because they bring up facts and raise emotions that most people prefer to suppress. When you think about how sophisticated we're all supposed to have become through the influences of the women's movement, the so-called sexual revolution, the Stonewall rebellion, and so on, it's really astonishing how uncomfortable most people—both white and black—still are with the fact of miscegenation, on which the greatness of this country is built! The fact is that there are no genetically distinguishable white people in this country anymore, which is about what you'd expect after four hundred years of intermarrying. And the longer a person's family has been in this country, the higher the likely proportion of African ancesty—bad news for the Daughters of the American Revolution, I'm afraid. When these issues are aired, white people in particular often seem to get very angry and very defensive. They clearly feel insulted by the suggestion, elaborated at length in *Cornered,* that they are probably black.

You would be amazed at how many knowledgeable and sophisticated acquaintances of mine who have seen that work have found some not very subtle ways of personally informing me that *they* certainly have no black ancestry in *their* family! I think this attempt to distance oneself from black self-identification demonstrates better than anything else could the pervasiveness of racism, even among the political cognoscenti. White people have just absolutely got to get over this ugly, prereflexive reaction of feeling defiled, dirtied by the possibility that they might be part black, because the fact of the matter is that they probably are. There just isn't any more room on this planet for these false distinctions between people that are keeping us polarized. The concept of racial difference is nothing but a myth that obscures the real issue, of how best to distribute the limited resources we all have to share, so as to empower the disadvantaged. In this country and others there are many wealthy white families who have aggrandized themselves socially and financially by disinheriting their African American progeny and denying their paternity. If these family

Adrian Piper, *Why Guess* #1 (1989). Two photo-text collages, 36 × 34 inches. Photo courtesy of John Weber Gallery, New York.

relationships were fully investigated, and the prolificacy of white miscegenation acknowledged legally, the configuration of social and economic resources in this country might look completely different—that is, assuming that blacks wouldn't refuse to be associated with those families altogether. Obviously, all this is a very deeply upsetting possibility for some people, since few are really willing to share power once they've wrested it away from someone else. But that's okay. My work often sparks emotional negation and rejection of personal involvement in its viewers, and I've come to expect that. It's just the first step in the process of coming to terms with these difficult facts and emotions. I try to press the issues even further in a new, related video installation, *Out of the Corner*, that will be at the Whitney this fall. These pieces force the viewer through a psychological process; once you are confronted with these emotions and ideas, you must in some way come to terms with them. Typically, the first step is denial. "It didn't happen." Then most people tend to disassociate themselves from the experience. "If it did happen, it is uninteresting and doesn't matter." Then perhaps we rationalize. "It isn't really what it seemed to be, it is more like something else." The parts that don't fit one's picture of oneself can be disregarded.

What is most important to me in this work is that at some psychological level everything we experience gets stored and affects the way we experience the world in the future. When I have confrontational interactions, I go through the process I described. The experience does its work for a long time afterwards. As the ripples smooth out, my behavior is changed in certain ways—even if I don't

credit the unpleasant, shaming, or disturbing experience that is at the root. The next time I'm in a comparable situation, my behavior will be more fine-tuned and I will be better able to respond in a sensitive and considerate way. *That* is the point at which, psychologically, I can allow the process of self-scrutiny to go on at a conscious level. The entire catalytic process takes longer for some people than for others.

MB: So you see confrontation as having a therapeutic function?

AP: Yes. Therapeutic and also catalytic. Change is effected in a person pretty much irrespective of the rational forms of evaluating the experience. The change is not only cognitive but also affective. Or so I would like to think. Part of the recalcitrance of racism to political solutions is because racism is not just a political problem. It's also a personal problem, and it is just as deeply rooted in personal psychology as problems with personal or professional relationships are. Until we are ready to own up to our individual emotional investments in perpetuating racism, we won't be able to move past it.

MB: So these confrontations can get to the psycho-emotional dynamic that is at the core of racism, rather than just address the general issues around racism?

AP: I would like to underline this distinction. It's laudable to depict and analyze issues of racism. But my work really does not function in that way. I actually want to change people. I want my work to help people to stop being racist (whether they ask for that help or not). Just as movies and encounter groups can change people, so, maybe, can my art.

MB: How do mainstream institutions respond to your politically and emotionally charged work?

AP: I'm beginning to see a pattern in the way these institutions deal with my work. When I first produce a work or a series of works, it meets with a vacuum of silence. Within two to five years people start talking or writing about it. Then perhaps seven to ten years later people say, "That was really a very important work." That's the kind of response I started getting in the early 1980s to the "Mythic Being" pieces I did in the early 1970s, and that I'm now getting to the installation pieces—like *Aspects of the Liberal Dilemma* and *Four Intruders plus Alarm Systems*—that I did in 1978 and '80. A process of psychological distancing is going on. As curators and writers retreat spatiotemporally from the immediate site of their confrontation with my work, they become more able to judge it aesthetically. *Cornered,* however, may represent a counterexample. It's just been acquired by the Museum of Contemporary Art in Chicago. This is very unusual, since I almost never sell anything.

In general I'm not exactly holding my breath waiting for unconditional approval from mainstream institutions. I just don't think that's in the cards. Very rarely there may be someone in a position of power in such an institution who has the courage to stick his or her neck out and support my work; but they always risk being punished for breaking rank, and often their stewardship of a

show of my work will be their last curatorial act before leaving the institution completely. I can't count the number of times I've witnessed this curious conjunction of events: they show my work, then they resign or are fired. I'm so naive about these matters. I was brought up as an art student to believe in the redemptive and progressive power of the avant-garde. I thought you were *supposed* to break new ground and push your media in new directions. I keep on needing to be reminded that only certain new directions are institutionally acceptable, and that you're not supposed to push in any direction that might question or change the way those "keepers of the flame" actually live their lives. All that nonsense about keeping art separate from politics is really nothing more than a demand to keep art from intruding into the personal realm, where of course politics reigns supreme in all relations. The demand to keep politics out of art is really a demand to keep art out of real life. But if art isn't allowed to address and transform the conditions of real life, I don't see the point of it. I try to ignore all those neo-Hegelian proclamations about the death of the avant-garde and the end of art history. I think art history itself will be the judge of what all that comes to, two hundred years or so down the road.

MB: Given the racism, sexism, homophobia, and classism of society and culture in the United States—exemplified by the war being waged against cultural producers by the New Right—do you think that artists come into the cultural scene with inherent ethical, moral, and political responsibilities?

AP: I absolutely do. Those who don't recognize these responsibilities are operating as what they call in political philosophy a "free rider"—someone who gets all the advantages and benefits of a moral system but doesn't do his or her part toward contributing to it. Many artists seem to feel that their only responsibility is to "just make the stuff" and leave control of its social interpretation and material fate to others. Others take the view that everything gets commodified and co-opted in the end anyway, so we might as well all just go along with it and enjoy the party. This is a sophomoric rationalization for avoiding the hard questions about how each of us can contribute to making things better for everyone. We all have a responsibility to try to work out these issues. Of course, we won't all come down on the same side, but thinking seriously about the moral consequences of one's actions is part of being a grown-up.

MB: In other venues you have expressed misgivings about the French structuralist and poststructuralist discourses that have pervaded much avant-garde art of the past decade. Can you discuss this?

AP: First of all, the very idea of anyone making art as an illustration of theory defies imagination. Of course people are influenced in their thinking by what they read, and their thinking influences their work. But I just can't believe that anyone makes the art they make solely because of what they read. I don't think that production of art objects can come from intellectual ideology alone, or it's

going to be pretty thin stuff. It may happen more often that people are motivated to make their work by the usual deep, sociocultural drives, and then they adopt the vocabulary of a particular theory that's in fashion in order to talk about it, when that theory fits conveniently with what they're doing. In that case I think the significance of the work is often independent of the significance of the intellectual fashion that contextualizes it. You can have great art by an artist whose theory of what she's doing is completely off the wall. In general I don't think that artists have privileged access to the significance of what they're doing, although they do have privileged access to their intentions in doing it. But even their intentions may be irrelevant to the real significance of the work.

I feel sorry for those artists who got stuck with poststructuralist discourse as a way to explain what they were up to just because it happened to be the fashion of a particular historical moment, because I really think poststructuralism is a plot! It's the perfect ideology to promote if you want to co-opt women and people of color and deny them access to the potent tools of rationality and objectivity. Whereas rationality and objectivity empower us to see clearly and plan strategically, poststructuralist discourses not only deconstruct so-called authoritative texts, they also deconstruct themselves. When women and people of color speak in this language, they render their own positions unintelligible to all but a very small and esoteric community of similarly trained, highly privileged intellectuals. This is self-defeating. Anyone who wants to carry the day intellectually with regard to the analysis of race and gender issues has to be willing to say that racism is objectively wrong. It's not just wrong for me. It's not just wrong for you. It is objectively wrong.

Moreover, you have to be able to explain *why* racism is wrong. In order to make such an argument stick, you have to be willing to use and claim the methods of rationality, logic, and conceptual analysis. Otherwise you end up talking a private language with a few cohorts who probably already agree with you anyway. What a waste of time. Equally fatuous are those deconstructionist/poststructuralist feminist claims about how logic and rationality are intrinsic expressions of the male lust for power and domination, so that in order for us to be good feminists we should all just talk nonsense and baby talk instead. We might as well just take out the guns and shoot ourselves in our collective foot straight off.

MB: But aren't poststructuralist critiques of colonialist and postcolonialist conditions successful exactly because they are questioning, even undermining, the system on its own terms? In effect aren't these arguments turning the tyrannical aspect of discourse—including poststructuralist discourse—back on itself? White theoretical writers and academics who use such discourses without questioning what they are doing are now being challenged by brilliant intellectuals—for example, Edward Said, Homi Bhabha, and Gayatri Spivak—

who speak as oppressed peoples through various autobiographical, analytic, and discursive forms.

AP: I think such writers succeed to the extent that their analyses transcend the arcane tools that are being appropriated. When such analyses get swallowed up into five-clause sentences with a large sprinkling of obscure or neologized three-dollar words, they fail. I take very seriously the claim of some French literary scholars that poststructuralist discourse is intended as a sort of concrete poetry. Ultimately it is not intended to do the work of political analysis. As long as we understand it as concrete poetry, there is really no problem. But if what we are doing is communicating with other people who don't share our views or who have not thought about these issues, then poststructuralism seems to me a self-defeating tool. I trained as an analytic philosopher, and that means that you try to write clearly; arguments are checked for coherence and consistency. I think the guidelines for plain speaking suggested by William Strunk and E. B. White's classic writing primer *The Elements of Style* (1959) are really neat.

MB: As a distinguished philosopher—and now a full professor of philosophy at Wellesley College—how do you reconcile your artistic production with your academic and philosophical work?

AP: For a long time I thought there was not much of a connection between my philosophy and my art. I'm now starting to see many connections. My philosophy work, in fact, provides the broad theoretical underpinnings of my art. There is a very deep connection.

MB: Could you tell me a little more about your philosophical work? Who are some of the philosophers that interest you?

AP: I guess my main influence is Kant, particularly his *Critique of Pure Reason, The Groundwork of the Metaphysics of Morals,* and the second *Critique.* These are my main texts. I studied them as an undergraduate and got brainwashed. I'm very influenced by Kant, but I'm not involved in Kant scholarship at the moment. I expect to be working on Kant's theory of action after I finish up my current project, which centers on metaethics and moral psychology. My greatest influence in this area was my dissertation adviser at Harvard, John Rawls. He wrote a book in the early 1970s called *A Theory of Justice.*[1] It revolutionized ethics and moral philosophy. One feature that makes it unique is that, unlike traditional social contract theory, it develops not only a theory of rights, freedoms, and liberties but also a theory of the distribution of economic and social resources. Rawls basically answers the Marxist demand to talk about material conditions as well as what Marx would call the "bourgeois questions" of civil rights. I'm not myself a Rawlsian; my view, though I am highly influenced by Rawls, is often critical of his theory. I take the Rawlsian project as a model of what a really good moral theory should be. It should have a firm theoretical foundation, but it shouldn't be just abstract. It should have specific

application. It should develop substantive views about a wide range of particular issues.

MB: Could you elaborate on the connection between your philosophy and your art?

AP: This is going to be a long answer, since I must first give you an overview of certain philosophical issues that are important to me now. In my view all moral theory has to presuppose a conception of the self—a picture of the kind of agent to whom the theory applies. That conception is descriptive rather than prescriptive. A conception of the self has two parts: a model of rationality that describes the conditions of equilibrium within the self, and a model of motivation that explains what transforms selfhood into agency. In all contemporary moral theory, whether Kantian, Humean, or Aristotelian in allegiance, the model of rationality is basically the model of utility maximization that is invoked by neoclassical economics. The theory of motivation is basically the Humean theory that says we are motivated solely by desires, and everything we do and think is instrumental to the satisfaction of desires. These two models combined are what I call the Humean conception of the self. I argue in my forthcoming book, *Rationality and the Structure of the Self,* that both of these models are intrinsically defective, that they are plagued by internal theoretical inconsistency. Furthermore, these models can't provide the justificatory foundation for a viable moral theory that has practical application in our lives, because the reasoning by which the theory is supposed to be justified is circular.

In my book I attempt to develop and defend a more workable conception of the self to ground moral theory. My conception is Kantian in inspiration, but unlike other Kantian moral philosophers I draw on the conception of the self that Kant develops in the first *Critique.* In this Kantian conception of the self, the models of rationality and motivation are the same, namely, rational consistency as described in the traditional canons of theoretical rationality. I'm suggesting that we are overridingly motivated to do and to believe what will preserve the coherence of our worldview. In the *Critique of Pure Reason* Kant argues that what is most important to us is a rationally consistent and conceptually coherent theory of the world that enables us to fit every kind of experience we have into a priori categories. According to Kant, if we cannot fit things into those categories, we can't experience them at all; they can't be incorporated into the structure of the self. Even though Kant's formulation is somewhat archaic, I think Kant is right in thinking that we need to make sense of the world in certain broad rational and conceptual terms. It is extremely difficult to take each experience uniquely unto itself, making sense of it entirely on its own, without years of training and discipline in spiritual meditation. And even there what you end up with is not knowledge in the ordinary sense. Information that violates our conceptual presuppositions threatens our belief system and thereby the rational integrity and unity of the self.

We need rationality in order to be unified subjects, but a dilemma arises because our conceptual schemes are invariably inadequate in making sense of the plethora of experience, information, and new phenomena that bombard us daily. As we enter the global community, we are getting new information all the time about ourselves, about other people, about the world at large, about science, and about the universe. It's just too much, and it's all too unfamiliar. The complexity of our world has outstripped our conceptual resources for dealing with it. On the other hand, if we bracket these categories, then we are stuck with confusion and panic at all the anomalies that confront us, and we feel the threat of personal disintegration. So we have to try to maintain the appearance of rational consistency for purposes of self-preservation. This is what I call pseudorationality. We deny some things. We rationalize other things. We disassociate phenomena that are too threatening to be incorporated. We try to shape this unmanageable conceptual input into a neat and coherent view of the world. We do this in science, we do it in politics, and we do it with individuals who are alien to us—people who look different, who talk differently, who don't fit our conceptions of how people ought to be and look. When we see people like this, we try to impose our categories. Then the categories don't work. We get nervous. We try to reimpose the categories, tidying up our conception of the person so that he or she will fit those categories. This is the paradox of human rationality; if we didn't have it, we couldn't function at all. Yet these rational categories are invariably inadequate and insensitive to the uniqueness of an individual.

MB: This paradox then becomes a point of reference for your art, which is concerned with the ways in which we construct our racism, sexism, and classism. Do pieces like *Cornered* or the *Calling Cards,* or the metaperformances such as *Funk Lessons*—works that draw connections between theory and consciousness raising—position us to understand that paradox?

AP: What I like to do in these works, and also in some of the installations like *Aspects of the Liberal Dilemma* and *Four Intruders plus Alarm Systems* is to focus our attention on the defenses we use to rationalize away the uniqueness of the "other." The problem, of course, is that when we come out with pseudorationalizations we're not at that moment being particularly self-aware; we're too busy defending ourselves intellectually against what we perceive to be a threat of boundary violation by the anomalous "other." I find that all you have to do is to echo or depict those defensive categorizations as they are, without too much aesthetic or literary embellishment, in order to generate a certain degree of self-awareness of how inadequate and simplistic they are. I've used this device in a number of pieces, such as the altered picketer's sign that says "THIS IS NOT A PERFORMANCE" in the photo-text piece *This Is Not the Documentation of a Performance* (1976); the installation audio monologues in *Art for the*

Adrian Piper, *Four Intruders plus Alarm Systems* (1988). Installation with four silk-screened light boxes, four audio monologues, and audio music sound track, 6 feet high, 5 feet in diameter. Photo courtesy of John Weber Gallery, New York.

Artworld Surface Pattern (1977), *Aspects of the Liberal Dilemma, Four Intruders plus Alarm Systems, Close to Home* (1987), and *Safe* (1990); the discussion of some people's perceptions of black working-class music as vulgar, unstructured, and meaningless in the collaborative performance *Funk Lessons;* and, of course, the game-theoretic response options I lay out in *Cornered.* I find that the more I search out and target these defenses, the more self-aware the viewer becomes, the more attenuated and irrational the pseudorationalizations become, and the more obvious it becomes that they are stereotypical classifications that are completely inadequate to the complexity and uniqueness of what one is actually experiencing.

My ultimate goal is to make viewers so aware of *all* of those defenses as *pseudorational defenses* that they stop generating them entirely; that they simply stand silently, perceiving and experiencing at the deepest level the singularity of the object or person, knowing in advance that any attempt at intellectualization is going to be invalid, and so allowing their concrete experience to quiet the intellect before it starts poisoning that experience. Anyone who is evolved enough to allow that to happen will have an overwhelming and humbling experience. At that point we can start considering the transformative powers of art and the possibilities of spiritual regeneration. What I really like is

when someone comes up to me after seeing one of these pieces and says huffily, "Well! You've pretty much said all there is to say!" and stalks off. Then I feel we're making real progress.

The more we examine our defensive rationalizations and acknowledge that our stereotypical categories don't fit, the more we will be able to sensitively expand those categories in order to encompass the singular reality of the "other." Such flexibility was something that Kant didn't envision—his idea was that we were just stuck with certain categories. I believe these categories are constantly being redefined and that they are evolving in response to the complexity of information and experiences that confront and overwhelm us. These categories are mutable. The more we learn to guide them consciously, with an eye to achieving certain goals like overcoming racism or understanding the natural world, the more we can evolve cognitively.

MB: I understand what you mean by these Kantian categories, but I am unclear on how you can reconcile Kantian aesthetic theories—purist, universalist, and metaphysical conceptions that are deeply problematic—with your own aesthetic inquiry on xenophobia.

AP: Kant's aesthetic theory is part and parcel of his larger project of giving an analysis of the universally applicable conditions inherent in subjectivity that enable subjects to have objective knowledge, act morally, and make valid aesthetic judgments. As an artist my interest is not in Kant's aesthetics but rather in his metaphysics and epistemology, where he attempts to provide an overarching explanation of how science and objective knowledge in general are possible. But even in examining his aesthetic theory I think it's important to emphasize that Kant is giving an account of the conditions inherent in the structure of the mind that make it possible for a subject to make valid aesthetic judgments. His claims about organization, intentionality, and the sublimity of nature emphatically do *not* stipulate external conditions that objects objectively must satisfy in order to count as art. The very idea of pontificating about the qualities things in themselves must have in order to be classified in this way or that would have been completely foreign to his project. So from the claims Kant makes about the independence of the aesthetic from the cognitive and moral, we can infer exactly nothing about what sorts of objects get to be identified as art. We can have Kantian-style aesthetic experiences of all sorts of things, including agitprop political art, without violating Kantian strictures.

And anyway, what's so wrong with purity and universality? Kant's attempts to isolate for purposes of analysis certain cognitive and affective features that all human beings have in common is not intrinsically offensive. Purity is not the same as elitism, and universality is not the same as hegemony.

MB: Do you think that Kant's universalist assumptions are accurate?

AP: Yes. This is what annoys me so much about the deconstructionists. They ignore much of what we all have in common as human beings, the cognitive

capacities we actually share. Anthropologists, for example, have often analyzed the things that we share. There is an interesting paper by Robin Horton that compares Western scientific theories and the religious systems of traditional African cultures.[2] Yes, there are differences, but there are also many similarities in methodology. It turns out that there are really more similarities than differences.

MB: But didn't Kant's universalist and purist positions offer modernist culture justification for its racism and imperialism?

AP: Of course, any text can be misinterpreted and used to justify all sorts of things, if no one else takes the time to check back and read what it actually says. It is the nature of rationality to provide reasons. The question is whether the reasons are good, whether the theory is sound. The soundness of scientific theories is determined by whether they are well confirmed by the data, make well-confirmed predictions about what should happen under certain conditions, and can account for *all* the data. If you have a theory—we might call this the parochial theory—that can only account for the data within a very circumscribed community, say the community of patriarchal, white males, you will not have a very powerful theory. Too much available data is omitted or left unexplained. It's like developing a theory of the universe that can only account for the apparent revolution of the sun around the earth but doesn't say anything about the planets or galaxies. In order for a theory to be powerful, it must account for all the available data. Sure, if you start out with a parochial theory, you can try to justify it. But that's pseudorationality, not rationality proper. Real rationality includes the recognition of fallibility.

MB: So you believe that Kant was misinterpreted rather than that racism is inherent to the Kantian position?

AP: I think that is absolutely right. The theory that you find in his *Critique of Pure Reason* and in *The Groundwork of the Metaphysics of Morals*—despite their exegetical problems—is quite universalistic in its embrace. That does not mean that Kant himself was not racist, sexist, and anti-Semitic. Indeed, there are other, lesser writings in which he makes known his embarrassing personal opinions. If you look at his primary works, however, his views apply impartially to the whole range of human agents, without respect to race, community, or gender.

MB: Your work is constantly asking questions about gender and class issues as well as those of race. Theoretically, conceptually, and politically, how do you reconcile discourses around questions of race and racism with feminism? In other words, how does racism overlap with sexism? How does this relationship function?

AP: If you look at *Genetic Abstracts* from about 1950 or the work of physical anthropologists and biologists, you find that there are no hard-and-fast biological connections between visual appearance and genetic ancestry. There has

been too much genetic intermixing in the Americas, Europe, and Africa for racially distinct groups to exist. Where do you think curly or wiry hair, swarthy complexions, full lips, or broad noses come from? Why do you think you find those physical characteristics scattered all over the globe, in all peoples and geographical locations? Surely all those "Negroid features" can't each be a genetic mutation? An American who is identified as white, for example, has a completely different genotype than an English person who is identified as white does. The reason for this difference is that Americans have intermarried and miscegenated so much with African Americans that they have a completely different genetic heritage. Similarly, if you look at an African American's genetic heritage, it's completely different from that of a South African or West African black. Racism is not about our actual genetic ancestry. Racism is a *visual* pathology, feeding on sociological characteristics and so-called racial groupings only by inference and conceptual presupposition. Primarily it is an anxiety response to the perceived difference of a visually unfamiliar "other." To the extent that the primary foundation of racism is visual, it is commensurate with sexism. Some people are discriminated against because they have breasts, while others are discriminated against because they have woolly hair. If you happen to have breasts *and* woolly hair, you are in double trouble. We need to understand how these deeply buried archetypes function in our character and personalities, how they engender a sense of security when people look and act as they are "supposed to" and fear and anger when they don't. These perceptual issues are fundamental.

MB: They are also fundamental to your art. Could you talk about how these issues enter your current aesthetic production?

AP: I've been using this very beautiful and iconic image, a photograph by Peter Turnley of a Somalian mother cradling a child in her arms. The mother is clearly poor and undernourished; the child is emaciated, uncomfortable, and obviously in pain. It's very much a substantive, earthy Madonna image—without the spiritual bleaching. It puts a different, more universal spin on the Christian rendering of the same subject matter and makes clear its cross-cultural applications. But what I like about it is that it confronts us simultaneously with our ancient origins in the African mother—that's why I title the various parts of this ongoing project "Ur-Mutter"—and with the ways in which we as Westerners have degraded and defiled both our ancestral African origins and our contemporary African siblings. That is, it is the image and the reproach of our collective racial self-hatred.

To my way of thinking, universality and singularity are opposite sides of the same coin: An individual is defined by a particular conjunction of properties, each of which is universal in its application. A unique individual is one such that only that individual bears that conjunction of properties. A unique image of universal meaning is a unique conjunction of universally applicable proper-

Adrian Piper, *Ur-Mutter #2*
(1989). Photo collage with
silk screen text, 23 × 40
inches. Photo courtesy of
John Weber Gallery, New
York.

ties, at least most of which apply across the universal set comprising all social contexts. I believe that this mother-child icon bears properties applicable across any human social context, regardless of how those properties are further interpreted. I try to expose the unique singularity of this woman and her son by situating the image in a wide variety of such contexts, each of which is individually expressive, but none of which is comprehensive of what she ultimately is. For example, one text I use is "We made you" (*Ur-Mutter #2* and *#5*). That's true; an African Ur-Mutter did make us, but she is more than just our mother. She's also an undernourished and politically oppressed woman, now, who must "Fight or die" (*Ur-Mutter #3, #8, #10,* and *#11*). But even that's not all there is to say, because what she's fighting for is not the guilty gluttony and self-cannibalism that characterize Western culture and that we strive so hard to defend. Thus her reassurance, "Relax. We don't want what you have" (*Ur-Mutter*

#4, #6, and *#9).* And so forth. Exhausting the range of available conceptual interpretations of it is analogous to the process of peeling off one pseudo-rational categorization after another so as to finally leave one with the bare experience of the object itself, which is a universal icon. So a system of permutations has developed out of this single image. I want to expose the viewer to a very wide range of visual and textual contexts in which that image is perceived, so that its essential singularity and uniqueness become more salient.

To get back to the Kantian model, racism works by imposing simplistic categories on people. No category can be completely accurate. In theory (and perhaps even in practice) I could deploy that image for the rest of my artistic life. I could use the image over and over again, with slightly different textual or contrasting visual content, and would still not exhaust its meaning. What I want to do is to flood the viewer's perceptual field with enough variations on that image to force the recognition that it is not possible to apprehend the singularity of that person through any simple act of categorization. I'm actually using a number of different images of black people this way, varying the conceptual interpretation of their visual singularity as a way of exposing their individuality and personhood.

In my most recent object work—the "Pretend" series (1990)—I've been dealing largely with the degradation and coercive penal supervision of a quarter of the black male population in the United States, by using a variety of different and repeated images of ordinary black men, mostly anonymous, in conjunction with occasional images of Martin Luther King, a repeated drawing of the Chinese sculpture of three monkeys who hear no evil, see no evil, and speak no evil, and a single text, "Pretend not to know what you know." And in *Out of the Corner,* I deploy sixty-four portrait images of black women of different ages together with video monitor talking-head images of eight white men and eight white women. I'm interested in building a visual family of black faces that are both anonymous and familiar to the viewer, and to that end I'm reusing images I first used in the late 1970s—for example, from *Aspects of the Liberal Dilemma* and *Four Intruders plus Alarm Systems.* In all of these works, old and new, the gaze is frontal and makes eye contact with the viewer, and the textual mode of address is the "I/You" first and second person, a device I've been using since the early 1970s in order to build intimacy and confrontational immediacy.

MB: Sometimes your work employs autobiography to significant political effect. Rather than speaking in master narratives, which might constitute a form of self-repression, you allow various discourses, including personal narratives, to function simultaneously. What do you feel is the role of the personal in your work?

AP: The personal plays the role of the concrete, immediate, and specific. I want to give concreteness to my work in order to blast the simplistic categories that we impose on people. I use my own experience—my own selfhood—when

it seems strategically the best way to make concrete those thoughts, sentiments, or beliefs that might be dismissed as being too theoretical or abstract. I dislike theory that remains so abstract as to absolve people of the need to apply it to their personal lives or think about what impact it might have on their lives. Interpersonal interactions are really the key to political transformation. Because they function at the level of the individual, they undermine or subvert the pseudorationalizing tendencies that we have when we are dealing with anomalous otherhoods. So I employ the personal as a way of subverting this pseudorationality.

In fact, I like to think that I'm attacking the problem of xenophobia from two directions simultaneously: from the direction of interpersonal and immediate experience in my artwork, and from the direction of the very broadly abstract conceptual underpinnings of xenophobia in my philosophy work. The artwork is like the experimental laboratory in which I find out and test what's true, and the philosophy is where I construct and refine the theory on the basis of what I've learned in the lab, which then leads me back to the lab to try out new things. Each discipline nourishes the other. The art grounds my abstract philosophical analyses in immediate experience, and the philosophy helps my art maintain a larger, long-term metaphysical vision. I find that both are very deeply a part of me—the concrete and immediate artwork expresses what is at stake personally, in the indexical present, and the abstract and conceptual philosophy articulates the big picture as I see it and the larger ethical implications of action. I like to think of my work in art and in philosophy as tools for spiritual transformation through political change—they form a kind of pincer movement for grasping xenophobia at both ends and squeezing it down flat into some kind of recyclable mental resource.

Notes

1 John Rawls, *A Theory of Justice* (Cambridge: Harvard University Press, 1971).
2 Robin Horton, "African Traditional Thought and Western Science," in *Rationality*, ed. Bryan R. Wilson (Evanston: Harper & Row, 1970), 131–71.

Patricia Thomson

Video and Electoral Appeal

The separability of image and substance in the age of living-room politics was hammered home with strength and persistence this last election year. New York governor Mario Cuomo's exhortation at the Democratic Convention to "look past the glitter, beyond the showmanship, to the reality, the hard substance of things" sounded a subtheme for the whole, long election year. But political image crafting as a campaign issue first burrowed deeply into the core of campaign coverage a full fourteen years ago, following Richard Nixon's 1968 run and Joe McGinnis's exposé, *The Selling of the President 1968*. It is this aspect of the electoral process—the politician's image: how it is decided upon, created, and delivered—to which video artists have also turned their attention in recent years.

In addressing this issue, the various video artworks produced since 1980 all fasten on to the technologies and repercussions of *new politics*. This term, which first gained currency in the late '60s, is shorthand for the shift in power from political parties to the mass media. Whereas earlier it was the parties that organized and mobilized voters, political records that were the stepping-stones to higher office, and family tradition that often guided one's vote, new politics supplants these factors with television, the computer, and the public opinion poll. By the early '70s, the term *new politics* had acquired negative overtones: "conduct polls to find out the qualities people want in a president and how the people see the candidate in relation to that; then overcome the gap through controlled television."[1] Today, at its worst, new politics refers to the candidate as a synthetic, packaged product around whom an ongoing series of media events are staged for an ever more passive public. All of the video artworks that I will discuss treat some aspect of the aforementioned technologies of new politics—television, the computer, and the public opinion poll—and allude to its negative connotations.

The means and results of political image making offer much fertile ground, but this is only part of the electoral process—though, by its very nature, one of the most visible. Of no less importance are a number of factors that are under-

reported by the press and, judging from the recent video productions, of little or no interest to video artists. No video works have touched on the difference between the personal traits and strengths that make for a successful candidate on the campaign trail versus those that are best suited for a seated president. Nor does one yet see work about the role of the electronic pulpit and fundamentalist foot soldiers. Nor has the influence of the political think tanks—undramatic, low profile, but absolutely key in developing position papers and party platforms—lured any video producers; nor have the political action committees. The political press has also escaped critique to a surprising degree.

There seem to be two reasons for video artists' concentration on the techniques of new politics to the exclusion of other relevant and timely aspects of the campaign process. First and most obviously, television is the common denominator. It is logical that media artists would be interested in the manipulation of mass media by politicians and their entourages. Second, this focus by artists on the creation and projection of a candidate's political image is indicative of the degree to which our way of thinking about campaigns is conditioned by news coverage, especially prime-time television journalism. Campaign reporting sets the parameters of discussion tightly around the candidates' "news-making" activities, their strategic intent, and their effect on the polls. On the campaign trail, public addresses are covered as bids for votes, with the campaign's strategic motive noted close behind the lead-off sentence. This emphasis on strategies for cultivating a certain political profile usually degenerates into questions on the horse race: who's ahead? and who's going to win? By posing the campaign as a race between individuals competing to generate more attention and greater enthusiasm on a national scale and by underplaying the ideological basis of the debate, the continuing power of party support, and the evolution of voting patterns since World War II (history being no more than stale news), the political press overlooks much of the campaign. Its skepticism, born of the lessons of 1968, repeatedly causes attention to be funneled back to the presidential image gap and a candidate's word and deed to be read as an ongoing attempt to close the gap between voters' perceptions of the candidate and their sense of what they want in a president.

The general parameters set by the press are reflected in the video artworks on campaign politics, but the existence of these parameters as such is rarely confronted head-on. One exception to this is Francesc Torres's installation, *Running Speech* (1980). This work is about the fundamental limits built into the American political system. It shows the superficial nature of the living-room campaign, but its principal critique questions the breadth of tolerated ideas in the political spectrum.

In *Running Speech* a large wooden platform is seemingly held up by a house of cards at each of its four corners. Imbedded into this platform are six video

monitors arranged in a configuration. The three on the left play a fifteen-minute tape of clips from Ronald Reagan's television campaign; Jimmy Carter is seen on the right three monitors. At the apex of the *V* is an old pedestal sink with running water flowing out of its two faucets. A microphone is conspicuously placed beside the sink. The sound of water constitutes the piece's only audio track, replacing the television clips' original sounds. To one side of the platform is a small glass display case, containing rocks of various textures and painted colors. The case is set on top of a pedestal base; on the side of the base is a running clock.

The content of *Running Speech* is expressed mainly through metaphor and the double meaning of words. The principal metaphor is water—colorless and without taste, a substance of sameness and interchangeability. In this installation, water replaces speech, as it issues from the two faucets and seems to be heard from the two parties on the aligned monitors. On both right and left, the water is recycled and is indistinguishable in sound and substance. Moreover, water seems to constitute the physical/political platform shared by the monitors/parties: the monitors, positioned at slightly different levels and angles in the platform, appear to bob in a body of water made of the twin faucets' spillover.

The implications of the metaphor are clear: the choice offered between the candidates is not a real choice. Rather, like the water, they are equivalent in substance. Their shared tacit assumptions are so fundamental and extensive as to narrow the contest to variations on a single principle of government. Alternate ideologies are relegated to the political fringes. But it is only a matter of time before they, like the rocks, break out of the fringes, perhaps violently.

The two videotapes embellish this proposition of equivalence. Particularly with the original sound removed, the motions of political campaigning are reduced to a series of ritualized gestures and codes. Ronald Reagan smiles and waves in front of country silos and cows, addresses a crowd of hard hats, dons a Mexican sombrero, flips pancakes at a senior citizens' gathering. Jimmy Carter meanwhile talks to us one-on-one from the Oval Office, poses with his extended family, listens with concern to senior citizens, and addresses an AFL-CIO banquet. The media events, press conferences, political ads, and formal dinners, all cribbed from television, blend into a continuum of short image bites, which are periodically emblazoned with the networks' campaign graphics for "The '80 Vote."

This view of the election says more about its stagecrafting and the symbiotic interplay between the press and the campaign managers than about the candidates' philosophies of government. Certainly on these grounds all campaigns are equal. But while *Running Speech* presents a disparaging look at the living-room campaign, its principal target is neither the press, the campaign strat-

egies, nor even the candidates themselves. Rather it is a political system in which both of the dominant parties conform to a single ideology.

Whether one accepts or rejects the argument implicit in *Running Speech* depends largely on how close to the center one falls in the political spectrum and to what degree one accepts the tenets of capitalism, whether liberal or conservative. Torres is hardly alone in his general argument about the lack of real choice in recent U.S. elections. Many saw the Democratic platform as a rush toward the political center, incorporating all the essential elements of Reaganism (continued military expansion, submission to the demands of the corporate system, the undermining of the welfare system, etc.).[2] Others argued that the election presented a clear ideological choice based on two different perceptions of government (good or bad, protector or oppressor) and the nature of individualism (linked with economic freedom or with social and cultural freedom).[3] Both sides would concur that political actions, practices, and policies are at stake in presidential elections and that the relationship between people in society is affected by the outcome. Some might even venture to say that voters cast their ballots with these consequences in mind. In short, politics is not all show, even today—a point that sometimes gets buried under the rampant speculations about television's effect on politics.

Torres's implicit critique of the redundancy of America's two major parties is an issue independent of new politics. Unlike *Running Speech,* the tapes by Doug Hall, Howard Fried, Max Almy, and Antonio Muntadas and Marshall Reese raise questions rooted in the instruments of new politics and examine their use in bridging the presidential image gap.

Doug Hall's *The Speech* (1982) demonstrates a "victory of form over content." In this tape a clean-cut, "generic" politician (played by Hall) makes a formal, televised speech. But the speech itself is beside the point; in fact, it is omitted. In its stead, the trappings of high office and the visual rhetoric of television suffice to create an aura of power and significance, while a few key buzzwords set the high moral tone.

The tape opens with the sound of applause and a frontal shot of the politician. He is standing behind a podium bearing an official seal, which is placed in a shallow, curtained space. An American flag is conspicuously placed. As the applause dies down, the camera moves in to a head-and-shoulders shot, followed by a series of cuts and dissolves between a set of standard camera angles: frontal and three-quarters head, head and shoulders, and middle distance. The politician smoothly adjusts his gaze and turns slightly to follow the camera switches. Several minutes into the tape he finally speaks, saying simply, "Honesty, self-reliance, moral strength and courage, modesty, humor, confidence, human vulnerability or sensitivity, respect for others (particularly those less fortunate), friendliness, and good health and virility." Shortly there-

after a booming voice-over repeats several of these virtues, while Hall silently faces the camera, his face a blank slate. Only four more short phrases are spoken by Hall before the tape's end: "He appears relaxed and in control. . . . It allows him to avoid difficult questions while seeming to be a nice guy. . . . And a final example. . . . Is the ultimate victory of form over context."

The Speech implies that the virtues of modesty, honesty, and the like exist in a politician through the power of suggestion. If a politician verbally surrounds himself with such character traits, he will seem to absorb them by osmosis. Hall said of the tape, "I think it's very funny. Literally nothing happens. It's all about a kind of posture that isn't even really accurate. . . . The facial expression is the same.[4] The politician acquires his stature and personal virtues from the outside: the accoutrements of political office, the presence of media as intermediary, and the verbal environment. *The Speech* can also be interpreted as a generic speech reduced to its essential personal, as opposed to political, message. It takes the shortcut for us, as it were, skirting the lengthy, tedious factual matter and getting right down to what the guy is like.

The Speech denies content. But of all the possible targets in the age of television politics, an attack on political speech making seems miscalculated. The speech is one of the few times voters can still hear candidates fully lay forth their views of the campaign's significance or explicate their policies firsthand, without editing or interpretation by the news media. It is an archaic format that continues to be vital. More to the point would be a critique of the abbreviations of media politics—for example, the language of media events or the packaging of news into image bites. (*The Amarillo News Tapes,* by Doug Hall, Chip Lord, and Judy Proctor [1980], while focusing on an apolitical tornado, is a fine and classic example of this tactic.)

The Speech was preceded by a closely related article in *Video 80,* "Ronald Reagan: The Politics of Image," in which Hall analyzes the "iconography of image archetypes" in Reagan's press conference of October 1, 1981.[5] The entire text of *The Speech* can be found in this article, which also attempts to demonstrate the victory of form over content. Hall writes:

> Ronald Reagan as President and media personality is brilliant at conveying the signifiers of Americanism. This is his greatest strength and the source of his political power. In his mannerisms, turns of phrase, gestures and vocabulary, he projects to a public a wide range of human attributes which reflect the American ideal. We must understand that what is being discussed here is not what the man is actually like (something we can never know), but what he *appears* to be like. Reagan as image speaks to America's concept of uniquely American virtues.

Or, Reagan as image bridges the presidential image gap; he successfully matches up to voters' abstract wants and requisites. The virtues or "signifiers of

Americanism" that Hall discusses are precisely the same as those in *The Speech*. The article is in effect a structural analysis of Reagan's facial expressions and vocabulary. More recently, Hall reiterated his point: "How is one to analyze the content of a presidency that's lacking content? You're left with a formalist analysis."

As Hall demonstrates, Reagan knows how to effectively parry reporters' questions with anecdotes, truisms, and humor. But when Reagan does more or less answer the questions put to him at such press conferences, his words do indicate, as did his predecessors', the administration's perceptions, policies, and plans. Reagan's beliefs as much as his bearing got him into office. To think otherwise is to underestimate the *real* source of his strength and political power—the growing conservative constituency.

Both "The Politics of Image" and *The Speech* suggest that political success is a consequence of an effective style. Many political watchers have tried, like Hall, to fathom Reagan's appeal on the basis of his amiability, his homily-studded speeches, his rhetorical effectiveness, his ease with the camera. Clearly his personal style has taken him far, as has his mastery of television. Without denying the mileage that Reagan and others have gotten from having television skills, one can argue with the degree to which such skills are key to political power. Jeff Greenfield, a political analyst and former media consultant with David Garth's firm, makes a particularly strong case for the need to revise our reading of the balance of factors that enter into a successful candidacy. In 1982, the same year as Hall's *The Speech,* Greenfield wrote:

> To assume that Ronald Reagan's 1980 victory was a consequence of his media skills is to miss the point almost entirely. With respect to his nomination, Reagan won principally because after 30 years of preaching conservative gospel, after 16 years as a key figure in the conservative Republican movement that seized control of the party in 1964 and never let go, after a decade and a half during which the once dominant Eastern moderate-liberal Republican wing all but disappeared as a force within the party, and during which conservativism became the overwhelming consensus belief of that party, the Republicans nominated the figure who had spoken the beliefs of that party, and whose political base had been gathering strength for 16 years.

Greenfield's book, *The Real Campaign: How the Media Missed the Story of the 1980 Campaign,*[6] is indicative of a growing journalistic countercurrent that runs against popular wisdom regarding the increasingly pervasive and invincible power of television. Such revisionist analyses are perhaps a sign of the waning of new politics—not of the tools themselves (for television, computers, and polls are inextricably entrenched in modern politics) but of the accompanying sense that mass media could gradually overtake all other factors.

Frame capture from *Perfect Leader* (1984) by Max Almy. Courtesy of Electronic Arts Intermix, New York.

Obviously, artists are not journalists and should not be judged by journalistic standards. Torres, Hall, and other artists who deal with political subject matters have very pointedly said that their aesthetic concerns take priority. But whenever an aspect of politics is isolated and simplified, whether by an artist, news writer, or whomever, its validity is open to question. Often the most elegant argument is the simplest one and summaries can be astute. But they can as easily divert as deepen understanding. Political art is no more exempt from this question than is any other form of public political discourse.

The rise in power of political consultants, pollsters, and behavioral experts, who in the 1960s displaced the Madison Avenue advertising agencies in preparing the candidates' pitches, forms the common ground for two otherwise dissimilar tapes: Howard Fried's *Making a Paid Political Announcement* (1981) and Max Almy's *The Perfect Leader* (1983).

The use of polls in determining campaign strategies and adjusting the candidate's tone, emphasis, and message has grown in importance as the technologies have been increasingly refined. As consultant Bob Squier said, "It used to be you'd take a poll, set up a media plan, and six months later find out how it worked. Nowadays, you can send out your media, check out how it

worked by the very next day, and fine-tune the message accordingly."[7] Just how much fine tuning consultants can get by with to accommodate the mood of the voters is a matter of some debate. Political scientist Edwin Diamond has pointed out that a candidate can always fire his consultant if he finds his message getting taken too far off track.[8] But others, such as Ron Friedman, a former political consultant and campaign manager, fear that "together with television, the consultants have produced a new kind of candidate—attractive, well-connected, and docile—attractive enough to come across on television, well-connected enough to bring in the kind of money needed to buy television time, and docile enough to tailor words, even ideas, to a consultant's instructions."[9]

Making a Paid Political Announcement is a hyperbole of the tailored message. In his project description, Fried proposed to "construct a political message in which I will make only promises which I reckon will win the favor of six specific citizens of Seattle. . . . I will make no attempt to sell myself or my concerns but rather only to please and ingratiate myself politically with these six people via their own interests."[10] In focusing on the pet peeves of a target group of six, rather than the huge demographic categories politicians usually court, Fried quickly arrives at a deadpan parody. He pledges to "subsidize actors and actresses in correlation to the degrees to which the roles they play are socially constructive" as a means of reducing the amount of sex and violence on television. He also proposes programs "to raise the intellectual level of game shows":

> The categories questions are chosen from should reflect more meaningful, more real values than rich, famous, fancy and sexy. They should be balanced between all fields of commonly accessible knowledge, especially those areas related to individual, day-to-day survival. What show has a category called Black Accents? Northern Industrial Street Slang? or Food Stamps? By legitimizing these areas of life in the form of question, operations like Tick Tack Dough and Hollywood Squares could do something to encourage people to take pride in their own identity.

The narration continues in this manner, with Fried making promises about junk food, immigration, Social Security, and the enforcement of voluntary military service.

The tape's visuals are simply vignettes of people engaged in mundane activities: a young hairdresser and her customer, a grocery clerk at work, a union man on strike, a restaurant worker chopping onions, an older housewife making waffles. According to Fried's project description, the people shown are the six target citizens, although the vignettes and narration do not necessarily coincide. Nor are they even suggestive of a direct correspondence without prior knowledge of Fried's method.

While Fried's off-screen candidate is a parody of a new politics politician, a

synthetic figment of the polls, the commercial itself is relatively homespun. Fried's voice-over slips into the droning cadences of a nonprofessional narrator, and the documentary camera work is decidedly low-tech.

Max Almy's *The Perfect Leader* goes the whole route, with a production as slick as the candidate. Like Fried, Almy's leader is synthetic, but in two senses of the word: he is a combination of disparate sources and is also artificially produced. As announced on the computer-cum-video screen, the tape is a "prototype development program." We are in effect looking over the shoulder of an off-screen programmer or, one could read, political consultant, as he runs the program for the perfect leader. After selecting a white male prototype, he tries out various personae, first going for the conservatively suited and clean-cut type, then the same "with a little charisma" added. Next, the command for "something a little stronger, more dominating" turns the prototype into an air-slashing, fascistic type, dressed in black with an American eagle pin. "Whoops! That's too much. That really didn't work last time. . . . Let's try morality." The computer obliges with a Bible-waving, blue polyester–suited figure. Satisfied with the material at hand, the consultant then lets the computer run the program.

The program alternately inserts these three types into an ever-denser graphic environment of grid charts, symbols, and pictographs. Tests are punched in for physiological modifications, media impact marketing projection, multinational profit factors, and global leadership strategies. Almy's tape clearly echoes political "consult-ese" and its jargon of attitudinal communications processes and psychodemographics. In the background, a female voice chants with increasing insistence, "We want to have the perfect leader. We need to have the perfect leader," against an infectious rhythm (synthetic percussion, naturally) and the sound of growing cheers. The final test places the leader's face inside a TV-screen template. The crowd goes wild.

Eliminating the flesh-and-blood candidate altogether is one way of closing the image gap. Almy's perfect CAD-CAM leader, like Fried's ingratiating, utterly malleable politician, points out some of the fears and doubts that have grown up in response to the adaptation of marketing techniques to politics.

Most candidates, however, choose to bridge the gap through more conventional means. Controlled television is the surest way presently available of shaping people's perceptions of a candidate to match up with their preconceived presidential profile. Political commercials are the keystone in this effort. They also are a lightning rod for heated debate about the effect of television on the electoral process. And they are the subject of the last recent tape under consideration, *Political Advertising* (1984), edited by Antonio Muntadas and Marshall Reese. Muntadas, whose works often address aspects of media and advertising, began work on this specific topic in 1981. He drew Marshall Reese into the project's final stages in the summer of 1984.[11]

Political Advertising is a thirty-five-minute anthology of forty-six spots from the campaigns of 1952 to 1984. They are arranged chronologically and presented without comment, except for a short, introductory text: "Looking back at these political ads provides a key to understanding the evolution of images on television and the marketing of politics." Asked to elaborate on this general preface, Reese said:

> If we come to the tape with the understanding that this medium affects the electorate in a very strong manner, and given the fact that we know the history of past elections and power of the image—certainly the power of the framework of the television commercial—[then *Political Advertising*] can clarify both our sense of history and why a specific candidate won. That knowledge further clarifies the role of the media.

Just how great a role political ads play in the success or failure of a given candidate is still largely a matter of guesswork. There are too many factors that enter into a voter's decision to be able to isolate and measure the impact of spot advertising. But as Edwin Diamond and Stephen Bates point out in their recent study, *The Spot: The Rise of Political Advertising on Television*[12] (to which Reese considers *Political Advertising* a companion piece), at least three things are certain. First, real events take dominance over advertising. As Gerald Rafshoon said of Jimmy Carter's 1980 media campaign, "If we had to do it all over again, we would take the $30 million we spent in the campaign and get three more helicopters for the Iran rescue mission."[13] Second, the least successful ads are those that present an image of the candidate that does not jibe with his or her actual conduct in the political arena, and thus run against the grain of news reports and public perception. The most successful ads are *credible*. Third, political ads can and sometimes do relay hard, accurate facts about a candidate's position on the issues. The spot format is not to blame for issueless campaigns or generalized sloganeering.

As it now stands, *Political Advertising* does not attempt to work in any kind of analysis or historical contextualization. This option was considered; in fact, Diamond was approached about providing such a narration. But time constraints, among other factors, intervened. The priority was to compile an anthology quickly and get it circulating before the 1984 election. Another option that was considered and rejected was to explore structures other than a simple A-B-A-B alternation, such as simultaneous presentations or framing ads with other ads—in other words, using the material for more of a video art piece. But Muntadas and Reese did not want to obscure the content in any way, so they opted for the most straightforward format. Anthologizing the ads both preserved their integrity and guaranteed that the spots themselves were being showcased, not Muntadas and Reese's personal viewpoint.

As artists, Muntadas and Reese chose to act as editors. Without rejecting the

ability of art to effectively address political subjects, they felt that artists should be able to wear other shoes—and not get their feet stepped on, as Reese put it. As editors, they did almost no editorializing, preferring a more invisible position. But in their choice of spots, they did not quite achieve an accurate, historically balanced survey. The "Eisenhower Answers America" series and the Stevenson ad, for example, were from 1952, not 1956; the choice of the simplest of the Eisenhower and Stevenson ads tends to exaggerate the primitivism of this early stage. The campaign of 1972 was omitted altogether, and the overall balance was lopsided, with more than half the ads coming from 1980 and 1984, including three virtually identical Reagan spots. But a quickly produced and slightly flawed anthology is far preferable to no anthology at all. Better still would have been a longer program that analyzed the whys and wherefores of the specific advertising campaigns. While such analyses have been written by Diamond and Bates, Greenfield, and numerous other print journalists, no one has yet produced a comparable, thorough analysis on tape— with the bonus of the television spots themselves.[14] This is the most effective course to understanding how political image making actually works; the ads themselves are just the tip of the iceberg. It is a shame that Reese and Muntadas were not able to go this route. Since the tape is "to be continued," perhaps they will expand in this way as well.

Even as it stands, *Political Advertising* is able to show a tremendous amount through the chronological juxtaposition of forty-six political spots. One is immediately struck by the consistency in the party platforms, particularly regarding domestic spending and defense. Tactical patterns also become evident—for example, the cross-firing of ad campaigns. While Barry Goldwater's "Peace through Strength" proposition is ostensibly offered to an off-screen question ("Mr. Goldwater, what's this about your being called imprudent and impulsive?"), one can well assume that Goldwater is rebutting the implications of the infamous Daisy ad. (Without ever using Goldwater's name, the Daisy ad, which shows a young girl plucking daisy petals followed by an atomic explosion, referred indirectly to Goldwater's seemingly casual attitude about nuclear devices and his opposition to the test ban treaty.) There are also more obvious retaliations, such as Jimmy Carter's response to Ted Kennedy's negative ad, with both the original spot and the reply, featuring an adding machine tallying up the opponent's deficit spending. *Political Advertising* also shows the general contours of the evolution of these "polispots." One can see the introduction of negative advertising, the adaptation of soft-sell techniques, and the appropriation of a kind of emotionalism peculiar to the parallel universe of television drama—something Reagan's "Bringing America Back" ad campaign reveled in with unprecedented abandon.

In sum, *Political Advertising* is an informative and welcome compilation edited by two individuals interested in media politics who happen to be art-

ists. Other than its choice of specific ads and its availability for rental, it differs very little from the sixty-minute anthology of political spots in the Museum of Broadcasting's collection. Reese considers his and Muntadas's tape an agitprop work; presumably the staid Museum of Broadcasting does not view its own tape in the same light. Whatever the case, *Political Advertising* has more in common with the museum's anthology—in which the editors are not even named—than it does with the video artworks and installations of Torres, Hall, Fried, and Almy.

The most interesting point about these works as a group, including *Political Advertising,* is the similarity of their angles on the electoral process. As we have seen, every one makes reference to television as the central arena of politics. Each also addresses the concomitant techniques of packaging, marketing, and stagecrafting that are visible in the commercial advertising of candidates, the spectacle of media events and televised addresses, and the leverage of computerized polls.

These are aspects of the electoral process that are very much in the public eye. As tools and techniques of new politics have grown in sophistication and in the extent of their use, news journalists, media analysts, and political scientists have correspondingly stepped up their analytic output on the subject. There is one recurrent observation made in such commentaries, which relates to a parallel point concerning recent video productions—the idea of the campaign as a spectator sport. The observation is often made that by focusing more on the candidates' positions in the horse race than on their positions on the issues, campaign coverage places the voters somewhere out on the sidelines. As Greenfield put it, "The dominance of television, the decline of the traditional public fervor through torchlight parades, encampments, and other devices of another time, has tended to enhance the notion that politics is something to be watched rather than something in which to participate."[15]

Video artists in the meantime have also stepped to the sidelines. In the process of critiquing the media campaign, they watch politics on television like the rest of us. This has not always been the case. The artist-as-spectator was preceded in the early days of video by the producer-as-participant. The shift had much to do with the general decline of the counterculture, of which video was originally a part, as well as the failed hope of cable television. But it might also be considered a reflection of the distancing of the mediated campaign, with the voter on one side of the TV screen and the candidates and campaign process on the other—which constitutes another kind of image gap. A brief glance back at Top Value Television's productions in 1972 and, even earlier, to Drew Associate's *Primary* (1960) is a reminder of the possible alternatives. Without going into either production at any length—a revealing comparison, but one which would constitute another entire essay—we will pause

long enough to note some basic differences in the final objectives of the production groups.

For TVTV, first organized to document the national conventions in Miami in 1972, both its means (shooting with Sony portapaks) and ends (the democratization of media through cable) were based on a participatory philosophy. On the level of the shoot, they, as documentary producers, not only acknowledged but celebrated their own presence and its effect on the scene. And TVTV's scene included work, play, and the long stretches of hanging out in between. They taped interviews with delegates, reporters, Nixonettes, Vietnam Vets against the War, and others. When the Secret Service men detained a production team at the convention floor entrance, they taped them, too; likewise when Skip Blumberg's harmonica solo drew a suspicious guard. At the local diner they convinced the hefty, platinum-haired waitress to show off her ankle bracelet with a little cheesecake. As Michael Shamberg explained to a reporter from *Newsweek,* "We're looking for a kind of information that's a little bit closer to giving a sense of the environment, of how people feel about being there."

TVTV's intimate, good-spirited, and often funny portraits of the conventions, produced without voice-over narration, were a clear departure from the methods and ostensibly objective stance of network newscasts. At the same time, the presence and power of the networks were often the focus of TVTV's attention. The convention setup, as TVTV and many others saw it, was created specifically by the networks for the networks.[16] The title of the Democratic Convention tape, *The World's Largest TV Studio,* underscores this belief. In this and *Four More Years,* TVTV danced circles around the networks' system of coverage. As an alternative to the limited, redundant, and spectacle-happy mass media, TVTV aimed to create a decentralized, "special purpose media." As described by Shamberg in *Guerilla Television,* the ultimate goal was to form "an information infrastructure in Media America, a grassroots network of indigenous media activity."[17] TVTV, in short, was out to change the way television worked and news was conveyed.

Primary, the first major American cinema-verité film, falls on the cusp of the age of television in politics. Produced for Time Inc.'s television affiliates by Drew Associates (Robert Drew, Richard Leacock, Donn Alan Pennebaker, Albert Maysles, and Terry Filgate), *Primary* documents the 1960 Wisconsin primary between Senators Hubert Humphrey and John F. Kennedy.

To Drew, *Primary* and the subsequent films on the Kennedy administration were the working out of a new, historically significant form of journalism. Up to that point, he felt that television and journalism had not done justice to each other.[18] In an approach 180 degrees from that of TVTV, Drew Associates attempted, as TVTV did later, to capture a side of the campaign process that was not ordinarily seen by the public.[19] They, too, wanted to give viewers a sense of being there on the scene, partaking in an unmediated reality. In order to accom-

plish this, they tried to minimize their presence (unlike TVTV) and imposed strict guidelines: "If we missed something, never ask anyone to repeat it. Never ask any questions. Never interview. We rarely broke them, and whenever we did, we regretted it."[20] The Living Camera of Drew and Leacock was a passive participant in the scene (something far different from today's spectator of the mediated event). "All filming until now," said Leacock in 1961, "has been essentially an extension of the theater, where you control what's happening. Only very few people . . . saw the camera not as controlling, but as observing, watching, which in a way ties up with journalism."[21] The ability of the camera team *not* to affect behavior and events *was* possible during this brief moment in history when portable sound-sync equipment had been developed but was still so new that people did not even register being filmed. For this reason, among many others, *Primary* is an extraordinary and powerful film and represents an ambitious effort to create a different form of television journalism.

Yet in spite of its strengths as a film, Leacock was not satisfied:

> *Primary* in no way achieved what I at least wanted to achieve. I wanted to see the political process at work, and we saw only the public aspects of the problem. There was no chance of our being privy to the real discussions that took place with the statisticians, with the public relations people, which is where modern politics operates. No one has ever got that on film, or, with our present system, ever will. There's more a chance of getting someone fucking on film than of getting politicians being honest.[22]

During the past fifteen years, film and video producers have not been able to get a much closer look or more candid pictures of candidates on the campaign trail than did Drew et al. of Kennedy and Humphrey in 1960. The honesty index in the meantime has been increasingly complicated by television's complicity in political image making. The marriage of convenience between television and politics is not likely to get any simpler, nor are the mediating layers between the candidate and the public likely to fall away. The campaign staff, media consultants, pollsters, and political press all play a hand in the shaping of a candidate and his or her message.

Since Nixon's media campaign in 1968, which attempted to make a historical untruth a political reality,[23] the mechanisms of political image making have been the longest-running campaign story. They have been scrutinized in countless articles every campaign year and, as we have seen, have been the almost exclusive subject of attention among recent video art productions on the campaign process. But as entrenched as these mechanisms are in modern politics, their effectiveness has its limits—a catch that was acknowledged from the start. As McGinnis wrote in 1968, "The perfect campaign, the computer campaign, the technicians' campaign, the television campaign, the one that would make them rewrite the textbooks had collapsed beneath the weight of

Nixon's greyness."[24] More often than not, it is the power of new politics' tools, rather than their limitations, that are talked about. When limits are discussed, they are usually brought up in reference to losing campaigns, like Gary Hart's, where they are easier to locate. But winners and losers both use the techniques of new politics. Candidates cannot win without them, but neither do they win because of them. Perhaps the time has come to refocus on the other political factors that ultimately do make the difference.

Notes

1 Edwin Diamond, *The Tin Kazoo: Television, Politics, and the News* (Cambridge: MIT Press, 1975), 235–36.

2 See, for example, Andrew Kopkind and Alexander Cockburn, "The Left, the Democrats, and the Future," *Nation* 239, no. 2 (21–28 July 1984): 33 ff.

3 See, for example, Richard Reeves, "The Ideological Election," *New York Times*, Sunday, 2 February 1984, sec. 6, 26 ff.

4 This and all unnoted quotations are from conversations with the author in November 1984.

5 Doug Hall, "Ronald Reagan: The Politics of Image," *Video 80* 4 (spring/summer 1982): 28–29.

6 Jeff Greenfield, *The Real Campaign: How the Media Missed the Story of the 1980 Campaign* (New York: Summit Books, 1982), 82–83.

7 Ron Suskin, "The Power of Political Consultants," *New York Times*, Sunday, 12 August 1984, sec. 6, 56.

8 Edwin Diamond and Stephen Bates, *The Spot: The Rise of Political Advertising on Television* (Cambridge: MIT Press, 1984), 278.

9 Quoted in Suskin, "The Power of Political Consultants," 32.

10 Howard Fried, "Project Description: Making a Paid Political Announcement," *Video 80* 5 (fall 1982): 28.

11 Because he was traveling, Muntadas was not available for interviewing at the time this article was written.

12 Diamond and Bates, *The Spot,* 350 ff.

13 Ibid.

14 Bill Moyers' "The 30 Second President" in the series *A Walk through the 20th Century with Bill Moyers* (broadcast on PBS, 8 August 1984) provides an excellent analysis and survey, including interviews with Rosser Reeves and Tony Schwartz. Moyers' sixty-minute time frame, however, permitted only a brief look at each of the ad campaigns. The ideal format for a thorough presentation of this material would of course be a six-or-more part series.

15 Greenfield, *The Real Campaign,* 272.

16 Actually it was the candidates' election committees, not the networks, which controlled the conventions. For a good report on the accidental discovery and attempted retrieval of the script for Nixon's "coronation," see Timothy Crouse, *The Boys on the Bus* (New York: Ballantine Books, 1973), 176 ff. Crouse also has some interesting comments on TVTV, 180–84.

17 Michael Shamberg, *Guerilla Television* (New York: Holt, Rinehart & Winston, 1971), 9.

18 M. Ali Issari and Doris A. Paul, *What Is Cinéma Vérité?* (Metuchen: Scarecrow Press, 1979), 85.

19 In print journalism, Theodore W. White was breaking similar ground with *The Making of a President* (1960)—a parallel that was noticed at the time. See Claude Julien, "A Man in the Crowd," *Artsept* 2 (April–June 1963): 45–48.

20 Richard Leacock in *Documentary Explorations*, ed. G. Roy Levin (New York: Doubleday, 1971), 197.

21 Issari and Paul, *What Is Cinéma Vérité?* 98.

22 Levin, *Documentary Explorations*, 206.

23 Ray Price in *The Selling of the President 1968*, by Joe McGinnis (New York: Pocket Books, 1969), 203.

24 Ibid., 166.

Patricia R. Zimmermann

Fetal Tissue: Reproductive Rights and Activist Video

Gender, sexuality, and reproductive rights in the 1990s are difficult to "see" and to "situate"—although they penetrate nearly every political discussion and media representation like a computer virus. Their polyvocal, heterogeneous, fluid, changing forms shatter borders between humans and machines and challenge the stasis of phallocentric systems of politics and representation. Donna Haraway identifies these shifting practices and mergers as the cyborg: "People are nowhere near so fluid, being both material and opaque. Cyborgs are ether, quintessence. The ubiquity and invisibility of cyborgs is precisely why these sunshine-belt machines are so deadly. They are as hard to see politically as materially. They are about consciousness—or its simulation."[1] In the case of the war over representation and reproductive rights, the cyborg provides access to these new places.

This argument about heterogeneity and cyborg identity must be hewn carefully, however, so as not to totally launch feminist-media political strategy into the potentially unproductive realm of cyberspace unhinged from concrete social relations. The realpolitik dimensions of gender, sexuality, and reproductive rights located in the courts, the law, public policy, health care, and the real material lives of women remain vital to any feminist media agenda. The difference that I am trying to argue for here is that while realpolitik is necessary, it is no longer sufficient to produce social change precisely because the web of social relations within which women live is *also* a compilation or assemblage of technology and representation. Haraway's imagining of the cyborg, then, proposes not to jettison the "real," but to actually expand it, complicate it, demonstrate its multivocal, multilayered construction that breaks down distinctions, borders, domination.[2]

Feminist battles over reproductive rights reflect the disturbances provoked by women in a differently ordered and constructed public sphere that has transformed politics in the 1990s. The most recent and horrific concrete example of this collapse of the borders between representation and the real is the assassination of Dr. David Gunn, an abortion provider in Florida, by Michael

Griffin, a pro-life supporter. Although the shooting of Gunn marks the first death of an abortion provider and therefore signifies the escalation of the civil war against women to deadly heights, it also occurred within the context of increasing clinic violence during the last several years (bombings, arson, toxic chemicals injected into Planned Parenthood clinics, assaults against clinic personnel, vandalism, trespass, and physical confrontation of abortion providers). The pro-life shift from ideological to physical warfare diffused to multiple clinics across the country and explicitly centered on assaulting the pregnant female body has unfolded for the last ten years, unimpeded by any intervention from the Justice Department to protect the civil rights of women or their access to health care.[3]

However, the pro-life political strategy has itself not been confined to the realm of the real or the domain of the law. It, too, has obscured the boundaries between female bodies, representation, politics, and reproductive rights. Operation Rescue chapters have instituted a campaign called No Place to Hide. The campaign features "Wanted" posters with pictures of doctors who perform abortions and their telephone numbers. Gunn was the subject of one of these posters. It would not be accurate to view the use of these Wanted posters as provocations to abortion violence, since that kind of analysis suggests an antiquated, instrumental model where media directly impels political action. Rather, these posters, the killing of Dr. Gunn, the Planned Parenthood media campaign afterward, and the embattled pregnant female body demonstrate quite forcibly that a new construct smearing the lines between media, technology, and politics has emerged that requires careful deconstruction if a new feminist media politics is to be forged.

In this essay, I want to explore reproductive rights as a specific battleground of great importance to women in order to investigate the multiple dimensions of recent realignments between media and politics, gender and representation, sexuality and visual imaginaries, the maternal and the pregnant body, the female body and the state. I argue that the collapsing of media and politics into a new configuration of power needs to be considered dialectically. On one hand, this merging reveals a strategy for containing feminist articulations of reproductive rights within mass forms of communications dependent on capitulating to the discursive dominance of textuality. On the other hand, the blurring between media and politics offers a strategy for feminist intervention that provides the oppositional female body with technologies like low-end video camcorders to build a new social and representational space that imagines new contexts and different material conditions. Constance Penley and Andrew Ross, along these same lines, have argued for the emancipatory potential of new technologies and for a revision of the definition of radical politics: "Activism today is no longer the case of putting bodies on the line; increasingly, it requires and involves bodies-with-cameras."[4]

Rather than pitting alternative media against dominant network or print media, a common strategy of radical media politics in the 1970s and 1980s, I want to examine these multiple registers—from the dominant media of commercials and news stories, to right-to-life videos, pro-choice activist video, and experimental art video—and trace the contours of the multiple battlegrounds in the fight for reproductive rights. This range of media discourses register particular multiple typographies of the female body: maternal, pregnant, militant, oppositional, cyborg. These typographies often overlap. On a theoretical level, the political urgency of media on reproductive rights hinges not on representation alone, but on its organization of the female body within these multiple zones.

If we junk these oppositions between dominant media and alternative media and concentrate instead on how the social, representational, and discursive dimensions of feminist reproductive rights converge, then the definition of political documentary must be revised, if not altogether abandoned as a false construct dependent upon separating media practice from politics in order to argue that each operates in a seesaw dependency with the other: politics creating the necessity of media intervention, media intervention changing politics and consciousness.

I begin with an incendiary yet necessary assertion: political documentary theory and criticism (with a few exceptions like Julia Lesage, Juliane Burton, E. Ann Kaplan[5]) are blind to gender, sexuality, and new technologies. They are addicted to or codependent on textual analysis of formal strategies or argumentation, locked into a Griersonian or neo-Marxist or religious conception of documentaries redeeming the nation and the spectator through good works and good intentions. Whether these documentary works depend on realist conventions of expository documentary or more deconstructive, interrogative, and self-reflexive forms is inconsequential: their relationship to spectators remains identical.[6] They pose as redemptive. They rescue the spectator from ignorance or passivity.

As interconnected modalities rather than parallel tracks, gender, sexuality and video technologies have the potential to revamp our theorization of political documentary. Documentary theory needs rehabilitation from its 1960s rhetoric of agitation and its fetishization of texts themselves as central to activating politics. During the 1980s, feminists not only lost ground on the legal front for reproductive rights, but also experienced a retrenchment on the visual front as the anti-abortion movement marshaled the visual representation of the fetus as its main artillery. As Margaret Cooper notes in a 1986 *Cineaste* article called "The Abortion Film Wars," since the dissemination of the anti-abortion film *The Silent Scream* in 1986, the abortion debate has engaged both right-to-lifers and feminist media producers in combat over representation.[7] In her decoding of the complicated relationship between media spectacle and clinical experi-

ence in *The Silent Scream* and imaging technologies like ultrasound, Rosalind Petchesky argues that not only has the pregnant body been effaced or peripheralized or absented, but the fetus itself has been represented as "primary and autonomous." Petchesky contends that "the strategy of anti-abortionists to make foetal personhood a self-fulfilling prophecy by making the foetus a *public presence* addresses a visually oriented culture. Meanwhile, finding 'positive' images and symbols of abortion hard to imagine, feminists and other pro-choice advocates have all too readily ceded the visual terrain."[8] Discussing a wide range of reproductive discourse in the 1980s from newspapers, magazines, and television shows, Valerie Hartouni maintains that the last decade can be characterized by the mass media's obsession with women and fetuses. She notes that an entire range of political debates about the family, the military, gays, careerism, hedonism, affirmative action, civil rights, and welfare, for example, have reproduction as their subtext.[9] The imaging of the fetus deploys science to institute visual identification and bonding, to reintegrate women with an essentialist maternalism.

As both longtime reproductive rights activists and feminist cultural theorists know, our opponents in the culture wars and the female body wars can conjure up the easily digestible, romanticized codes and maternalized conventions of visual imagery of fetuses and children. They can marshal discursive homologies equating abortion to the Holocaust or slavery to invoke civil rights within a rhetoric dependent upon metaphor and emotion unhinged from historical specificity. I want to examine the power of visual rhetoric in the pro-life movement by analyzing the following pro-life advertisement.

During the last year, the De Moss Foundation aired commercials on the networks in selected markets and on CNN depicting a multiculturally correct group of about thirty smiling six-year-olds exiting a clean, suburban school. The Arthur S. De Moss Foundation, located in Philadelphia, was founded nearly forty years ago by Nancy De Moss, wife of Arthur S. De Moss, president of the National Liberty Corporation in Valley Forge, Pennsylvania. Upon Arthur's death in 1979, Nancy committed herself to celebrating what she terms "life." Nonprofit and expressly committed to producing educational publications and media presentations on what the foundation statement terms "major concerns within our society," the De Moss Foundation accepts no contributions. Instead, it asks that potential contributors donate money to one of the pro-life organizations whose addresses are reprinted in a thirty-two-page glossy brochure that is mailed to anyone inquiring about the organization.[10] The television ads are part of an elaborate media campaign by the De Moss Foundation. In its own statement, it proclaims that "this campaign celebrates life. It deals with family values and treats a delicate subject in a kind and gentle way. It seeks to change minds, not laws, by getting people to think about a difficult subject in a new light. These spots simply ask the question: What could be

more important than the right of someone to be born?"[11] The foundation refuses to disclose the names of the producers and will not circulate the tapes.[12]

In the current ad running on cable television, the voice-over proclaims that their mothers chose life for them, and that is why we can "see" them now. The De Moss Foundation has run this series of pro-life, pro-family spots for over a year during prime time. Other notorious spots feature happy white parents doting over a child in a playground, with a syrupy, concerned male voice-over explaining that the couple had considered terminating the pregnancy because they weren't sure they could afford a child.

With their perfect composition, soft lighting, pastel costuming, and bourgeois mise-en-scène, these slick commercials merge the commodity fetishism of advertising with the psychoanalytic overlays and conventions of Hollywood melodrama. These ads elaborate an emotional brocade of the family romance. Here, both the production and representation of children collapse into each other: the 35 mm image of the happy yet voiceless child is reproducible on the level of representation precisely because biological reproduction on the level of the woman's body was not tampered with by "unnatural" forces such as abortion. These De Moss ads invert classical melodramatic modes: rather than contradiction between sexuality and convention, between a woman's independence and her place within the confines of the home, between repression and expression (tropes that form the resistant, oppositional potential of all melodrama), these De Moss ads present us with upscale versions of happy home movies where all contention is deleted.[13]

But most important, this ad pictures the child without the mother as parent, as an independent, autonomous being almost outside of familial relations. The woman's body and mothering are invisible, not simply erased, which would suggest an active deletion. Carole Stabile notes a similar move in mass media representations of fetuses: "The maternal space has, in effect, disappeared and what has emerged in its place is an environment that the fetus alone occupies."[14] Numerous close-ups amplify the child's identity, subjectivity, and presence while the mother is reduced to a verbal construct with no visual valence or power. In other words, the maternal space is jettisoned to the outside of the image as a sort of distant satellite, still transmitting but on the "outside," secondary to the needs or the image of the child.

The suppression of the figure of the mother in the De Moss ad and the rhetoric of the pro-life movement is reiterated in the media's coverage of President Bill Clinton's reversal of five rulings on abortion on the twentieth anniversary of Roe v. Wade on January 22, only two days after he took office. Women's groups pressured the Clinton administration to initiate some significant interventions on abortion on this important historical day to show the symbolic end to twelve years of Republican and Supreme Court chiseling away at Roe v. Wade. To summarize, the rulings reversed the prohibition on counseling

women about abortion in federally funded clinics (the gag rule), permitted military hospitals to perform abortions if the woman paid, reassessed the ban on RU 486, opened the way to provide money to international groups that provide abortions, and allowed research on fetal tissue to proceed.[15]

On the discursive and political level, Clinton's actions on abortion signaled his debt to the women's vote, which helped him to win the presidential election. While his campaign position specified that abortion should be safe and legal, but rare, this position is hardly feminist. What has emerged in the Clinton administration's discursive construct around women is a splitting of the subject of women into multiple parts, each of which can be handled in specific ways to curb any potential destabilization of neoliberal pluralism by a radical multiplicity. For example, abortion is severed from the discourse of equality and access, women appointees to cabinet positions are positioned as women and *not* as women interested in women's issues, and Hillary Rodham Clinton is remade as a quilt of the perfect mother, supportive mate, glamorous fashion plate, and health care policy wonk.

Despite what is on the level of policy a breath of liberal—but certainly not radical—fresh air after the virulently antiwoman regimes of the past decade, on the level of visual representation and narrative structure, the *New York Times* coverage of the Clinton reversals structurally duplicates the De Moss Foundation's ads.[16] The news coverage of this event deletes women, feminism, and reproductive rights visually and discursively. Out of twenty-four paragraphs in the *New York Times* story, only one featured a response from a pro-choice leader, Kate Michelman of the National Abortion Rights Action League. That sole sentence was located on the jump page, a visual and ideological displacement of women.

The De Moss ads and the news coverage of the Clinton legal reversals demonstrate some of the very complicated congruencies that exist between conservative and neoliberal politics, especially when filtered through the processes of representation and the constructions of the female body. Both positions depend on disentangling women from mothering, mothering from social relations, social relations from representation, and representation from the female body. Both positions demonstrate an inability, or perhaps a refusal, to situate women within a more complex, multiple formation.

A feminist oppositional political and media practice must dismantle all of these intertwined levels of representation, politics, media, technology, and the female body, and be multistrategic. The De Moss ads and the Clinton reversals are both locked within conventions of home movies, commercials, state mandates, and melodrama that smooth over sexual and racial difference, struggle across common political interests, the historical position of women's bodies, and collective struggle on multiple sites. These two media representations systematically eradicate women's struggle and bodies by means of both the law

and high-end, commercial media production. The law and high-end media blur together like a stereoscope.

But what about independent film and video in these struggles over representation and reproductive rights? What possibilities does video, especially low-end video, offer in this age of defunding and privatization of the Corporation for Public Broadcasting (CPB), the Public Broadcasting Service (PBS), and federal and state grants?[17] What sort of intervention do new technologies like amateur video provoke in an era of increasing concentration and centralization of all media industries?

First, it is important to recognize here that the 1992 attacks against public television by Laurence Jarvik, the Heritage Foundation, the Family Research Council, and various conservative senators like Bob Dole and Jesse Helms were not new salvos against the so-called perverse, postmodern, antifigurative, artistic Left, but merely the culmination of twelve years of complaints by conservatives that arts agencies and public television evidenced a liberal bias that axed out conservative viewpoints.[18] Conservative arguments hinged on a three-pronged attack: first, invocation of a reinterpretation of the law that narrowed its scope; second, a philosophical rejection of postmodernism by reconstructing a modernist and scientific truth claim; and third, a reinstitution of boundary lines between the high culture of form and the low culture of emotion and rage. The conservatives' terror of this threat of instability—both political and aesthetic—was epitomized in the outcry by Pat Buchanan and some conservative groups when they attacked local public television stations for airing Marlon Riggs's black gay anthem, *Tongues Untied*. It is not just sexuality that threatens the status quo here, as some radical culture critics have claimed, but a proliferation of multiple sexualities and the situating of this difference within historical specificity. Let us not forget that the latest cycle of PBS and CPB bashing was blamed on two women, none other than Nina Totenberg for breaking the story on Anita Hill.

However, this debate about the funding and program priorities of public television and the National Endowment for the Arts becomes even more complicated when we focus on women, feminism, and reproductive rights. The 1980s witnessed two potentially contradictory movements: on the one side, the conglomerization of media and drastic reductions in network public affairs programming, and on the other side, the dissemination of technologies like amateur camcorders and satellite communication that decentralize and democratize media production and distribution.[19] This democratization and dissemination of access facilitated what I would like to call the explosion of "difference through diffusion," a phrase I utilize to denote the convergence between representation and politics and technology. In this context, media groups like Paper Tiger Television, Deep Dish Satellite, AIDS activists such as ACT UP and reproductive rights media groups such as the Buffalo Media Coali-

tion for Reproductive Rights have linked low-end, low-tech technologies with deconstructive argumentative and visual strategies. The amateur camcorder could be retrieved from the privatized confines of the bourgeois nuclear family—the gulag where all amateur media technologies have been deposited to stunt their democratic potential. This retrieval process pivots on two political moves: (1) access to media production to alter the social relations of production, and (2) discursive and textual realignments in between history, the present, and the future in the analysis of reproductive rights and tapes to arrest erosion of the public sphere.

The parallels between democratic access to media as potentially subversive of dominant media and unrestricted access to abortion as a woman's civil right are almost uncanny in both discourse and practice: both protect *differences of voices and bodies,* in particular female ones whose specificity poses unique interventions. A true democratization of both media and abortion depends on the practice and protection of access and not just on a commitment to equality and plurality. The issue of access, then, emerges as the fulcrum upon which rights can be imagined as articulations of multiple differences of voices on the level of discourse and multiple bodies on the level of practice.

Sean Cubit, in his book *Time Shift,* argues that the proliferation of video technologies multiplies the number of sites for cultural struggle. They fragment a coherent market of consensus broadcasting with diffused and intensely localized practices. He writes: "We have to think of the term 'technology" as a centrifugal net of interacting discourses, and as a function of them: educational, legal, aesthetic, sociocultural, scientific. . . . The first break is to rid ourselves of the prescriptive power of definition, and to think instead in terms of process and relations."[20] Cubit's notion of inscribing technology within process and relations and removing it from static definitions evokes Donna Haraway's cyborg; the videomaker, then, emerges as a sort of traveler between discourses and practices, a weaver of fractured social and aesthetic spaces and creator of new frontiers. Along this same line of excavating the radical potential of improved technologies, particularly consumer technologies like camcorders, Dee Dee Halleck observes, "The challenge is to develop Mumford's insights into emancipated uses of technology in a decentralized and genuinely democratic way. . . . In fact, it is evident that pockets of resistance have arisen that have the potential to evolve into more highly organized and autonomous centers of democratic communications."[21]

These discussions of the radical potential of consumer technology concentrate not on their dissemination and control by major corporations, but on their ability to increase access to production and to diffuse the sites where media intervention can occur.[22] Systematic exclusion of independent political voices can be challenged by inclusions of multiple voices via access to technology and a commitment to rephrasing the normative modes of production offered by

Reproductive Rights and Activist Video 255

commercial media. Rather than a technological nihilism that views all technology as reactionary and co-optive, Cubit and Halleck argue that video technology presents possibilities for altering social relations that did not exist within previous media forms. Both of their arguments stress the context and usage of the technologies rather than their inherent properties. With the relocation of the anti-abortion crusade to clinics, video has become increasingly important as part of the artillery that feminist groups can use to destroy ideology with visual evidence.[23]

The case of the Buffalo, New York, Media Coalition for Reproductive Rights (MCRR) exemplifies this move. The coalition uses low-end amateur camcorders to combat Operation Rescue clinic blockades. Its most recent tape, *Spring of Lies* (1992), chronicles the recent attacks in May 1992 against abortion clinics in Buffalo, New York. The tape places the videomakers in the middle of the action through hand-held camera work. The videographers themselves frequently speak to the right-to-life protesters. The tapes, which are distributed to anyone for fifteen dollars, have been used as courtroom evidence to document illegal barrier of entry to clinics by Operation Rescue. Circulating in a different sphere from more traditional oppositional films of the 1970s, the MCRR tapes exploit the proliferation of personal VCRs to form underground feminist networks. Although the tapes' videography is often shaky and out of focus, their confrontational style overrides formal coherence with the feverish pitch of war photography.

While the tapes are shot in the '60s style of aggressive cinema verité, with the camera provoking action from either anti-abortion or reproductive rights activists, they document the extent of Operation Rescue's interference by placing the spectator in the subject position of a *pregnant woman* going to the clinic. These tapes put the woman's body—excised and exiled by the Supreme Court and mass media representations—back into abortion confrontations. They compare media representations of the attacks that even out the conflict with the immediate and visceral ambience of their own cinematography where the camera, and by extension representation, is often physically in the center of the struggle and debate. These tapes do not simply serve as alternatives to the networks; they provoke a new social usage of technology and a new social configuration of spectatorship as resistant, active, and social. The tapes function as a sort of feminist cyborg, the video technology provoking slippage between feminist intervention and representation, between technology and women's bodies.

U.S. Bans Abortion (1990), produced by Paper Tiger Television in New York City, also inserts the female body into the health care system surrounding abortion via low-end video technology. This thirty-minute tape discusses the Bush administration's restrictions on Title X, which provides funding for health care clinics for poor women. The restrictions would limit health care

providers in clinics from providing information on abortion as an option in dealing with pregnancy in federally funded clinics. The tape alternates between four feminist health care activists analyzing the impact of Title X restrictions on poor women's health and footage of a Women's Health Action Mobilization (WHAM) demonstration at the New York City Department of Health, shot from the point of view of the participants.

The interview sequences with the four activists demonstrate how media representation, public policy on health care, and specifying the female body coagulate in both discourse and practice. These interviews, threaded in between the demonstration footage, provide analysis of the media blackout on Title X and analysis of its impact on poor women and women of color. These activists speak directly to the camera and argue that Title X restrictions could be potentially more devastating than the Webster decision in that it would affect over five million women and four thousand clinics.

Marianne Staniszewski, a cultural critic from the Rhode Island School of Design and a member of WHAM, explains that the media create our social landscape and collective memory; she claims that the lack of coverage on the restrictions can be directly related to the fact that they would affect marginalized groups of women: teenagers, people of color, poor women. Later in the tape, Staniszewski shows how the language of Title X redefines life as beginning at conception; she quotes from Title X: "The health care worker must promote the interests of the unborn child."

Tracy Morgan, a health educator who works in a clinic, narrates an example of what her work life would be like under Title X restrictions. If a pregnant teenager came to her clinic, Morgan would currently outline three options: prenatal care if she decided to carry the baby to term, adoption, and abortion if she chose to terminate the pregnancy. Under Title X, abortion would remain legal, but Morgan would be prohibited from mentioning it as an option. A young man in the group explains that although Roe v. Wade made abortion legal in 1973, the strategy of the federal government has been to attempt to cut off women's access to abortion through measures like the Hyde amendment, which revoked Medicare funding for abortion. A WHAM activist concludes the tape by arguing that all of the attempts to curtail abortion constitute "retaliation against the massive gains" made by women; she asserts, "We never achieved reproductive freedom. We have to incorporate all women from all classes, races, and ethnic backgrounds." These interviews anchor our reading of the demonstration footage within the larger issue of health care as a right for all women. Although most of the interviews are with white activists, the political analysis creates a discursive subject position for a pregnant teenager of color. It is precisely this pregnant teenager of color who is denied reproductive rights, and whose access to information and care tempers our perception of the success of "reproductive freedom."

Mirroring the camcorder strategy of *Spring of Lies,* the demonstration foot-age in *U.S. Bans Abortion* is shot with low-end, hand-held video. While cover-age of demonstrations from the point of view of demonstrators has a long tradition in political documentary film, extending as far back as the Workers' Film and Photo League's coverage of demonstrations during the Depression and continuing through cinema verité of the 1960s, this camcorder footage offers a slightly different intervention. The arbitrary border between videogra-pher as omniscient and omnipresent and the subject as distant and pacified is abandoned. This strategy is not merely a participatory form of media produc-tion to stimulate active spectatorship; it situates the video camera and its oper-ator within the sexualized and gendered subject position of a cyborglike woman opposing governmental policy and fighting back for reproductive rights.

In a move similar to that of *Spring of Lies, U.S. Bans Abortion* uses cam-corder video to both reinsert and reassert the pregnant female body. While the camera work in *Spring of Lies* positions the pregnant female body under virtual physical and psychical attack, the camera in *U.S. Bans Abortion* imagines a pregnant, raced, and classed female body of the future that bureaucracy and politics try to mute and restrain but that, in the end, refuses to be silenced or immobilized. While many film theorists have interrogated the multiple subject positions constituting female spectatorship, this cyborglike confederation of the camcorder, reproductive rights politics, and the sexualized female body proposes a different twist on psychoanalytic identification and more of an ethnographic reception theory: not only is the female body made visible and vocal; it is also empowered and powerful through video technology that facili-tates a militant subjectivity and a collective participation.

Another example of feminist oppositional public-sphere video is *Access Denied* (1991), a new tape by the activist group Reprovision, part of the Wom-en's Health Action Mobilization. This tape works on a more explanatory level than the visceral level of *Spring of Lies,* yet it also obscures the line between spectator and participant, the law and the body. While showing street demon-strations, the tape elaborates the multiple contexts of restrictions on abortion across race, age, and sexual preference lines, effectively deconstructing the complaint that abortion rights politics evidenced white, middle-class, single-issue feminism of the 1960s and 1970s. Constructed in segments outlining reproductive rights issues within a larger context of race, health care, and teenagers, the tape interweaves demonstration footage with interviews, mark-ing each segment historically with a short montage of archival footage that valorizes motherhood.

The tape begins with clinic defense against Operation Rescue and interviews with WHAM volunteers and escorts. It then moves from the streets to the legal plane, where it discusses the Supreme Court Webster decision restrictions on

abortion. An African American woman activist, relating how Webster affects women of color, cites evidence that prior to 1973, 80 percent of illegal abortions were had by women of color. Another black woman describes her friend hemorrhaging from an illegal botched abortion. Other segments refuse to position abortion as a single issue of privacy, focusing instead on the relationship between AIDS research and fetal tissue research, between prohibitions on sexual preference and the issue of women's right to health care, to a description of a menstrual extraction and to teenagers protesting parental-consent restrictions. On the argumentative and visual levels, *Access Denied* explicates the multiple geographies of abortion politics. The tape ends with the direct address to viewers: "Come join us." *Access Denied* circulates between the private and the public, between the law and the clinics, between health care and sexuality. It constructs a discursive multiplicity that argues for reimagining the larger political context of abortion—one that goes beyond proper, white middle-class unified discourse.

Although it does not utilize hand-held, camcorder videography, Kathy High's remarkable new tape, *Underexposed: Temple of the Fetus* (1992) also centers on women's clinics as the space where the female body, technology, and politics converge. The clinical space outlined in this tape is not that of abortion providers, but of clinics of the future that retrieve embryos and implant them in women desperate for children. Kathy High deciphers the clinical space within which women's bodies have been and will be suspended and how new reproductive technologies continue the discursive move of separating women from their wombs, turning the womb into what one character in the tape calls "a fetal environment." The tape later visualizes this discursive amputation with images of wombs like spaceships. This clinical space is a feminist nightmare of male doctors controlling women's bodies through technology. One doctor exhorts, for example, that in vitro fertilization "is therapeutic for these women, the best way for some women to resume useful lives."

Like *Access Denied, Underexposed: Temple of the Fetus* weaves together multiple discursive and explanatory modes to define the space within which reproductive politics operates.[24] It layers together several different genres to investigate the politics of new reproductive technologies, specifically in vitro fertilization: historical archival footage of pregnancy and birth, a fictional, docudramalike story about a newscaster covering her friend's in vitro fertilization, straight documentary interviews with international feminists who study reproductive politics, and a science fiction narrative about the future control of in vitro fertilization by male doctors and corporations. Deploying these multiple textual strategies to unpack the position of new reproductive technologies within a feminist health politics, *Temple of the Fetus* locates the pregnant and desiring-to-be pregnant female body within a network of politics, practices, discourses, science, and imaginings about the future.

Frame enlargement from Kathy High's *Underexposed: Temple of the Fetus* (1993). Photo courtesy of Video Data Bank, Chicago.

Temple of the Fetus insists that scientific exploration of new reproductive technologies is inextricably linked to the state. In a faked interview in the future, the head of the newly formed Department of New Reproductive Technologies proclaims, "This is not just a baby, it is a national issue." By utilizing the conventions of network news interviews, the narrative sequences with doctors practicing in vitro fertilization and with the woman patient expose how scientific intervention into reproduction and pro-natalist ideologies can be reframed as commonsensical solutions and miracle cures for the complicated biological and social issue of infertility. The utopian possibilities of in vitro fertilization are undercut by the narrative of the tape, however: the woman who was implanted lost her baby at twenty-two weeks. In one faked interview, a woman proclaims that the doctor at the clinic "was looking at my stomach and seeing dollar signs." The narrative of one woman's quest for a child now that her career is under way is located within two registers: the family melodrama of the impregnation and its subsequent failure told from the point of view of the woman patient, and rational, instrumental muckraking of the in vitro business by her best friend, an aggressive news reporter. Thus the "story" of in vitro fertilization in this tape is multitiered, simultaneously narrated from the emotional, and personal point of view of the female patient and

Frame enlargement from
Kathy High's
*Underexposed: Temple of
the Fetus* (1993). Photo
courtesy of Video Data
Bank, Chicago.

logically, publicly exposed by a female news reporter. Both routes arrive at the
same conclusion, a condemnation of the trivialization of women's reproduc-
tive autonomy. Both routes are positioned in this tape as equally politically
urgent. The constant mobility between personal and public suggests that a
complex political strategy is crucial to counter the poor treatment of women's
anatomy.

In addition, the tape suggests the sexual preference, class, and race dimen-
sions of reproductive technologies. The female reporter interviews a pregnant
lesbian couple who contend that the Department of Reproductive Ethics and
Procedures, a government agency, restricts sperm to protect the unborn from
AIDS. The couple explain that they procured sperm from "two Harvard guys"
and argue that they, too, constitute a nuclear family. In a later fictionalized
interview, a black woman doctor exposes the fact that in vitro fertilization is
reserved for middle-class whites. Consequently, *Temple of the Fetus* offers a
critique of male-controlled reproductive utopias by rerouting its narrative tra-
jectory into a failed pregnancy that then produces consciousness about how
these technologies serve science, the state, and capitalism rather than women.

Temple of the Fetus establishes the point that historical images of birth and
reproduction, scientific training films, and narratives about the utopian future
prospects for reproductive technologies all concoct imaginary fictions about
the female body that rob it of autonomy, activity, and specificity. This fic-
tionalizing of disparate materials and sources demonstrates the pacification of
the maternal and pregnant body in discourse, practice, and image making.
Actual documentary interviews with feminists from around the world who
study the social consequences of new reproductive technologies are counter-
posed against these fantasy constructions of the female body that neutralize
and confine the body within science.

As *Temple of the Fetus* alerts us, reproductive politics travels like a cyborg,

reconstructing temporality along less linear, phallocratic lines: between histor-
ical formations that remove woman from the womb, new technologies that
reconfigure the race, class and imperial relations of reproduction, and male
fantasies of a technological utopia where women's individual control over
their bodies aids patriarchal agendas for reproduction.

S'Aline's Solution (1991), a short experimental video by Aline Mare, utilizes
technological and representational strategies that are similar to those of the
more activist tapes discussed above. The very title of the tape suggests the
cyborg merging of the medical/technological and the specified female subject:
since saline solution is a method of abortion, (S)Aline's solution is one wom-
an's solution to an unwanted pregnancy. Thus the title of the tape functions not
only as a pun on abortion, but also demonstrates that the convergence of medi-
cine and subjectivity constitutes the material site of abortion.

This compelling and evocative tape performs an ideological exorcism on
abortion, wresting it from the limiting discursive domain of the law and public
policy and sheathing it within not only the female body, but the speaking
female subject and medicalized, imaged female organs. The tape specifies not
only the female body, but the site of abortion through medical imaging technol-
ogy that allows for close-up views inside the body and its organs. S'Aline's
Solution traverses three different political registers: the social/medical organi-
zation of the female body, the imaginary, emancipated female body of a specific
woman who chooses, and the aborted, pregnant speaking subject. The tape is
organized in three sections corresponding to these three registers: medical
images of the interior female body; close-ups of a woman's mouth and images
of a woman swimming; and a lyrical voice-over that fuses assertions of per-
sonal choice, loss, science, and autonomy. Subjectivity here is redefined along
multiple trajectories rather than linear unities.

The social/medical organization of the female body engaged in reproduction
is presented through the use of slow-motion scientific imaging of female re-
productive organs, sperm, ova, and embryos. The tape opens with a traveling
shot through the vagina into the womb through a high-tech, miniaturized video
camera accompanied by slow, eerie electronic music. This particular image
presents a gendered intervention into the semiotics of the "traveling shot" of
classical Hollywood cinema. Rather than moving through public space, this
traveling shot literally invades the private and invisible space of the female
interior.

Various slow-motion medicalized, high-tech images of sperm, ova, and em-
bryos floating in space unanchored to the female body emerge throughout the
tape, evoking science, medicine, and the activity of the womb as mysterious
melodramas and spectacles. On the level of representation and politics, the
lethargy of these images removes these sperm, ova, and embryos from the anti-

abortion ideological construct that they *are* "life" by showing that they are actually only representations. This visual strategy employs a pun on reproduction: while the images are severed from the referent of biological reproduction, they operate as an interrogation of visual reproduction and a deconstruction of anti-abortion ideological constructs that argue that life begins at conception. In *S'Aline's Solution,* a woman's life begins when she chooses. Indeed, to underscore the physical and scientific difference between fertilized eggs and babies, the tape concludes with a birth scene, where a baby's head emerges from a woman's vagina. Although on first viewing, this birth scene may appear to be out of place, the construction of the tape actually changes the signification of the birth. It simultaneously confirms on the level of representation the biological difference between fertilized eggs and babies.

The tape employs live-action footage of Aline to counterpose medicalized representations of an idealized and sanitized "woman's" organs. The extreme close-ups of a woman's mouth and of a woman swimming compose another part of this splitting of the female body. These images also evoke a dreamlike quality through slow motion and some distortion from wide angle–lens videography, suggesting that subjectivity is tied to physicality. While the medical imagery dislocates female body parts with a scientific, fragmenting gaze, these image-manipulated close-ups and long shots of a specific woman relocate the right to choose abortion within the female body. The repeated use of close-ups of a woman's mouth link identity with speech.

S'Aline's Solution also crafts the aborted, female body as a speaking subject and as an active participant in the abortion. The speaking, pregnant body counters medicalized, distant female body parts. The sound track is composed of a somber, incantatory woman's voice-over intoning the words "I choose, I chose, I have chosen," and other descriptive vocalizations of the experience of abortion. The voice-over concludes with an affirmation that abortion is located not within the abstract and ideological, but within the material, social relations of the gendered and sexualized female body.

In all these tapes, video technology reinvents the political project of abortion rights through an emancipatory merging of technology and women's bodies. If Supreme Court decisions have detached women from abortion, these tapes produce and reproduce women's bodies, restoring specificity to this war on the female body. The resistant, biological woman suspended between multiple discourses and identities is reinvigorated via the video camera, physically inserted into the action, her voice, body, and spectatorship central rather than erased as in the De Moss Foundation ads or Clinton's press conference or mass media narratives. Rather than melodrama, these tapes function as combat videography mapping the location of the gendered body and voice in politics. Rather than texts or discourses, these tapes function as physical intersections

between the body, abortion politics, and technology. To discuss them solely on the level of formal innovation as avant-garde texts or on the level of argumentative structure to elaborate political context is to miss their political agenda entirely.

A day after Clinton signed the reversals of the abortion rulings, pro-life activists exclaimed they would now take their struggle to the streets, thereby suggesting that the war on the female body was not simply discursive but physical, located within a specific time and place at clinics. However, the right-to-life invocation of '60s-style yippie politics is hopelessly outdated, because the street as a material place, although clearly important for activism in the 1990s, is insufficient for the struggle over reproductive rights and the gendered body.

The days when political activity solely focused on the streets could change the world and make it a better place are gone. The inability of the so-called Left to deal with the mass-mediated phantasmagoria of the Gulf War is verification that activist politics needs a different kind of vehicle, one with more power and an ability to maneuver over multiple terrains—real, discursive, and representational. We must recapture pleasure and desire in our consumption of media images, just as we must ensure that camcorder technology is used by us and on our behalf. These low-end videos assert that the current war on women's bodies can only be fought by reimagining the woman's body within the construct of a feminist cyborg public sphere. Low-end video not only serves as documentation that women's bodies are the battlegrounds, to paraphrase a famous Barbara Kruger poster—it is a physical manifestation that this new guerrilla construct of women's bodies as powerful video cyborgs is the fetal tissue of an emerging feminist public sphere.

Notes

I would like to thank Zillah Eisenstein for her helpful criticism on the original draft of this essay. I would also like to thank my research assistant, Lenore DiPaoli, for her diligent excavation of documents. For alerting me to these tapes on reproductive rights I thank Scott MacDonald, Sally Berger, and Kathy High. The tapes cited in this article are available: For *Spring of Lies,* contact Media Coalition for Reproductive Rights, P.O. Box 33, Buffalo, N.Y. 14201. For *U.S. Bans Abortion,* contact Paper Tiger Television, 339 Lafayette Street, New York, N.Y., 10012, (212) 420–9045. For *Access Denied,* contact Women Make Movies, 462 Broadway, Suite 501, New York, N.Y. 10013, (212) 925-0606. For *Underexposed: Temple of the Fetus,* contact Video Data Bank, 37 S. Wabash Avenue, Chicago, Ill. 60603, (312) 899-5172. For *S'Aline's Solution,* contact The Kitchen, 512 W. 19th Street, New York, N.Y. 10011, (212) 255-5793.

1　Donna J. Haraway, "A Cyborg Manifesto: Science, Technology, and Socialist Feminism in the Late Twentieth Century," in *Simians, Cyborgs, and Women: The Reinvention of Nature* (New York: Routledge, 1991), 153.

2　Ibid., 174.

3　Larry Rohter, "Doctor Is Slain during Protest over Abortions," *New York Times,* 11 March

1993, 1, B-10; Anthony Lewis, "Right to Life," *New York Times,* 12 March 1993, 29; David A. Grimes et al., "An epidemic of antiabortion violence in the United States," *American Journal of Obstetrics and Gynecology* 165, no. 5 (November 1991), 1263–68; "Highlights of Recent Violence against Planned Parenthood Clinics," Planned Parenthood flyer, 11 March 1993; see also a series of Planned Parenthood news releases issued on the heels of the Dr. Gunn shooting: Statements by Pamela J. Maraldo, president of Planned Parenthood Federation of America Planned Parenthood Action Fund, 10, 11 and 12 March 1993; "Planned Parenthood Establishes Clinic Defense Fund in Aftermath of Florida Physician's Murder," flyer, 12 March 1993; Statement by Alexander C. Sanger, president and CEO, Planned Parenthood of New York City, 12 March 1993; "Unwanted in Any Florida City, David LaMond Gunn," Planned Parenthood flyer of clip from *Washington Times,* 12 March 1993.

4 Constance Penley and Andrew Ross, eds., *Technoculture* (Minneapolis: University of Minnesota Press, 1991), xv.

5 See for example E. Ann Kaplan, "Theories and Strategies of the Feminist Documentary," *New Challenges for Documentary,* ed. Alan Rosenthal (Berkeley: University of California Press, 1988), 78–102. See also Vivian C. Sobchack, *"No Lies:* Direct Cinema as Rape," Patricia Erens, "Women's Documentary Filmmaking: The Personal is Political," and Linda Williams, "What You Take for Granted," in Rosenthal, *New Challenges for Documentary;* Julia Lesage, "Feminist Documentary: Aesthetics and Politics," in *Show Us Life: Towards a History and Aesthetics of the Committed Documentary,* ed. Thomas Waugh (Metuchen, N.J.: Scarecrow Press, 1984); Julianne Burton, "Transitional States: Creative Complicities with the Real in *Man Marked to Die: Twenty Years Later and Patriamada,"* in Julianne Burton, ed., *The Social Documentary in Latin America* (Pittsburgh: University of Pittsburgh Press, 1990), 373–401.

6 While recent writing on documentary invokes feminist film theorization on the body and the gaze, this work does not offer a theoretical interrogation of what would constitute a feminist documentary practice. See Bill Nichols, *Representing Reality* (Bloomington: Indiana University Press, 1991). Nichols' argument for example, insists that documentary is linked with history, ethics, and rhetoric. His book masterfully outlines the various formal and rhetorical modes of address and organization that documentary occupies; yet he offers no distinctions in terms of gender. In his line of argument, gender is subsumed under the category of the social, but not viewed as a system of difference requiring different modes of theorization.

7 Margaret Cooper, "The Abortion Film Wars: Media in the Combat Zone," *Cineaste* 15, n. 2 (1986): 8–12.

8 Rosalind Pollack Petchesky, "Foetal Images: The Power of Visual Culture in the Politics of Reproduction," in *Reproductive Technologies: Gender, Motherhood and Medicine,* ed. Michelle Stanworth (Minneapolis: University of Minnesota Press, 1987), 58.

9 Valeri Hartouni, "Containing Women: Reproductive Discourse in the 1980s," in Ross and Penley, *Technoculture,* 51.

10 Statement by the Arthur S. De Moss Foundation, n.d.; "Life. What a Beautiful Choice," brochure published by the Arthur S. De Moss Foundation.

11 Statement by the Arthur S. De Moss Foundation, 1.

12 Letter to the author from Mrs. Rebecca S. McKay, for the Arthur S. De Moss Foundation, March 3, 1993.

13 These tropes of melodrama have been elaborated in Laura Mulvey, "Notes on Sirk and Melodrama," in her *Visual and Other Pleasures* (Bloomington: Indiana University Press, 1989), 39–44, and "Melodrama Inside and Outside the Home" in Mulvey.

14 Carole A. Stabile, "Shooting the Mother: Fetal Photography and the Politics of Disappearance," *Camera Obscura* 28, January 1992, 180.

15 Gwen Ifill, "Clinton Ready to Act on 2 Abortion Regulations," *New York Times*, 17 January 1993, 21; Robin Toner, "Anti-Abortion Movement Prepares to Battle Clinton," *New York Times*, 22 January 1993, 1 and 16; "Since Roe v. Wade: The Evolution of Abortion Law," *New York Times*, 22 January 1993, 11; Robin Toner, "Clinton Orders Reversal of Abortion Restrictions Left by Reagan and Bush," *New York Times*, 23 January 1993, 1 and 10.

16 My argument here analyzes an article and two photographs from Toner, "Clinton Orders Reversal of Abortion."

17 For a thorough discussion on the attack against public broadcasting, see Josh Daniel, "Uncivil Wars: The Conservative Assault on Public Broadcasting," *The Independent* (August/September 1992): 20–25. See also Walter Goodman, "Pull the Plug on PBS?" *New York Times*, 22 March 1992, H-33; Martin Tolchin, "Public Broadcasting Bill Is Sidelined," *New York Times*, 5 March 1992, A-14; Mark Schapiro, "Public TV Takes Its Nose out of the Air," *New York Times*, 3 November 1992, H-31; "Attacks on CPB and ITVS Threaten Funding for TV Documentaries," *Documentary* (May 1992): 1, 8–9.

18 Kim Masters, "Big Bird Meets the Right Wing," *Washington Post*, 4 March 1992, 21; William J. Eaton and Sharon Bernstein, "GOP Senator Blasts Public Broadcasting," *Los Angeles Times*, 4 March 1992, 11; Kim Masters, "Hill Clash Set over Public TV," *Washington Post*, 3 March 1992, 14; Robert Knight, "Free Big Bird," *Miami Herald*, 6 March 1992, 8-C; Laurence Jarvik, "Monopoly, Corruption, and Greed: The Problem of Public Television," reprint of a speech delivered as part of the Heritage Foundation Lecture Series, February 25, 1992; Richard Zoglin, "Public TV under Assault," *Time*, 30 March 1992, 58; S. Robert Lichter, Daniel Amundson, and Linda S. Lichter, "Balance and Diversity in PBS Documentaries," unpublished research study, Center for Media and Public Affairs, March 1992.

19 Ben Bagdikian, *The Media Monopoly* (Boston: Beacon Press, 1992); Ken Auletta, *Three Blind Mice: How the TV Networks Lost Their Way* (New York: Random House, 1991); Douglas Kellner, "Public Access Television and the Struggle for Democracy," in *Democratic Communications in the Information Age*, ed. Janet Wasko and Vincent Mosco (Norwood, N.J.: Ablex, 1992), 100–13; Gladys D. Ganley, *The Exploding Political Power of Personal Media* (Norwood, N.J.: Ablex, 1992).

20 Sean Cubit, *Time Shift: On Video Culture* (London: Routledge, 1991), 13–14.

21 Dee Dee Halleck, "Watch Out, Dick Tracy, Popular Video in the Wake of the Exxon Valdez," in Penley and Ross, *Technoculture*, 217. For a discussion of the use of camcorders for AIDS education and empowerment, see Alexandra Juhasz, "WAVE in the Media Environment: Camcorder Activism and the Making of HIV TV," *Camera Obscura* 28, January 1992, 135–50.

22 This argument on increasing access to media production as a democratic right has also been made by media producers working in public access in less urban and smaller communities. See, for example, Chris Hill and Barbara Lattanzi, "Media Dialects and Stages of Access," *Felix* 1 n. 2 (spring 1992): 98–106.

23 See Steven Greenhouse, "Praise and Protest on Clinton's Decisions," *New York Times*, 24 January 1993, 6; Adam Clymer, "Abortion Rights Supports are Split on U.S. Measure," *New York Times*, 2 April 1993, A-16; Felicia R. Lee, "On Battle Lines of Abortion Issue: Debate Rages On Outside of Clinics," *New York Times*, 17 May 1993, B-1 and B-4; Felicity Barringer, "Slaying Is a Call to Arms for Abortion Clinics," *New York Times*, 12 March 1993, A-1 and A-17; Alisa Solomon, "Harassing House Calls," *Village Voice*, 23 March 1993, 20.

24 Many feminist theoreticians have advanced similar arguments that reproductive technologies are controlled by men, thereby circumscribing and limiting choice. See, for example, Michelle Stanworth, "Reproductive Technologies and the Deconstruction of Motherhood," and Hilary Rose, "Victorian Values in the Test-Tube: The Politics of Reproductive Science and Technology," in Stanworth, *Reproductive Technologies*, 10–35 and 151–73, respectively.

Lorraine O'Grady

Olympia's Maid: Reclaiming Black Female Subjectivity

The female body in the West is not a unitary sign. Rather, like a coin, it has an obverse and a reverse: on the one side, it is white; on the other, not-white or, prototypically, black. The two bodies cannot be separated, nor can one body be understood in isolation from the other in the West's metaphoric construction of "woman." White is what woman is; not-white (and the stereotypes not-white gathers in) is what she had better not be. Even in an allegedly postmodern era, the not-white woman as well as the not-white man are symbolically and even theoretically excluded from sexual difference.[1] Their function continues to be, by their chiaroscuro, to cast the difference of white men and white women into sharper relief.

A kaleidoscope of not-white females, Asian, Native American, and African, have played distinct parts in the West's theater of sexual hierarchy. But it is the African female who, by virtue of color and feature and the extreme metaphors of enslavement, is at the outermost reaches of "otherness." Thus she subsumes all the roles of the not-white body.

The smiling, bare-breasted African maid, pictured so often in Victorian travel books and *National Geographic* magazine, got something more than a change of climate and scenery when she came here.

Sylvia Ardyn Boone, in her book *Radiance from the Waters* (1986), on the physical and metaphysical aspects of Mende feminine beauty, says of contemporary Mende: "Mende girls and women go topless in the village and farmhouse. Even in urban areas, girls are bare-breasted in the house: schoolgirls take off their dresses when they come home, and boarding students are most comfortable around the dormitories wearing only a wrapped skirt."[2]

What happened to the girl who was abducted from her village, then shipped here in chains? What happened to her descendants? Male-fantasy images on rap videos to the contrary, as a swimmer, in communal showers at public pools around the country, I have witnessed black girls and women of all classes showering and shampooing with their bathing suits *on,* while beside them their white sisters stand unabashedly stripped. Perhaps the progeny of that

African maiden feel they must still protect themselves from the centuries-long assault that characterizes them, in the words of the *New York Times* ad placed by a group of African American women to protest the Clarence Thomas–Anita Hill hearings, as "immoral, insatiable, perverse; the initiators in all sexual contacts—abusive or otherwise."[3]

Perhaps they have internalized and are cooperating with the West's construction of not-white women as not-to-be-seen. How could they/we not be affected by that lingering structure of invisibility, enacted in the myriad codicils of daily life and still enforced by the images of both popular and high culture? How not get the message of what Judith Wilson calls "the legions of black servants who loom in the shadows of European and European-American aristocratic portraiture,"[4] of whom Laura, the professional model that Edouard Manet used for Olympia's maid, is in an odd way only the most famous example? Forget euphemisms. Forget "tonal contrast." We know what she is meant for: she is Jezebel *and* Mammy, prostitute and female eunuch, the two-in-one. When we're through with her inexhaustibly comforting breast, we can use her ceaselessly open cunt. And best of all, she is not a real person, only a robotic servant who is not permitted to make us feel guilty, to accuse us as does the slave in Toni Morrison's *Beloved* (1987). After she escapes from the room where she was imprisoned by a father and son, that outraged woman says: "You couldn't think up what them two done to me."[5] Olympia's maid, like all the other "peripheral Negroes,"[6] is a robot conveniently made to disappear into the background drapery.

To repeat: castrata and whore, not madonna and whore. Laura's place is outside what can be conceived of as woman. She is the chaos that must be excised, and it is her excision that stabilizes the West's construct of the female body, for the "femininity" of the white female body is ensured by assigning the not-white to a chaos safely removed from sight. Thus only the white body remains as the object of a voyeuristic, fetishizing male gaze. The not-white body has been made opaque by a blank stare, misperceived in the nether regions of TV.

It comes as no surprise, then, that the imagery of white female artists, including that of the feminist avant-garde, should surround the not-white female body with its own brand of erasure. Much work has been done by black feminist cultural critics (Hazel Carby and bell hooks come immediately to mind) that examines two successive white women's movements, built on the successes of two black revolutions, which clearly shows white women's inability to surrender white skin privilege even to form basic alliances.[7] But more than politics is at stake. A major structure of psychic definition would appear threatened were white women to acknowledge and embrace the sexuality of their not-white "others." How else explain the treatment by that women's movement icon, Judy Chicago's *Dinner Party* (1973–78) of Sojourner Truth, the

lone black guest at the table? When thirty-six of thirty-nine places are set with versions of Chicago's famous "vagina" and recognizable slits have been given to such sex bombs as Queen Elizabeth I, Emily Dickinson, and Susan B. Anthony, what is one to think when Truth, the mother of four, receives the only plate inscribed with a face?[8] Certainly Hortense Spillers is justified in stating that "the excision of the genitalia here is a symbolic castration. By effacing the genitals, Chicago not only abrogates the disturbing sexuality of her subject, but also hopes to suggest that her sexual being did not exist to be denied in the first place."[9]

And yet Michele Wallace is right to say, even as she laments further instances of the disempowerment of not-white women in her essay on *Privilege* (1990), Yvonne Rainer's latest film, that the left-feminist avant-garde "in foregrounding a political discourse on art and culture" has fostered a climate that makes it "hypothetically possible to publicly review and interrogate that very history of exclusion and racism."[10]

What alternative is there really—in creating a world sensitive to difference, a world where margins can become centers—to a cooperative effort between white women and women and men of color? But cooperation is predicated on sensitivity to differences among ourselves. As Nancy Hartsock has said, "We need to dissolve the false 'we' into its real multiplicity."[11] We must be willing to hear each other and to call each other by our "true-true name."[12]

To name ourselves rather than be named we must first see ourselves. For some of us this will not be easy. So long unmirrored in our true selves, we may have forgotten how we look. Nevertheless, we can't theorize in a void, we must have evidence. And we—I speak only for black women here—have barely begun to articulate our life experience. The heroic recuperative effort by our fiction and nonfiction writers sometimes feels stuck at the moment before the Emancipation Proclamation.[13] It is slow and it is painful. For at the end of every path we take, we find a body that is always already colonized. A body that has been raped, maimed, murdered—that is what we must give a healthy present.

It is no wonder that when Judith Wilson went in search of nineteenth-century nudes by black artists, she found only three statues of nonblack children—Edmonia Lewis's *Poor Cupid* (1876); her *Asleep* (1871); and one of the two children in her *Awake* (1872)[14]—though Wilson cautions that, given the limits of current scholarship, more nudes by nineteenth-century blacks may yet surface.[15] Indeed, according to Wilson, the nude, one of high art's favorite categories, has been avoided during most of "the 200-year history of fine art production by North American blacks."[16] Noting exceptions that only prove the rule, that is, individual works by William H. Johnson and Francisco Lord in the thirties and Eldzier Cortor's series of Sea Island nudes in the forties, she

calls "the paucity of black nudes in U.S. black artistic production prior to 1960 . . . an unexamined problem in the history of Afro-American art."[17] And why use 1960 as a marker of change? Because, says Wilson, after that date there was a confluence of two different streams: the presence of more, and more aggressive, black fine artists such as Bob Thompson and Romare Bearden, and the political use of the nude as a symbol of "Black Is Beautiful," the sixties slogan of a programmatic effort to establish black ethnicity and achieve psychic transformation.[18]

Neither of these streams, however, begins to deal with what I am concerned with here: the reclamation of the body as a site of black female subjectivity. Wilson hints at part of the problem by subtitling a recent unpublished essay "Bearden's Use of Pornography." An exterior, pornographic view, however loving, will not do any more than will the emblematic "Queen of the Revolution." But though Wilson raises provisional questions about Bearden's montaging of the pornographic image, her concerns are those of the art historian, while mine must be those of the practitioner.[19] When, I ask, do we start to see images of the black female body by black women made as acts of auto-expression, the discrete stage that must immediately precede or occur simultaneously with acts of auto-critique? When, in other words, does the present begin?

Wilson and I agree that, in retrospect, the catalytic moment for the subjective black nude might well be Adrian Piper's *Food for the Spirit* (1971), a private loft performance in which Piper photographed her physical and metaphysical changes during a prolonged period of fasting and reading of Immanuel Kant's *Critique of Pure Reason.*[20] Piper's performance, unpublished and unanalyzed at the time (we did not have the access then that we do now), now seems a paradigm for the willingness to look, to get past embarrassment and retrieve the mutilated body, as Spillers warns we must if we are to gain the clear-sightedness needed to overthrow hierarchical binaries: "Neither the shameface of the embarrassed, nor the not-looking-back of the self-assured is of much interest to us," Spillers writes, "and will not help at all if rigor is our dream."[21]

It is cruelly ironic, of course, that just as the need to establish our subjectivity in preface to theorizing our view of the world becomes most dire, the idea of subjectivity itself has become "problematized." But when we look to see just whose subjectivity has had the ground shifted out from under it in the tremors of postmodernism, we find (who else?) the one to whom Hartsock refers as "the transcendental voice of the Enlightenment" or, better yet, "He Who Theorizes."[22] Well, good riddance to him. We who are inching our way from the margins to the center cannot afford to take his problems or his truths for our own.

Although time may be running out for such seemingly marginal agendas as the establishment of black female subjectivity (the headlines remind us of this every day) and we may feel pressured to move fast, we must not be too concep-

Adrian Piper, *Food for the Spirit* (1971). Photo courtesy of Lorraine O'Grady.

tually hasty. This is a slow business, as our writers have found out. The work of recuperation continues. In a piece called *Seen* (1990) by the conceptual artist Renee Greene, two of our ancestresses most in need, Saartjie Baartman ("the Hottentot Venus") and Josephine Baker, have been "taken back." Each in her day (early nineteenth and twentieth century, respectively) was the most celebrated European exhibit of exotic flesh. Greene's piece invites the viewer to stand on a stage inscribed with information about the two and, through a "winkie" of eyes in the floor and a shadow screen mounted on the side, to experience how the originals must have felt, pinned and wriggling on the wall. The piece has important attributes: it is above all cool and smart. But from the perspective being discussed here—the establishment of subjectivity—because it is addressed more to the other than to the self and seems to deconstruct the subject just before it expresses it, it may not unearth enough new information.

The question of to whom work is addressed cannot be emphasized too strongly. In the 1970s, African American women novelists showed how great a leap in artistic maturity could be made simply by turning from their male peers' pattern of "explaining *it* to *them*," as Morrison once put it, to showing how it feels to *us*.[23]

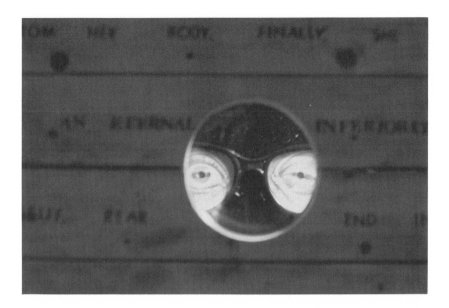

Renee Greene, *Seen* (1990). Photo courtesy of Lorraine O'Grady.

Besides, pleading contains a special trap, as Gayatri Spivak noted in her discussion of the character Christophine in Jean Rhys's *Wide Sargasso Sea:* "No perspective *critical* of imperialism can turn the Other into a self, because the project of imperialism has always already historically refracted what might have been the absolutely Other into a domesticated Other that consolidates the imperialist self."[24] Critiquing *them* does not show who *you* are; it cannot turn you from an object into a subject of history.

The idea bears repeating: self-expression is not a stage that can be bypassed. It is a discrete moment that must precede or occur simultaneously with the deconstructive act. An example may be seen in the work of the painter Sandra Payne. In 1986, at the last show of the now legendary black avant-garde gallery Just Above Midtown in SoHo, Payne presented untitled drawings of joyously sexual and sublimely spiritual nudes. The opening reception was one of those where people speak of everything but what is on the walls. We do not yet have the courage to look.

Understandably, Payne went into retreat. Three years later, she produced attenuated mask drawings that, without the hard edge of postmodern*ism,* are a postmodern speech act in the dialogue of mask and masquerade. Without the earlier subjective nudes, she may not have arrived at them.

A year ago, as a performance artist in a crisis of the body (how to keep performing without making aging itself the subject of the work?), I opted for the

Lorraine O'Grady, *Gaze 1* (1991). Black and white photomontage, 24 × 20 inches. Photo courtesy of Lorraine O'Grady.

safety of the wall with a show of photomontages. My choice of the nude was innocent and far from erotic; I wanted to employ a black self stripped of as many layers of acculturation as possible. The one piece in the show with explicitly represented sexuality, *The Clearing,* a diptych in which a black female engaged with a white male, was to me less about sex than it was about culture. It was not possible to remain innocent for long, however. I soon encountered an encyclopedia of problematics concerning the black body: age, weight, condition, not to mention hair texture, features, and skin tone. Especially skin tone. Any male and female side by side on the wall are technically married. How to arrange a quadriptych such as *Gaze,* composed of head and shoulder shots of differently hued black men and women? Should I marry the fair woman to the dark man? The dark woman to the fair man? What statements will I be making about difference if I give them mates matching in shade? What will I be saying about the history of class?

There was another problematic, as personal as it was cultural. Which maimed body would be best retrieved as the ground of my biographic experience? Young or middle-aged? Jezebel or Mammy? The woman I was or the woman I am now? And which body hue should I use to generalize my upper-middle-class West Indian–American experience? A black-skinned "ancestress," or the fairer-skinned product of rape? I hedged. In the end, I chose an African-British high-fashion model, London-born but with parents from Sierra Leone. For me, she conveyed important ambiguities: she was black-skinned, but her nude body

Lorraine O'Grady, *Gaze 2*
(1991). Black and white
photomontage, 24 × 20
inches. Photo courtesy of
Lorraine O'Grady.

retained the aura of years of preparation for runway work in Europe. In *The
Strange Taxi: From Africa to Jamaica to Boston in 200 Years,* where the subject
was hybridism itself, my literal ancestresses, who to some may have looked
white, sprouted from a European mansion rolling on wheels down the African
woman's back. Although they may have been controversial, I liked the ques-
tions those beautifully dressed, proudly erect, ca. World War I women raised,
not least of which was how the products of rape could be so self-confident, so
poised.

As I wrestled with ever shifting issues regarding which black woman to
shoot, I came to understand and sympathize with Lorna Simpson's choice of a
unified response in such montages as *Guarded Conditions* (1989), in which a
brown-skinned woman in a shapeless white shift is shot from behind—with
every aspect of subjectivity both bodily and facial occluded, except the need to
cover up itself—and then multiplied. No doubt about it. This multiple woman
showers and shampoos in her shift.

But, I tell myself, this cannot be the end. First we must acknowledge the com-
plexity, and then we must surrender to it. Of course, there isn't any final an-
swering of the question, "What happened to that maid when she was brought
here?" There is only the process of answering it and the complementary process
of allowing each answer to come to the dinner party on its own terms. Each of
these processes is just beginning, but perhaps if both continue, the nature of the
answers will begin to change and we will all be better off. For if the female body

GUARDED CONDITIONS

Lorna Simpson, *Guarded Conditions* (1989). Photo courtesy of Lorraine O'Grady.

in the West is obverse and reverse, it will not be seen in its integrity—neither side will know itself—until the not-white body has mirrored herself fully.

Postscript

The paragraphs above were drafted for delivery before a panel of the College Art Association early in 1992.[25] Rereading them, I can see to how great an extent they were limited by the panel's narrowly feminist brief. The topic assigned was "Can the naked female body effectively represent women's subjectivity in contemporary North American media culture, which regularly presents women's bodies as objects for a voyeuristic and fetishizing male gaze?"

I think I was invited because I was the only black female artist employing the nude anyone on the panel had heard of. I felt like the extra guest who's just spilled soup on the tablecloth when I had to reject the panel's premise. The black female's body needs less to be rescued from the masculine "gaze" than to be sprung from a historic script surrounding her with signification while at the same time, and not paradoxically, it erases her completely.

Still, I could perhaps have done a better job of clarifying "what it is I think I am doing anyway."[26] Whether I will it or not, as a black female artist my work is at the nexus of aggravated psychic and social forces as yet mostly uncharted. I could have explained my view, and shown the implications for my work, of the multiple tensions between contemporary art and critical theory, subjectivity

and culture, modernism and postmodernism, and, especially for a black female, the problematic of psychoanalysis as a leitmotif through all of these.

I don't want to leave the impression that I am privileging representation of the body. On the contrary: though I agree, to alter a phrase of Merleau-Ponty, that every theory of subjectivity is ultimately a theory of the body,[27] for me the body is just one artistic question to which it is not necessarily the artistic answer.

My work in progress deals with what Gayatri Spivak has called the "'winning back' of the position of the questioning subject."[28] To win back that position for the African American female will require balancing in mental solution a subversion of two objects that may appear superficially distinct: on the one hand, phallocentric theory; and on the other, the lived realities of Western imperialist history, for which all forms of that theory, including the most recent, function as willing or unwilling instruments.

It is no overstatement to say that the greatest barrier I/we face in winning back the questioning subject position is the West's continuing tradition of binary, "either:or" logic, a philosophic system that defines the body in opposition to the mind. Binaristic thought persists even in those contemporary disciplines to which black artists and theoreticians must look for allies. Whatever the theory of the moment, before we have had a chance to speak, we have always already been spoken and our bodies placed at the binary extreme, that is to say, on the "other" side of the colon. Whether the theory is Christianity or modernism, each of which scripts the body as all-nature, *our* bodies will be the most natural. If it is poststructuralism/postmodernism, which through a theoretical sleight of hand gives the illusion of having conquered binaries, by joining the once separated body and mind and then taking this "unified" subject, perversely called "fragmented," and designating it as all-culture, we can be sure it is *our* subjectivities that will be the most culturally determined. Of course, it is like whispering about the emperor's new clothes to remark that nature, the other half of the West's founding binary, is all the more powerfully present for having fallen through a theoretical trapdoor.

Almost as maddening as the theories themselves is the time lag that causes them to overlap in a crazy quilt of imbrication. There is never a moment when new theory definitively drives out old. Successive, contradictory ideas continue to exist synchronistically, and we never know where an attack will be coming from, or where to strike preemptively. Unless one understands that the only constant of these imbricated theories is the black body's location at the extreme, the following statements by some of our more interesting cultural theorists might appear inconsistent.

Not long ago, Kobena Mercer and Isaac Julien felt obliged to argue against the definition of the body as all-nature. After noting that "European culture has

privileged sexuality as the essence of the self, the innermost core of one's 'personality,'" they went on to say: "This 'essentialist' view of sexuality . . . *already contains racism.* Historically, the European construction of sexuality coincides with the epoch of imperialism and the two interconnect. [It] is based on the idea that sex is the most basic form of naturalness which is therefore related to being *un*civilized or *against* civilization" (my emphasis).[29]

Michele Wallace, on the other hand, recently found herself required to defend the black body against a hermeneutics of all-culture. "It is not often recognized," she commented, "that bodies and psyches of color have trajectories in excess of their socially and/or culturally constructed identities."[30] Her statement is another way of saying: now that we have "proved" the personal is political, it is time for us to reassert that the personal is not *just* political.

Wallace and Mercer and Julien are all forced to declare that subjectivity belongs to *both* nature *and* culture. It's true, "both:and" thinking is alien to the West. Not only is it considered primitive, but it is now further tarred with the brush of a perceived connection to essentialism. For any argument that subjectivity is partly natural is assumed to be essentialist. But despite the currency of anti-essentialist arguments, white feminists and theorists of color have no choice: they must develop critiques of white masculinist "either:or-ism," even if this puts them in the position of appearing to set essentialism up against anti-essentialism. This inherent dilemma of the critique of binarism may be seen in Spivak's often amusing ducking and feinting. To justify apparent theoretical inconsistencies, Spivak once explained her position to an interviewer as follows: "Rather than define myself as specific rather than universal, I should see what in the universalizing discourse could be useful and then go on to see where that discourse meets its limits and its challenge within that field. I think we have to choose again strategically, not universal discourse but essentialist discourse. I think that since as a deconstructivist—see, I just took a label upon myself—I cannot in fact clean my hands and say, 'I'm specific.' In fact I must say I am an essentialist from time to time. There is, for example, the strategic choice of a genitalist essentialism in antisexist work today. How it relates to all of this other work I am talking about, I don't know, but *my search is not a search for coherence*" (my emphasis).[31] Somebody say Amen.

If artists and theorists of color were to develop and sustain our critical flexibility, we could cause a permanent interruption in Western "either:or-ism." And we might find our project aided by that same problematic imbrication of theory, whose disjunctive layers could signal the persistence of an unsuspected "both:and-ism," hidden, yet alive at the subterranean levels of the West's constructs. Since we are forced to argue both that the body is more than nature, and *at the same time* to remonstrate that there is knowledge beyond language/culture, why not seize and elaborate the anomaly? In doing so, we might uncover tools of our own with which to dismantle the house of the master.[32]

Our project could begin with psychoanalysis, the often unacknowledged linchpin of Western (male) cultural theory. The contradictions currently surrounding this foundational theory indicate its shaky position. To a lay person, postmodernism seems to persist in language that opposes psychoanalysis to other forms of theoretical activity, making it a science or "truth" that is not culturally determined. Psychoanalysis's self-questioning often appears obtuse and self-justifying. The field is probably in trouble if Jacqueline Rose, a Lacanian psychologist of vision not unsympathetic to third-world issues, can answer the question of psychoanalysis's universality as follows: "To say that psychoanalysis does not, or cannot, refer to non-European cultures is to constitute those cultures in total 'otherness' or 'difference'; to say, or to try to demonstrate, that it can is to constitute them as the 'same.' This is not to say that the question shouldn't be asked."[33]

The implication of such a statement is that no matter how many times you ask the question of the universality of psychoanalysis or how you pose it, you will not arrive at an answer. But the problem is not the concept of "the unanswerable question," which I find quite normal. The problem is the terms in which Rose frames the question in the first place: her continuing use of the totalizing opposition of "otherness" and "sameness" is the sign of an "either: or" logic that does not yet know its own name.

If the unconscious may be compared to that common reservoir of human sound from which different peoples have created differing languages, all of which are translated more or less easily, then how can any of the psyche's analogous products be said to constitute *total* "otherness" or "difference"? It's at this point that one wants, without being *too* petulant, to grab psychoanalysis by the shoulders and slap it back to a moment before Freud's Eros separated from Adler's "will-to-power," though such a moment may never have existed even theoretically. We need to send this field back to basics. The issue is not whether the unconscious is universal, or whether it has the meanings psychoanalysis attributes to it (it is, and it does), but rather that, in addition, it contains contradictory meanings, as well as some that are unforeseen by its current theory.

Meanwhile, psychoanalysis and its subdisciplines, including film criticism, continue having to work overtime to avoid the "others" of the West. Wallace has referred to "such superficially progressive discourses as feminist psychoanalytic film criticism which one can read for days on end without coming across any lucid reference to, or critique of, 'race.' "[34]

But that omission will soon be redressed. We are coming after them. In her most brilliant theoretical essay to date, "The Oppositional Gaze," bell hooks takes on white feminist film criticism directly.[35] And Gayatri Spivak brooks no quarter. She has declared that non-Western female subject constitution is the main challenge to psychoanalysis and counterpsychoanalysis and has said:

"The limits of their theories are disclosed by an encounter with the materiality of that other of the West."[36]

For an artist of color, the problem is less the limits of psychoanalysis than its seeming binarial *rigidity*. Despite the field's seeming inability to emancipate itself from "either:or-ism," I hope its percepts are salvageable for the non-West. Psychoanalysis, after anthropology, will surely be the next great Western discipline to unravel, but I wouldn't want it to destruct completely. We don't have time to reinvent that wheel. But to use it in our auto-expression and auto-critique, we will have to dislodge it from its narrow base in sexuality. One wonders if, even for Europeans, sexuality as the center or core of "personality" is an adequate dictum. Why does there have to be a "center:not-center" in the first place? Are we back at that old Freud-Adler crossroad? In Western ontology, why does somebody always have to win?

"Nature:culture," "body:mind," "sexuality:intellect," these binaries don't begin to cover what we "sense" about ourselves. If the world comes to us through our senses—and however qualified those are by culture, no one would say culture determines *everything*—then even they may be more complicated than their psychoanalytic description. What about the sense of balance, of equilibrium? Of my personal *cogito*'s, a favorite is "I dance, therefore I think." I'm convinced that important, perhaps even the deepest, knowledge comes to me through movement, and that the opposition of materialism to idealism is just another of the West's binarial theorems.

I have not taken a scientific survey, but I suspect most African Americans who are not in the academy would laugh at the idea that their subjective lives were organized around the sex drive and would feel that "sexuality," a conceptual category that includes thinking about it as well as doing it, is something black people just don't have time for. This "common sense" is neatly appropriated for theory by Spillers in her statement: "Sexuality describes another type of discourse that splits the world between the 'West and the Rest of Us.'"[37]

Not that sex isn't important to these folks; it's just one center among many. For African American folk wisdom, the "self" revolves about a series of variable "centers," such as sex and food; family and community; and a spiritual life composed sometimes of God or the gods, at others of aesthetics or style. And it's not only the folk who reject the concept of a unitary center of the "self." Black artists and theorists frequently refer to African Americans as "the first postmoderns." They have in mind a now agreed understanding that our inheritance from the motherland of pragmatic, "both:and" philosophic systems, combined with the historic discontinuities of our experience as black slaves in a white world, have caused us to construct subjectivities able to negotiate between "centers" that, at the least, are double.[38]

It is no wonder that the viability of psychoanalytic conventions has come into crisis. There is the gulf between Western and non-Western quotidian per-

ceptions of sexual valence, and the question of how psychic differences come into effect when "cultural differences" are accompanied by real differences in power. These are matters for theoretical and clinical study. But for artists exploring and mapping black subjectivity, having to track the not-yet-known, an interesting question remains: Can psychoanalysis be made to triangulate nature and culture with "spirituality" (for lack of a better word) and thus incorporate a sense of its own limits? The discipline of art requires that we distinguish between the unconscious and the limits of its current theory, and that we remain alive to what may escape the net of theoretical description.

While we await an answer to the question, we must continue asserting the obvious. For example, when Elizabeth Hess, a white art critic, writes of Jean-Michel Basquiat's "dark, frantic figures" as follows, she misses the point: "There is never any one who is quite human, realized; the central figures are masks, hollow men. . . . It can be difficult to separate the girls from the boys in this work. *Pater* clearly has balls, but there's an asexualness throughout that is cold."[39] Words like "hot" and "cold" have the same relevance to Basquiat's figures as they do to classic African sculpture.

The space spirituality occupies in the African American unconscious is important to speculate upon, but I have to be clear. My own concern as an artist is to reclaim black female subjectivity so as to "de-haunt" historic scripts and establish worldly agency. Subjectivity for me will always be a social and not merely a spiritual quest.[40] To paraphrase Brecht, "It is a fighting subjectivity I have before me," one come into political consciousness.[41]

Neither the body nor the psyche is all-nature or all-culture, and there is a constant leakage of categories in individual experience. As Stuart Hall says of the relations between cultural theory and psychoanalysis, "Every attempt to translate the one smoothly into the other doesn't work; no attempt to do so can work. Culture is neither just the process of the unconscious writ large nor is the unconscious simply the internalization of cultural processes through the subjective domain."[42]

One consequence of this incommensurability for my practice as an artist is that I must remain wary of theory. There have been no last words spoken on subjectivity. If what I suspect is true, that it contains a multiplicity of centers and all the boundaries are fluid, then most of what will interest me is occurring in the between-spaces. I don't have a prayer of locating these by prescriptively following theoretical programs. The one advantage art has over other methods of knowledge, and the reason I engage in it rather than some other activity for which my training and intelligence might be suited, is that, except for the theoretical sciences, it is the primary discipline where an exercise of calculated risk can regularly turn up what you had not been looking for. And if, as I believe, the most vital inheritance of contemporary art is a system for uncovering the unexpected, then programmatic art of any kind would be an oxymoron.

Why should I wish to surrender modernism's hard-won victories, including those of the Romantics and Surrealists, victories over classicism's rearguard ecclesiastical and statist theories? Despite its "post-ness," postmodernism, with its privileging of mind over body and culture over nature, sometimes feels like a return to the one-dimensionality of the classic moment. That, more than any rapidity of contemporary sociocultural change and fragmentation, may be why its products are so quickly desiccated.

Because I am concerned with the reclamation of black female subjectivity, I am obliged to leave open the question of modernism's demise. For one thing, there seems no way around the fact that the method of reclaiming subjectivity precisely mirrors modernism's description of the artistic process. Whatever else it may require, it needs an act of will to project the inside onto the outside long enough to see and take possession of it. But, though this process may appear superficially *retardataire* to some, repossessing black female subjectivity will have unforeseen results both for action and for inquiry.

I am not suggesting an abandonment of theory: whether we like it or not, we are in an era, postmodern or otherwise, in which no practitioner can afford to overlook the openings of deconstruction and other poststructural theories. But as Spivak has said with respect to politics, practice will inevitably norm the theory instead of being an example of indirect theoretical application: "Politics is assymetrical [*sic*]," Spivak says; "it is provisional, you have broken the theory, and that's the burden you carry when you become political."[43]

Art is, if anything, more asymmetrical than politics, and since artistic practice not only norms but, in many cases, self-consciously produces theory, the relation between art and critical theory is often problematic. Artists who are theoretically aware, in particular, have to guard against becoming too porous, too available to theory. When a well-intentioned critic like bell hook says, "I believe much is going to come from the world of theory-making, as more black cultural critics enter the dialogue. As theory and criticism call for artists and audiences to shift their paradigms of how they see, we'll see the freeing up of possibilities,"[44] my response must be: Thanks but no thanks, bell. I have to follow my own call.

Gayatri Spivak calls postmodernism "the new proper name of the West," and I agree. That is why for me, for now, the postmodern concept of *fragmentation,* which evokes the mirror of Western illusion shattered into inert shards, is less generative than the more "primitive" and active *multiplicity.* This is not, of course, the cynical *multi* of "multiculturalism," where the Others are multicultural and the Same is still the samo. Rather, paradoxically, it is the *multi* implied in the best of modernism's primitivist borrowings, for example in Surrealism, and figured in Éluard's poem: "Entre en moi toi ma multitude" (Enter into me, you, my multitude).[45] This *multi* produces tension, as in the continuous equilibration of a *multiplicity of centers,* for which dance may be a brilliant form of training.

Stuart Hall has described the tensions that arise from the slippages between theory development and political practice and has spoken of the need to live with these disjunctions without making an effort to resolve them. He adds the further caveat that in one's dedication to the search for "truth" and "a final stage," one invariably learns that meaning never arrives, being never arrives, we are always only becoming.[46]

Artists must operate under even more stringent limitations than political theorists in negotiating disjunctive centers. Flannery O'Connor, who in her essays on being a Catholic novelist in the Protestant South may have said most of what can be said about being a strange artist in an even stranger land, soon discovered that though an oppositional artist like herself could choose what to write, she could not choose what she could make live. "What the Southern Catholic writer is apt to find, when he descends within his imagination," she wrote, "is not Catholic life but the life of this region in which he is both native and alien. He discovers that the imagination is not free, but bound."[47] You must not give up, of course, but you may have to go belowground. It takes a strong and flexible will to work both with the script and against it at the same time.

Every artist is limited by what concrete circumstances have given her to see and think, and by what her psyche makes it possible to initiate. Not even abstract art can be made in a social or psychic vacuum. But the artist concerned with subjectivity is particularly constrained to stay alert to the tension of differences between the psychic and the social. It is her job to make possible that dynamism Jacqueline Rose has designated as "medium subjectivity" and to avert the perils of both the excessively personal and the overly theoretical.

The choice of *what* to work on sometimes feels to the artist like a walk through a minefield. With no failproof technology, you try to mince along with your psychic and social antennae swiveling. Given the ideas I have outlined here, on subjectivity and psychoanalysis, modernism and multiplicity, this is a situation in which the following modest words of Rose's could prove helpful: "I'm not posing what an ideal form of medium subjectivity might be; rather, I want to ask where are the flashpoints of the social and the psychic that are operating most forcefully at the moment."[48]

I would add to Rose's directive the following: the most interesting social flashpoint is always the one that triggers the most unexpected and suggestive psychic responses. This is because winning back the position of the questioning subject for the black female is a two-pronged goal. First, there must be provocations intense enough to lure aspects of her image from the depths to the surface of the mirror. And then, synchronously, there must be a probe for pressure points (which may or may not be the same as flashpoints). These are places where, when enough stress is applied, the black female's aspects can be reinserted into the social domain.

I have only shadowy premonitions of the images I will find in the mirror, and my perception of how successfully I can locate generalizable moments of so-

cial agency is necessarily vague. I have entered on this double path knowing in advance that as another African American woman said in a different context, it is more work than all of us together can accomplish in the boundaries of our collective lifetimes.[49] With so much to do in so little time, only the task's urgency is forcing me to stop long enough to try and clear a theoretical way for it.

Notes

The first part of this article was published in *Afterimage* 20, no. 1 (summer 1992). The revised version of this essay originally appeared in *New Feminist Criticism: Art, Identity, Action,* ed. Joanna Frueh, Cassandra L. Langer, and Arlene Raven (New York: Icon, 1994).

1 Hortense J. Spillers, "Interstices: A Small Drama of Words," in *Pleasure and Danger: Exploring Female Sexuality,* ed. Carole S. Vance (Boston: Routledge and Kegan Paul, 1984), 77.

2 Sylvia Ardyn Boone, *Radiance from the Waters: Ideals of Feminine Beauty in Mende Art* (New Haven: Yale University Press, 1986), 102.

3 "African American Women in Defense of Ourselves," advertisement, *New York Times,* 17 November 1991, 53.

4 Judith Wilson, "Getting Down to Get Over: Romare Bearden's Use of Pornography and the Problem of the Black Female Body in Afro-U.S. Art," in *Black Popular Culture,* ed. Gina Dent (Seattle: Bay Press, 1992), 114.

5 Toni Morrison, *Beloved* (New York: Knopf, 1987), 119.

6 George Nelson Preston, quoted in Wilson, "Getting Down," 114.

7 For an examination of the relationship of black women to the first white feminist movement, see Hazel V. Carby, *Reconstructing Womanhood: The Emergence of the Afro-American Woman Novelist* (New York: Oxford University Press, 1987), chs. 1 and 5, and bell hooks, *Ain't I a Woman: Black Women and Feminism* (Boston: South End Press, 1981). For insights into the problems of black women in the second white feminist movement, see Audre Lorde, "Age, Race, Class, and Sex: Women Redefining Difference," in *Out There: Marginalization and Contemporary Cultures,* ed. Russell Ferguson, Martha Gever, Trinh T. Minh-ha, Cornel West (New York: New Museum of Contemporary Art, 1990), and Bernice Johnson Reagon, "Coalition Politics: Turning the Century," in *Home Girls: A Black Feminist Anthology,* Barbara Smith (New York: Kitchen Table: Women of Color Press, 1983). For problems of women of color in a white women's organizations at the start of the third feminist movement, see Lorraine O'Grady on WAC, "Dada Meets Mama," *Artforum,* 31, no. 2 (October 1992): 11–12.

8 See Judy Chicago, *The Dinner Party: A Symbol of Our Heritage* (New York: Anchor/ Doubleday, 1979).

9 Spillers, "Interstices," 78.

10 Michele Wallace, "Multiculturalism and Oppositionality," in *Afterimage* 19, no. 3 (October 1991): 7.

11 Nancy Hartsock, "Rethinking Modernism: Minority vs. Majority Theories," in *Cultural Critique* 7, special issue: "The Nature and Context of Minority Discourse II," ed. Abdul R. JanMohamed and David Lloyd, 204.

12 See the title story by Merle Hodge in Pamela Mordecai and Betty Wilson, eds., *Her True-True Name* (London: Heinemann Caribbean Writers Series, 1989), 196–202. This anthology is a collection of short stories and novel extracts by women writers from the English, French, and Spanish-speaking Caribbean.

13 The understanding that analysis of the contemporary situation of African American women is dependent on the imaginative and intellectual retrieval of the black woman's experience under slavery is now so broadly shared that an impressive amount of writings have accumulated. In fiction, a small sampling might include, in addition to Morrison's *Beloved*, Margaret Walker, *Jubilee* (New York: Bantam, 1966); Octavia E. Butler, *Kindred* (1979; reprint, Boston: Beacon Press, 1988); Sherley A. Williams, *Dessa Rose* (New York: William Morrow, 1986); and Gloria Naylor, *Mama Day* (New York: Ticknor and Fields, 1988). For the testimony of slave women themselves, see Harriet A. Jacobs, edited by Jean Fagan Yellin, *Incidents in the Life of a Slave Girl* (Cambridge: Harvard University Press, 1987); *Six Women's Slave Narratives*, the Schomburg Library of Nineteenth-Century Black Women Writers (New York: Oxford University Press, 1988); and Gerda Lerner, ed., *Black Women in White America: A Documentary History* (New York: Vintage Books, 1972). For a historical and sociological overview, see Deborah Gray White, *Ar'n't I a Woman? Female Slaves in the Plantation South* (New York: W. W. Norton, 1985).

14 Wilson, "Getting Down," 121, note 13.

15 Ibid., 114.

16 Ibid.

17 Ibid.

18 Judith Wilson, telephone conversation with the author, January 21, 1992.

19 Wilson, "Getting Down," 116–18.

20 Adrian Piper, "Food for the Spirit, July 1971," in *High Performance* 13 (spring 1981). This was the first chronicling of *Food* with accompanying images. The nude image from this performance first appeared in Piper's retrospective catalogue, Jane Farver, *Adrian Piper: Reflections 1967–87* (New York: Alternative Museum, April 18–May 30, 1987).

21 Hortense J. Spillers, "Mama's Baby, Papa's Maybe: An American Grammar Book," in *Diacritics* 17, no. 2 (summer 1987): 68.

22 Hartsock, "Rethinking Modernism," 196, 194.

23 Toni Morrison, in Charles Ruas, "Toni Morrison's Triumph," an interview, in *Soho News*, 11–17 March 1981, 12.

24 Gayatri Chakravorty Spivak, "Three Women's Texts and a Critique of Imperialism," in *"Race," Writing, and Difference*, ed. Henry Louis Gates Jr. (Chicago: University of Chicago Press, 1986), 272.

25 "Carnal Knowing: Sexuality and Subjectivity in Representing Women's Bodies," a panel of the College Art Association, 80th Annual Conference, Chicago, February 15, 1992.

26 A riff on Barbara Christian's title, "But What Do We Think We're Doing Anyway: The State of Black Feminist Criticism(s)," in *Changing Our Own Words: Essays on Criticism, Theory, and Writing by Black Women*, ed. Cheryl A. Wall (New Brunswick: Rutgers University Press, 1989), which is itself a riff on Gloria T. Hull's title, "What It Is I Think She's Doing Anyhow: A Reading of Toni Cade Bambara's *The Salt Eaters*," in Smith, *Home Girls*, which is in turn a riff on Toni Cade Bambara's autobiographical essay, "What It Is I Think I'm Doing Anyhow," in *The Writer on Her Work*, ed. Janet Sternberg (New York: W. W. Norton, 1980).

27 "But by thus remaking contact with the body, and with the world, we shall also discover ourselves, since, perceiving as we do with our body, the body is a natural self and, as it were, the subject of perception." Quoted by Edward R. Levine, unpublished paper delivered at College Art Association, 80th Annual Conference, Chicago, February 13, 1992.

28 Gayatri Chakravorty Spivak, "Strategy, Identity, Writing," in *The Post-Colonial Critic: Interviews, Strategies, Dialogues*, ed. Sarah Harasym (New York: Routledge, 1990), 42.

29 Kobena Mercer and Isaac Julien, "Race, Sexual Politics and Black Masculinity: A Dossier,"

in *Male Order: Unwrapping Masculinity,* ed. Rowena Chapman and Jonathan Rutherford (London: Lawrence & Wishart, 1987), 106–7.

30 Wallace, "Multiculturalism," 7.

31 Spivak, "Criticism, Feminism, and the Institution," in *The Post-Colonial Critic,* 11.

32 See the oft-quoted phrase, "For the master's tools will never dismantle the master's house," in Lorde, "Age, Race," 287.

33 Jacqueline Rose, "Sexuality and Vision: Some Questions," in *Vision and Visuality,* ed. Hal Foster, Dia Art Foundation, Discussions in Contemporary Culture no. 2 (Seattle: Bay Press, 1988), 130.

34 Wallace, "Multiculturalism," 7.

35 bell hooks, *Black Looks: Race and Representation* (Boston: South End Press, 1992), 115–31.

36 Spivak, "Criticism, Feminism, and the Institution," 11.

37 Spillers, "Interstices," 79.

38 See the famous description of African American "double-consciousness" in W. E. B. Du-Bois, *The Souls of Black Folk* (New York: New American Library, 1982), 45.

39 Elizabeth Hess, "Black Teeth: Who Was Jean-Michel Basquiat and Why Did He Die?" *Village Voice,* 3 November 1992, 104.

40 "The expressionist quest for immediacy is taken up in the belief that there exists a content beyond convention, a reality beyond representation. Because this quest is spiritual, not social, it tends to project metaphysical oppositions (rather than articulate political positions); it tends, that is, to stay within the antagonistic realm of the Imaginary." Hal Foster, *Recodings: Art, Spectacle, Cultural Politics* (Seattle: Bay Press, 1985), 63.

41 Cited in Teresa de Lauretis, *Feminist Studies/Critical Studies* (Bloomington: Indiana University Press, 1986), 17.

42 Stuart Hall, "Theoretical Legacies," in *Cultural Studies,* ed. Lawrence Grossberg, Cary Nelson, Paula Treichler (New York: Routledge, 1992), 291.

43 Spivak, "Criticism, Feminism, and the Institution," 47.

44 bell hooks, interviewed by Lisa Jones, "Rebel without a Pause," in the *Voice Literary Supplement* (October 1992): 10.

45 Paul Éluard, quoted in Mary Ann Caws, *The Poetry of Dada and Surrealism: Aragon, Breton, Tzara, Éluard, and Desnos* (Princeton: Princeton University Press, 1970), 167.

46 Hall, "Theoretical Legacies," passim.

47 Flannery O'Connor, *Mystery and Manners: Occasional Prose,* selected and edited by Sally and Robert Fitzgerald (New York: Farrar, Straus & Giroux, 1961), 197.

48 Rose, "Sexuality and Vision," 129.

49 Deborah E. McDowell, "Boundaries," in *Afro-American Literary Study in the 1990s,* ed. Houston A. Baker Jr. and Patricia Redmond (Chicago: University of Chicago Press, 1989), 70.

Ioannis Mookas

Fault Lines: Homophobic Innovation in
Gay Rights, Special Rights

Civil rights may be thought of in a broad sense as all those rights necessary to participate fully in society—the rights that make citizenship operative. Civil rights are the birthright of democracy, not an added enhancement to citizenship.
—Renee DeLapp

Any lingering doubts one may have had about the conservative revolution under way in this country ought to have been erased in the seismic rearrangement of our political landscape that resulted from the 1994 midterm congressional and gubernatorial elections. Republicans are standing tall, but the sound and the fury of their triumph is supplied by the Religious Right, a growing countercultural movement to which over 15 million Americans who identify themselves as born-again Christians pledge allegiance. The Religious Right's leaders, increasingly influenced by the militant theocratic ideology of Christian reconstructionism,[1] have embarked on a quest to subdue our secular government at every level and subordinate it to biblical law to establish a Christian nation as the kingdom of God on earth, in preparation for the second coming of Christ. Sounds preposterous, doesn't it? But the Religious Right has made giant strides toward this goal. It chose the previously moribund Republican Party as its earthly vessel out of practical necessity, and now the GOP committees in eighteen states are dominated by religious conservatives aligned closely with the Christian Coalition, a political juggernaut run by the extreme rightist Marion "Pat" Robertson.[2] The November 1994 elections were thus a chilling testament to the Religious Right's extraordinary effectiveness in mobilizing disciplined Christian voters to elect Christian candidates; more than 60 percent of the six hundred candidates fielded by the Religious Right won their races, with Christian conservatives reported as casting fully one-third of the vote nationwide.[3]

Although these developments have only surfaced to widespread attention over the past two years—essentially, since the apocalyptic televised spectacle of the 1992 Republican National Convention in Houston where Robertson and

other Religious Right potentates held center stage—their foundations have been painstakingly laid, with little fanfare, over the past twenty.[4] To properly contextualize the following essay, it is necessary to bear in mind the history of this period, with its convergence of three discrete social trajectories: the ascendancy of the Religious Right and its alter ego, the New Right; the deindustrialization and globalization of the American economy; and the steadily worsening economic disenfranchisement of enormous sectors of the populace and a concomitant social polarization. Without this context, we cannot begin to make sense of how lesbians and gay men, as a distinct social category, have come to be the object of a concerted political assault of epic proportions. In the past several years, the Religious Right has renewed efforts first undertaken in the late 1970s to repeal the existing protections against discrimination toward lesbians and gay men, and to put in their stead constitutional or statutory revisions aimed at keeping such protections permanently in abeyance—and more generally, at criminalizing homosexuality.[5] In the absence of any federal civil rights law including lesbians and gay men, the only legal protection lesbians and gay men have from homophobic discrimination is a patchwork of local and state laws and judicial rulings; it is this patchwork that the Religious Right is intent upon dismantling. Its vehicle is the initiative, a process of citizen petitioning for the placement of a question (referendum) onto a ballot, which has also, and not incidentally, been historically abused by majorities of voters to the detriment of people of color and the poor.[6]

Many people are now familiar with the statewide initiative campaigns waged in 1992 for the failed Ballot Measure 9, sponsored by the Oregon Citizens Alliance, and its successful counterpart, Amendment 2, sponsored by Colorado for Family Values. Although Amendment 2 has been found unconstitutional by the Colorado State Supreme Court,[7] its passage by a majority of Colorado voters confirmed the homophobic initiative as a viable national strategy for the Religious Right. In 1994, Amendment 2 spawned a round of eight proposed statewide antigay initiatives, all virtually identical in design, two of which qualified for the November 1994 ballot, in Idaho, and again in Oregon.[8] While both of these were defeated (by the narrowest of margins), a pair of initiatives were passed in Alachua County, Florida, the newest of several smaller initiatives to be passed in municipalities and counties across the United States—and there is no sign of abatement. Each antigay initiative has thrust lesbian and gay communities and others alarmed at the erosion of democratic principles into the typically arduous work of mounting electoral campaigns, leaving even seasoned organizers emotionally and physically exhausted, and straining community resources to the limit, as already scarce funds are diverted from other pressing needs, such as health services or antiviolence work, to finance campaign-related costs. Conversely, the Religious Right's base expands, as each initiative boosts organizational fund-raising and hones its get-out-the-vote mechanism.

Gay Rights, Special Rights
(1993), produced by
Jeremiah Films. Frame
capture by Ioannis Mookas.

This sweeping political program of action is the context for the production of *Gay Rights, Special Rights*, the videotape to which we now turn.

Gay Rights, Special Rights was produced by Jeremiah Films, a Southern California–based fundamentalist production company, principally for use by the Traditional Values Coalition and its adherents. The Traditional Values Coalition is widely identified as one of the foremost political institutions of the Religious Right, with an annual operating budget of approximately half a million dollars; staffed offices in California, Colorado, Nebraska, and Washington, D.C.; and active chapters in twenty states.[9] The Traditional Values Coalition's founder and chairman, the Reverend Lou Sheldon, occupies the highest echelon of Far Right leadership. An inveterate homophobe, Sheldon has made opposition to lesbian and gay enfranchisement the stock-in-trade of his political career and seems almost pathologically obsessed with homosexuality. Significantly, he represents a concrete link between the antihomosexual crusade of the late 1970s and its most recent manifestation. In 1978, Sheldon served as executive director of California Defend Our Children, the organized support behind then–state senator John V. Briggs for the so-called Briggs Initiative, an initiative overtly modeled on born-again entertainer Anita Bryant's successful repeal of a Dade County, Florida, gay rights ordinance the preceding year. The conservative avalanche of the November 1994 elections has, among other things, brought extreme rightists like Rev. Sheldon into closer proximity to governance than ever before. As the *New York Times* duly noted after the elections: "Sheldon counts as a friend the new assistant majority leader of the Senate, Trent Lott of Mississippi. The Republican Senator was featured in the coalition's 1993 videotape, *Gay Rights, Special Rights*."[10]

Like *The Gay Agenda*, its notorious precursor, *Gay Rights, Special Rights* is vivid propaganda, a titillating peep show that conceals a battering ram designed to soften the viewer's judgment and pave the way for the Right's ideolog-

Gay Rights, Special Rights (1993), produced by Jeremiah Films. Frame capture by Ioannis Mookas.

ical cut and thrust. Whereas *The Gay Agenda* tied together almost every strand of previously heard homophobic rhetoric, *Gay Rights, Special Rights* represents a genuine, if dreadful, innovation. Brilliantly extending the twin notions of "special rights" and "minority status" coined in *The Gay Agenda, Gay Rights, Special Rights* cynically seeks to cash in on the moral capital accumulated by the civil rights establishment by having African American fundamentalists, who are presented as the ultimate arbiters of "legitimate" and "illegitimate" minorities, inveigh against the lesbian and gay movement—and by extension, lesbians and gay men as a whole—as a fraudulent trespasser upon the hallowed ground of civil rights struggle. At the same time, the Traditional Values Coalition and its cohorts are portrayed as stalwart defenders of African Americans, eager to expose the malevolent nature of the "militant homosexuals." The argument set forth in *Gay Rights, Special Rights* is poised between two emblematic historical events: the 1963 March on Washington and the 1993 March on Washington for Lesbian, Gay and Bisexual Equal Rights and Liberation. Even as *Gay Rights, Special Rights* actively molds the image of lesbians and gay men in relation to race, it recycles the familiar stereotype of homosexuals as predatory pedophiles and offers AIDS as "proof" of the essential unworthiness (or *unfitness*) of lesbians and gay men to participate in what it constructs as a closed system of rights, and as an implicit justification for violence against us. Furthermore, *Gay Rights, Special Rights* exacerbates the self-hatred experienced by many lesbians and gay men in ways that are profoundly damaging. With *Gay Rights, Special Rights*, the Traditional Values Coalition ushers in the latest phase of the Religious Right's cruel cultural war.

Many observers in queer activist circles have surmised, upon seeing *Gay Rights, Special Rights* for the first time, that the Religious Right has a new audience in mind: conservative people of color.[11] As a largely unknown quantity, conservative people of color may barely be a blip on the radar screen of

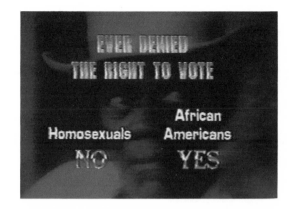

Gay Rights, Special Rights (1993), produced by Jeremiah Films. Frame capture by Ioannis Mookas.

many white queers, or whites in general. But as Black gay journalist Eric K. Washington observes, if conservative African American opinion appears implausible, it's because popular demography hasn't been geared to reflect it.[12] The Far Right's overtures to people of color are actually not all that new; *Gay Rights, Special Rights* may have been just a glimmer in Lou Sheldon's eye when he was mobilizing African American pastors in 1991 to lobby senators in favor of then–Supreme Court nominee Clarence Thomas.[13] Yet while the cooperation of fundamentalist African American ministers in using *Gay Rights, Special Rights*[14] could bring the Religious Right a step closer to its sought-after goal of incorporating the congregations of conservative African American churches into its already formidable voting bloc,[15] contradictions within the videotape's own structure suggest that it is born-again whites—the Right's historic political constituency—who constitute the tape's master subject position and who remain its most important audience.

To simulate a broad consensus among people of color on the question of lesbian and gay rights, *Gay Rights, Special Rights* fetishistically includes Lou Lopez and Raymond Kwong, individuals claiming to speak for the Hispanic and Asian American communities, respectively, and denouncing homosexuals' demands for civil rights. It is bitterly ironic, then, that *Gay Rights, Special Rights* should be the tool used to call the lesbian and gay movement so incisively on its "diversity bluff."[16] For while lesbians and gay men belong to every race and ethnicity, the institutional leadership of the lesbian and gay political movement has been disproportionately white and, intentionally or not, has put a decidedly white face on its public countenance. This dilemma is compounded, on the one hand, by the tendency of many individual white lesbian and gay activists to unproblematically conflate homophobia with racism, overlooking the historic specificities of these and other oppressions,[17] and, on the other hand, by a chronic lack of commitment on the part of lesbian and gay political institutions to a broad antiracist agenda. We can immediately

Homophobic Innovation 291

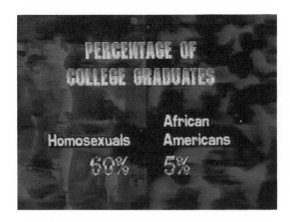

Gay Rights, Special Rights
(1993), produced by
Jeremiah Films. Frame
capture by Ioannis Mookas.

observe, as many queer activists have, that *Gay Rights, Special Rights* includes virtually no lesbians or gay men of color in its inventory of homosexual "types." Yet this is no more an absence structured by the tape as it is a measure of the place of lesbians and gay men of color within the leadership of the gay movement at large. After all, it's not as if there were a surfeit of African Americans, Asian, Pacific Islanders. Arabs, Latinos, or indigenous Americans at the forefront of the 1993 March on Washington for Lesbian, Gay and Bisexual Rights and Liberation for the Religious Right's—or anyone's—cameras to record. Mainstream news coverage of the March on Washington was also marked by the same absence, yet white lesbian and gay spokespeople were almost unanimously approving of it.[18] To the Traditional Values Coalition, lesbians and gay men of color may be the great unimaginable, and while their presence would certainly disequilibrate the neat binary opposition between African Americans and lesbians and gay men, their invisibility in *Gay Rights, Special Rights* is a painfully accurate index of their status in the gay movement's public life as well.

Gay Rights, Special Rights offers an indelible image of polarization in the split-screen device, which places a color image of white gay men next to a black-and-white image of African Americans on the right, while a Black male voice-over asks the viewer to compare the advantages enjoyed by homosexuals with the hardships suffered by African Americans, measured in alleged percentages of each group's participation in such activities as graduating from college, working in management-class jobs, and taking vacations abroad. On the one side, two youthful white gay men clad only in shorts and sneakers are seen at close range, dancing energetically, with other white gay men visible in the background behind them. On the opposite side, African Americans are clustered together in a large, undifferentiated mass, seen from a distance at a high angle, in grainy, black-and-white archival footage. Whereas the close-up

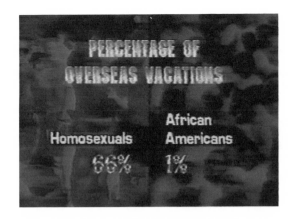

Gay Rights, Special Rights (1993), produced by Jeremiah Films. Frame capture by Ioannis Mookas.

image of the topless gay men emphasizes their corporeality and the brightness of their shorts underscores the pinkness of their skin, the image of African Americans presents a disembodied wall of heads and shoulders. The carefree homosexuals dance festively, while the African Americans are composed in motionless order, solemnity incarnate. First by literalizing a dividing line, then by attempting to quantify discrimination, the split-screen device renders a near-perfect representation of mutual exclusivity, thereby cementing the premise of two groups in competition with each other and distilling the tape's signifying systems into a stark binarism that literally leaves no room for lesbians and gay men of color.

Gay Rights, Special Rights retreads a well-worn conservative discourse of scarcity and deservedness, which says that rights are advantages, and in mean times there aren't enough advantages to go around. Developing the theme of scarcity in relation to people of color, *Gay Rights, Special Rights* says that the attainment of civil rights by lesbians and gay men will rob people of color of theirs and diminish the achievements of the African American–led civil rights movement of the 1950s and 1960s. It's a propagandistic reversal worthy of Orwell: the Religious Right tells us that lesbians and gay men are opportunistically trying to hitch their wagon to African Americans' political gains, when it is the Religious Right itself that, in the same breath, is making this bid. Emmanuel McLittle, the first African American conservative to appear in *Gay Rights, Special Rights,* tells us, "Homosexuals are using not only the language, but they are beginning to insist that the statutes, the laws, all of the *advantages* gained by civil rights leaders such as Martin Luther King be now applied to homosexuals" (my emphasis). Such a statement immediately suggests competition and implies that civil rights confer an edge over others. Civil rights, of course, are not advantages but highly partial, constantly evolving remedies for historic disadvantages. Fortunately for the Religious Right, most people's mis-

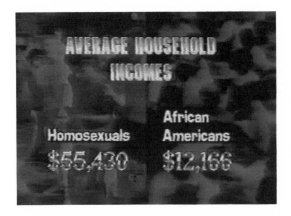

Gay Rights, Special Rights
(1993), produced by
Jeremiah Films. Frame
capture by Ioannis Mookas.

understanding or lack of understanding of civil rights law and its history permits such claims to sound credible. Appropriately, Lou Sheldon utters the statement that encapsulates the tape's core argument, hitting all of the irrational chords that make it resonate with African American and white conservatives alike: "Homosexuals have equal rights under the First Amendment, the Fourteenth Amendment, and the state constitution of every state in which they reside. But the issue here today is *special rights,* a special category of protection. They want to be *elevated . . .* to a true *minority status* that would give them *special rights*" (emphasis mine).

In order to fix what is in fact a continually evolving cultural and legal process of interpreting the meaning and scope of civil rights, *Gay Rights, Special Rights* tries to stabilize the picture of civil rights struggle, to enshrine in the rearview mirror of history, as it were, a static, totalizing, and mythic representation of the Civil Rights Era. The authenticating aura that surrounds the black-and-white footage of the 1963 March on Washington, coupled with the almost sacred presence of Dr. Martin Luther King Jr.,[19] locates the civil rights narrative as belonging to a safely remote past. Dr. King's magisterial voice—the first sound to be heard in *Gay Rights, Special Rights*—is shrewdly calculated to induce a visceral surge of identification, not only in African American viewers, for whom Dr. King signifies moral authority itself, but significantly, in whites also. Impossible as this would have been thirty years ago, the Religious Right's white constituents, sufficiently acquainted with the heroic narrative popularized in *Eyes on the Prize,* can today accept Dr. King as the personification of moral authority, with which he invests the African American fundamentalists who appear in *Gay Rights, Special Rights,* and which in turn certifies them, in the white spectator's mind, to pronounce lesbians and gay men as pretenders to the civil rights struggle. How cunning, then, that the emotional swelling cued by Dr. King sets the stage for a potent *dis*identification as the black-and-white

Gay Rights, Special Rights (1993), produced by Jeremiah Films. Frame capture by Ioannis Mookas.

footage of King at the 1963 march abruptly gives way to the rather less-than-charismatic figure of Larry Kramer, dyspeptic diva of contemporary gay politics, who paraphrases King in front of a scattered-looking assembly of folks at the 1993 March to Washington for Lesbian, Gay and Bisexual Rights and Liberation.

Any discourse on rights is also necessarily a discourse on democracy. The Far Right's vision of American democracy flows from a warped interpretation of the Constitution as the final word on rights. As conservatives never tire of repeating, the founding documents of the United States government hold that all men [sic] are created equal. Civil rights laws and social service entitlements created to repair the imbalances wrought by discrimination are therefore seen as special. By this illogic, the Far Right can claim that "homosexuals have equal rights . . . but the issue here today is special rights, a special category of protection." In a moment of surreal comedy, Edwin Meese, the porcine former attorney general who appears in Gay Rights, Special Rights, states, "As a white male, I have no rights whatsoever, other than what is shared with everybody else." Over archival black-and-white shots of storefronts displaying Jim Crow signs, he continues: "We have granted certain rights to take care of past discrimination . . . based on such things as race." Meese soothingly speaks of racism as a thing of the past, a thing "taken care of" (partly to efface contemporary racism, of which Meese himself is a pillar).[20] But just how was this accomplished? Depending on the viewer, the reading of this statement can cut two ways. Conservative people of color—the target audience of Gay Rights, Special Rights—might indeed agree that de jure racial discrimination was vanquished by the African American civil rights movement mythologized in the videotape through the enactment of the 1964 Civil Rights Act and subsequent civil rights legislation; and that, as white supremacist Charles Murray would have it, any vestigial inequities experienced by African Americans or other people of color

are a matter of one's personal deficiencies. The "we" that Meese speaks for and counts himself among, however, will implicitly understand that the conferral of such rights (or, for that matter, their withdrawal) is the sovereign function of those properly ordained to regulate them; namely, heterosexual white males.

Further elaboration of this notion is provided by Michael P. Farris, a favorite son of the Religious Right, in his 1992 book, *Where Do I Draw the Line?:* "We have decided as a nation that some things are so important that we are willing to give up a little of our freedom to achieve other goals. We have decided, for instance, that racial equality is so important we've given up our 'freedom' to discriminate against another person on the basis of race. That decision is a good one and widely supported by the American people. We have similar laws banning discrimination on the basis of gender, national origin, or religion . . . "

Farris continues: "For a gay rights law, we have to ask ourselves: Is homosexuality so important that we are willing to sacrifice our freedom to grant special protection to homosexuality? I don't think so. Why should we lose our freedom to advance their choice of sexual practices? Racial harmony is good for the nation and worthy of some sacrifices. Homosexuality cannot be construed to be good for our nation."[21] In the scheme of things delineated by Farris, he and the other guardians of white supremacist, patriarchal order benevolently restrain their freedom—their "right"—to discriminate. The threat of exercising this prerogative, which remains only thinly veiled with regard to people of color, is simply made explicit against lesbians and gay men.

Gradually, *Gay Rights, Special Rights* shifts in emphasis, leaving behind its African American spokespeople and giving way to an almost uninterrupted succession of white male authorities who drive the tape's latter half. Although the same black male voice-over continues to narrate during interstitial transitions, a virtual hit parade of Far Right savants—Ralph Reed of the Christian Coalition, David Noebel of Summit Ministries, former Secretary of Education William Bennett—assumes the task of telling us what's what. This shift signals a repositioning in subjectivity, returning our attention to the white, born-again, middle-class viewers of *Gay Rights, Special Rights* for whom the themes of scarcity and deservedness are crucial.

By reexamining the genealogy of "special rights" as a discourse of white reaction, spawned in the 1970s in opposition to busing, affirmative action, and equal opportunity programs, the racist underpinnings of "special rights," and the *transference* that this discourse effects when applied to lesbians and gay men, becomes clear. In the Right's self-styled attempt at mainstreaming, overt racism, which was once part and parcel of rightist idiom, was jettisoned from its public rhetoric in favor of submerged messages on race that a broad-based constituency would not find objectionable. In their classic study of race and reaction, Michael Omi and Howard Winant detail how overt racism was rearticulated in numerous ways by neoconservatives and the New Right. They

observe: "The culprit behind this new form of 'racism' was the state itself. In attempting to eliminate racial discrimination, the state went too far. It legitimated group rights, established affirmative action mandates, and spent money on a range of social programs which, according to the right, debilitated rather than uplifted, its target populations. In this scenario, the victims of racial discrimination had dramatically shifted from racial minorities to whites, particularly white males."[22]

The discourse of "reverse discrimination" identified by Omi and Winant reached its apex with the now-infamous 1990 electoral campaign advertisement for Senator Jesse Helms, which depicted a white male hand crumpling a job rejection slip while a male voice-over ominously intoned, "They had to give it to a minority because of a racial quota." This spot struck the nerve of a majority of the electorate in North Carolina who voted against Harvey Gantt, Helms's African American opponent.

Gay Rights, Special Rights tells us that homosexuals "want to be *elevated . . . to a true minority status* that would give them *special rights."* A term without any legal definition, "minority status" is actually a clever mutation of "protected classes," the legal term for discrete groups historically prevented from sharing fully and equally in civic realms such as employment, housing, and public accommodations because of bias, discrimination, or prejudice. Since we are still accustomed to thinking of minorities as primarily racial, "minority status" is employed to inflame the deeply rooted anxieties in white subjectivity over economic displacement. The pairing of homosexuals and "minority status" within the theme of scarcity articulated by *Gay Rights, Special Rights* instigates a transference of racial associations wherein lesbians and gay men, rather than people of color, are encoded as eroding the employment opportunities of economically threatened whites. *Gay Rights, Special Rights* is a spectacular example of this subterranean approach, because it enlists people of color to enunciate its theme of racial deservedness, and through them, aligns white viewers with this argument.

To better understand how the meanings produced by *Gay Rights, Special Rights* are assimilated by the conservative audience it addresses, we can selectively adapt Jacques Ellul's helpful distinction between agitational and integrational propaganda.[23] To do so, however, we must yet again distinguish between the Religious Right's leaders and their born-again followers. *Gay Rights, Special Rights* is designed to promote the strategic interests and advance the political platform of the Religious Right's leadership, the political professionals who run such national institutions as the Christian Coalition, Focus on the Family, or Concerned Women for America, and the scores of local organizations affiliated with them that both direct the course of a homophobic political program and incorporate audiovisual resources such as this tape in its execution. Theirs is the concentrated ideological base to which *Gay Rights, Special Rights* seeks

to align the rank-and-file viewer/voter. This is not to say that garden-variety evangelicals do not maintain or even cherish homophobic perspectives of their own. On the contrary—it is exactly the prosaic homophobia felt by most hetero-sexuals, regardless of race or religion, that brings coherence and cohesion to *Gay Rights, Special Rights*. The videotape is a sorting mechanism for the sur-plus homophobia that no one in a heterosexist culture can be free of. But by situating lesbians and gay men specifically as the group against which the average evangelical's identity is defined and sharpened, it crystallizes an oth-erwise random structure of feelings into purposeful expression. *Gay Rights, Special Rights* is thus simultaneously integrational *and* agitational. I have al-ready tried to suggest ways in which the tape's integrational strategies seek to fuse conservative African American sentiment with white fundamentalist sub-jectivity; additionally, *Gay Rights, Special Rights* serves the integrational func-tion of consolidating the raw material of ordinary prejudice into orchestrated public opinion. It is agitational by forming a spur to action, whether inten-tional, in the case of securing votes for initiatives such as Measure 9 or Amend-ment 2, or putatively unintentional, in the case of those who use knives, fire, or just their fists instead of the ballot.

Violence is always already present in the everyday lives of lesbians and gay men; it is part of the air we breathe. To comprehend the extent to which vio-lence permeates our lives, we may think of a *continuum* of violence on which it is possible to situate the manifold registers of violent expression. At one end is liminal or latent violence, expressed through looks or gestures of hostility; following this are all the violent speech acts—the slurs, catcalls, taunts, epi-thets—that any visibly out lesbian or gay man is so accustomed to that they almost become ambient; these fall just short of intimidation and harassment, which then can spill with terrifying ease into vandalism and, finally, bodily harm. When added to the daily circulation of homophobic messages in popular culture, *Gay Rights, Special Rights* becomes a powerful incitement to violence, too powerful for some to resist. It would, of course, be absurd to suggest that the mere consumption of a videotape could in and of itself transform the viewer into a bloodthirsty queer-basher. However, *Gay Rights, Special Rights* grants the homophobic viewer who has a propensity for violence an unequivocal per-mission to obey violent impulses, a permission preceded by and stamped with the authority that the video borrows from the African American civil rights struggle, enabling the homophobe to feel not only sanctioned but righteous in the administration of violence. Needless to say, the Religious Right's refusal to acknowledge the brutality inflicted on lesbians and gay men as one by-product of its campaigns, let alone accept any responsibility for it, is a tactical absolute of the cultural war as basic as the very practice of scapegoating.

Ironically, queer viewers may find themselves just as agitated by the distor-tions these tapes traffic in and consequently disposed to take action toward

disputing them. Much of the organized lesbian and gay response to the Religious Right's homophobic campaign has been propelled by the "corrective" urge, according to Ella Habib Shohat and Robert Stam, who observe that, "an obsession wth 'realism' casts the question as simply one of 'errors' and 'distortions,' as if the 'truth' of a community were unproblematic, transparent, and easily accessible, and 'lies' about that community easily unmasked."[24] Yet while the necessity—indeed, the urgency—of vehemently contradicting the falsity of *Gay Rights, Special Rights* is indisputable, to anchor one's criticism of it in truth claims is in some sense to miss the point that, to a large extent, the video operates best in the cognitive realms outside of logic. Consider, for example, the trope of child molestation common to all homophobic discourse. When publicly conducting analyses of *Gay Rights, Special Rights* and similar videos, lesbian and gay organizers routinely point out the exhaustively documented fact that child abuse is a crime overwhelmingly committed by heterosexual males, as a means of refuting the Religious Right's patently distorted construction of lesbians and gay men as menacing pedophiles, out to "recruit" unsuspecting minors to the "homosexual lifestyle." This matter-of-fact approach can hardly be faulted, but still proves inadequate in addressing the attendant question of the persistence of this trope. Its resonance, I suspect, has to do with a projection of the real anxieties felt by parents about child abuse onto the representational figure of the child—a figure that is itself an externalization of the parent. *Gay Rights, Special Rights* raises many such questions that, although beyond the scope of the present essay, clearly warrant further analysis.

I have had the opportunity to be present in a number of different lesbian and gay audiences where *Gay Rights, Special Rights* has been screened. These audiences have been variously small and large, composed of people who identify themselves as activists or just interested viewers, and alternately multiracial and predominantly white. Yet there is an audience response common to every one of thes screenings: laughter. At specific moments, the tape invariably elicits a peculiar laughter that cannot solely be ascribed to the camp sensibilities and readings-against-the-grain that queers bring to a text. This laughter may be interpreted as expressing at least two corresponding anxieties. On its surface, it seems to say, you can't be serious, this is too outrageous, how over the top can you be? The cursory knowledge of where *Gay Rights, Special Rights* originates activates a facile and commonplace condescension toward bornagain Christians, prompting the more worldly, urban queers to scoff—after all, aren't those fundamentalists just kooks, crackpots? This very condescension, however, also allowed many a cloistered urban queer to avoid treating the Oregon Citizen Alliance and Colorado for Family Values as serious political entities capable of manipulating the democratic mechanism of the initiative for their own antidemocratic purposes, until the fruit of their efforts could no

longer be ignored. But the queer laughter at *Gay Rights, Special Rights* may also be understood as nervous, or should I say embarrassed, laughter[25]—an embarrassment rooted in the element of self-recognition in viewing a caricature of oneself. *Gay Rights, Special Rights* isolates members of the lesbian and gay community's own marginalized sexual subcultures—S/M leatherfolk, drag queens and drag kings, homocore punks—and combines them with the spectacle, unique to homophobic propaganda, of the "reformed" or "recovered" homosexual, to puncture the respectable veneer of straight-acting lesbians and gay men and underwrite their construction of the essential pathology of lesbians and gay men. The laughter heard while watching *Gay Rights, Special Rights* results from the sparks thrown up by the scraping of the Right's wedge against the shell of queer identity.

Durham, North Carolina, was the site of 1993's Creating Change conference, an annual gathering sponsored by the National Gay and Lesbian Task Force. During a three-day-long intensive workshop on fighting the Religious Right, *Gay Rights, Special Rights* was screened before an audience of nearly four hundred organizers and activists from around the United States, many of whom had not seen the tape previously. As usual, some people laughed out loud while watching the tape, but for the most part emotions were brought to a rolling boil. The discussion that followed was punctuated by several impassioned comments about the more outrageously flamboyant leatherfolk and drag queens depicted in that tape's Gay Pride parade footage. Prior to the screening, one of the facilitators had rather sternly cautioned participants against making statements that marginalized leatherfolk or other sexual subcultures, thereby replicating the same marginalization practiced by heterosexuals against lesbians and gay men as a whole. Despite this injunction, one anguished participant, who had evidently summoned all her courage to stand up in front of the roomful of people and speak, tearfully demanded to know: "Why do they have to go out there and do that when we know that these people will be there with their cameras? Don't they know it only hurts us?" In this woman's cri de coeur there was a distant echo of gay liberationist Martha Shelley's observation, made after the North American Conference of Homophile Organizations twenty-five years earlier: "I have seen the respectable homosexual wincing in agony at the presence of a swish queen, or an obvious bull dyke—not out of dislike for [them] as a person, but out of fear of being associated with 'that queer,' even in an all-gay crowd."[26]

A staple of queer activist discussions such as the one at Creating Change is the ritual invocation of Internalized Homophobia. As activist shorthand that serves to denote a queer-specific mode of "false consciousness," Internalized Homophobia is at once taken to stand for a complex edifice of meaning and presumed to be transparent to every lesbian or gay man; much like a parking garage, Internalized Homophobia is a massive structure that you can see right

through. Self-hatred, however, refuses to be banished quite so easily. Gay clinical psychologist Walt Odets even submits that self-hatred is constitutive of contemporary gay identity, noting that "homophobia . . . instills in the developing [lesbian or gay] adolescent a self-hatred and self-doubt that are, to varying degrees, lifelong problems."[27] Thus the repetition of the mantra of Internalized Homophobia not only diverts us from the actual operation of self-hatred within lesbian and gay experience, but it elides a more nuanced inquiry into how homophobic representations such as those issued by *Gay Rights, Special Rights* generate contradictions within victims of homophobia and how antigay propaganda, of which *Gay Rights, Special Rights* is emblematic, functions directly as psychological warfare against lesbians and gay men.

The psychic toll of homophobic propaganda upon lesbians and gay men goes far deeper than activist discourse admits. The incendiary rhetoric and images of *Gay Rights, Special Rights* have traumatized many lesbians and gay men who have viewed it. Bombarded with the concentrated pressure of its images, our ever-fragile self-esteem begins to bifurcate. We shudder at the "spoiled" images of our collective selves. I do not mean to suggest that *Gay Rights, Special Rights,* by itself, causes this bifurcation or fragmentation in the lesbian or gay viewer; rather, it is the cumulative force of having virtually every awful thing straight society has ever said about us—"sick," "guilty," "worthless," "doomed"—amalgamated into one terrific wallop. Apart from the obvious feelings of anger that tapes like *Gay Rights, Special Rights* and *The Gay Agenda* provoke, many viewers I have spoken with described feelings of overwhelming disconsolation or despair after seeing it. The tape blends half-truths with gross distortions and outright lies so seamlessly that even for the viewer equipped with critical viewing skills and vocabulary, the cumulative effect is one of inundation or helplessness. One scarcely knows where to begin to refute the claims made in the tape. The toxic nuggets lodge tenaciously, like shrapnel, in the unconscious of the queer viewer, where they continue to seethe long afterward.

Although the power of the Religious Right can no longer be underestimated, there are also ample reasons why it should not be exaggerated, either. Demagogues such as Pat Robertson and Lou Sheldon are enjoying a moment of legitimation, but the Far Right's hold on the actual levers of government is not as hegemonic as its spokespeople would have it. To some extent, this is because the extreme views of the Religious Right's leaders on a spectrum of issues engender internecine ambivalence, if not outright scorn, within many of the secular and comparatively more moderate precincts of the Republican Party. What is more, the November 1994 elections have had the incontrovertible effect of putting the Far Right's ascendance, and strategies for reversing it, firmly on the agenda of progressive activists and intellectuals virtually everywhere, thus occasioning a flood of public discussion and debate that is long

overdue. Cultural producers, in particular, have been quick to recognize the phenomenon of the Far Right as both a challenge and an incentive.[28] Even among the media interventions produced by queers specifically to address the Right's homophobic agenda, we can already look to examples as formally varied as electoral campaign commercials, feature-length documentaries (Deborah Fort and Ann Skinner-Jones's *The Great Divide* [1994], Heather MacDonald's *Ballot Measure 9* [1995]), portions of public television series ("Culture Wars," the second installment of Testing the Limits' *The Question of Equality* [1995]), first-person video diaries (Pam Walton's Family Values [1996]), and experimental shorts (Tom Kalin's *Confirmed Bachelor* [1994]). There is a tendency, evident in many of these works, to refute or replace the claims made by such tapes as *Gay Rights, Special Rights* or *The Gay Agenda* with truth claims of our own. Yet even when this tendency takes the form of satire or inversion, as in last year's lesbian and gay film festival favorite, *The Straight Agenda* (by John Binninger and Jacqueline Turnure, 1994), it seems to bind these works in an ultimately circuitous relationship, in which the work ends up chasing the tail of its referent. A more efficacious strategy for progressive media producers might be to examine any number of the larger social, cultural, or economic issues raised by the Religious Right's propaganda, instead of trying to dismantle this propaganda itself.

At the end of the day, even the smartest piece of media is no replacement for the exacting work of political organizing. In conclusion, I want to mention just one example of community-based "fight the Right" organizing that holds unique potential for mining the contradictions in the current situation, a few of which I have attempted to outline above. Early in 1994, several longtime African American lesbian and gay movement professionals, including Mandy Carter, of the Washington, D.C.–based Human Rights Campaign Fund (HRCF), and Donald Suggs, of the New York branch of the Gay and Lesbian Alliance against Defamation, initiated a peer-oriented dialogue about the Religious Right's nascent alliance with conservative people of color; the reactions of white lesbian and gay leaders to this alliance; and the larger cultural confrontation over the rhetoric of special rights. The result of this dialogue was the National Call to Resist, a joint project of the HRCF and the Black Gay and Lesbian Leadership Forum. Carter took the Call to Resist on the road and spent much of 1994 traveling to St. Louis, Detroit, Cleveland, and other cities targeted by the Religious Right for antigay initiatives, where she worked with African American lesbians and gay men on formulating local strategies for counteracting the incursions made by the Religious Right into communities of color. At every step, Carter screened and facilitated analyses of *Gay Rights, Special Rights* with local organizers. Her "traveling dialogue" then culminated in a September 1994 summit of lesbian and gay people of color that convened in Washington, D.C., on the same weekend as the Christian Coalition's annual Road to Victory

conference, where once again, *Gay Rights, Special Rights* was screened, and the communitywide analysis of the videotape and the issues it raises evolved even further. I do not cite the efforts of Carter or other activist lesbian and gay people of color simply because their efforts are exemplary or because they systematically combine media education with organizing, but because such activists are, as they themselves have pointed out, ideally situated to cultivate and exploit the contradictions involved in the courtship of people of color by the historically racist Religious Right. For it is these irreconcilable contradictions that will short-circuit the religious right's ability to use *Gay Rights, Special Rights* to pit queers and people of color against each other by falsely constructing us as rivals over constitutional rights.

Notes

1 See Bruce Barron, *Heaven on Earth? The Social and Political Agendas of Dominion Theology* (Grand Rapids: Zondervan, 1992), 9–18, and Sara Diamond, *Spiritual Warfare* (Boston: South End Press, 1989), 136–39.

2 See Joe Conason, "The Religious Right's Quiet Revival," *Nation,* 27 April 1992; Kate Cornell, "The Covert Tactics and Overt Agenda of the New Christian Right," *Covert Action Quarterly* 43 (winter 1992–93): 46; and John F. Persinos, "Has the Christian Right Taken Over the Republican Party?" *Campaigns and Elections* 14 (September 1994): 21.

3 Marc Cooper, "Salvation City," *Nation,* 2 January 1995, 9.

4 Jerome L. Himmelstein, *To The Right: The Transformation of American Conservatism* (Berkeley: University of California Press, 1990).

5 Jean Hardisty, "Constructing Homophobia," *Public Eye* (March 1993): 1.

6 Derrick A. Bell Jr., "The Referendum: Democracy's Barrier to Racial Equality," *Washington Law Review* 54, no. 1 (1978).

7 Dirk Johnson, "Colorado Justices Strike Down a Law against Gay Rights," *New York Times,* 12 October 1994, A-1.

8 Elise Harris, "Seizing the Initiative," *Out* 17 (November 1994): 102.

9 Frederick Clarkson and Skipp Porteous, *Challenging the Christian Right: The Activist's Handbook* (Great Barrington, MA: Institute for First Amendment Studies, 1993), 183.

10 David W. Dunlap, "Minister Brings Anti-Gay Message to the Spotlight," *New York Times,* 19 December 1994, A-16.

11 Renee DeLapp, Summary of Discussion Points, Traditional Values Coalition Videotape *Gay Rights/Special Rights* (report prepared by the Western States Center, Portland, Oreg., fall 1993), 7.

12 Eric K. Washington, "Freedom Rings: The Alliance between Blacks and Gays is Threatened by Mutual Inscrutability," *Village Voice,* June 29, 1993, 25. See also Deborah Toler, "Black Conservatives," *Public Eye* 7, nos. 3, 4 (September, December 1993).

13 Sara Diamond, "The Right's Grass Roots," *Z Magazine* (March 1992): 19.

14 Donald Suggs and Mandy Carter, "Cincinnati's Odd Couple," *New York Times,* 13 December 1993, A-17.

15 James M. Perry, "Soul Mates: The Christian Coalition Crusades to Broaden Rightist Political Base," *Wall Street Journal,* 19 July 1994, A-1.

16 Mab Segrest, *Memoir of a Race Traitor* (Boston: South End Press, 1994), 231.

17 For two divergent but mutually enriching perspectives on the differences and similarities

between racism and homophobia, see Henry Louis Gates Jr., "Backlash?" *New Yorker,* 17 May 1993, 42, and Phillip Brian Harper, "Racism and Homophobia as Reflections on Their Perpetrators," in *Homophobia: How We All Pay the Price,* ed. Warren J. Blumenfeld (Boston: Beacon Press, 1992), 57.

18 I am grateful to Donald Suggs, public affairs director at the Gay and Lesbian Alliance against Defamation (GLAAD) for this observation.

19 Washington, "Freedom Rings."

20 Liz Galst, "Voting with the Enemy," *Village Voice,* 8 December 1993.

21 Michael P. Farris, *Where Do I Draw the Line?* (Minneapolis: Bethany House, 1992), 142.

22 Michael Omi and Howard Winant, *Racial Formation in the United States from the 1960s to the 1990s* (New York: Routledge, 1986), 117.

23 Jacques Ellul, *Propaganda: The Formation of Men's Attitudes* (New York: Vintage, 1973), 70.

24 Ella Habib Shohat and Robert Stam, *Unthinking Eurocentrism: Multiculturalism and the Media* (New York: Routledge, 1994), 178.

25 I am indebted to David Deitcher for suggesting this to me.

26 Martha Shelley, "Respectability," *The Ladder* 14, nos. 1 and 2 (October/November 1969): 24.

27 Walt Odets, "Psychological and Educational Challenges for the Gay and Bisexual Male Communities" (paper presented to the AIDS Prevention Summit sponsored by the American Association of Physicians for Human Rights, Dallas, Tex., July 1994).

28 These films and videos are available from the following distributors: *Ballot Measure 9* (1995), produced by Heather MacDonald, distributed by Zeitgeist Films, 247 Centre Street, 2d Floor, New York, N.Y. 10012; *Confirmed Bachelor* (1994), produced by Tom Kalin, distributed by Electronic Arts Intermix, 536 Broadway, 9th Floor, New York, N.Y. 10012; *The Great Divide* (1994), produced by Deborah Fort and Ann Skinner-Jones, distributed by DNA Productions, P.O. Box 22216, Santa Fe, N.Mex. 87505; *Family Values* (1996), produced by Pam Walton, distributed by Filmmaker's Library, 124 East 40th Street, New York, N.Y. 10016; *The Question of Equality* (1995), produced by Testing the Limits, distributed by KQED Books and Tapes, 2601 Mariposa Street, San Francisco, Calif. 94110–1400; *The Straight Agenda* (1994), produced by John Binninger and Jacqueline Turnure, Fair Is Fair Productions, 784 Dolores Street, San Francisco, Calif. 94110.

Contributors

Maurice Berger is a Senior Fellow at the Vera List Center for Art and Politics, New School for Social Research. He is the author of numerous books, articles, and curatorial essays. His most recent books are *White Lies: Race and the Myth of Whiteness* and *The Crisis of Criticism*.

Richard Bolton is an artist, writer, filmmaker, and Web designer. He lives in Los Angeles.

Ann Cvetkovich is an Associate Professor of English at the University of Texas, Austin. She is the author of *Mixed Feelings: Feminism, Mass Culture, and Victorian Sensationalism* and coeditor with Doug Kellner of *Articulating the Global and the Local*. She has published articles in the collections *Lesbian Erotics* and *Butch/Femme: Inside Lesbian Gender* and in *GLQ: A Journal of Gay and Lesbian Studies*.

Coco Fusco, an artist and writer, is currently Assistant Professor in the Department of Painting, Drawing and Sculpture at the Tyler School of Art. She is the author of *English Is Broken Here: Notes on Cultural Fusion in the Americas*.

Brian Goldfarb teaches theory and production of new media technologies at the University of Rochester. He was Curator of Education at the New Museum of Contemporary Art in New York, where he curated *alt.youth.media*, an exhibition of electronic media by and for youth. His writing on education, public art, and new media technologies has appeared in *Incorporations* (Zone volume 6), *The Independent*, and *Iris*.

Mable Haddock is Executive Director of the National Black Programming Consortium in Columbus, Ohio.

Grant H. Kester is Assistant Professor of Art History in the Department of Fine Arts at Washington State University. He is the editor of the "Aesthetics and the Body Politic" issue of the *Art Journal* (spring 1997). Between 1990 and 1995 he was coeditor and senior editor of *Afterimage*.

Chiquita Mullins Lee is Program Development Coordinator at the National Black Programming Consortium in Columbus, Ohio.

Darrell Moore is an Assistant Professor of Philosophy at DePaul University. He researches and teaches in the fields of political philosophy and cultural theory.

Ioannis Mookas is an independent producer, writer, and media activist. His videos include *Peer Education, Not Fear Education* (1995), and *Only Human: HIV-Negative Gay Men in the AIDS Epidemic* (1998). He is the editor of *The AIVF Self-Distribution Toolkit*, a comprehensive resource guide published by the Association of Independent Video and Filmmakers.

Lorraine O'Grady is an artist and critic living in New York City. Her work has been included in numerous one-person and group exhibitions at such venues as the Institute of Contemporary Art in Boston (1996), the Southeastern Center for Contemporary Art (1993), and the Bronx Museum/Paine Weber Gallery (1992). She is currently an instructor at the School of the Visual Arts and a Senior Fellow at the Vera List Center for Art and Politics at the New School for Social Research.

Michael Renov is Professor of Critical Studies in the School of Cinema-Television at the University of Southern California. He is the author of *Hollywood's Wartime Woman: Representation and Ideology*, editor of *Theorizing Documentary*, and coeditor of *Resolutions: Contemporary Video Practices*.

Martha Rosler is an artist working primarily with photography, text, and video. She is Professor of Art at Rutgers University and occasionally writes about art.

Patricia Thomson is editor in chief of the *Independent Film and Video Monthly*.

David Trend is the Chair of the Studio Art Department at the University of California, Irvine. He is the author of *Cultural Democracy: Politics, Media, New Technology; The Crisis of Meaning in Culture and Education;* and the editor of *Radical Democracy: Identity, Citizenship, and the State*.

Charles A. Wright Jr. is a curator and critic living in New York City.

Patricia R. Zimmermann is Associate Professor of Cinema and Photography at Ithaca College. She is currently working on a book, *Endangered Species: Documentaries and Democracies,* from which her *Afterimage* article is excerpted.

Index

Library of Congress Cataloging-in-Publication Data
Art, activism, and oppositionality : essays from "Afterimage" /
Grant H. Kester, editor.
ISBN 0-8223-2081-9 (alk. paper). — ISBN 0-8223-2095-9 (pbk. : alk. paper)
1. Arts—Political aspects—United States. 2. Multiculturalism—
United States. 3. Artists and community—United States.
I. Kester, Grant H. II. Afterimage.
NX180.S6A677 1998 700'.973—dc21 97-32124 CIP